Praise for *Faces of Compassion*

"I appreciate Taigen Dan Leighton's elucidation of the bodhisattvas as archetypes embodying awakened spiritual human qualities and his examples of individuals who personify these aspects. In naming, describing, and illustrating the individual bodhisattvas, his book is an informative and valuable resource."

—Jean Shinoda Bolen, M.D., author of *Goddesses in Everywoman and Gods in Everyman* .

"Vigorous and inspiring, *Faces of Compassion* guides the reader into the clear flavors of the awakening life within both Buddhist tradition and our broad contemporary world. This is an informative, useful, and exhilarating work of deeply grounded scholarship and insight."

—Jane Hirshfield, author of *Women in Praise of the Sacred*

"Such a useful book. Mr. Leighton clarifies and explains aspects of Buddhism which are often mysterious to the uninformed. The concept of the bodhisattva—one who postpones personal salvation to serve others—is the perfect antidote to today's spiritual materialism where 'enlightened selfishness' has been enshrined as dogma for the greedy. This book is useful as a fine axe."

—Peter Coyote, actor and author of *Sleeping Where I Fall*

"In *Faces of Compassion*, Taigen Leighton provides us with a clear-as-a-bell introduction to Buddhist thought, as well as a short course in Far Eastern iconography and lore that I intend to use as a desk reference. What astonishes me, however, is that along the way he also manages, with surprising plausibility, to portray figures as diverse as Gertrude Stein, Bob Dylan, and Albert Einstein, among many likely and unlikely others, as equivalent Western expressions of the bodhisattva archetype. His discussion provides the sort of informed daring we need to make Buddhism our own."

—Zoketsu Norman Fischer, Senior Dharma Teacher of San Francisco Zen Center and author of *Jerusalem Moonlight*

"Like boys flying kites, spiritual writers tend to let their teachings jounce high in the clouds somewhere. Not so Taigen Dan Leighton. He resolutely reels them down. In *Faces of Compassion* he presents Buddhist ideas and ideals embodied in flesh-and-blood people, examples whom we can love, admire, emulate: a stroke of genius. The result: A sparkler among contemporary Buddhist writings."

—Brother David Steindl-Rast, O.S.B., author of
Gratefulness the Heart of Prayer

FACES OF COMPASSION

Faces of Compassion

Classic Bodhisattva Archetypes and
Their Modern Expression

REVISED EDITION
Formerly published as *Bodhisattva Archetypes:*
Classic Buddhist Guides to Awakening
and Their Modern Expression

Taigen Dan Leighton
Foreword by Joan Halifax

Wisdom Publications • Boston

Wisdom Publications
199 Elm Street
Somerville, MA 02144 USA
www.wisdompubs.org

© 2003 Taigen Dan Leighton

Library of Congress Cataloging-in-Publication Data
Leighton, Taigen Daniel.
 Faces of Compassion : classic Bodhisattva archetypes and their modern
expression / Taigen Dan Leighton.— 1st Wisdom edition
 p. cm.
Includes bibliographical references and index.
 ISBN 0-86171-333-8 (pbk. : alk. paper)
 1. Bodhisattvas. 2. Bodhisattva (The concept) 3. Bodhisattvas in
art. 4. Religious life—Buddhism. 5. Mahayana Buddhism—Doctrines.
I. Title.
 BQ4695 .L46 2002
 294.3'4213—dc21 2002155475

First Wisdom edition
07 06 05 04 03
5 4 3 2 1

Grateful acknowledgement is made for permission to reprint the following copyrighted works:
Poem by Daigu Ryokan, translated by Taigen Dan Leighton and Kazuaki Tanahashi, from *Essential Zen*,
 edited by Kazuaki Tanahashi and Tensho David Schneider. Copyright © 1994 by HarperCollins
 Publishers. By permission of HarperCollins Publishers.
Three selections from *Temple Dusk: Zen Haiku* (1992) by Mitsu Suzuki with permission of Parallax Press,
 Berkeley, California, www.parallax.org.
Excerpt from "Maitreya Poem" from *Ring of Bone* by Lew Welch. Copyright © 1979 by permission of
 Grey Fox Press.
Excerpt from *One Generation After* by Elie Wiesel. Copyright © 1965, 1967, 1970 by Elie Wiesel. Reprinted
 by permission of George Borchardt, Inc., for the author.

Designed and typeset in Monotype Garamond by Gopa & Ted2
Author's photo by Tim Szymanski

*This book is dedicated
to my parents, Joseph and Rosalind,
who were teaching me about bodhisattvas
before they ever heard the word.*

Publisher's Acknowledgment

The Publisher gratefully acknowledges the kind generosity of the
Hershey Family Foundation in sponsoring the publication of this book.

May all awakening beings extend with true compassion
their luminous mirror wisdom.
May the merit and virtue
of these considerations of the bodhisattvas,
both of the words herein and in the readers' hearts,
be extended to all beings,
that all may find their unique, sparkling place
in the way of awakening;
and may the practice of awakening go on endlessly.

—Adapted from a traditional Soto Zen dedication chant

Contents

List of Illustrations

Manjushri goddess on bicycle
painting by and photograph courtesy of Mayumi Oda

Chapter 6. Samantabhadra

Samantabhadra, China
collection of Djann Hoffman

Lotus Sutra Samantabhadra, Japan, circa 13th–14th centuries
Asian Art Museum of San Francisco, The Avery Brundage Collection,
B60D41+. Used by permission.

Samantabhadra, Japan, 18th century
photograph by Taigen Dan Leighton

Samantabhadra, China
photograph by Rob Lee

Samantabhadra, Japan
photograph by Taigen Dan Leighton

Samantabhadra goddess on bicycle
painting by and photograph courtesy of Mayumi Oda

Chapter 7. Avalokiteshvara (Guanyin, Kannon)

Kwanseum, Korea, 17th century
Asian Art Museum of San Francisco, The Avery Brundage Collection,
B65D44. Used by permission.

Kannon, Japan
photograph by Rob Lee, image courtesy San Francisco Zen Center

Chenrezig, Tibet, 18th century
Asian Art Museum of San Francisco, The Avery Brundage Collection,
B60B138. Used by permission.

Multi-armed Kannon, Japan, circa 12th century
restoration and photograph by lack Van Allen

Nyoirin Kannon, "Turning the Wish-Fulfilling Gem," Japan
photograph by Rob Lee, image courtesy San Francisco Zen Center

Kitchen Kannon
painting by and photograph courtesy of Mayumi Oda

Guanyin in royal-ease pose, China, 12th century
Asian Art Museum of San Francisco, The Avery Brundage Collection,
B60S24+. Used by permission.

Hotei
photograph by Rob Lee

Maitreya Goddess
painting by and photograph courtesy Mayumi Oda

CHAPTER 10. VIMALAKIRTI

Votive stele with upper scene of Vimalakirti debating Manjushri, China, dated 549
Asian Art Museum of San Francisco, The Avery Brundage Collection, B62S2+. Used by permission.

Vimalakirti holding a galaxy, adapted from a sutra illustration, China
Photograph by Edward Brown

Vimalakirti's Silence, painting by Zen Master Hakuin, 18th century
Image from *Manual of Zen Buddhism*, D. T. Suzuki, used by permission of Grove/Atlantic, Inc.

Foreword
Lotus in a Sea of Fire

WHEN WE CONSIDER the history of the bodhisattva archetypes, we touch the whole and long history of Buddhism. We also touch the present moment, and the suffering of all beings in the world today. And we are invited to consider the future and how we must live, with courage and love wrapping around each other that we and all beings may awaken from this rough dream of our present world to a world that is sane and kinder.

The bodhisattvas blossomed like fine and rare flowers in China some two thousand years ago—though their seeds are everywhere in the old Buddhism of India and we feel their presence in the four boundless abodes of loving-kindness, compassion, sympathetic joy, and equanimity.

With the advent of Buddhism to China and the opening of practice and devotion to the world of lay people, active and compassionate archetypes developed in the ground of everyday life and in the popular imagination. These archetypes have a very human feel to them. They are not remote or passive—but rather involved with the world, with you and me, with all beings.

The bodhisattva archetypes all manifest flavors of compassion, and each bodhisattva has delayed her or his departure from the world of samsara until beings everywhere are free of suffering. Their sacrifice touches us and has inspired millions for thousands of years. And their presence is in our very time pointing to guiding principles for a more compassionate and sane world.

Though bodhisattvas are mythic figures, they also are functions within the psyche, archetypes of compassion; and myth and psychology fuse in the presence and activity of these compassionate beings.

Tibetan Buddhists call bodhisattvas "Awakened Warriors," for they manifest great strength of character and virtue for the sake of others. And as all bodhisattvas forever practice the perfections of generosity, wholesomeness, patience, enthusiasm, mental stability, wisdom, steadfast dedication, skillful

modes, powers, and helpful knowledge, they nourish these qualities in us as we study, practice with, offer devotion to, and emulate them; finally we may discover that we are they.

The heart of the bodhisattva is always turned toward other beings. Such a one chooses to place herself in the most difficult situations, and has the energy and natural commitment to harrow souls from the hells that they have created. And she does this with no attachment to outcome, with a spirit of radical optimism.

Indeed, the whole life of the bodhisattva is nothing other than helping others. Yet the bodhisattva is like a wooden puppet whose strings are pulled by the suffering of the world. There is a feeling of choicelessness and egolessness when the archetype of the bodhisattva is realized. The right hand takes care of the left without hesitation, not shining from praise or shrinking from blame.

Bodhisattvas also realize the great natural boundlessness of mind and heart, and are the exemplars of mother-wisdom. They cannot be burned by the fire of the world though they stand in the middle of it, a lotus in a sea of fire. They inspire veneration—whether we are Buddhist, Christian, Jew, Muslim, or just plain human—and remind us of what we can be and how we can be in the face of outrage and misery.

Faces of Compassion is a wonderful resource and source of guidance and teaching. I am very grateful to Taigen Leighton for his careful research and inimitable spirit. Both make this important work an invaluable companion to our lives.

Each night, the echoes of this chant, the Four Bodhisattva Vows, can be heard in many Buddhist temples around the world:

> *Creations are numberless, I vow to free them.*
> *Delusions are inexhaustible, I vow to transform them.*
> *Reality is boundless, I vow to perceive it.*
> *The enlightened Way is unsurpassable, I vow to embody it.*

This is we who are making the bodhisattva's vows—and what are we vowing, other than to be who we really are?

Joan Halifax Roshi
Upaya Insitute, New Mexico

Preface

THIS BOOK is an introduction to the psychology of bodhisattva practice, imagery, and imagination, directed at the many Westerners now exploring traditional resources for spiritual values and for wholesome, productive lifestyles. We will explore the major East Asian bodhisattva figures who represent various aspects of enlightened activity and awareness and are forces for well-being in our lives.

These bodhisattvas are Manjushri, expounder of wisdom; Samantabhadra with shining practice; compassionate Avalokiteshvara (perhaps more familiar as Kannon, Guanyin, or Chenrezig); Kshitigarbha (certainly far more familiar as the Japanese Jizo); Maitreya, the future Buddha (well known in the guise of the Chinese fat, laughing buddha); Vimalakirti, the enlightened layman; and the historical Buddha Shakyamuni (before becoming the Buddha, himself a bodhisattva known as Siddhartha Gautama). All of these figures, in their images and even their names, have entered Western culture as Buddhist practice has been transplanted here. But as yet, there has been no comprehensive introduction to the background and significance of these characters and their enlightening realms, a need this volume aims to redress.

This book does not aspire to present a scholarly, exhaustive survey of the full historical development, or every symbolic aspect of the iconography of the major bodhisattva figures. Nor would I presume or desire to present a neat systematic encapsulation of all Mahayana Buddhist doctrine and potentiality. Rather, this is an overview for a general audience of the bodhisattva figures and their stories as valuable psychological and spiritual resources. This book will provide general surveys of the history and modes of the bodhisattvas as a reference for seasoned Buddhist practitioners and students, while also serving as an introduction to the tradition for spiritually interested newcomers. Although it is clear from the work of modern his-

torians that the realities of Asian history and of social organization in Mahayana cultures often have fallen short of actualizing the bodhisattva ideal, in studying that ideal we may reclaim the Mahayana rhetoric and worldview and apply it to the urgent issues in our world today. I sincerely hope that this introductory survey will inspire further studies of the bodhisattvas and their history, both scholarly and practical, as well as renewed creative application and integration of these figures into modern Western cultures.

My focus for this study is the bodhisattva imagery and lore from East Asia, although I will make some reference to Indian origins and contemporary Tibetan understandings. My own background as a longtime practitioner and priest in the Japanese Soto Zen tradition—mostly in America with a number of Japanese and American teachers, and also for two years in Japan—may inevitably color my approach to a certain degree. Yet, I also have some small practice experience with Tibetan, Vietnamese, and Burmese Buddhist teachers, and have attempted to incorporate as wide a perspective as possible into this presentation of the bodhisattva figures. I have offered some interpretations and perspectives arising from my own practice and experience, hoping to provoke further interest and contemplation of the bodhisattvas and their work. But certainly this book is not the final word on the bodhisattvas, and significant viewpoints and interpretations of the bodhisattvas may remain unnoted.

The archetypal bodhisattva figures are living and evolving as dynamic embodiments of spiritual life and activity and are not the property of any particular tradition or religious institution. Included here among exemplars of the different archetypal bodhisattva figures are a variety of familiar, modern personages from non-Buddhist spiritual traditions. It is my hope that this will demonstrate that we may readily view the bodhisattvas as spiritual helpers in the world quite apart from any restriction or allegiance to the "Buddhist religion."

By featuring some of the people in our own world who are spiritual benefactors, I wish to encourage recognition that, indeed, despite all the problems, cruelty, and despair of our world, we need not see the bodhisattva ideal as irrelevant, idealistic, or beyond our reach. I have enjoyed selecting these exemplars, taking the opportunity to celebrate some of the people who have been personally inspiring to me. Although I have attempted to mention people from a range of arenas and contexts, any personal selection will be to some degree idiosyncratic. A great many more bodhisattva guides will come to mind for each reader upon even slight consideration.

The examples herein include persons of our own time, and some still alive. This is not to demean the ageless ancient great cosmic bodhisattvas, but rather to incite deeper consideration of the meaning of awakening activity and awareness in the contemporary world. I hope these sometimes provocative examples will demonstrate that the timeless inclination toward awakening is still active. Spiritual development and awakening still occur in the world, and enlightening beings still walk among us, perhaps helping and inspiring us where we might least expect them.

The three opening chapters provide an overview and introduction to Mahayana philosophy, history, and practice as a background to consideration of the seven featured bodhisattva figures. In the interest of making this book more accessible to general readers, I have refrained from using extensive footnotes, but have given citations for sources of quotes in notes at the end of the book, divided by chapters. An annotated bibliography also appears at the end to reference the sources used for each chapter. A chart with aspects of the seven major bodhisattvas is given as an appendix, including their names, main sutras and schools, primary iconographic features, associated figures and sacred sites, and principal modes of practice. This chart may serve readers as a helpful reference tool while navigating the strange Asian names in the text.

The names of the bodhisattvas are given first in the text in Sanskrit, with Chinese and Japanese versions provided, as well as in Tibetan and Korean as relevant. In most cases I have primarily used the Sanskrit names, even when referring to their East Asian manifestations. An exception is made for Kshitigarbha, who because he is so much better known by his Japanese name Jizo, is referred to by that one instead. Avalokiteshvara is also well known by her Chinese name Guanyin and her Japanese names Kannon and Kanzeon, and I use all of these names for Avalokiteshvara as appropriate to context—but in terms of the overall Avalokiteshvara archetype these names can be seen as generally interchangeable.

I have employed the common simplified systems of transliterations, refraining from macrons and other diacritical marks. In Sanskrit words, *sh* has been used as an approximate pronunciation for the various *s* letters that would appear technically with diacriticals. Similarly, I have used *ch* in accord with the pronunciation for Sanskrit words traditionally transliterated with *c* letters before vowels, for example *Yogachara* instead of *Yogacara* and *bodhichitta* instead of *bodhicitta*.

The contemporary pinyin transliteration system has been employed for Chinese words and names. The greatest difficulties of pronunciation with this system are syllables beginning *q*, pronounced like *ch*; *x*, which is pronounced like *hs_*; and *c*, pronounced like *ts_*. An exception to the use of pinyin in this book is made for references to the Chinese religion Taoism, which has entered English usage with that spelling, rather than the pinyin *Daoism*.

Acknowledgments

OVER A PERIOD OF YEARS a number of people have contributed to my thinking about bodhisattvas as archetypes, either in informal discussion or in classes. Others have suggested exemplars I cite herein, or shared with me their personal experiences of some of these exemplars. I would like to thank the following people for their helpful input: Stephen Colgan, Sonja Gardenswartz, Djann Hoffman, Lisa Faithorn, Joanna Macy, Reb Anderson, Alan Senauke, Diane Martin, Tom Skomski, Jack Earley, Patricia Gleeson, A. J. Dickinson, Rick Sowash, Michael Monteko, John Heinz, Mark Tatz, Shari Young, Gary Snyder, Linda Grotelueschen, Wendy Lewis, Linda Kotcher, Ann Overton, Mayumi Oda, Mel Weitsman, Fran Macy, Norman Waddell, Preston Houser, Jack Van Allen, Richard Payne, Melvin McLeod, Peter Rutter, Elaine Parliman, Charles Page, Martha Wax, Marge Franz, Ruth Poritz, and David Chadwick. Of course, any misstatements, errors, confusion, or distortions in what follows are solely my responsibility.

I am grateful for the scholarly edit as well as general reading and helpful suggestions of Nancy Tingley. In addition, Susan Moon, Ellen Randall, Gaelyn Godwin, Stephen Colgan, Shari Young, Gary Thorp, and Rosalind Leighton read portions of the work and all contributed valuable suggestions. Thanks also for the valuable research assistance of Rosalind Leighton and Ellen Randall; and for consultations on Sanskrit terms, thanks to Myo Lahey. Thanks to my agent, Victoria Shoemaker, for patience and assistance with myriad questions and details; also to David Stanford, who skillfully helped in the initial honing of this book. I am grateful to Josh Bartok and Wisdom Publications for help with this revised edition, and for keeping this book in print.

Many thanks for assistance with the collection and providing of illustrations are due Mayumi Oda, Rosalie Curtis, Djann Hoffman, Rob Lee, Jack

Van Allen, Lani Roberts, Ed Brown, Hanni Forester, Ann Overton, Alan Senauke, Dorje Lama at the Tibet Shop in San Francisco, Thomas Flechtner, Marc Alexander, Meiya Wender, Blanche Hartman, Dennak Murphy, and John Einarsen. Credits for the specific photographs are listed following the table of contents.

Along with sources cited in the bibliography, I am especially grateful to Daniel Ellsberg for kindly providing me with excerpts from his forthcoming memoirs containing material referred to in chapter 4.

I would like to thank all of my teachers for their guidance. But it would be impossible to name them all since teachers are everywhere, in all our life experiences. Of the exemplars of the bodhisattva archetypes to be cited in the text, about a dozen of them have been, mostly from afar, important examples and mentors in my own life. Many other particularly helpful guides have appeared in various circumstances. Although too numerous to name, without many of them this book would not have happened.

I am especially thankful for the personal guidance in the study of the Buddhist texts of Reb Anderson, Thomas Cleary, Kaz Tanahashi, Yi Wu, and Shohaku Okumura. I also acknowledge and express my deep gratitude to my formal spiritual teachers, Zen masters all, firstly Kando Nakajima, who initiated me into Zen Buddhist practice, as well as Richard Baker, Dainin Katagiri, Blanche Hartman, Shohaku Okumura, Shinkai Tanaka, and Ikko Narasaki, to all of whom I am indebted. Foremost, from early on and throughout, I thank my ordination and transmission teacher, Reb Anderson, for whose subtle, patient, and at times drastic guidance I am unspeakably grateful.

Finally, I am deeply grateful to Ellen Randall, whose support, patience, and loving-kindness during the process of writing this book was a great encouragement.

1 The Bodhisattva Ideal
Benefiting Beings

BODHISATTVAS are beings who are dedicated to the universal awakening, or enlightenment, of everyone. They exist as guides and providers of succor to suffering beings, and offer everyone an approach to meaningful spiritual life. This book is a practical, contemporary guide to the major traditional bodhisattva figures. Through the models of these bodhisattvas we may find our own approach to the spiritual journey that acknowledges and connects with all of creation.

A buddha, or "awakened one," has fully realized liberation from the suffering of afflictive delusions and conditioning. This liberating awakening of a buddha is realized through deep experiential awareness of the inalienable undefiled nature of all beings and phenomena, all appreciated as essentially pristine and imbued with clarity. There is a way in which everything is all right, just as it is. Such insight in turn can be said in some ultimate sense to actualize this liberation for all beings, who may, however, not yet realize this truth of openness and freedom themselves due to obstructions from their own individual, deluded consciousness.

A bodhisattva, carrying out the work of buddhas, vows not to personally settle into the salvation of final buddhahood until she or he can assist all beings throughout the vast reaches of time and space to fully realize this liberated experience.

The bodhisattva path is not restrictive or exclusive, but offers a wide array of psychological tools for finding our personal path toward a meaningful, constructive lifestyle. By following teachings about generosity, patience, ethical conduct, meditative balance, and insight into what is essential, we can

come to live so as to benefit others. Thereby we also learn compassion for ourselves and see that we are not separate from the persons we have imagined as estranged from us and as opposing our hopes and desires. Self and other heal together.

The bodhisattva is the heroic ideal of Mahayana "Great Vehicle" Buddhism, the dominant branch of Buddhism in North Asia: Tibet, China, Mongolia, Taiwan, Korea, and Japan, as well as Vietnam in Southeast Asia. This tradition is now spreading and being adapted to Western cultures. The word *bodhisattva* comes from the Sanskrit roots *bodhi*, meaning "awakening" or "enlightenment," and *sattva*, meaning "sentient being." *Sattva* also has etymological roots that include "intention," meaning the intention to awaken, and "courage" or "heroism," referring to the resolution and strength involved in this path. Bodhisattvas are enlightening, radiant beings who exist in innumerable forms, valiantly functioning in helpful ways right in the middle of the busy-ness of the world. As soon as we are struck with our own urge or intention to take on such a bodhisattva practice, we also are included in the ranks of the bodhisattvas. Bodhisattvas can be awesome in their power, radiance, and wisdom; or they can be as ordinary as your next-door neighbor.

Bodhisattvas are not restricted to the Buddhist religious institution. A bodhisattva appears in whatever milieu is most helpful according to this way of seeing spiritual practice, which has been preserved not only in Buddhism but in many of humanity's cultures through aesthetic, socially progressive, philosophical, technological, or charitable forms. We may acknowledge as bodhisattvas persons from all spiritual and cultural traditions, not only Buddhism. In the opening chapters we will discuss some of the principles of bodhisattva activity common to all of them, before exploring the stories of each of the major archetypal bodhisattva figures.

BODHISATTVAS AS ARCHETYPES

We can gain insight and guidance into how to engage in spiritual practice and live wholeheartedly, in accord with the light of the bodhisattva tradition, by studying seven bodhisattva figures as psychological and spiritual models. Some of these bodhisattvas are mythical figures; others are based on actual persons in human history. Most appear in a variety of forms. Many specific historical personages traditionally have been designated as incarnations or representatives of these primary bodhisattva figures.

The bodhisattvas presented in this book are considered as archetypes, fundamental models of dominant psychic aspects of the enlightening being. They certainly overlap in their qualities as bodhisattvas, sometimes considerably, but each emphasizes particular aspects or modes of awakening, and each reveals an overall character and style that practitioners may identify or align with at different times or phases in their practice. As they work together for universal liberation, as archetypes all of these bodhisattvas have their own psychological approach and strategy toward practice and their own function as spiritual resources. They exist as external forces to provide encouragement and support, as internal energies to be fostered, and, above all, as examples of modes of awakened practice to emulate and incorporate.

Archetypes are crystallizations of components of the psyche, and catalysts to self-understanding. In Western psychology Carl Jung and his followers have studied the way in which humans externalize and project certain unconscious, instinctual patterns of their own character onto others. Many of the world's mythologies reflect these psychological patterns and potentialities. By examining such common patterns we can recognize and understand aspects of ourselves. *If all beings have the capacity for clear, open, awakened awareness posited by the teaching of buddha nature, then by seeing the bodhisattvas as archetypes, patterns, or approaches to awakening activity, we may learn models with which we can each express the elements of our own enlightening and beneficial nature.*

Some of the major bodhisattva figures are traditionally androgynous, especially Avalokiteshvara, who is venerated in both male and female forms. In their archetypal expressions among worthy people in our world, all these figures are manifested by both women and men. Unlike the Greek gods and goddesses, the bodhisattvas are not archetypes specifically *of men* or *of women*, but of all human beings as positive spiritual agents. Occasions when some of these bodhisattvas have taken on forms or practices that illuminate gender issues will be discussed, but these distinctions are always secondary to the fundamental problem of alleviating suffering and liberating all beings.

The bodhisattvas do not usually have as wide a body of mythic tales as the Greek gods and goddesses; they are not archetypes of aspects of the psyche in the same sense as the fleshed-out characters of Greek myth. Yet, we may view bodhisattvas archetypally because, in the lore that has accumulated around each figure, we may indeed discern emerging patterns and styles of spiritual activity.

The archetypal characters of the bodhisattvas are clarified through the stories about their complex, varying iconography, the different forms in

which they commonly appear, through their evolving role in Mahayana cultural traditions, and through their diverse forms in different Buddhist cultures and in the cults that have venerated them. Many of the bodhisattvas have particular mountains or other sacred sites dedicated to their worship, as well as a rich folklore of colorful teaching anecdotes about them. Traditionally the different figures also are considered to embody particular sutras, schools, and philosophical branches of the Mahayana teaching. Thus we might make sense of the full range and diversity of the Mahayana Buddhist doctrines by seeing how they are represented by the various bodhisattva figures.

SUGGESTING CONTEMPORARY EXEMPLARS

In addition to identifying people who have been designated historically as examples of these bodhisattvas, we may speculate about contemporary and traditional figures of Western culture who might be viewed as representatives of these archetypes. Some of the exemplars mentioned herein will be my own associations, including those who have personally inspired me. Other exemplars come from the suggestions of students in classes that I have led concerning the bodhisattvas. You are invited to identify further examples, in your own life as well as among culture heroes. There is nothing ironclad about the associations presented in this book, and many exemplars might easily fit into more than one category. The process of suggesting exemplars may help us to see the aspects of these spiritual archetypes that are closest to us, and that we can more fully adopt for ourselves. This may also give us a perspective on the relevance to contemporary spiritual needs and concerns of the different bodhisattvas.

I want to make it explicit at this point that by designating known persons as examples of the bodhisattva archetypes, I am certainly not saying that these persons are (or are not) bodhisattvas, or even "saints" for that matter. Nor am I attempting to "claim" them for the Buddhist religion. The point is that everyone has the capacity to act as a bodhisattva. Furthermore, everybody, at some times and in ordinary everyday ways, does act kindly and beneficially as a bodhisattva. All human beings, even great cultural heroes, might also at times act in unfortunate ways, out of small-mindedness and from petty concerns or desires.

The persons to be cited as exemplars, as diverse as Albert Einstein, Martin Luther King, Jr., Mother Teresa, Muhammad Ali, Rachel Carson, Clint

Eastwood, and Gandhi, are mentioned because whatever worthiness they are known for exemplifies and clarifies aspects of particular bodhisattva archetypes. I have no desire, nor have I the perfect knowledge, to make judgments about the true character of these persons. My accounts of them will of necessity be speculative, cursory—even playful and provocative— intended simply to suggest how they illuminate aspects of the bodhisattvas. Where these persons have shadow sides to their personalities or careers, I hope to mention these flaws only inasmuch as they may illuminate the archetypal qualities of the bodhisattvas being discussed.

I am mentioning some famous people in the context of discussing bodhisattvas only because they may be generally familiar as examples. Bodhisattvas usually are unknown and anonymous rather than celebrities, and function humbly and invisibly all around us, expressing kindness and generosity in simple, quiet gestures. Having opened their hearts beyond delusions of craving and estrangement, bodhisattvas can just be themselves, not seeking out good deeds to perform, but in their very ordinariness presenting inspiring examples that help others. The glamour and worldly fame of celebrity are contrary to the approach of bodhisattvas. Any bodhisattvic qualities of the people to be mentioned might be seen as manifesting in spite of their fame and renown, although some exemplars have skillfully used their reputation as a means to support enlightening work.

As it happens, a number of the noted modern exemplars who will be cited are involved in facing social issues, some of them even opposing governmental or other authorities in activist campaigns. Traditionally recorded bodhisattva lore and Mahayana history tend to emphasize the contemplative and devotional aspects of the bodhisattva work, apart from political embroilments. Although bodhisattvas take on innumerable styles and approaches, all bodhisattvas are in some way concerned for their fellow beings, especially for all those suffering in unfortunate conditions. Even the bodhisattva yogi sitting in meditation by himself near a remote mountaintop can never truly sit alone. Myriad beings are mysteriously present, and all society is subtly and intimately affected, whenever one takes on the bodhisattva project. Insight into the wholeness of reality, and acceptance of its dynamic presence just as it exists in our immediate state, are not separate from the responsibility to regard and respond creatively to the suffering of our fellow creatures.

THE PRIMARY BODHISATTVA FIGURES

Many Mahayana scriptures, called sutras, include descriptions of numerous assemblies that have gathered to hear the Buddha's teaching, sometimes including pages full of names of different bodhisattvas. Some of these bodhisattvas exist in our own realm and context, while some come from other "world systems," which we might describe as other solar systems or galaxies, or even alternate universes. The Mahayana vision is vast. It includes many different dimensions of space, time, and mind. Some sutras clarify that there are innumerable bodhisattvas, that in fact there is not a single place or time where there are *not* bodhisattvas and buddhas. Some of these bodhisattvas may be as immense as solar systems, some as tiny as molecules. Nevertheless, only a handful or so of bodhisattva figures stand out most prominently in the culture of East Asian Mahayana Buddhism.

The bodhisattva figures featured in this book are cherished mainstays within all branches of the East Asian Buddhism of China, Korea, and Japan, and more recently in the unfolding interest in Buddhism in the West. They are all part of the Tibetan pantheon of bodhisattvas as well, although with varying degrees of importance. A great array of other bodhisattva figures have significant roles in the Vajrayana "Diamond Vehicle" tradition, a specialized development of the Mahayana also known as tantric or esoteric Buddhism, which dominates Tibetan Buddhism and also was foundational in Japanese Buddhism.

The following brief introduction to our major bodhisattva archetypal figures will allow the reader to begin to envision how the bodhisattva teachings are embodied during the rest of the introductory material, before the chapters focusing on each bodhisattva.

The first bodhisattva we will examine is Siddhartha Gautama, who became the historical Buddha Shakyamuni in sixth-century B.C.E. India. His life story and path to awakening constitute an important model for all Buddhist practitioners. His home-leaving is an especially significant part of the tradition that has become controversial in the contemporary context of feminism and family values, requiring our renewed attention to its inner levels of meaning.

Manjushri is the bodhisattva of wisdom and insight, who penetrates and expounds the fundamental emptiness or true nature of all things. He often rides a lion and wields a sword, which he uses to cut through delusion. He sits at the center of Zen meditation halls, encouraging deep introspection

and the awakening of insight. Often depicted as a young prince, he also may manifest as a beggar.

Samantabhadra is the bodhisattva of enlightening activity in the world, representing the shining function and application of wisdom. His name means "Universal Virtue." He rides on a six-tusked white elephant, but he is hard to encounter, often performing his beneficial purpose while hidden in worldly roles. Samantabhadra especially represents luminous vision of the interconnectedness of all beings.

Avalokiteshvara, the bodhisattva of compassion, is probably the most popular bodhisattva and appears in more different forms than any other bodhisattva. He is called Chenrezig in Tibet, the "Goddess of Mercy" Guanyin in China, and Kannon, Kanzeon, or Kanjizai in Japan. Sometimes he has a thousand hands and eyes, sometimes he has a wrathful mien and horse's head. One meaning of his name is "Regarder of the World's Cries," implying empathy and active listening as primary practices of compassion. An emanation himself of the popular cosmic Buddha Amitabha, Avalokiteshvara's own female complement, Tara, is also very popular. Both Bodhidharma, founder of Zen in China, and His Holiness the Dalai Lama, the Tibetan spiritual leader, are considered incarnations of Avalokiteshvara.

Kshitigarbha is of lesser importance than the other bodhisattva archetypes in terms of philosophical doctrine, but is perhaps equal to Avalokiteshvara in popularity in Japan, where he is called Jizo. His name means "Earth Storehouse" or "Earth Womb." Popularly considered a guardian of travelers and children, in Japan he is associated with ceremonies for deceased children. Traditionally he is guardian in the intermediate states between births, and especially practices to benefit those in the hell realms. Jizo usually appears as a shaved-head monk, carrying a wish-fulfilling gem.

Maitreya is the disciple of Shakyamuni Buddha who the Buddha predicted would become the next incarnate buddha in the distant future. Awaiting his destiny as the future Buddha, the Bodhisattva Maitreya now sits in the meditation heavens of our human realm of desire, contemplating how to save all suffering beings. Many of his messianic followers believe it is our job to prepare the world for him. But he also has incarnated in the world as a bodhisattva. In China, Maitreya is nearly synonymous with his incarnation as the historical Chinese Zen monk Hotei, familiar as the fat, jolly buddha of Chinese restaurants.

Vimalakirti, the hero of a popular sutra, was a lay disciple of Shakyamuni whose wisdom and enlightenment surpassed those of all the other

disciples and bodhisattvas. As a layman he practiced in the midst of the delusions of the world without being caught by them, all the while benefiting beings and outshining even Manjushri in eloquence and understanding. Famous for his thunderous silence, Vimalakirti fully expressed the inconceivable quality of the bodhisattvas.

As inspirations, models, and spiritual resources, all these bodhisattva characters are alive and dynamic. The descriptions of them in this book are introductions, not the final word by any means. As the bodhisattvas enter our culture, they will find new guises and evolving qualities. Each of us may bring them to life in our own way. Before we proceed with more detailed discussion of the minds and activities of each bodhisattva figure, some more background into the world of the bodhisattvas will be helpful.

THE INCONCEIVABLE VOW

A key aspect of bodhisattva practice is the commitment or dedication to the way of awakening, and to carrying out this commitment and practice for the benefit of all. The aspiration to care for and to awaken all beings (in Sanskrit *bodhichitta*, literally "enlightening mind") is considered mysterious and auspicious. This heartfelt care for suffering beings and fundamental questioning into the meaning of our lives arises unaccountably amid the multitude of psychological conditionings in our experience, known and unknown. The Buddhist scriptures give various detailed descriptions of the course of the bodhisattvas' personal development of character and deepening of capacity, from this first impulse until the fulfillment of buddhahood. But although bodhisattva qualities may unfold over great stretches of time, the initial aspiration of beginners seeking the Way is said to be identical in nature and value to that of an advanced bodhisattva.

The commitment to awakening developed from such original intention is expressed in terms of numerous different bodhisattva vows. Sometimes these are limited and specific, as in the vow to alleviate some particular social problem, or to help a situation of personal suffering in one's purview. But the bodhisattva vow is also vast and all-inclusive. Many of the different bodhisattva figures we will discuss have their own particular set of vows. But there are also general bodhisattva vows common to all Mahayana practitioners. The best known are the four inconceivable vows. They are:

Living beings are infinite, I vow to free them.
Delusions are inexhaustible, I vow to cut through them.
Dharma gates are boundless, I vow to enter them.
The Buddha Way is unsurpassable, I vow to realize it.

These vows seem impossible in terms of the conventional human per-spective on the world. But the bodhisattva viewpoint demands and is acti-vated by this thorough, universal level of commitment, while simultaneously encompassing the ordinary kindness and helpfulness that we all may per-form in our everyday lives.

The salvation implied in the first vow of liberating all beings is expressed in the teaching that all creation is endowed with buddha nature. The awak-ening experienced by a buddha is this realization that all beings are funda-mentally open, clear, and totally integrated with the whole of existence. This experience, tasted by many yogis or spiritual practitioners throughout the ages, is not about becoming a different person than who we already are. It is not a matter of achieving some new state of being or of mind in some other, "higher" place or time. Rather, it is the nature of reality already pres-ent and always available to everyone. The problem is that we are obstructed from realizing and enjoying this reality, and then creatively embodying it. This obstruction comes from our confusion, our grasping, and our aversion, which are produced through the complex web of psychological and cul-tural conditioning affecting us throughout our whole lives. Our work, indi-vidually and collectively, is to break through or let go of the attachments that block our inherent freedom and radiance.

The vow to free beings is enacted by helping others when possible to find ways to express their own distinct awakened buddha nature. Such activ-ity is geared to what is truly practical and effective. In addition to this lim-ited assistance, the bodhisattva also leaps into the inconceivable by seeing the need to sustain this vow, extending it beyond all limits. The limited vow, while carried out as a practical expedient, is self-defeating if we are willing to avert our gaze from those beyond the boundaries we have constructed. The commitment of the bodhisattva is to join the fellowship that will even-tually carry this clear, serene, and dynamic awareness to all dissatisfied beings. The job of the community of bodhisattvas is to nurture and finally bring out the kindness and clarity of all humanity (not excluding concern and connection with all the other creatures in our greater environment).

The universal inclusivity of freeing every single being in space and time

may make this vow seem impossible, inconceivable, or simply irrelevant to our own lives. But if we contemplate truly saving only a smaller sampling, say all of those who live in the same neighborhood as us, or all the people with whom we work, or perhaps just those in our immediate family, we may realize that this task is also far from simple, perhaps equally inconceivable. Opening up to the infinite scope of all beings allows us to relate cooperatively with particular, familiar beings, but also to see our vital intention as directed to the wider unlimited context. This spaciousness helps us to interact more clearly in our ordinary realm.

The second of the four vows is the work of cutting through our inexhaustible delusions about self and others. The word "delusions" in this vow is sometimes translated as "desires." But desires in themselves are not the problem as much as our attachments and graspings activated by desires. Certainly it is very helpful to find satisfaction in the wonder of our life just as it is, without seeking to acquire more and more, of both material and spiritual goodies. Living simply, needing less, increases the richness of our lives as surely as, if not more than, accumulating wealth. But we must also realize that seeking to rid ourselves of all desires is just another desire.

Attractions and aversions that may form desires are wired into our being as fundamentally as the positive and negative charges of protons and electrons in the atoms of our bodies. As the great Japanese Zen master Dogen says, "In our attachment blossoms fall, and in aversion weeds spread."[1] This is how the world works; we cannot avoid its changing. But we are caught by delusion when we become attached to objects of attraction or aversion, when we seek to hold in our grasp the things we have imagined will guarantee our happiness, or to repel what we fear will harm or displease us. The bodhisattva way offers practices to help us face our passions and let go of our obsessiveness about them. We can acknowledge our feelings of likes and dislikes without trying to escape from ourselves, yet without having to reflexively act them out in the world. We can also experience that these objects of desire and aversion are not ultimately separate from ourselves and do not have independent reality or power over us.

The third vow, to enter the boundless dharma gates, refers to the richness of the teachings that are available about how to live most fully. The bodhisattva vows to follow through and take on all beneficial practices and teachings. The Sanskrit word *dharma* has a complex web of meanings, which include, firstly, "truth," or "reality" itself. Dharma also indicates the teachings

about that truth, often referring specifically to the Buddhist teachings, or Dharma, so "dharma gates" refers primarily to teachings or entryways into reality. The word *dharma* is also used for the manner, method, or path of following the teaching so as to come into accord with the truth of reality. Finally, as a technical term in early Buddhist psychology, dharmas are the specific elements of mind and matter that make up this reality and that are delineated in a complex analytic system about the component realities in our experience, useful as a guide for understanding the world. In this book, the word *Dharma* will be capitalized when it refers primarily to the Buddhist Dharma, that is Buddhism, and will be lower-cased when it refers more generally to reality, teachings, or the other meanings, although the word often implies more than one meaning.

The bodhisattva studies all of the gateways to reality, using whatever teaching systems or approaches may be helpful, slowly and steadily developing the tools to act effectively. These gateways to reality are boundless because the opportunities for finding teaching are as numerous as the people or events we encounter. Each person and every situation we face has something to teach about how to be more fully ourselves. When we see every encounter as a potential teaching and source of awakening, regardless of the apparent status or position of those encountered, we are fulfilling this vow.

The fourth vow, to accomplish the unsurpassable Way of awakening, emphasizes the practical, experiential side of the bodhisattva ideal. The bodhisattva teachings are not an intellectual doctrine or system to be debated or taken as an object of belief. The point is to embody and personally fulfill concrete expressions of bodhisattva intention and attitude in the context of our own situation. We may humbly recognize our present shortcomings and lack of awareness, but we can also forgive ourselves and dedicate ourselves to actualizing universal awakening.

This fourth vow of enactment of Buddha's Way refers to the fundamental practice of taking refuge in buddha. We return home to the principle of awakening and trust the enlightening ones of the world to guide us, also radically trusting our own true, awakened self. We return home to our deepest, kindest, most dynamic and open self that is fully interconnected and integrated with all others, beyond our conditioned prejudices about our estrangement. This taking refuge is a psychological orientation and direction, and also the fundamental formal ritual and practice of Buddhism.

SELF AND OTHER: THE ILLUSION OF SEPARATION

In approaching the bodhisattvas as "archetypes," the question may arise as to whether these figures are external entities to venerate, or simply internal forces to uncover and express. In the understanding of Buddhist nondualism, both of these facets are germane.

Traditionally, Mahayana devotees often petition the bodhisattvas to come and render personal aid and support. A prominent sutra (which is itself part of the *Lotus Sutra*), the *Universal Gateway of Avalokiteshvara Bodhisattva*, the bodhisattva of compassion, specifically guarantees that endangered believers need only call out her name and this bodhisattva will arrive to rescue the faithful. Along with invoking the bodhisattva figures, Mahayana devotees in all Asian cultures similarly call on a variety of nature spirits and deities. While these spirits derive from the indigenous shamanic and animist spirituality native to all Asian countries, they have also been integrated into Buddhism. In Japan, for example, an elaborate system was devised to identify native spirits with respective bodhisattvas. Meditative practices may naturally open awareness to such nonconventional spirit dimensions.

A psychological reductionism that understands the bodhisattvas solely as internal, psychic forces fails to capture the basic spirit and dynamic richness of Mahayana Buddhism as a religion that has brought spiritual support to many throughout the ages. We can honor the traditional view of the bodhisattvas as external, cosmic beings while simultaneously seeing them as internal, psychological forces available as potentialities to be realized within us. Zen and tantric teachers have emphasized that we must incorporate the bodhisattva teachings into our own life experience and activity. It is not enough to have some intellectual conceptualization of buddha nature if it is not actualized and manifested in practice in the world.

However, teachers from the more explicitly devotional Pure Land schools of Buddhism may counter by pointing out the egoism and even arrogance exhibited by Zen people if they think that they can fulfill buddhahood solely by their own talent and effort. Instead, the Pure Land outlook within the Mahayana encourages humbly entrusting oneself to the benevolence of the buddhas and bodhisattvas working in the world. This debate has been characterized within some Pure Land schools as between "self-power" versus "other-power." But we may transcend this conceptual dichotomy by remembering the fundamental Buddhist teaching about the illusory nature of self-other distinctions.

In Mahayana understanding, all dualities are seen as provisional, conceptual discriminations that may be functionally practical in specific situations, but are barriers to openness and awakening if conceived of as ultimately real. The sacred is not seen as existing separate from, or outside, the ordinary worldly realm. Nirvana, the serene salvation from all struggle, exists in the midst of samsara, the endless run-around of cause and effect and grasping for gain, like a lotus blossoming out of muddy water. Practitioners may retreat for some time into meditation hermitages or monastic enclosures, but the point of this training is to better equip them to emerge and work calmly and effectively to benefit all beings in the world.

The teaching of universal buddha nature and interconnectedness describes how we do not exist in isolation. Rather, all beings are intimately interrelated in our effects on each other. We are the product of our genetic and cultural inheritance; of the intricate web of influence of family, friends, and acquaintances; and of innumerable other unknowable conditions that bring us to our present state. One famous Mahayana depiction of this reality is the net of Indra, the Indian creator deity. In this metaphor the universe is described as a vast net, and at each junction where the meshes meet sits a jewel. Each jewel reflects the light of all the jewels around it; and all of those jewels reflect others around them. In this way, the whole universe of jewels is ultimately reflected in every single jewel. This holographic image expresses our deep intimacy and interrelatedness with everything in the universe.

Given this truth, the Mahayana goal of universal liberation is simply a realistic approach. When we understand our deep connection to each other, the dichotomy between self and other—which is basic to our usual psychological, ego operations—is exposed as a provisional fiction. Ultimately we are each distinct expressions of one whole, not separate competing entities. It is impossible to be truly free and enlightened oneself if others down the street are in misery. To ignore the suffering of others is to ignore some part of oneself. This does not mean that we destroy the ego, or deny the presence of our particular body and mind, our own life situation. Rather, we more fully engage in and care for our own unique personhood by understanding the larger view as well. We begin to live and practice with awareness of the illusory nature of this self-other separation that is continuously produced by our conditioned mentality.

If self and other are not separate, we need not discern whether bodhisattvas are inside or outside. The point is to effectively help beings, either as self or as others. We can see bodhisattvas as external forces when that is

helpful, or we can see bodhisattvas as components of ourselves when that helps us to find spiritual well-being for self or others. The reality of our lives includes both attitudes.

BODHISATTVA TIME AND THE NATURE OF REBIRTH

When we look at the world around us, we cannot avoid seeing the cruelty and atrocities, the suffering and misery, both in news headlines and in the lives of people we know personally. The problems sometimes seem so intractable that it may appear ludicrous to *hope* for even a slightly better world—let alone "freeing" all living beings! While acknowledging these problems, the bodhisattva also sees the situation through other perspectives. Informed by Buddhist awakening, one experiences the fundamental rightness of things just as they are, while not ignoring the awareness of beings enmeshed in suffering and distress. Bodhisattva practice aimed at relieving and ending this suffering is not only a lifelong affair, but is also seen as a commitment to be carried out over many lifetimes. This is manifested historically by magnanimous, enlightening traditions in spiritual and social realms that are carried on by caring individuals over many generations. But commitment over innumerable lifetimes is also understood in terms of bodhisattvas' rebirth.

The historic reach of the Mahayana Buddhist viewpoint includes vast stretches of time. Shakyamuni Buddha is not regarded as having originated a brand-new teaching or practice, but rather, as one who rediscovered something very ancient and fundamental to existence. A series of seven buddhas, culminating in Shakyamuni Buddha, are commonly named in the Mahayana liturgy. These seven are the buddhas of our own age, or *kalpa*, but they represent a great number of other buddhas before them, in previous kalpas.

In modern cosmological terms, we might equate the cycle of one universe from the big bang to its final collapse with one kalpa. Buddhist cosmology sometimes also equates our universe with a progression of four kalpas, the arising, enduring, and fading kalpas of a world system, and then the fourth, vacant or empty kalpa between material universes. A traditional, more poetic expression of the duration of a kalpa is the time it would take for a bird with a piece of silk in its talon, flying once every century over the top of Mount Everest so that the silk brushes the peak, to completely erode the mountain.

Various times are given for the period before Maitreya Bodhisattva will become, as predicted by Shakyamuni, the next incarnate Buddha. One calculation is 7.5 billion years. Over such reaches of time, the Mahayana claims, generation after generation of bodhisattvas have experienced this awakening, and transmitted the teachings and practice to keep it alive. Even when the teaching passes away, new buddhas emerge to rediscover it.

Returning to the more familiar reaches of human history (of this kalpa), we can see bodhisattva practice being transmitted over many generations in the activity and inspiration of great individuals, both famous and unknown. Such dedicated people work in diverse ways and through various social movements, both ongoing and newly arising, to better the world and ennoble humanity.

In Asian cultures from India through East Asia, the traditional belief, often predating Buddhism, is that all people are reborn over many lifetimes. Tibetans say that we have all lived so many lives that every single person we pass in the street was in some former life either our parent, child, or spouse. The bodhisattva vow is to continue enlightening practice throughout these many rebirths. Great bodhisattvas are said to choose their rebirth so as best to benefit beings, and reappear over the generations doing helpful work.

This idea of rebirth may be familiar in Asia, but it can be quite alien to Western cultures. Despite the recent fashionableness of notions of reincarnation, the strangeness of the teaching of rebirth is a significant obstacle to many Westerners interested in Mahayana practice. A noted American scholar of Tibetan Buddhism, Robert Thurman, has proclaimed that bodhisattva practice is meaningless without the belief in rebirth. Another fine Buddhist scholar told me that she cannot herself be a Buddhist because she cannot bring herself truly to believe in rebirth. But bodhisattva practice is still possible if this teaching is understood only metaphorically. We can engage in bodhisattva activity and help maintain the teaching so that other generations can continue this work and be "reborn" into bodhisattva dedication. In history we see many people doing valuable work after being inspired by the examples, either personal or historic, of previous noble individuals. Yet the whole of the teaching of rebirth might also be seen as sensible and coherent.

Buddhist rebirth is not the same as reincarnation. It is axiomatic in Buddhism that there is no separate, eternal, or personal self to be reborn. Rebirth is a matter of cause and effect. The pathways of the intricate web of causation are never clear and apparent, and cannot be untangled in a linear

manner so as to satisfy limited human rational faculties. But all actions do have results, and all these effects in turn have their impact, even if not apparent to us. In this sense rebirth occurs moment after moment. We take on the changing limitations of the life appearing before us as a result of having done so previously. We continue to identify ourselves in accord with the habits of our conditioned awareness and with the continuing production of the illusions of this world that result from the intricate web of phenomenal causation. This happens moment after moment, day after day.

The particular mind and person we are now will not be reborn in some other body after death. But the sum of our spiritual and psychic energy and intention does have its effect. This spiritual vector, including our conscious and unconscious vows and predispositions, may be taken up and carried on by some other being born into a body in the world. In this way, also, over the course of many lives, the bodhisattva vow is continued in the world. According to this understanding, an incarnate Tibetan lama does not invade and take over a new body after death like some parasitic extraterrestial alien. Rather, the lama passing away sends out his or her blessing of bodhisattva vows into the world. Then some new being with sufficient openness, clarity, and compassion takes on that intention.

We need not adopt unquestioning belief in such a doctrine of rebirth "on faith." But attentive and mindful meditative practice may lead us to experience the truth of the interdependent co-arising of all things as it operates in our own life, and to see this individual life emerging out of emptiness right now, moment after moment, due to the tangled web of causes and conditions. When we try to analyze these rebirth teachings from our background of Western rational logic we are likely to be confounded and perplexed. But this teaching can also allow us to see our life and its meaning afresh, from a wider, deeper perspective. An old friend shared with me an illuminating and marvelously nonlinear teaching that our past lives in our "next life" may well be different from our past lives in this current life.

A bodhisattva need not have any certain theoretical understanding of rebirth. In fact, all fixed theoretical understandings are considered serious obstacles to awakening. I know of contemporary Buddhist practitioners who have had visions of persons in specific places and times, which may well be their "past lives." But these practitioners do not hold to any particular interpretation of what those visions represent and do not care if anybody else perceives the visions according to some defined theory of rebirth.

The point is to take on bodhisattva commitment in our life here today.

How we take care of this present life and the world that meets us does make a difference. Over the range of bodhisattva time our ongoing contribution to awakening conduct and awareness helps to actualize such an outlook for others. The ever-present reality of the radiant beauty of all things may also be universally recognized over time. This is the bodhisattva ideal.

ASCENDING AND DESCENDING BODHISATTVAS

It may be helpful to consider the relationship of bodhisattvas and buddhas, how they are different and how they work together. One account of the bodhisattva path might be described as ascending to buddhahood. Step by step, over seemingly endless lifetimes, the bodhisattva develops enlightening understanding and practice, and skillfulness in helping beings, until at some time she is finally ready to realize *anuttara samyak sambodhi*, Sanskrit for the "unsurpassed complete perfect enlightenment" of a buddha. In this practice of cultivation, through strenuous effort and diligent practice—whether by meditation, chanting, or intense faith—the bodhisattva works her way up to the stage of buddha. By stripping away delusions and realizing emptiness, in this practice one aims to achieve enlightenment.

We might also describe the bodhisattva descending from buddhahood. The story goes that it was only at the urging of the Indian deity Brahma that Shakyamuni Buddha agreed to stay in the world to help teach those beings who were ready how to enter into the way of awakening. Although a buddha teaches and demonstrates this awakening, a buddha is also one who already sees the world as whole and perfected. In this sense, a buddha does not need to do anything and has nothing to accomplish. Bodhisattvas, on the other hand, do the work of the buddhas in the world, acting to relieve suffering and liberate all beings.

All the bodhisattvas that we will discuss as primary archetypes are known as "tenth-stage," or fully developed, bodhisattvas (although Maitreya is sometimes described as abiding in the eighth stage). Practically speaking, they have the same understanding as a completely awakened buddha, but they take on the job of helping all suffering beings also to actualize, or make real, this awareness. Although they may have realized the equivalent awareness of a buddha, they return to the state of bodhisattva to perform beneficial work for beings. The role of a bodhisattva as a buddha's assistant is depicted iconographically by bodhisattvas standing as attendants around the image of a buddha. In this way, individual bodhisattvas may be commonly

associated; for example, Manjushri and Samantabhadra are attendants on either side of Shakyamuni Buddha, and a retinue of twelve bodhisattvas, including Avalokiteshvara and Jizo, descends to the world along with Amitabha Buddha as he manifests.

The descending bodhisattva practices in order to enact and express enlightenment, not to achieve it. There is nothing to gain; it is only a matter of all beings reintegrating and reconnecting with their own fundamental, inherent buddha nature. But the descending bodhisattva practices no less intensely than the one ascending, demonstrating cultivation for those who will be encouraged by it. The great cosmic bodhisattva figures may sometimes intentionally appear in a limited incarnate human body for some specific temporary purpose. But when bodhisattvas descend and return to delusion for the sake of beings, usually they actually return to delusion. A bodhisattva manifesting in the limitation of a particular body, in a specific time and place, necessarily is fooled by the world of delusion. He does not just pretend to be in that world, but actually takes on and is gripped by delusion for the sake of demonstrating awakening in the midst of it.

The classic illustration of this aspect of the bodhisattva path is the parable of the prodigal son in the *Lotus Sutra*. In this story a son and father have a falling-out. The son leaves home and travels the world, getting involved in various misadventures. Meanwhile the father works and acquires a fortune. One day the son, in his wanderings, arrives at the town where the father is living. The son, reduced to a beggar in rags by the troubles of the world, loiters in front of the gates of a magnificent mansion, which happens to belong to the father. The father instantly recognizes his son and sends his attendants to bring the son to him. But the son, full of self-contempt, is terrified and runs away when he sees people approaching him from the big house. The father understands and has one of his men don rags and befriend the son, then offer him a job shoveling manure in the fields of the father's estate.

Gradually the son becomes comfortable and skilled in his job as a menial laborer and is given increasing responsibilities in the father's business. Eventually, after many years, the son is given the job of managing the whole property. On his deathbed the father gives the son ownership of the whole business and finally announces that his new heir is, in fact, his true biological son. In the same way, bodhisattvas return to the world of delusion, forgetting they are children of buddha, and work their way back to realizing their original, inalienable buddha nature.

Bodhisattvas engaged in their beneficial work in the world take on whatever roles may be helpful. The *Flower Ornament Sutra* offers comprehensive and colorful accounts of the different practices of bodhisattvas. These narratives make clear that bodhisattvas may take on many guises aside from that of formal spiritual teacher. Bodhisattvas may be female or male, and may appear as lay person or priest; doctor, scientist, or fortune-teller; king or beggar; engineer, bus driver, architect, or laborer; or a musician, magician, teacher, or writer. A bodhisattva may be a janitor, gardener, farmer, actor, soldier, storyteller, athlete, dancer, housewife, courtesan, child—even a politician or lawyer! Any of these may be great bodhisattvas.

2
Mahayana History
Major Sutras and Schools

THE MAHAYANA BUDDHIST movement developed prominently beginning about one century B.C.E. in northern India, though its undocumented roots go back much further. Christianity and Mahayana Buddhism emerged around the same time and shared an emphasis on compassion, altruism, and universal salvation. Indeed, there was some mutual influence between the Mideast and northern India carried on by pilgrims and merchants for several centuries after Alexander's invasion of India in the fourth century B.C.E. Some religious scholars speculate that Jesus may have been influenced by ideas percolating over from Buddhist India, and the teachings of early Christianity might in turn have had some influence on the development of the Mahayana. Putting aside such provocative yet unverifiable speculations, Mahayana Buddhism was certainly an organic development from early Buddhism dating back to the historical Buddha Shakyamuni, who lived in northern India in the sixth century B.C.E.

The ideal of the early Buddhists was the *arhat*, the saintly purified one who had transcended all desires, conditioning, and defilements in personal enlightenment. This approach to practice continues in the Theravada "Path of the Elders" tradition, which is still the dominant branch of Buddhism in South and Southeast Asia: Sri Lanka, Burma, Thailand, Laos, and Cambodia. These teachings are expressed in the Pali scriptures or *suttas* (called *sutras* in the Sanskrit of the later Mahayana teachings). Although the Pali suttas are said to have been compiled shortly after Buddha's death in the fifth or possibly the fourth century B.C.E., they were not committed to writing until

around the second century B.C.E., or shortly before the Mahayana sutras began to appear.

The early Mahayana espousal of the bodhisattva ideal placed this movement in sharp contrast to the arhat ideal, which it found to be incomplete and even uncompassionate in its exclusivity. The name Mahayana, meaning "Great Vehicle," was taken as a criticism of arhat teaching, which was pejoratively named Hinayana, or "Lesser Vehicle." The Mahayana sutras appeared in written form for several centuries beginning around 100 B.C.E., and historians now believe that some were compiled in Central Asia or China. Like the Pali suttas, however, the Mahayana sutras claim to record events and sermons from the life of Shakyamuni Buddha. These sutras are said to have been transmitted orally or hidden because his followers were not yet ready to hear them. Along with the historical disciples, the assemblies of Buddha's followers and students in these sutras are replete with cosmic bodhisattva figures from many different world systems interacting with Shakyamuni. In some of these sutras the enlightened arhats, close disciples of the Buddha, are sharply criticized for misunderstandings or shallowness of practice, since they aspired only to personal rather than universal enlightenment, unlike the bodhisattvas.

However, the pejorative term *Hinayana* is currently inappropriate for any particular branch of the teachings or schools of Buddhism. The surviving Theravadin schools clearly have been maintained by openly offering religious sustenance and teaching to all of the larger community surrounding their monastic cores. In the mature development of the Mahayana tradition, all branches of the teachings are fully recognized as appropriate and beneficial for some beings, and all are included in the greater Mahayana vehicle. The arhats are specifically honored in East Asian Mahayana Buddhism as exemplars of awakening in the world. The Zen tradition appreciates the quirkiness and character of some of the colorful legendary arhat figures, and Zen ceremonies include veneration of and prostrations to many groupings of arhats.

When the lowercased term *hinayana* is used in later Buddhist writings, or today, we can see its aptness to describe the tendency toward small-mindedness and self-centered practice in any branch of Buddhism. In this sense all schools and teachings, and each spiritual practitioner, may have hinayana and mahayana aspects.

The Mahayana teachings are implicit in the Pali suttas, as the bodhisattva figure is presented in the early teachings in terms of the practice of Shakya-

muni before he became the Buddha. Shakyamuni's efforts as Siddhartha Gautama on the journey to buddhahood form a primary archetype for all of Buddhist practice. The term bodhisattva is used to designate Siddhartha in his life struggle, leaving his palace and princely position and undergoing austerities before finding the middle path to his awakening. Shakyamuni is also designated as a bodhisattva in the early *jataka* tales, which are legendary stories about his many previous lives before the one in which he attained buddhahood, sometimes as an animal, during which he was deepening his capacity to benefit beings.

EARLY DEVELOPMENT: MADHYAMIKA AND YOGACHARA

The early sutta teachings are philosophical underpinnings to the later Mahayana teachings. It is beyond the scope of this book to go into detailed analysis of Mahayana Buddhist philosophical doctrines as they evolved, and many of these doctrinal conceptualizations are unnecessary to appreciation of the psychological meaning of the bodhisattva archetypal figures. But it will be helpful background to identify briefly the two primary inclinations of Mahayana thought as it developed in India—the Madhyamika and Yogachara.

The Madhyamika branch focused on the teaching of *shunyata*, usually translated as "emptiness." Although the Madhyamika thinkers used a rhetoric of radical negation to make their point, this should not be confused with Western ideas of nothingness or nihilism that such terms as "void" or "emptiness" may suggest. Buddhist emptiness categorically does *not* mean that nothing matters, or "just to live for the moment." Nor does it imply, "Whatever happens is okay; just go with the flow." Rather, *shunyata* is a technical term denoting the *emptiness of independent, inherent self-existence of all phenomena*, or the ultimate nonseparation of phenomenal entities from each other. All things are totally interconnected; nothing exists independent of the intricate web of mutual causation. *Shunyata* may also be translated as "relativity," indicating the interrelatedness of all things.

Early Theravada Buddhist teachings emphasized the lack of existence of the practitioner's personal self. Practices of contemplation of the body's impermanence and impurity were followed, showing that no essential self of a person was identifiable. These practices, such as observing a corpse decay, break down the self-clinging and egoism that interfere with spiritual insight and awakening.

The lack of inherent existence of the self was taught in early Buddhism in terms of the intricate chain of causation of phenomena and consciousness, and ultimately in the mutual dependent co-arising, or conditioned coproduction of all things. Madhyamika logic and analysis clarified the limitations of our conventional view of the causation of phenomena and further elucidated the deep mutual interrelationship of all events and entities.

The Madhyamika developed these teachings to show that all phenomena and all viewpoints about them are also "non-selves," empty of independence and ultimate reality. No entity or understanding has an unchanging reality that always can be relied upon. The great Madhyamika master and philosopher Nagarjuna, who lived between 150 and 250 C.E. and was venerated by all later branches of Mahayana, used the methodology of negation, but stressed that any fixed view of emptiness or of negation was itself the most dangerous delusion. Emptiness is not just another thing. "Emptiness" is most accurately a verb rather than a noun, referring to the dynamic process of abandoning or emptying out false conceptions and delusions.

The Yogachara branch of Mahayana developed as a response and complement to the negative language of Madhyamika dialectics. Instead of talking about "emptiness," Yogachara referred to this same interconnected reality of mutual causation in more positive terms, such as "suchness" or "thusness." The name Yogachara also implies the yogic quality of these teachings, which were developed out of the meditative practice and experience of generations of Mahayana Buddhist adepts.

"Consciousness-only" is another name for the Yogachara branch of teaching. A great part of the Yogachara effort was directed to attentive, phenomenological study of the nature of consciousness, with various levels and functions of consciousness identified. This is an outgrowth of the Abhidharma psychological teachings of early Buddhism with their dissection of phenomena into material and mental entities. In the Yogachara all of experience and phenomena was described in terms of the totality of "Mind." This philosophy is the doctrinal background of later Mahayana slogans such as "Mind itself is Buddha" or "Everyday Mind is the Way."

One primary polarity within Mahayana teaching can be defined in the differences in the styles between Madhyamika and Yogachara vocabulary and outlook, although both are relating to the same essential teaching and reality, whether described as "emptiness" or "suchness." Madhyamika applies its rhetoric of negation and its insightful, intellectual approach to the

problems of ignorance and delusion and to the emptying out of any set view of reality. By contrast, Yogachara uses the positive terms of suchness or thusness and an emphasis on yogic practice to celebrate the wonder of interconnectedness. Among the bodhisattvas, Manjushri is associated most closely with Madhyamika teaching and Maitreya with Yogachara, but we might look at aspects of each of the bodhisattva figures in terms of these different orientations.

THE DIVERSITY OF THE SUTRAS

When Buddhism was introduced from India to China, the abundance of different teachings and philosophical movements was confusing. It took time for them to be sorted out and become part of Chinese life. This is certainly no less the case today for Westerners interested in Buddhism. A further complication is the great variety of cultural colorations taken on by Buddhism and its different branches as it has traveled among Asian countries and interacted with native traditions. Thanks to modern communication and transportation, and the modern ecumenical spirit engendered by the great spiritual thirst and needs of contemporary people, all of Buddhism is now in contact and dialogue for the very first time since one or two centuries or so after Shakyamuni Buddha. In America, for example, there are now fine Asian teachers, as well as their Western successors, from all the Asian Buddhist countries and traditions.

The main written scriptural repository of the various Buddhist teachings are the sutras. Although some were recorded many centuries after his historical ministry, they all are framed as teachings given by Shakyamuni Buddha. The word *sutra* means "thread," related etymologically to our *suture*, referring to things kept together by threads piercing through them. Early sutras were written on palm leaves threaded together. The sutras also stitch together all beings with the teachings of the path that help us find our interrelatedness and our individual true place in the universe.

Sutras may be unfamiliar as a literary form. They are not for the most part philosophical, doctrinal discussions and may not easily submit to familiar linear forms of intellectual analysis. Many of these texts are instrumental rather than didactic, designed to produce a specific psychic effect. Often they are intended to be recited or chanted in order to arouse *samadhi*, a state of heightened concentration and awareness. They may best be read as if reading a poem, or listening to a symphony.

As the Mahayana developed in India and later in China, doctrinal schools emerged, often centered around specific sutras or groups of sutras. Most of these schools developed their own systems of classifying the different teachings, usually with their own school's sutra at the pinnacle. Most of our major bodhisattva figures appear in many of these sutras, but they also are considered especially representative of particular sutras or schools. The associations of the bodhisattva archetypes with different sutras may give us a nonsectarian framework in which to understand the diversity of sutras.

What follows is a brief, simplified introduction to the major Mahayana sutras and schools, and their primary teaching focus. It is certainly not necessary to remember all of the schools and sutras to appreciate the archetypal qualities and guidance of the bodhisattvas. But this information is offered for those who may want to pursue study of specific aspects of bodhisattva activity, as they are represented in the various sutras and schools. The following characterizations about sutras and schools should be understood as general tendencies rather than sharp discriminations, as there is much overlap. The names of the archetypal bodhisattvas most generally associated with the particular sutras and schools are given in the headings. However, there is also much overlap of the bodhisattvas within the sutras. For example, although Samantabhadra is most fully associated doctrinally with the *Flower Ornament Sutra,* he is probably more commonly known in Japan through his presence in the *Lotus Sutra.*

MANJUSHRI AND THE PRAJNAPARAMITA SUTRAS

The *Prajnaparamita,* or "perfection of wisdom," sutras generally express the emptiness teaching of the Madhyamika branch, although they are highly valued in all of Mahayana Buddhism. These texts date back to at least 100 B.C.E. and continued to be produced over the next millennium. Our sketchy historical knowledge of the period of origin of sutras is often based on the dates of their later translation into Chinese, as many Sanskrit texts did not survive the extermination of Buddhism in India in the thirteenth century by Islamic invaders.

The prajnaparamita group includes a large number of sutras of different lengths, with four versions being most prominent and available in English. The different versions are all considered expressions of the same teaching; in accordion fashion they are either expanded to great length or compressed to their refined essence. The largest is the *Perfection of Wisdom in One Hun-*

dred Thousand Lines. One of the oldest of the prajnaparamita texts is the *Perfection of Wisdom in Eight Thousand Lines.* Other versions are of 18,000 or 25,000 lines. Of much shorter length is the famous *Diamond Cutter Sutra* (*Vajracchedika* in Sanskrit), known commonly as the *Diamond Sutra.* This sutra clarifies that enlightenment, and the Buddha, cannot be identified or recognized by any particular characteristic or mark, and that the Buddha has nothing to teach and not a single, definable truth to proclaim.

The most compressed prajnaparamita text is the one-page *Great Perfection of Wisdom Heart Sutra.* The *Heart Sutra* is chanted daily in many Mahayana temples throughout East Asia and now in the West. It includes in highly capsulated form all Buddhist doctrinal strategies, each of which it "negates" in Madhyamika fashion. This prajnaparamita *no* regarding each teaching is not the dualistic *no* of "no as opposed to yes." Rather, this absolute negation acknowledges the teachings, but in their lack of ultimate, fixed status.

The *Heart Sutra* ends with a six-word mantra, or incantation, which is said to be an ultimate distillation of the entire wisdom teaching. It goes: *Gate* (pronounced "*gah-tay*"), *gate, paragate, parasamgate, bodhi svaha ("svah-hah").* Its literal meaning is something like "Gone, gone, gone beyond, altogether gone beyond, awakening, hurrah!" But it also has many deeper levels of meaning, expressing the letting go of all worldly and conceptual attachments. Manjushri Bodhisattva is emblematic of all these prajna wisdom sutras, which cut through delusion by subtly negating all preconceptions.

MAITREYA AND YOGACHARA

The Yogachara trend of teachings, with its positive emphasis on mind, is represented by a number of loosely associated discourses and sutras that reflect aspects of Yogachara thought. The great fourth-century Indian Buddhist philosophers, the brothers Asanga and Vasubandhu, wrote a number of commentaries and long verses and are considered founders of the Yogachara School, although these teachings clearly have antecedents in Buddhism's origins. The *Samdhinirmochana (Unfolding the Intention) Sutra*, from the first or second century C.E., presents basic Yogachara teachings, including the storehouse consciousness (see below), and the three levels of reality: the imagined reality of the conventional world; the perfected reality, or suchness; and the dependent or conditioned aspect of reality, which is an intersection of the first two levels—that is, of the illusory and absolute.

One of the most popular of Yogachara-influenced texts is the *Awakening of Faith*, a short treatise written sometime between the second and sixth centuries, purportedly in India, although scholars speculate about a Chinese origin. The *Lankavatara Sutra*, a conglomeration of teachings that generally is concerned with psychology and the study of consciousness, also includes a chapter discouraging eating of meat. The Lankavatara began to be translated into Chinese in the early fifth century. The legendary founder of Chan/Zen in China, Bodhidharma, particularly cited this sutra, so that very early Chan was called the Lanka School and later the Mind School.

One of the central doctrines of the Yogachara or "Consciousness Only" teachings involves a system of eight levels of consciousness. The first six are the awareness of the six senses, the five usually considered in the West—sight, sound, smell, taste, and touch—along with the awareness of mental objects or thoughts. This latter awareness is equated with the sense perceptions. Encouraged by meditation, this viewpoint allows us the spaciousness to not necessarily identify with "our" thoughts (or objects of thought), but rather to see thought-objects in a more nonattached manner, as we might colors or sounds.

The seventh consciousness is our faculty for distinguishing and separating our self from our surroundings, and identifying the latter as objects, external and "other" from us. This mental capacity, although necessary to our conventional ego functioning, is also the source of our sense of estrangement and isolation from the world of which we are actually an integral part.

The eighth, storehouse consciousness (in Sanskrit *alaya vijnana*) is one of the most intriguing Buddhist psychological teachings. This consciousness is the repository of impressions from all our previous experience that in turn influence us as predispositions, affecting our responses. How we actually respond, within the parameters available from our predispositions, then further strengthens or influences our conditioned tendencies. Awareness of these mental processes may allow their transformation into corresponding awakening qualities.

Among the bodhisattvas, the Yogachara teachings are most closely related to Maitreya. As he awaits his appearance as the future Buddha, Maitreya contemplates the workings of consciousness, seeking to find how to save all beings from their delusions. Historically, a number of early Yogachara teachers took the name Maitreya.

SHAKYAMUNI AND THE BUDDHA WOMB TEACHING

An important development of Yogachara thought, although not adopted by all branches of the Yogachara school, is the buddha womb or embryo, in Sanskrit *tathagata garbha*. The word *tathagata* is a standard epithet for a buddha, and means "one who comes and goes in thusness." *Garbha* means both the womb and the embryo, and also storehouse or treasury. This teaching was based on the idea that all beings are fundamentally endowed with buddha nature, the potential and capacity to realize and find practical expression of their own unique openness and clarity. The tathagata garbha teaching amplifies this view to describe the whole world as a nurturing buddha womb from which can be born the embryo of buddhahood present in each practitioner and, further, in all beings. Conversely, the world itself is a buddha embryo and each practitioner is a womb of buddha, which can give birth to the world as a perfected buddha field upon our awakening. This account of the path reflects the instrumental intimacy and interconnection of all beings in the process of enlightenment. Buddhas and the whole world simultaneously awaken together.

The sutra that most fully expounds the development of the teaching of the universal buddha nature is the Mahayana *Mahaparinirvana Sutra*, the *Great Passing into Nirvana* of Shakyamuni Buddha, which expresses the Mahayana view of the Buddha's final teaching before he passed away. This wide-ranging sutra, first translated into Chinese in the fifth century and at least a century older in India, also discourses on the *dharmakaya* or "reality body" of buddha, which is unconditioned, infinite, and eternal. Shakyamuni states that such an enduring, cosmic body is also attained by bodhisattvas when they perform acts of kindness toward beings and follow ethical practices.

The buddha womb teaching is developed in an early sutra, the *Lion's Roar of Queen Shrimala*, which probably dates back to the third century in southern India, where there were Buddhist queens who ruled, and other women in important social positions. In the sutra, Queen Shrimala is an adept practitioner whose future buddhahood and pure land are predicted by Shakyamuni, and whom we may now appreciate as an early exemplar of the dharma capacity of women. She especially expounds buddha nature and buddha womb teachings.

THE VIMALAKIRTI SUTRA

While the Madhyamika and Yogachara Schools were important doctrinally in the early spread of Buddhism throughout East Asia, the *Vimalakirti Nirdesha Sutra*, "The Sutra of Displays (or Teachings) of Vimalakirti," became widely popular without producing any particular school. One of the older Mahayana sutras, appearing in the first or early second century, it recounts the sickness of Shakyamuni's great lay disciple Vimalakirti and what happens when the Buddha asks his disciples and bodhisattvas to call at Vimalakirti's sickbed. As an enlightened layman, Vimalakirti was a model for lay practitioners countering the earlier monastic emphasis. This sutra especially appealed to Chinese and other East Asians who wanted to find spiritual value in the mundane world, and it elaborated the basic Mahayana principle of nondualism and spiritual immanence and value in the world.

The *Vimalakirti Sutra*, with its teaching of the inconceivable aspect of bodhisattva awareness, is highly entertaining as literature. The famous scene of the debate between Manjushri and Vimalakirti at his sickbed will be described in the chapter on Vimalakirti. In another scene, when his disciple Shariputra complains about the defilements of the world, Shakyamuni demonstrates the true wonder of reality by touching his toe to the ground. Thereupon the world is revealed to all in its fundamental purity as a buddha field (the bountiful land constellated by a buddha's awakening, replete with bodhisattvas and imbued with awesome, resplendent attributes). The Buddha lifts his toe and the world again appears as in the disciples' usual vision, filled with suffering and defilement.

The layman Vimalakirti embarrasses the Buddha's disciples by exposing the flaws in their practice. Later an awakened goddess-bodhisattva also shames Shariputra for his spiritual pride, notions of purity, and prejudice against women. When Shariputra asks why she doesn't change out of her (supposedly inferior) female form, she explains that such a change is unnecessary, and then transforms Shariputra temporarily into a woman to raise his consciousness. Through such dramatic episodes, the *Vimalakirti Sutra* tricks us out of our conventional worldviews and demonstrates the inconceivable quality of bodhisattva activity.

AVALOKITESHVARA AND THE LOTUS SUTRA

One of the most popular and influential sutras in East Asia is the *Wondrous Dharma Lotus Sutra* (in Sanskrit *Saddharma pundarika*). It is also among the oldest Mahayana sutras, dating back to the first century C.E., except for a few of its final chapters, which were added later. With many colorful parables, the *Lotus Sutra* emphasizes skillful means, or the importance of teachings appropriately tailored to particular students. When all useful approaches are valued as worthy for individual persons, then all teachings, whether judged Greater or Lesser from different vantage points, belong in the inclusive "One Vehicle" (in Sanskrit *ekayana*) expounded in the *Lotus Sutra*.

The *Lotus Sutra*'s principles of skillful means and One Vehicle are demonstrated in the parable of the burning house. A man comes home to find his house burning. He tells his children playing inside to hurry out, but they are enchanted by their toys and refuse. Then the father entices them out by promising that many fabulous, attractive carts are waiting for them outside the burning house, describing different carts to appeal to each child. When they come out, they find that there is only one great cart for all of them. The sutra emphasizes that the promise of many splendored vehicles is not an untruth, but a necessary expedient for the preeminent purpose of saving the children.

The *Lotus Sutra* is also known for its teaching about the vast extent of Shakyamuni Buddha's lifetime, that Buddha is always present, intentionally choosing to appear to pass away or else to reveal himself, whichever is most beneficial. Thanks to his cosmic omnipresence, bodhisattvas are also pervasive in time and space. Although we do not always know of them, when needed they can pop out of the ground, from the soil of the earth and from the ground or roots of our own being.

The scholarly Chinese Tiantai School (in Japanese Tendai) esteemed the *Lotus Sutra* as foremost, while systematically incorporating all of the Buddhist practices and teachings. This was perhaps the most important school of Buddhism throughout East Asia until the rise of Zen and the Pure Land as independent schools.

Although many bodhisattvas appear prominently in the *Lotus Sutra*, the bodhisattva of compassion, Avalokiteshvara, is especially emblematic of this openhearted teaching and its emphasis on skillful means. One of the *Lotus Sutra* chapters, the *Universal Gateway of the Bodhisattva Regarder of the Cries of the World*, considered a sutra in its own right, is devoted to the saving powers of Avalokiteshvara.

SAMANTABHADRA AND THE FLOWER ORNAMENT SUTRA

Many of the Mahayana sutras are vast and visionary in their scope. Yet none is as profusely picturesque as the *Flower Ornament Sutra* (in Sanskrit *Avatamsaka*). This most psychedelic of all religious texts depicts the workings of bodhisattva practice from all perspectives. It is said to consist of the first awareness and expressions by Shakyamuni Buddha immediately after his enlightenment, which were too exalted for anyone at that time to comprehend. As for its historical emergence, some parts of the sutra may reach back to the first century B.C.E. and were first translated into Chinese in the late third century.

As it develops its alluring mood of awe and splendor, the lengthy *Flower Ornament Sutra* weaves a web of similes (such as the previously mentioned Indra's net, the network of jewels each reflecting all others) to expound the interconnectedness of all phenomena and the whole universe. The *Flower Ornament* vision is far-reaching and comprehensive; from the macroscopic to the microscopic, throughout many universes and dimensions, there is not a single place where there are not buddhas and bodhisattvas.

On a more down-to-earth level, the sutra details many mindfulness practices as guides for everyday activities. The primary buddha of the *Flower Ornament* is Vairochana Buddha, the cosmic dharmakaya "truth body" buddha whose body is equivalent to the universe itself. He represents the aspect of buddha as the total nature of reality. While the *Flower Ornament Sutra* features lists of numerous bodhisattvas, Samantabhadra, the bodhisattva of practice functioning in the world, is especially prominent here.

Some chapters of this sutra are considered as independent sutras themselves, such as the *Ten Stages* of bodhisattva development (in Sanskrit *Dashabhumika*). The long final book of the *Flower Ornament Sutra*, called the *Gandavyuha Sutra*, is the thirty-ninth chapter in the longest, most commonly used of the old Chinese translations of the *Avatamsaka*, from the late seventh century. The *Gandavyuha*, or "Entry into the Realm of Reality," is the story of the pilgrim Sudhana. Manjushri sends Sudhana off on his long pilgrimage, which becomes a sequence of visits to fifty-two teachers from every walk of life. Near the end Sudhana comes to Maitreya, who shows him a vast tower that epitomizes the bodhisattva understanding of the universe. Sudhana enters and finds other vast towers, all overflowing with their own amazing sights, including the previous course of the diverse enlightening careers of Maitreya in many strange new worlds. Each tower is as extensive

as all of space, but without any one of them interfering with the space of the others. Amid visions far beyond the accomplishments of all the Hollywood special-effects wizards put together, Maitreya sends Sudhana back to Manjushri for more teachings. With a pat on the head, Manjushri in turn sends Sudhana to Samantabhadra for the wondrous final teaching (elaborated in chapter six).

Based on the profuse imagery of this sutra, the Chinese Huayan School (*Avatamsaka* is written *Huayan* in Chinese) developed many profound and intricate philosophical systems for interpreting and classifying awakening practices. This Huayan teaching is considered by many to embody the pinnacle of Mahayana philosophy, which includes articulating the dialectical interrelation of the universal and phenomenal aspects of reality, allowing the mutual unobstructed interpenetration and interconnection of all particular or relative phenomena. This philosophy of the processes and dialectics of interconnectedness, and the sutra itself, have many implications for contemporary environmental thought, and especially the Deep Ecology movement.

THE VAJRAYANA APPROACH TO BODHISATTVA PRACTICE

Aside from schools of Mahayana Buddhism based on individual sutras, major movements in the history of Mahayana practice are the Vajrayana, the Pure Land schools, and the Chan, or Zen, tradition. The Vajrayana, meaning "Diamond Vehicle" or "Thunderbolt Vehicle," is a development of Mahayana teaching also known as tantric or esoteric Buddhism. Tantrism first developed in India in the native spirituality that venerated the deity of transformation, Shiva. It was gradually adopted into Indian Buddhism and became the main form of Buddhism in Tibet and Mongolia.

Tantric Buddhism evolved in India between the seventh and thirteenth centuries c.e., and developed intricate systems of bodhisattva figures. The tantric bodhisattvas were each expressions of complex programs of spiritual practice called *sadhanas*. Each sadhana involved meditation and visualization exercises and yogic postures or hand gestures called *mudras* focused on specific iconographic details of bodhisattva figures. The devotional practices of tantric Buddhism use mantras and visualizations to transform the practitioner's consciousness toward identification with and embodiment of bodhisattva, deity, or buddha figures. This approach to the bodhisattva archetypes is very much an outgrowth of the basic Mahayana teachings.

Though not including tantric identification rituals, many of the Mahayana sutras give mantric and visualization practices for invoking the bodhisattvas and their active functioning.

The elaborate, colorful, and ritually complex Vajrayana tradition was transmitted to China and Japan as well as Tibet, and its ritual forms and bodhisattva and deity figures are very much present in the background of all of the East Asian Mahayana traditions. Esoteric Buddhism was an especially predominant force in early Japanese Buddhism through the Shingon "Genuine Word," or "Mantra" School, which in turn strongly influenced the Tendai School; thus, esoteric Buddhism maintained lasting, if indirect, influence in Japan. The Vajrayana includes and venerates all of the seven major bodhisattva figures described in this book. A detailed description of the vast array of other colorful figures—deities, bodhisattvas, and buddhas—included in Vajrayana Buddhism is beyond the scope of this book, but some of these other bodhisattvas will be mentioned as figures prominently associated with the East Asian archetypal bodhisattvas.

While honoring the Mahayana sutras, the Vajrayana also includes a separate body of scriptures known as *tantras*, said to be delivered by alternate bodies of the Buddha in other cosmic or psychic dimensions. Due to the massive, harsh persecution of the Tibetans by the current Chinese government, good translations of many valuable Tibetan texts are now being made widely available by the many excellent Tibetan lamas in exile, as well as by their Western disciples.

AMITABHA BUDDHA, AVALOKITESHVARA, AND THE PURE LAND SCHOOLS

All of the major bodhisattvas received predictions from Shakyamuni as to their future buddhahood. In fact, in the *Lotus Sutra* Shakyamuni predicted that all persons who ever hear, read, or venerate the teaching therein would eventually become buddhas. Coinciding with their attainment of total awakening, buddhas always purify and adorn the realms of their bodhisattva activity, which become buddha fields. Some of these buddha fields are pure lands, where all defilements and delusions have dissolved. Other buddha fields, like that of Shakyamuni Buddha, which we inhabit, are described as impure buddha fields, since some of the beings here are still obstructed by defilements and karmic conditioning from realizing this land's underlying purity and perfection.

Historically, groups of devotees grew up around the bodhisattvas, with the popular belief that devotional practice of appropriate mantras or visualization exercises would lead to rebirth in their various buddha lands. Entry into the purified buddha fields, or pure lands, such as would be produced by the major bodhisattvas to be discussed herein, was considered highly auspicious. Residence in these pure lands was thought to make one's own eventual realization more attainable.

In Mahayana folk religion these pure lands were popularly considered realms to enter in future rebirths. But the early texts discussing these buddha fields, texts which were respected in all branches of the Mahayana, make clear that the pure lands are actually always present. Devotional practices are engaged in to help realize and celebrate the immediate presence of these pure lands here and now, as well as their continued realization throughout rebirths.

Historically in East Asia, popular devotional groups focused especially on the pure lands of Maitreya and Manjushri, and on the pure lands of other bodhisattvas to lesser degrees. But eventually, around the eleventh and twelfth centuries, this devotionalism coalesced primarily around Amitabha Buddha (Amida in Japanese) to such an extent that now Pure Land Buddhism usually is assumed to refer just to Amitabha's Pure Land, said to be to the west of us. This tradition derived from the three *Sukhavativyuha* "Array of Blissful Lands" *Sutras*, which appear in shorter, longer, and meditation versions. The Bodhisattva Dharmakara, who would later become Amitabha Buddha, vows that he will not become a buddha unless all believers who merely chant homage to his name ("Namu Amida Butsu" in Japanese) can be reborn into his pure land. His present state as Buddha attests to the success of his vow. Avalokiteshvara Bodhisattva, considered an emanation of Amitabha, is especially associated with this tradition.

The pure land teachings and the meditation practices emphasized in the Chan movement were both part of earlier Mahayana teachings transmitted from India to China. They emerged as independent movements in Tang China (eighth and ninth centuries). In Song dynasty China (the tenth to thirteenth centuries), the Pure Land and the Chan movements came to dominate Buddhism, but remained mostly separate. However, around the sixteenth century the Chinese Chan and Pure Land traditions thoroughly integrated to include both meditation and devotionalism, and they are not considered separately in modern Chinese Buddhism.

In Japan, however, the Pure Land and Zen schools have maintained sectarian separation, with the major Pure Land Schools (Jodo Shu and Jodo

Shinshu in Japanese) collectively the most widespread branch of modern Japanese Buddhism. The Amida Pure Land Schools and the Zen Schools developed as independent forces in thirteenth-century Japan, and became more influential than the old scholastic schools, which had largely become socially elitist, ministering predominantly to the aristocracy.

Out of the Japanese Pure Land Schools came the ideal of the *myokonin*, "people of wondrous faith." The myokonin are humble lay devotees of the buddhas and bodhisattvas who are inspired in the midst of their ordinary worldly lives by devotion to the bodhisattvas and selflessly enact virtues of compassion and caring for suffering beings.

In the same reformist period in thirteenth-century Japan, the Nichiren School also emerged with an intense devotional practice, although not aimed at a pure land but centered around chanting homage to the *Lotus Sutra* ("Namu Myoho Renge Kyo" in Japanese). In accord with *Lotus Sutra* parables and methodology, this school offers expedient promises of tangible rewards in this world resulting from practice. By such seemingly materialistic means of encouraging entry into the teaching, devotees eventually enter more deeply into the essential meaning through exposure to the teachings. A variety of forms of Nichiren Buddhism remain a popular aspect of modern Japanese Buddhism, and also a significant branch of newly developing Western Buddhism. For example, it is the form of practice depicted in *What's Love Got to Do with It?*, the inspirational film version of the life story of Tina Turner, a Nichiren follower, who found the support and inner spiritual strength to break free of an abusive relationship through her devotional chanting practice.

ZEN

The Chan movement began in China around the sixth century. *Chan* is Chinese for the Sanskrit word *dhyana*, meaning "meditation," and is better known by the Japanese pronunciation *zen*. Chan acted as a kind of postgraduate movement in Chinese Buddhism, functioning to help all the accomplished scholarly monks from the various doctrinal schools free themselves from attachments to specific descriptions of the truth. Chan above all emphasized actual personal experience of the dharma, and of bodhisattva awareness and activity, in one's own life. In this tradition, such experience is usually entered into through sitting meditation practice, mindful attention to practice of everyday activities, and checking one's practice

and understanding with awakened teachers and their traditions.

While being greatly influenced by each one of the teachings and sutras of Mahayana Buddhism already mentioned, Chan developed its own voluminous body of literature, largely built on the dialogues and encounters of the great masters of the "golden age" of Chan in the Tang dynasty of China in the eighth and ninth centuries, with many subsequent commentaries.

These Chan masters developed their styles of teaching based on everyday life and activities, and down-to-earth, often rough expression, more than on the lofty philosophy of Indian cosmology. Much of their humorous and paradoxical manner derives from native Chinese Taoism, although their teachings clearly are expressions of the traditional Mahayana texts, with which the masters were fully conversant. The extensive literature of teaching stories with commentaries, called *koans* ("public cases"; in Chinese, *gongan*), has been used in training in all branches of Zen; sometimes the koans have been used in more schematized meditation programs, and sometimes informally as study tools. The koans are filled with references to the sutras, and many of the stories also directly concern the bodhisattva figures, or refer to them, and constitute a significant piece of the archetypal lore.

Along with encouraging personal realization of awakening, the Chan movement in Tang China emphasized everyday activity and work practice, ideally aimed at developing self-sufficiency for the communities that gathered around various masters, often in the remote mountains. The more established doctrinal schools, based on individual sutras and dependent on impressive, large edifices, were all substantially weakened by a massive though short-lived persecution of all Buddhism by the Chinese emperor in 845. In the aftermath of the destruction of many temples, images, and sutras, and enforced laicization of many monks and nuns, the Chan and Pure Land movements emerged as the dominant remnant of Mahayana Buddhism, and Chan/Zen eventually became prominent and culturally influential in Korea, Vietnam, and Japan. Teachers from the Japanese, Chinese, Korean, and Vietnamese Zen traditions are all currently active in the West.

3 The Ten Transcendent Practices

PERFECTION AND WHOLENESS AS LIBERATION

TEN TRANSCENDENT PRACTICES or perfections, *paramitas* in Sanskrit, are fundamental to all bodhisattva function. Perfection in Buddhist teaching does not refer to being correct, or right as opposed to wrong; perfection is a matter of completion or wholeness. All bodhisattvas, at every stage, study the paramitas to develop their capacity to carry out these practices completely in all their activities. The word *paramita* also denotes crossing or carrying beings over to the other shore beyond the stream of suffering. This meaning emphasizes the import of these practices as vehicles for the liberation of all beings, the bodhisattva work.

The ten paramitas are generosity, ethical conduct, patience, effort, meditation, wisdom, skillful means, vow, powers, and knowledge. The first six are often considered separately, as in most Zen and Tibetan presentations of the paramitas, while all ten are featured in the *Flower Ornament Sutra*, which expounds interconnectedness. The first six perfections may be seen as developing bodhisattva qualities. The last four are beneficial practices of accomplished bodhisattvas returning to the world for the sake of saving others. But all these practices are as endless as the various beings and their situations, and all are inspirations, sources of encouragement for the practitioners, and for all those around them.

The ten practices are most illuminating when seen in interconnection; specific combinations of two or three of these practices clarify the essence of each. For example, generosity is informed by wisdom and skillful means, and the active practice of giving, in turn, helps develop wisdom and skillful means. Although all bodhisattvas have some relationship and engagement

with all of the paramitas, the archetypal characters of the major bodhisattva figures are revealed in part by which combinations of these perfections they each particularly emphasize in their practice. After the following discussion of each of the ten practices, the ensuing chapters on the seven archetypal bodhisattvas will include further discussions of how each bodhisattva engages in specific mixes of these paramitas.

1. Generosity

The ten interrelated perfections form a circle, beginning and culminating with generosity. Generosity is the starting point, and develops with the practice of all the other paramitas. Bodhisattva generosity (*dana* in Sanskrit) is perfected when no difference in status and no separation is seen between giver and receiver. Imperfect giving occurs inasmuch as these roles are seen as separate and estranged. Those in helping professions, for example, are particularly vulnerable to feelings of superiority and paternalistic arrogance. Those who receive charity may become prone to dependency and a cycle of debilitation. People who are providers and caregivers, either by profession or temperament, can experience burnout and cease giving if their energy is depleted by giving to others in a way that is experienced as self-diminishing. True generosity is a subtle art requiring sensitivity, judgment, and patience. It is all too easy to give someone what we feel he needs, or should have, rather than what is actually useful or appropriate. It might even be best in the long range to give someone what he thinks he wants, even if it seems harmful at the time.

The art of mutual giving also demands that we learn the art of receiving. In the perfection of giving the roles of giver and receiver form a subtle interrelationship. Sometimes the giver may receive more benefit than the recipient from the act of giving, due to the sense of satisfaction from being able to help, or from seeing the recipient benefited. Who is truly giver and who receiver? The two are mutually defining, and many professional helpers and healers appreciate the reward of this connection.

Giving is a function and response of gratitude. When we receive and experience generosity, or when we simply appreciate with gratefulness the wonder and mystery of being alive, we are moved to acts of generosity ourselves. The perfection of giving is not about the quantity or material value of the gift. To give as the natural function of appreciating others, while seeing ourselves as intimately interconnected with others, is generosity practiced within the sense of wonder and gratitude for our ordinary life, just as

it is. When we can accept with gratitude even the difficulties that life provides us, and see the gifts offered even in situations of misfortune or grief, we find our own generous impulses unhesitatingly released. This grateful generosity, or thanksgiving, heals the split between self and others, our estrangement from our own world and life.

The complexity of giving has been played out in Buddhist history in the material patronage given by laypeople to monastic establishments, with spiritual teaching given in return by monks. Monks ideally abide outside of the flow of the mainstream economy and culture, in Buddhism as mendicants or beggars. The fundamental practice of a Buddhist monk is to receive, to accept what is given, both in material sustenance from donors, and in the immediacy of what one is given by the world, what one is faced with.

Through all of his spiritual practice, even after his enlightenment, Shakyamuni Buddha was simply a mendicant monk, without any material advantage or privilege resulting from his position as head of the community. Like all the monks of his order, the Buddha went out on daily begging rounds, except during the retreats of the rainy season, and lived on the food so gathered. The wandering mendicant *sadhu*, or spiritual seeker, has been an accepted role in Indian culture from before the Buddha's time. Buddhism spread the model of mendicant spiritual practitioner throughout all Asian cultures, although in China, Chan/Zen did establish a concurrent model of manual labor as a legitimate livelihood practice for monks.

In Buddhist teaching, giving is considered auspicious and beneficial to all concerned, a cause for later good fortune. The gift itself is understood as ephemeral, fleeting, and empty, as it flows in benefit to many beings. The gift is passed along in the chain of interconnected beings so that everyone benefits. But true giving is done without expecting reward for oneself, simply for the sake of giving. It is considered preferable not even to know to whom one is giving, and not to know from whom one is receiving. Just to give is the point, without assessing or knowing the results, without making strategic judgments about the effects or fruits of one's giving.

While monastic mendicants practice receiving, they also give by providing the laity with the opportunity to practice giving through their support of spiritual establishments or practitioners. Many laypeople throughout Asian history have engaged in spiritual practices such as meditation, chanting, or prostrations while sustaining their ordinary work in the world, but their material support of monks' intensive practice is also considered an important and respected pillar of the community.

In Western society we have no model of respect for mendicants. All beggars are considered "bums." Therefore, American Buddhists do not have the opportunity to do the traditional begging practice. A Japanese priest told me, calmly, that he tried to do the formal begging practice in Los Angeles and was beaten up. When I was practicing, in a monastery in Kyushu, the southern island of Japan, I was able to do one of the versions of this formal practice, called *takuhatsu*, literally "entrusting the eating bowl." There is a designated form of conduct and recognized monastic attire, with formulaic blessings chanted as one walks, or at each door one approaches, dedicated to Avalokiteshvara, the bodhisattva of compassion. Chants acknowledging the oneness of giving and receiving are recited after each donation. This practice is performed either individually or by a group of monks walking in line, silent except for the chanting. Each monk wears a conical straw hat that comes down over the eyes to preserve the anonymity of both giver and receiver (though small children love to peek under it!).

The monastery where I practiced was in the remote mountains, but twice a month we would make the rounds begging in a nearby town or in the closest large city, and all of our food came from what was received. Walking and chanting all day is physically arduous, but I found this repeated ritual enactment of receiving and giving both humbling and very invigorating and inspiring.

Such formalized exercises in giving and receiving can help us deepen our sense of the meaning of generosity and inspire us to practice it. Even if we cannot easily do begging rounds, volunteer activities or service work to help those in need, even if only done occasionally, functions as a training ground for many modern Western practitioners. Within a structure that supports the activity of giving, we can examine the limitations and rewards of our own giving and gradually learn how to be more open and effective. But we might also attempt to create ways to allow others in our own communities to give to us, for example as mentors, teachers of new avocations, or entertainers. Thereby we can also learn the practice of grateful acceptance that is integral to generosity. True gifts do not necessarily entail possessions. To feel wonder and truly appreciate a flower, the sky, or a smile is to give these to buddha, and to extend generosity to all beings.

2. Ethical Conduct

Ethical conduct, morality, or discipline (*shila* in Sanskrit) has been defined in terms of precepts, monastic regulations, and mindfulness practices,

realms in which bodhisattvas work to help benefit all beings. Mahayana Buddhism does not legislate morality, but rather sees ethical conduct and discipline as the natural expression of an awakened mind. The specific precepts are descriptions of enlightening activity rather than proscriptions on conduct. As we recognize the limitations of our own realization, we then use ethical guidelines as necessary tools to help attune ourselves to our fundamental, open heart.

Morality is not an absolute, but varies relative to particular cultures and situations. And yet, principles of helpfulness, of not harming, and of acting to enlighten all beings can be applied appropriately in each instance. Even while we recognize the emptiness or insubstantiality of the conventional social realm, we must also recognize that all actions unavoidably have consequences. We cannot evade responsibility for the effects of our conduct. Precisely because of the changing nature of the phenomenal world and social conventions, ethical norms and standards are ever in flux, so the bodhisattva must continuously assess and perfect her effect in the world. Moreover, the Mahayana affirms that this very veil of illusion is no other than our site for awakening; bodhisattvas demonstrate their awareness while facing particular cultural contexts. The communal regulations and guidelines promulgated by the Buddha in the *vinaya*, the code of conduct and discipline for the Buddha's order, were given not as innate principles; each item was a response to some specific incident or problem requiring adjudication.

In the Mahayana, precepts are interpreted based on encouragement toward staying in the world. Checking out of the realm of suffering into personal enlightenment is seen as the fundamental violation of the spirit of bodhisattva ethics. The intention to save all beings is the primary moral imperative. Therefore, one of the *Maharatnakuta* "Great Jewel Heap" sutras, "The Definitive Vinaya," states that, for bodhisattvas, flaws or faults based on greed or attraction that keep one involved with others are less dangerous than transgressions based on anger or aversion, which might tend to impel one to abandon the arena of bodhisattva struggle and development.

The Mahayana precepts all unfold from taking refuge in buddha, from our return to the awakening practices of wisdom and knowledge. Taking refuge in buddha means returning to and trusting in our own innermost, open awareness, which includes and goes beyond all phenomena and conditions. This is an ongoing intention and direction, heading back home to the sanctuary of our deepest, whole self that is completely unestranged from and inclusive of all "other" beings. The buddha we take refuge in is

beyond self or other, a return to the primary wholeness that is not restricted by all our discriminations. Refuge in buddha unfolds as taking refuge in dharma, or the truth of reality, its teaching, and the path to its manifestation; and taking refuge in *sangha*, or spiritual community. One major Mahayana ethical system features sixteen precepts. The three refuges are followed by what are called the three pure precepts: avoiding evil, doing good, and benefiting all beings.

The last ten of these sixteen precepts are called the ten grave or heavy precepts: that a disciple of buddha does not kill; does not take what is not given (that is, steal); does not misuse sexuality; does not lie; does not intoxicate mind or body of self or other; does not slander; does not praise self at the expense of others; is not possessive of anything (including the teaching); does not harbor ill will; and does not abuse the three treasures of buddha, dharma, and sangha. Each of these poses large areas for consideration, with varying levels of interpretation available. They are worded simply as descriptions of awakened conduct, not as proscriptions or commandments, and serve as guideposts or reminders to help us align our conduct with our own awakened nature.

Practically speaking, these ten precepts may be most alive when we believe that we have violated one of them, or at least entertain such a question. We may be furthest from accord with the precepts when we smugly assume that we are perfectly in compliance. The precepts are ongoing questions to uphold and care for with mindfulness. They thereby allow us to consider and wonder about our own conduct, and to be available to others' uncertainties and feedback about our actions.

The first grave precept, the simple injunction not to kill, might appear to be fairly straightforward. But even not killing may have a large combination of interpretations and considerations involved. This precept traditionally has given rise to practices, still honored (but with varied approaches), of vegetarianism, of releasing captive animals, and of concern for the diversity of living beings. The precept not to kill has been interpreted by contemporary socially engaged Buddhists to include not allowing others to kill and doing whatever possible to protect life and prevent war. Some Buddhists have participated in modern nonviolent social movements aimed at not condoning killing by others, even by governments. Considerations of the societal implications of this precept have encompassed right livelihood and the intention to find vocations that harm neither humans nor nature. How to appropriately support and celebrate life is often a difficult problem.

In a deeper sense, not killing encourages vitality, energy, creative livelihood, and wonder. In accord with this precept we profoundly appreciate and are grateful for the awesome gift of just being alive. We violate the precept against killing whenever we discourage ourself or others from expressing the fullness of our being and love. When we see the world as estranged and alienated, merely a collection of dead objects to be manipulated or exploited to satisfy our selfish desires, we have killed the dynamic, vital world and its lively being, and have most fundamentally violated this precept.

From the example of not killing we may see that bodhisattva precepts have both a conventional and a universal, ultimate aspect. The conventional moral realm cannot be ignored or casually violated, even when we fathom deeper meanings of precepts. But without being blind to commonplace mores, we can also see the precepts as teachings about the essence of reality and our subtle interdependence with all being.

In this sense, the ten precepts cannot be broken, nor can they be fully followed or perfectly mastered. We cannot accord with absolute precepts based on our personal machinations. These precepts are not simply about avoiding negative future consequences. More deeply, the spirit of precepts helps us see the whole quality of this living person we are right now. Precepts are a road map of buddha nature, a guide to the way things are, and how we are, when we are in dynamic harmony with the world.

In terms of the other transcendent practices, ethical discipline is especially important as a precondition for meditative concentration. This moral discipline is a kind of mental housecleaning, clearing the karmic ground to allow settling. In the process of meditation and concentration, as we remain upright and unshaken amid the complex mental scenery, doubts and misgivings based on ethical ambiguities and our guilt or shame become serious obstacles. Returning to conduct based in moral precepts gives us the stability to enact concentration.

3. Patience

Patience, forebearance, or tolerance (*kshanti* in Sanskrit) is the helpful attitude toward accepting and working with the difficulties of existence. Basically, patience is simple: it means waiting. No matter how good our conduct or practice, expecting or grabbing at some reward or result is a hindrance. When we do our best without any particular expectation, we can actually be ready for whatever happens. Patience is flexible, open, and ready to respond

to the world before us. When the world presents hardships, when we are stuck in misery, trying to force ourselves out of the situation may only embed us more deeply. Patience allows us the space to see some other option. But we must be willing to wait.

In Buddhist meditation we explore patience by learning to maintain upright posture and attitude in the midst of our fears, confusions, and anger. We do not need to react, to deny or vanquish this turmoil. Developing patience, just continuing, we gradually can see through such emotional upheavals and even befriend the parts of us that are used to being impatient. We can sing ourselves lullabies, soothe our wounds, while remaining open to and aware of our inner conflicts and also the underlying calmness. One theory about the origin of meditation is that it evolved from the practice of hunters, just sitting, knowing where to wait, then remaining still until the game appeared in view. This was a practical activity for most of humankind's time on this planet. Modern technological society puts a premium on speed and busyness, on keeping up to the nanosecond with the latest fashion. Our culture does not provide much intentional training in patience.

In Buddhist cosmology, this world in which Shakyamuni was the Buddha is called the world of endurance, *saha* in Sanskrit. This is considered an auspicious place to practice. Living in this difficult place, filled with situations of apparent suffering, cruelty, and injustice, we can develop our capacity to endure, to be patient with our life, to learn how to respond appropriately and helpfully, without feeling overwhelmed or compelled to react impulsively.

People and situations that hassle us are our great teachers. Receiving praise sometimes may be an encouragement to persevere, but flatterers are more often like thieves, stealing our opportunity for practice. We may be encouraged to slack off, believing that we can rest on illusory laurels. But our enemies and critics show us our weaknesses and the areas where we can grow, and it is helpful to see them as guides and teachers. The *Vimalakirti Sutra* indicates that only a bodhisattva can hassle another bodhisattva. Vimalakirti was able to needle great bodhisattvas and get under their skin only because he was also a great bodhisattva. When we are engaging in bodhisattva practice, those who give us a hard time are in some way our great friends, showing us areas we can grow in our practice. We might appreciate them as bodhisattvas aiding us, whether or not their difficult lessons are intentional.

The fundamental patience or tolerance is for the constant changing and ungraspability of all phenomena. This tolerance is technically named

patience with the unborn, unconditioned nature of all things (*anutpattika dharma kshanti* in Sanskrit). It is the intersection of wisdom and patience. Realizing that all things change, and that all things are totally conditioned by everything else, we must be patient with the fact that we cannot ultimately rely on any separate, particular thing, person, approach, or teaching. When we try to hold on to any limited entity or idea, we cause suffering. Wisdom naturally inspires patience, and patience lets us stay calm and available to the arousal of this wisdom.

4. Effort

Effort or diligence, *virya* in Sanskrit, is etymologically related to the word *virile*. The perfection of effort is the intensity, enthusiasm, and zeal to continue amidst adversity. Spiritual strength and stamina are required to persist on the path. Such heroic effort is about sustaining practice and attention. We continue and sustain our enthusiasm by keeping our balance. If our effort is too severe, if we push ourselves too hard and become too tightly wound, we may snap from the pressure. If we are too easy and lax with ourselves and our efforts, our energy will flag and we will also fail to continue. Enthusiasm and patience support each other and are complementary. Sustainable effort and endurance are two sides of the balance in continuing practice.

We can understand effort in terms of physical and yogic energy. Many spiritual and meditative exercises are concerned with developing our energy, strengthening and toning our body and mind to a balanced state. Buddhist practitioners have availed themselves of techniques from Indian tantric meditation and Chinese Taoist practice that work with psychic energy channels in the physical body to develop and strengthen spiritual energy. The diverse traditions of Vajrayana Buddhism also have developed tantric practices for working with psychophysical energies. Energizing practices may naturally arise in meditation, for example when focusing on the breath.

Many Buddhist monks have studied martial arts as a way of working in a mode that is more physically active than sitting meditation. The Chan founder, Bodhidharma, is also revered in legend as the founder of kung fu by East Asian martial arts students. Japanese samurai warriors sought to strengthen their mental and spiritual will to match their physical prowess by studying meditative techniques with monks and practicing meditation.

Strenuous persistence is the stuff of bodhisattva legends. Even the Buddha

Shakyamuni practiced diligently for six years before his great awakening. His heroic effort included mastering the most severe ascetic practices available at the time, bringing himself to the edge of death for the sake of his spiritual quest.

Milarepa, the famous eleventh-century Tibetan yogi and poet, had used his yogic skill and magical powers for the unwholesome aim of destroying his family's enemies before he took up the Buddhist path. To burn up and purify this karmic obstruction, Milarepa's teacher, Marpa, made him undergo many trials and frustrations. For example, Marpa asked Milarepa to build a stone house. Then he was asked to tear it down and rebuild it. Marpa had him repeat this ten times. Thanks to Milarepa's dedication and energy, he persisted.

Because of the relationship between *virya* and *virility*, we might associate this kind of heroic effort or energy with the stereotypical masculine image of a warrior. But effort also includes a more nurturing side, balancing firmness with flexibility. The fulfilled steadfastness and self-confidence of a heroic bodhisattva includes joyfulness and rest or recreation as well as exertion. This is sometimes referred to as effortless effort, persisting and continuing on our way as just the ongoing steps of our ordinary, everyday life. An aspect of holding firm is letting go, the willingness to start fresh from any point, to continue our efforts even when it seems we are starting all over, as Milarepa did with his house.

Bodhisattva effort is fortified by the aspiration and intention to aid suffering beings and to realize awakening. When we look around at the suffering of the world, in the larger world or in our own lives, we can feel and recognize some urgency not to become lazy and give up our best efforts. Each of us has a unique job to do. Each of us has our own special calling, something each of us can offer that is asking us to pay attention and exert ourselves.

Enthusiasm supports and depends on many of the other practices. Meditation and mindfulness practices can help us marshal and care for our energy. Effort is an expression of vow or commitment. Such a bodhisattva vow is the starting point for developing our spiritual energy and vitality.

5. Meditation

The perfection of meditation or concentration is called *dhyana* in Sanskrit, which denotes meditation in general; but more technically it is the name for the traditional Indian pre-Buddhist system of meditative trance states.

Chinese Chan and Japanese Zen gets its name from the transliteration of *dhyana*. The dhyana system was a practice intently followed by Shakyamuni Buddha before his awakening.

The dhyana system involves four stages of mental purification, beginning with transcending desire for a heightened apprehension of elemental form, resulting in states of meditative bliss and joy. Feelings of enjoyment are then forsaken for equanimity, and perceptions of all forms are transcended in concentration on formless qualities, leading to heightened awareness. In bodhisattva practice such mental states and exercises are not valued for their own sake, but may be explored to gain perspective on conventional mental outlooks. Experience of unusual mental realms may help develop skillfulness in helping the diversity of beings. The bliss states may also be useful as rests amid the struggles of bodhisattva work in the world. However, attachment to meditative bliss is strongly warned against as a serious obstacle to true awakening.

The perfection of meditation is associated with meditative concentration (*samadhi* in Sanskrit), which helps make many of the other perfections more effective. In the sutras, there are many lists of diverse, colorfully named samadhis, and recitation of the sutras may induce these concentration states. Many techniques are included in the literature, offering a wide catalog of effective concentration objects. These objects include colored discs; death and bodily decay; qualities of friendliness; images of buddhas and bodhisattvas; words and phrases, either in incantations such as mantras or in phrases from teachings; physical gestures and postures; and abstract qualities such as space and time. Breath is a particularly popular and helpful concentration object, with many techniques developed for attending to inhalation and exhalation and watching breath so as to stimulate awareness.

Samadhi is transformative, helping the meditator to settle more deeply into true self and openness. Such settling allows one to cut through delusions and obsessive thought patterns, seeing the insubstantiality of preconceptions and cherished assumptions. Samadhi is thus complementary and ultimately not separate from the insight of prajna, seeing self-other discriminations as illusory. This penetrating aspect of meditation, evoking the wisdom of emptiness teaching, is associated with Manjushri, who sits on the altar in meditation halls. Samadhi also allows experience of the radiant, holographic quality of existence associated with Samantabhadra. A number of the specific samadhi instructions presented by Samantabhadra open up awareness of universal interconnection.

Meditation also includes the Yogachara aspect of introspection, investigating the phenomenology of consciousness. The perfection of meditation helps uncover emptiness and the vision of interconnection, but also shows us how our usual thought processes obstruct such insights and gives us a means of studying our mental chatter. Through meditation one tangibly discerns the texture of ordinary mental states, the weaving and grasping of our streams of thought. One may learn to find one's presence more constructively amid these mental phenomena, without being caught by the patterns of conditioned attachments. In meditation, we maintain upright posture amid the swirl of conflicted thoughts and emotions, without feeling the need to react and act out; thus, meditation allows the space and calm for us to settle more deeply.

In a number of Buddhist traditions, nondual objectless meditation is considered the highest development of meditation practice. In this approach, no specific concentration objects are focused on. Standard samadhi objects may be used as needed in settling the mind, but then one lets go of these objects, and the whole field of awareness becomes the object of concentration. Whatever mental or physical phenomenon arises is observed, but without trying to manipulate or direct one's experience. One just lets it go and returns to the uprightness modeled in the sitting posture, ready to be present and calmly attentive with whatever appears amid the whole flux of arising and ceasing.

This style of meditation is also objectless in the sense that it has no particular goal or objective—one does not meditate as a means to achieve some resultant mental state or experience. Meditation becomes simply an ongoing expression or celebration of our fundamental openness and awakening, rather than a method of fulfilling expectations or attaining some desired state imagined to be identifiable with enlightenment.

6. Wisdom

Wisdom (*prajna* in Sanskrit) is the experiential insight into the essential emptiness or insubstantial nature of all phenomena. All material and mental events are fundamentally empty, void and vast as space. This "emptiness" does not mean vacancy or nonbeing in a nihilistic sense. Rather, in the nature of their very existence all things are empty of any independent, substantial quality and are not separate and estranged from the totality of all being, and each other.

Prajna is the experience of the essential unity and sameness of all things, in the midst of their diversity. All things appear and finally cease; all of us will pass away. In spite of all the distinctions we cherish, all people are alike in having fears, needs, and desires, in wanting to love and to be loved. This penetrating insight into the oneness and emptiness of all creation is embodied in the Bodhisattva Manjushri, who eloquently cuts through and opens up each of the delusions of our discriminative consciousness. The awakening to this insight slices through the confusions of our conditioning, which habitually obstruct our life and awareness.

Emptiness is not a thing, some new toy or crutch to grab hold of. The greatest delusion, warned against by masters of emptiness teaching, is attachment to emptiness. Even emptiness is empty. It is simply a way of being that releases and lets go of attachments. It is a practice of opening and letting go.

The wisdom of prajna is not a matter of book knowledge or accumulation of information. Rather, prajna is insight—innate and immanent; anyone can turn to look within and apprehend this truth without becoming someone other than who she already is. Buddhas and deluded, suffering beings are completely alike in having access to wisdom and insight. The only difference is in whether or not it is actually realized and enacted. Anyone can awaken to the experience of insight into emptiness. Then the activity of wisdom is to cut through and illuminate the obstructions of greed, hatred, and confusion that block us from witnessing and expressing our fundamental radiance and openness.

A classic story about the universality of prajna is that of the Sixth Ancestor of Chan, Huineng, who lived in seventh-century China. According to the story he was a poor, illiterate woodcutter in the backwaters of southern China. One day he heard a passerby reciting a line from the *Diamond Sutra* about bringing forth the mind that does not dwell anywhere, and Huineng was suddenly awakened to the essence of this wisdom. He journeyed to northern China, to the temple of the Chan Fifth Ancestor, who confirmed his insight and later secretly gave him transmission as the Sixth Ancestor, much to the dismay of the many veteran monks ensconced around the Fifth Ancestor. After departing from the Fifth Ancestor, Huineng, still a layman, lived anonymously in the world for fifteen years, awaiting an appropriate time to share his understanding.

When Huineng finally began teaching, although still illiterate, he could hear sutras and explain their meaning. Without having previously studied

scriptures and commentaries, Huineng could look within, and out of his own experience of prajna would spontaneously flow sparkling utterances to illuminate the inner depths of the teaching.

Prajna is the final of the first six perfections, which develop bodhisattva qualities. While these first six are already a complete set, the four further paramitas are beneficial practices of accomplished bodhisattvas returning to the world for the sake of saving others.

7. Skillful Means

Skillful means (*upaya* in Sanskrit) is the expedient methodology of bodhisattvas, tailoring teaching and beneficial practice to the needs of particular beings. The individuality of each person is acknowledged. Everybody has her own unique tendencies, inclinations, and path to awakening. The diversity of spiritual teachings and tools exists because of the variety of those in need. There is no single right method or means for all. If we receive some well-being or relief from a given practice or teaching we naturally may want to share our benefit with others. But when this swings over to self-righteousness, insisting that others must take up our personal approach to the truth and abandon their misguided ways, we cause suffering. Indeed much of the misery in human history has been caused, or at least rationalized, by such confusion of specific means with ultimate purpose.

Some otherwise excellent methodologies may be harmful for those not ready to accept them. When the Buddha began preaching the *Lotus Sutra* some of his audience walked out. They were satisfied with the purification practices in which they were already engaged, and the new Mahayana teachings were unsettling and alarming. Shakyamuni encouraged and supported their leaving; the teachings of the Lotus would have been inappropriate and useless for them.

The practice of skillful means involves knowledge of a variety of tools, symbolized by the different implements in the thousand hands of the bodhisattva of compassion, Avalokiteshvara. It also demands astute discernment of other beings, with knowledge of the precise aspects of consciousness one may encounter in people. Although the perfection of knowledge may be an important support for skillful means, the actual practice of the perfection of skillful means has an immediate quality that precedes all calculations and deliberations about techniques.

In the immediacy of helpful practices on behalf of the myriad beings of

the world, one develops the art and craft of skillful and appropriate response out of the resources at hand, based on the experience of patience, wisdom, commitment, and trial and error. Holding on to methods that worked before is likened to carrying the raft on your back after reaching the other shore, or returning to the physical site of past good fortune hoping, in effect, for lightning to strike twice. To allow what is useful to come to hand we must patiently open our grasp in readiness and be willing to let go of methods that may no longer be effective.

Skillful means involves trusting buddha and trusting the world to supply what is required. Such Buddhist faith in the awakening nature of reality entails trusting all beings to help all beings and opening oneself to being an instrument of skillful means. As we allow our practice of such skillfulness to blossom, it can be a support and guide to the perfections of enthusiastic effort and generosity.

8. Vow or Commitment

Vow or commitment (*pranidhana* in Sanskrit) is the dedication and intention elaborated in many ways by different bodhisattvas, sustaining effort, meditation practice, and beneficial activities in general. The four inconceivable vows of bodhisattvas, practicing to liberate all the many beings throughout space and time, are described in the first chapter. All the other groups of Mahayana vows are based in the fundamental vow to remember and benefit all beings, which is inspired by the impulse of caring for others.

Although the bodhisattva vow has an ultimate, cosmic quality, inconceivable from the viewpoint of our mundane life, the practice of vow also includes distinct limited commitments. Bodhisattva work includes vows to carry out specific public works or welfare projects to better the lives of people or other creatures. Such projects may include, for example, building or caring for schools, hospitals, bridges, or roads, or helping to feed hungry people. This spirit of vow may be expressed in the daily commitment to care for one's family or a relationship, to learn a skill or how to use a new tool, or to complete a work of art. Our many unconscious vows from cultural conditioning can be reexamined in the light of the practice of insight, and can then be abandoned or renewed, informed by intention to express our innermost, open nature.

For the Mahayana devotee, vows may mean commitment to certain spiritual practices. One may just sit in meditation for forty minutes every day;

or decide to join an intensive meditation retreat for a day, a week, or a season; or chant daily some sutra or homage to buddhas or bodhisattvas; or decide to read, recite, or copy the whole of a lengthy sutra; or make full prostrations to buddhas, bodhisattvas, or teacher images, either daily or completing some large number of prostrations over time. All of these are traditional means of perfecting the practice of vow and can express commitment to benefiting all beings.

There are many stories in the Mahayana tradition of practitioners carrying out vows of commitment to specific limited religious projects. In the late seventeenth century a young monk from the Obaku Zen School vowed to publish a complete version of the sutras, which had not yet been done in Japan. The monk went on begging rounds, slowly collecting funds to make the printing blocks. When he had raised a sufficient amount, floods led to a widespread famine, and the monk gave away all the money to feed the populace. After some years the monk again had raised money for the sutras, but due to another famine he again gave the money to save starving people. A third time the monk raised the money, and finally the sutras were printed. The woodblocks for the 6,771 volumes are still on view in a temple south of Kyoto.

Such stories of sustained vows in the context of traditional practice continue today. A monk I practiced with in Japan recently completed his vow to raise money through many months of begging rounds in order to cast a large bell for his temple in the mountains west of Kyoto. Previously the temple had not had the customary large signal bell.

Another old Japanese tale of determination and vow, the basis for the film *El Topo*, involves a samurai who in self-defense slew an official, the husband of his lover. The man and his lover fled and lived as thieves. He became disgusted and left her and vowed to do something worthwhile to atone for all of his misdeeds. He began to dig a long tunnel to bypass a treacherous mountain road in a remote area. After thirty years of digging at night and begging for his food by day, he was two years from finishing the tunnel when the son of the official appeared, determined to kill him in revenge. The former samurai asked the son to allow him first to finish the tunnel, after which he would allow the son, who had become a skilled swordsman, to kill him. The son watched him dig and after several months began to help with the digging. When the tunnel was completed the former samurai told the son he could now kill him, but the official's son, moved by the strength of the tunnel digger's vow, refused and called the old samurai his teacher.

The traditional Buddhist stories demonstrate how the practice of vow can generate great power. We can see the dedication of vow as supporting ethics and effort, and being sustained through patience and meditation. In our own day we can also find stories about determination and the fulfilling of specific vows or commitments. Among the exemplars of the bodhisattva archetypes that will be described in ensuing chapters, many of them have vowed to accomplish specific beneficial goals. The Nobel Peace Prize recipient Aung San Suu Kyi resolutely continues to act on her vow to oppose the Burmese military dictators; Jackie Robinson accomplished his vow to integrate baseball; and Pete Seeger has done much to fulfill his vow to clean up the Hudson River. These three can all be seen as exemplars of Samantabhadra. In addition, the Maitreya exemplar Johnny Appleseed spent his life fulfilling his vow to propagate apple trees.

9. Powers

Powers (*bala* in Sanskrit) refers to psychic abilities often developed through meditation and used to support expedient beneficial practices. Mahayana sutras and lore refer to a variety of such supernormal powers, such as the ability to generate heat (very useful for mountain yogis); to foretell the future; to see the past lives of beings; to read minds; to radiate light; or to cause rain—sometimes of flowers!

Buddhist attitude toward such powers has often been ambivalent, particularly in the Zen tradition, which emphasizes attention to ordinary, everyday activity. This outlook was epitomized in the legendary utterance by the great eighth-century Chinese adept, Layman Pang, that the ultimate supernatural power was chopping wood and carrying water. The ordinary world, just as it is, can be appreciated as an amazing, wondrous event. And experiences that seem supernatural and miraculous may only appear so to the limited portions of our mental and spiritual faculties that we conventionally employ.

We can also see the perfection of powers as applying to our "natural" strengths and powers of character. We can study and develop how to properly use whatever strengths and spiritual resources are available to us and, perhaps more importantly, how to avoid their misuse.

The great Chinese master Huangbo (pronounced Obaku in Japanese), when still a student monk, was on pilgrimage visiting different teachers and met a strange, impressive-looking monk on the road. The two hit it off

famously and happily continued on their travels together. They came to a wide river and Huangbo stopped uncertainly. The other monk called him to follow and calmly walked across the surface of the water to the other shore. Disappointed by such wasteful showing off of powers, Huangbo yelled angrily that if he had known the monk would carry on like that he would have broken his legs! The unusual monk sighed in admiration of Huangbo and vanished into the sky.

Powers can be used frivolously, as by Huangbo's companion, or can be used as a transcendent practice when applied to truly beneficial activities. When used as skillful means, our powers can be valuable tools for the bodhisattva's liberative work, either to help alleviate suffering or to demonstrate other possibilities in order to release beings from conditioned views.

The practice of powers especially refers to mantra and *dharani* incantations. These combinations of sounds were developed by yogis and date back to pre-Buddhist Indian Vedic practices. As used in Buddhism, mantras and dharanis, which are usually longer than mantras, may have portions with literal meaning, but much of the mantras have solely symbolic significance, or exist simply as pure sounds that have no translatable meaning. Their inner import and application are to evoke positive mental and spiritual states and to attune us to the energy of the bodhisattvas. In East Asian Mahayana practice, traditional mantras have been chanted using Chinese pronunciations of the original Sanskrit, then in Korean or Japanese pronunciations of the Chinese. But their effect even in adapted forms has resonated throughout centuries of practice.

A mantra can be likened to a conscious vow. Unconscious "mantras" already fill our heads. How many song lyrics or television commercial jingles intrude into our thought stream uninvited? We also play host to many slogans and descriptions, which give us unconscious negative messages about ourselves and the world. We come to believe our own inculcated, discouraging litanies about our lives. Mantra as an intentional transcendent practice counters this numbing and deadening conditioning. In addition to uplifting our outlook, mantra practice is said especially to help develop our powers of memory and mindfulness. The memorization of longer dharanis is a tool used by bodhisattvas to develop memory and mental capacity.

We can use the many mantras from the Mahayana tradition, or "find" mantras from our own experience. Instead of song lyrics that discourage us, we can take as mantras lines or phrases from lyrics, sayings, or poetry that support our personal intention to awaken ourselves and others. Using such

mantras, which often reappear in meditation, or the traditional ones associated with the bodhisattvas, we can support the perfections of enthusiasm and insight.

Many of the bodhisattva figures can be invoked by particular mantras mentioned in the sutras. Perhaps best known is the mantra for Avalokiteshvara, *Om mani padme hum*, which is widely recited by Tibetan Buddhist practitioners, who consider this mantra the actual embodiment in sound of the bodhisattva. A similar mantra for Jizo is *On ka ka kabi sanmaei sohaka* in Japanese; *Om ha ha vismaye svaha* in Sanskrit. A much longer dharani is given by Samantabhadra in the *Lotus Sutra* to protect those who care for the teaching of that sutra.[1]

In Vajrayana practice mantras are used as portions of visualization exercises designed to produce mental identification with the figure invoked. In such practice mantras generally are used only after formal initiation ceremonies or instruction from authorized teachers. However, the mantras mentioned here are offered in Mahayana sutras for unrestricted use by those who wish support for well-being and awakening practice. Of course, an aim of this practice is to develop in ourselves the qualities of the bodhisattvas.

10. Knowledge

Knowledge (*jnana* in Sanskrit, etymologically related to the Greek *gnosis*) is contrasted with wisdom, as this knowledge refers to practical understanding of the workings of phenomena in the conventional world—not useless knowledge just learned for knowledge's sake, memorizing facts and information by rote as is done for regurgitation on tests in some unimaginative educational systems. As the flip side of wisdom, the perfection of knowledge can be seen as the function or implementation of wisdom—but fully informed by wisdom's insight into the essential. This knowledge, also referred to as the perfection of truth, is at the service of wisdom, putting wisdom to work in the world. Such knowledge may be the product of detailed study in the ordinary realm or in any of the physical sciences, but coming from mature intention to use the knowledge beneficially.

The perfection of knowledge refers ultimately to the aspiration for the omniscience of a fully awakened buddha. This omniscience is not akin to the capacity of a supercomputer that already has data files on everything that ever has happened or will happen. Rather, when encountering a specific realm or being, one with such omniscience can immediately see the current

workings and the totality of past causes and conditions of that being's consciousness, including "past lives," and knows how to respond productively given the situation. Such knowledge encompasses a variety of supernormal, mystic knowledges, including comprehension and experience of all realms and of myriad awarenesses, ordinary and paranormal. Informed by the ninth perfection of powers, the bodhisattva comes to have detailed understanding of the consciousness, needs, and obstructions of all the different beings, and how to apply appropriate correctives to guide them on the path of liberation.

When awakened by insight, ethical conduct, and the basic bodhisattva vow and intention to care for beings, whatever intuitive or acquired knowledge is available to us can be applied to strengthen appropriate skillfulness and generosity. We can study the details of how people respond, how to apply our tools, and how we ourselves think and feel. Such information, used wisely, can be applied to all the complex situations of the world to accomplish bodhisattva work.

4 Shakyamuni As Bodhisattva
The Long Path to the Bodhi Tree

A BODHISATTVA IN HISTORY

THE HISTORICAL BUDDHA is not a cosmic, archetypal bodhisattva in the same sense as the other bodhisattvas discussed in this book. Rather, he was a human being whose life had a profound impact on human history, originating a major world religion and mode of spiritual orientation that has inspired much of humanity throughout Asia and beyond. The story of Prince Siddhartha Gautama, who became Shakyamuni Buddha, has been a prime example for all Buddhist practitioners. The name Shakyamuni means sage of the Shakyas, the tribe into which he was born in northern India. The major events of his life in the sixth century B.C.E. are often referred to as characteristic of the lives of all buddhas.

The dramatic story of his life as Siddhartha Gautama, prior to his becoming the Buddha, or Awakened One, is more often recounted than the events of his long ministry as the Buddha Shakyamuni. Even in the early Pali teachings, Prince Siddhartha is considered a bodhisattva (or *bodhisatta* as it is pronounced in Pali). In a sense, the elements of Shakyamuni Buddha's life that are most prominent establish the basic archetype for all bodhisattva practice.

THE CHOICE: SPIRITUAL OR WORLDLY, BUDDHA OR EMPEROR

We can identify five fundamental archetypal elements in the story of Siddhartha Gautama as bodhisattva. They consist of his choice between worldly or spiritual pursuits, his awakening to the truth of suffering, his

home-leaving, his ascetic practice leading to the Middle Way, and his complete enlightenment under the bodhi tree.

The first aspect of archetypal choice derives from Siddhartha's birth as a prince. Seeing the infant, a wandering sage named Asita, known for his psychic abilities, predicted either great worldly or great spiritual sovereignty for Siddhartha. Some sutras identify thirty-two physical marks or attributes common to all buddhas, such as long ears, tongue, and arms; a radiant curl between his eyebrows; dharma wheels on his palms and soles; and a protuberance on the crown of his head. (However, as mentioned in chapter 2, the *Diamond Sutra* declares that there are no marks or characteristics by which a buddha may be identified.) At any rate, the physical marks ascribed to buddhas in early sutras are said to be possessed equally by great, virtuous, and powerful world rulers, known in Sanskrit as *chakravartins*, those turning the wheel of the law. This epithet was also used for buddhas, sovereigns of spiritual law. Putting aside mixed assessments of their virtue and character, we might imagine figures such as Alexander, Kublai Khan, or Napoleon as representing the global, imperial potential of worldly chakravartin rulers. The destiny predicted by the seer for Siddhartha was either as a buddha or as a wide-ranging monarch. Ruler of a small kingdom in northern India, Prince Siddhartha's father, Shuddhodana, of course hoped for worldly, political dominion for his son.

The options presented by Asita pose the fundamental dilemma and choice for all humans, regardless of innate talent or social endowment: whether to use our potential and capabilities to pursue worldly, material values and purposes, or spiritual ones. Many Buddhist figures through history followed this pattern of being born into a noble family and facing this choice. Other princes besides Siddhartha have become great Buddhist teachers. But the basic choice between worldly and spiritual endeavor confronts us all. All Buddhist followers are conventionally addressed in the sutras as "sons and daughters of good family," acknowledging the choice they have made and their innate nobility. Practitioners are often exhorted to abandon attachment to fame and gain, to persist in the choice they have made to work for awakening.

We may make this choice at some critical juncture in our lives, determining our future paths or careers. But we also face this basic choice again and again every day, in the middle of our ordinary activities. In whatever life we are already leading, just as it is, we can choose to direct our energies toward accumulations of worldly power and material wealth, either with well-

meaning or self-serving intentions, or else toward beneficial consideration of all concerned, aimed at the development of spiritual awakening and the liberation from suffering.

THE SHELTERING PALACE
AND AWAKENING TO SUFFERING

The second archetypal element of Gautama's bodhisattva career is his upbringing, leading a comfortable, highly sheltered existence in the palace, in contrast to his subsequent awakening to the truth of suffering and to the possibility of leading a spiritual life. Siddhartha was trained for his role of political leadership as a prince in the warrior class, mastering all the martial arts of his period. His father sought to protect him from any spiritual inclination and lavishly provided all the material and sensual comforts Siddhartha might conceivably desire. We may recognize the protective impulse common to many well-meaning parents.

The traditional story indicates a great deal of innocence, or naïveté, on the prince's part. Siddhartha is said to have been totally oblivious of all possibility of sickness, old age, and death, until he witnessed them as a young adult. On a sequence of unsanctioned excursions outside the palace, he observed a sick person, then an old person, and finally a dead body. These experiences awakened in Siddhartha a deep, unquenchable concern for the problem of human suffering.

This awakening to the reality of suffering and to the desire for awakening, known as *bodhichitta* in Sanskrit, is fundamental to all bodhisattva practice. This initial caring impulse is said to contain all the qualities of awakening, although long years or lifetimes of cultivation may be required for their fulfillment. On his fourth visit to the world beyond the palace walls, Siddhartha noticed a wandering mendicant, a typical figure in Indian religion, and was informed by his charioteer-attendant of the possibility of spiritual seeking as a life calling. Once informed of this alternative, Siddhartha's awakening heart and mind seemed driven to the conquest of suffering for the sake of all beings. The abundant pleasures and comforts of the palace were meaningless in light of the essential question of how beings could be liberated from life's suffering.

Sooner or later, no matter how comfortable we may feel and no matter how much we have been protected from material want, life provides us with the opportunity to experience loss, suffering, anguish, and the pain of anx-

iety over our destiny and that of our loved ones. Such opportunities force
the basic choice upon us, often again and again. We cannot avoid old age,
sickness, and death.

THE HOME-LEAVING

The third, and pivotal, element in the story of Siddhartha as archetypal
bodhisattva is his great home-leaving, abandoning family and position, fame
and gain, to seek spiritual truth. The version that has been generally
recounted in the West is that at age twenty-nine, after his experiences of
worldly suffering, in the middle of the night Siddhartha left his beautiful
young wife and infant son in the palace and began a life of spiritual auster-
ity in the Himalayan forests. In some accounts he is described giving a last
loving look back at his sleeping wife, Yashodhara, and their child, before
departing. Sometime after his enlightenment six years later, his wife and
son, along with his stepmother, joined the Buddha's order, and his son
Rahula became one of Shakyamuni's celebrated ten foremost disciples.

Siddhartha's dramatic departure from the palace is so fundamental a
motif in Buddhist practice that all Buddhist monks are referred to formally
as home-leavers. This has had physical implications for the forms of monas-
tic practice. Theravada monks sometimes avoid personal contact with
laypeople to avoid the temptations of home life. Mahayana monks in East
Asia are frequently housed in communal dormitories, often the same as the
meditation or practice halls, renouncing private personal space. While the
model of solitary or sometimes loosely associated spiritual seekers predated
Shakyamuni in India, in East Asian societies family loyalty and structured
social roles were fundamental to all human identity. A Buddhist order com-
posed of monks and nuns who had left home and turned their back on
family ties and conventional social position posed an ongoing, radical alter-
native to the usual way of being in the world. Although Buddhist monas-
teries in later Asian societies sometimes became conservative and
comfortable establishments where those seeking security could settle in as
monks, this tendency also was criticized strongly by many noted Buddhist
teachers. The vision of Dharma community as a counterculture challenging
the established social order never completely faded.

Aside from its social implications, home-leaving also denotes a deeper
psychological meaning, abandoning the "home" of conditioned psychic
patterns inherited through family dynamics and also from society. These

mental habits are the psychic karma we derive first from our parents and develop later to protect the self, as we imagine ourselves separate from all others. Such conditioning may be necessary to function in the conventional realm, but when we take these mechanisms as real and settle into them as a shelter, they become an obstacle to the open awareness of the buddha nature. Inspired by dissatisfaction with the world and by the wish to enlighten all beings, bodhisattvas must leave this protective, comfortable psychological palace and enter the unknown mental wilderness of awakening practice. Siddhartha's determination exemplifies this concern and the aspect of liberation that requires wrenching free from our unconscious, deep conditioning.

Shakyamuni's home-leaving is especially controversial in the modern transition of Buddhism to the West, with its valorization of lay life, family practice, and the spiritual value of intimate relationships. The value of monastic or semi-monastic training and ordination has been accepted by many Westerners. But even more than in China, where the sutra of the layman Vimalakirti was popular, many emerging Western Buddhist communities are dominated by sincere and often rigorous practice by laypeople, congruent with nondualistic Mahayana teaching that this very world is the realm for realization. This is reflected in an emphasis on spiritual practice in the family setting, with recognition that parenting and care for personal, intimate relationships may be challenging, and even enlightening, spiritual activities.

The insights of feminism also have been influential and have led to changes in traditional community practices developed over centuries in patriarchal cultures, which were as dominant during the past few millennia in Asia as in Europe. There have been only occasional precedents in Asian Buddhist history for residential practice communities composed primarily of laypeople, with men and women, and families with children, practicing together, such as those that have developed in America.

In this modern Western context many have questioned the need for Shakyamuni to leave his wife and child, and issues of family values demand reexamination and reframing of this key aspect of the archetype. The story usually related in the West about Siddhartha abandoning his wife and child is a late Theravada version, based on postcanonical Pali sources, and implies that the home-leaving was a total abandonment of any ties to family. Thus Theravada monks follow precepts that enforce separation from the world. However, the Pali suttas themselves do not mention abandonment of his wife and child at his home-leaving, but only departure from his parents.

Interestingly, early Sanskrit accounts from the vinaya (precepts) texts of the Mulasarvastivada precursors of the Mahayana, roughly contemporary or earlier than the Theravada sources, offer a story that is less world-rejecting. This text states that just before departing the palace Siddhartha made love to Yashodhara and conceived his son, contrary to the story of his merely looking back at them sleeping. This version offers a rather different image of Siddhartha's home-leaving, one in which he fulfills his husbandly obligations (by producing a son) and does not turn from sexuality in abhorrence.

The Mahayana accounts indicate that Siddhartha's family received regular news of his activities and spiritual progress after his departure. Five attendants were sent to observe the prince and relay back reports, and ended up joining Siddhartha in his ascetic practices. Based on their messages and those of other courtiers, the prince's wife, Yashodhara, simultaneously engaged in the same meditative, ascetic, and dietary practices as Siddhartha, while remaining in the palace. One version of the story, with the full taste of Mahayana magical symbolism, records that Yashodhara remained pregnant with Rahula throughout Siddhartha's six years of ascetic practices, finally giving birth on the same night as her husband's enlightenment under the bodhi tree! While we may not care to take literally such miraculous anecdotes from Mahayana lore, this account certainly acknowledges the great value of childbearing and birthing, symbolically equated with Buddha's enlightenment itself.

Although Siddhartha's home-leaving is central in all versions of the tale, the Mahayana attitude toward family has a strikingly different flavor, with his family having some role in Siddhartha's spiritual pursuit. There is an implied promise by the prince to return and enlighten them as well, which is fulfilled when his wife and son join his order, and his stepmother, Mahaprajapati Gautami, becomes leader of the order of nuns. Many of his other relations also joined Shakyamuni's community, such as his cousin, the prominent disciple Ananda, and Shakyamuni's half-brother, Nanda. In the Mahayana, Shakyamuni's enlightenment is thus seen as a family affair, with blood ties acknowledged and loved ones included among the beings to be saved. Historically in Buddhism, the families of children who become monks or nuns are said to receive great merit upon their ordination.

The different versions of Shakyamuni's departure from his family offer the opportunity for renewed attention to the inner meaning behind the home-leaving. The home-leaving may be understood in terms of shedding the antiquated home of familial conditioning for the ultimate homecoming

to the awakened heart. This is the homecoming to our original, inalienable true nature, not separate from all being (which is indicated in Zen slogans such as "to see your original face before your parents were born"). Buddhist disciples are referred to as children of Buddha, indicating the new "home" of Buddhist practice and community. Ancestry is seen by East Asian Buddhists in terms of historical lineages of teachers, similar to traditional genealogies of genetic ancestors, and transmission of the teaching is nicknamed "maintaining the family business." The fellowship of bodhisattvas working for universal awakening is seen as a wider, more fundamental family. Practitioners or devotees are encouraged to see each other as buddhas, more closely related to one another than genetic siblings.

ASCETIC PRACTICES AND THE MIDDLE WAY

The fourth basic archetypal element in the story of Siddhartha as bodhisattva is of his six years of arduous practice before his great awakening. Following the common religious practices of the time, Siddhartha took on the meditation trainings of the two leading contemporary Indian spiritual teachers. These practices involved the four dhyanas, or meditative trances, from which Chan/Zen later derived its name. While not universally adopted into later Buddhist practice, this dhyanic yogic system of mental purification and exaltation continued to be followed by some Buddhist meditators, especially in the Theravada.

The meditative practices of Siddhartha's two teachers led respectively to a mental state of vacancy, and to awareness beyond perception or nonperception. Siddhartha mastered these practices and was recognized by both teachers sequentially as their most adept disciple. Siddhartha refused, however, their offers to take over their congregations, as he recognized that this progression into lofty, ethereal mental realms did not in truth lead to the ultimate liberation from suffering that he sought. Rather, these elevated mental states were escapes from ordinary consciousness and evaded confronting the practical realities of suffering.

Siddhartha continued to follow the spiritual and yogic customs of his time, undergoing rigorous austerities. Many ascetic practices have been retained in various Buddhist traditions, Mahayana as well as Theravada. Such practices as never eating after noon, never lying down, never carrying money, strict celibacy, prolonged meditation or silence, and numerous full prostrations have been followed not only by Theravada monks but also by

some monks in many of the Mahayana traditions. Along with these, Gautama's ascetic regimen followed some of the more extreme contemporary Indian practices, which included severe fasting, never going indoors under shelter, and even self-mortifications such as staring at the sun or eating excrement (although the latter two were not recorded practices of Siddhartha). The aim of such effort was to totally purify and expunge all worldly desires and defilements, to transcend all attachment to the physical. Siddhartha is sometimes depicted during his period of severe fasting as gaunt and emaciated, with ribs showing sharply, either sitting in meditation or walking.

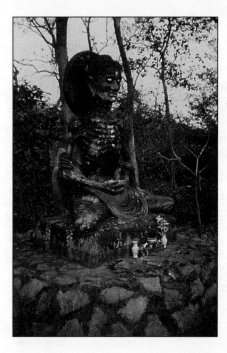

Emaciated Shakyamuni,
Thailand

The story describes how Siddhartha, near the point of death, came to realize that such exertion was not conducive to true spiritual well-being or development. He was offered milk as nutrition by a cowherd, and then given rice pudding by a sympathetic maiden. He accepted this food, embracing the "Middle Way" between excessive asceticism and materialist hedonism. Greatly refreshed and with renewed health from this nourishment, Siddhartha determined to sit in contemplation without moving until he had

realized the end of all suffering. He sat down under a fig tree, which has been known as the bodhi tree, or tree of awakening, ever since.

This Middle Way enacted by Shakyamuni before his enlightenment has been a prime motif accepted in all subsequent Buddhist practice. However, there have been a great variety of interpretations of where this middle lies. For the Theravadin monk, the Middle Way lies in obedience to hundreds of strict precepts and regulations. At the other end of the spectrum, for priests in the Mahayana traditions as they developed in Japan, the Middle Way may include marriage and some degree of material comfort. The point is not to be caught by worldly, material pleasures and pressures, but also not to be caught by extreme acts of denial of the material. Excessively austere reactions against the physical may only be further expressions of entrapment by them. But a casual or lax attitude without some kind of physical dedication or mindful practice that actually embodies or expresses the teaching also misses the helpful, awakening awareness and Middle Way of the bodhisattva.

AWAKENING UNDER THE BODHI TREE

Shakyamuni's sitting uprightly under the bodhi tree, vowing not to move until he could solve the problem of suffering, can be designated as the fifth and final element in the archetypal story of Prince Siddhartha as bodhisattva on the path to buddhahood. Some accounts say he sat there seven days, some seven weeks. This is still commemorated in the Zen tradition with seven-day intensive sittings.

As Shakyamuni sat in meditation he reviewed the dhyana system and contemplated the mental phenomenology of suffering, which he later taught as the twelvefold chain of causation. He realized that the world and its round of suffering are produced by a chain of causation leading from fundamental ignorance to habituated mental formations. These predispositions produce a consciousness that perceives the world as composed of estranged objects, which it names and categorizes. Some of these are felt as distasteful, others as desirable. This discrimination leads to craving and grasping at the objects of desire, which produces frustration and suffering, and the cycle of birth, old age, and death.

As Siddhartha sat under the tree clarifying this realization, he was faced with the temptations of Mara, the personified spirit of obstructive delusion. Mara attempted to unseat Siddhartha with worldly power, with fierce intimidating demons, and then with enticing women. Through it all, the prince

remained unshaken and unmoved, aware of the temptations but intent on his meditation, thus modeling the determination to awaken and dissolve the suffering of all beings. Siddhartha's unshaken resolution is emblematic of the dedication of all bodhisattvas.

For his last-ditch effort, Mara challenged Siddhartha by demanding to know how the prince could claim to be an awakened buddha. Siddhartha responded by calmly touching the ground before him, calling the earth itself as his witness. This gesture, known as the "earth-touching mudra," is memorialized in many images of Shakyamuni Buddha sitting cross-legged in meditation with his right hand outstretched and fingertips lightly touching the ground. (See the accompanying illustrations on page 96.) Some versions of the story state that the Earth Goddess thereupon emerged from the ground to verify Shakyamuni's qualifications for awakening.

The image of Shakyamuni touching the ground, and the emergence of the Earth Goddess as witness, reveal the quality of Buddhism as an earth religion. This is a central fact of bodhisattva practice. Everything we need for awakening is present in the very ground upon which we sit. Enlightenment is not a matter of achieving some brand-new state of being or consciousness, or of traveling to some distant realm, or of becoming some different person. Rather, the transformation embodied in Shakyamuni's awakening is simply about fully settling into the deep, wide self we already are, totally interconnected with the whole universe, but expressed uniquely in this individual life. This experience is as close to us as the ground beneath our feet. It is not achieved in some other, external, heavenly realm. The earth we sit on is rich and fertile, teeming with life and awareness. The earth-related aspect of bodhisattva practice is further developed in the archetype of Kshitigarbha or Jizo, the Earth Womb Bodhisattva, as discussed in chapter 8.

After Siddhartha defeated Mara and continued sitting through the night, the morning star appeared. When he saw it, Shakyamuni was thoroughly awakened. The nature of this enlightenment is described in the Mahayana as the Buddha's realization that all beings fundamentally are expressions of the clear, openhearted awareness referred to as "buddha nature." Although some may not realize it due to their conditioning and ignorance, when Siddhartha was awakened, the whole world and all its creatures were awakened together.

Many followers of the Buddha over the past two and a half millennia have partaken of this awareness, sometimes to a great degree. Although some Buddhist traditions encourage their practitioners to experience this

opening themselves, or to strive to "achieve" enlightenment, it is important to note that Shakyamuni's enlightenment was the beginning of Buddhism, not its end or conclusion. Thereafter, Shakyamuni started the movement later known as "Buddhism," and devoted the remaining four decades of his life to spiritual teaching. Practice does not stop with enlightenment. Although this was the culmination of Siddhartha's bodhisattva career and the beginning of his buddhahood, in another sense the bodhisattva work begins with, and assumes, this enlightenment.

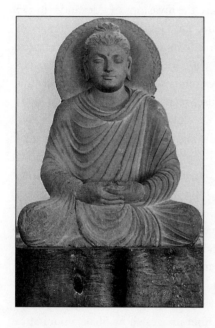

Shakyamuni, Gandhara

It is said that Shakyamuni's first students were the five companions who had pursued austerities together with him. When he took nourishment and adopted the Middle Way, they had departed from him in disgust, assuming that he had abandoned his spiritual quest. Some Mahayana accounts state that these five had been following him since he left the palace, that in fact they were noble courtiers sent by Siddhartha's father, King Shuddhodana. Although they were inspired to follow and join in the prince's various spiritual practices, they also continued to keep the palace informed of his activities. Later, when they saw him after his awakening, they recognized and appreciated some new quality in his bearing, and became his first disciples.

ICONOGRAPHY OF SHAKYAMUNI

Historically in Buddhism, depictions of Shakyamuni have evolved some-what differently in diverse cultures, but much of the imagery reflects the story of his awakening. In early Buddhism there were no images of Shakyamuni as a person, but simply images of the Buddha's footprints, of the bodhi tree, or of wheels of the dharma, which represented his teaching. During the second century C.E., the first images of Shakyamuni appeared in Mathura in north central India, and in Gandhara in northwest India, a region influenced by Greek art and culture since the invasions of Alexander in 327 B.C.E. Based on Greek figure sculpture, the Gandharan stone statues of Shakyamuni Buddha were in the Hellenistic mode, with Caucasian features. (See the accompanying illustration on page 93.) They share characteristics common to most depictions of Shakyamuni, who generally is depicted as unadorned, without any of the profuse, resplendent ornaments such as necklaces and crowns that often adorn bodhisattva images.

As statuary of the Buddha spread through Asia, a number of images of Shakyamuni were frequently depicted, based on the story of his life. Among these motifs are the gaunt Siddhartha, emaciated with ribs showing during his fasting. Sometimes he is seated. Other images of the ascetic Shakyamuni show him walking as if haltingly, sometimes interpreted as his "coming down the mountain" from his severe austerities after deciding to adopt the Middle Way, headed toward the bodhi tree.

Many images are of Shakyamuni seated in lotus posture under the bodhi tree, his right hand grazing the ground in the earth-touching mudra as he calls the earth as witness. He is often shown seated in meditation, sometimes holding his begging bowl in his lap. Other images show Shakyamuni after his awakening with his hands held up in the dharmachakra mudra of turning the wheel of the teaching. This gesture has a number of variations, but generally the right hand is held in front of his chest, palm out, with the left hand below it, palm turned inward, as if holding the round wheel of the teaching turned by the Buddha.

Another common image of Shakyamuni shows him lying peacefully on his right side as he passed into parinirvana, a buddha's final extinction and transcendence of the rounds of rebirth. In paintings he is shown lying between two trees, surrounded by disciples, as is recorded in the sutra accounts of his passing. This reclining posture, on the right side, traditionally has been recommended as a yogic sleeping posture for monks and other practitioners.

An amusing image of Shakyamuni displayed especially during annual Buddha's birthday celebrations is that of the baby Buddha. The figure of a smiling baby, sometimes with the characteristic protuberance on his head, stands upright with one hand pointed straight down and the other extended up with a finger pointed to the sky. For his birthday, statues of such baby images are set in water basins garlanded with flowers and then bathed with ladles full of water by the celebrants, especially including children. This image commemorates a legend about the infant Siddhartha soon after his birth. The future Shakyamuni Buddha is said to have taken seven steps, pointed up to the sky and down to the ground, and proclaimed, "Below the heavens and above the earth, I alone am the World-Honored One."[1] This seems to be a late-developing fable, in accord with the story of Asita's prediction of Siddhartha's coming greatness.

Another Shakyamuni motif relates to the story that he remained seated upright under the bodhi tree for seven weeks after his awakening, during which time torrential rains fell. The Buddha was protected from the storms by the naga or serpent king Mucilinda, who is depicted like a five- or seven-headed cobra, coiled under the meditating Shakyamuni as a pedestal with hooded heads spread above him as a protective nimbus.

As statues and paintings of Shakyamuni proliferated in Buddhist countries, a range of cultural styles and forms were used. For example, later Thai images characteristically feature a conical protuberance on Shakyamuni's crown, representing the flame of enlightening knowledge. In Cambodia and other Southeast Asian countries, snakes were widespread and feared, but also venerated as supernatural in native shamanic and animistic traditions, so images of Shakyamuni being protected by the guardian Mucilinda were especially popular.

THE JATAKA TALES

Another aspect of the bodhisattva archetype deriving from Shakyamuni Buddha is the unique and rich literature of the jataka tales (*jataka* meaning "birth stories"). These texts date back to Pali sources and the Theravada tradition and were first recorded in the first century B.C.E. Often based on popular pre-Buddhist Indian legend and folklore, these stories are framed as Shakyamuni's past lives as bodhisattva, during which he was developing the qualities needed to be born into his final life, in which he would become the Buddha.

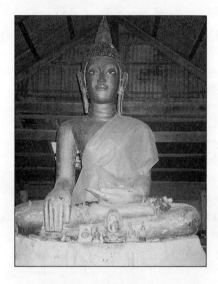

*Shakyamuni in earthtouching
mudra, Thailand*

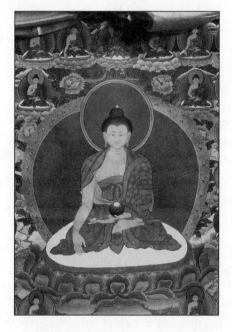

*Shakyamuni in earthtouching
mudra, Tibet*

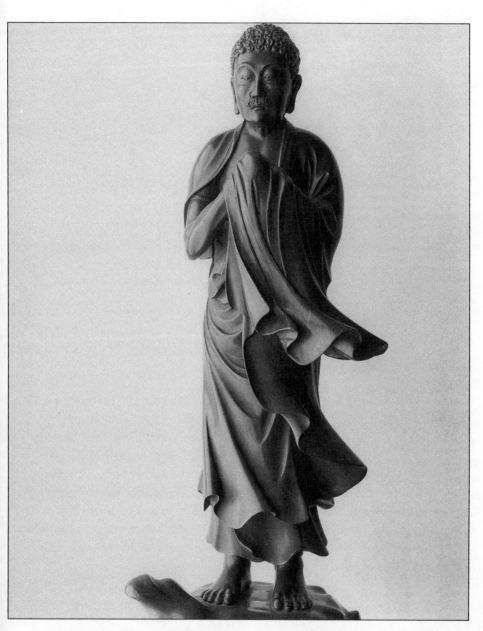

Walking Shakyamuni, China

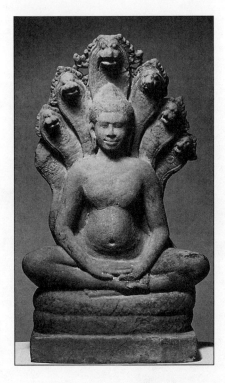

*Shakyamuni protected by
Mucilinda, Cambodia, circa
10th–11th centuries*

The more than five hundred jataka stories have been used as moral stories for children, a sort of Buddhist *Aesop's Fables* that have remained popular through the ages. In the stories Shakyamuni appears in former lives as some other being, a prince or a humble human or an animal, doing some noble or selfless deed, venerating a previous buddha, or often sacrificing himself for others. In one famous story he is a young prince who comes to the edge of a cliff, below which is a starving tigress and her cubs. Seeing that the desperate mother is about to eat her cubs, this prince, who in a future life will become Shakyamuni Buddha, hurls himself from the top of the cliff to become food for the hungry animals below.

BUDDHA'S INCONCEIVABLE LIFE SPAN AND HUMANITY

There are many illuminating stories from Shakyamuni Buddha's life after his enlightenment. But one of the most defining stories about the nature of buddhas and bodhisattvas in the Mahayana canon is from the *Lotus Sutra*. As Shakyamuni is preaching the *Lotus Sutra*, bodhisattvas who have gathered

from many distant dimensions of space, time, and mind ask the Buddha if they can help preserve this teaching for beings in the distant future, after his passing. From our vantage point, 2,500 years later, I imagine the question as: "In the distant future age of television, computers, automobiles, and nuclear weapons, how will people hear the true teaching of universal awakening?" The Buddha tells them not to worry, and suddenly from out of the empty, open space under the ground spring vast multitudes of noble, gentle beings, dedicated to the emancipation of all creation. The Buddha declares that these bodhisattvas practice diligently within the earth, forever guiding confused, worldly people. Moreover, they have all trained intently with him, even though many apparently are ages older than the Buddha himself.

Seeing this vast array of previously hidden bodhisattvas, Buddha's disciple, the Bodhisattva Maitreya, voices the question of the assembly by asking how Shakyamuni could have trained them all, given the limited number of years since his departure from the palace and his awakening under the bodhi tree. Thereupon the Buddha proclaims that although it may appear that he was born, left the palace, attained enlightenment, taught, and would pass away into the extinction of parinirvana, in reality, a buddha's life span is inconceivably vast. The regular archetypal events of his life are only displayed for the benefit of beings, in accord with what would be most helpful to their development. Ultimately a buddha's life span is nearly eternal, inconceivably vast beyond our imagining. While buddhas may seem to arise and disappear, there is actually no place or time where there are not buddhas. The implication is clear that bodhisattvas, too, springing up out of the ground, are everywhere and in every time, with inconceivably long life spans. This is especially true for the cosmic bodhisattva archetypes we are studying.

The flip side of this story, also proclaimed by Shakyamuni in the pivotal episode of the *Lotus Sutra*, is that there is a helpful aspect to seeing the Buddha as mortal, an ordinary person, not a superhuman god. Historically, it is recorded that Shakyamuni died at about age eighty from dysentery, probably after eating tainted pork accidentally offered by a well-meaning lay devotee. As a mendicant the Buddha ate whatever was offered, a traditional policy of Buddhist monkhood that sometimes outweighed the general preference for vegetarianism and the avoidance of killing animals. Although he had realized the end of suffering, as a historically manifested human with a limited body, the Buddha was still subject to sickness, old age, and death. In his recorded death Shakyamuni was calm, teaching to the last, encouraging his awakened disciples to realize that all conditioned things pass. We cannot

ignore the aspect of buddhas and bodhisattvas as regular mortals, subject to the limitations of physical incarnation. Buddhas and bodhisattvas were previously ordinary people just like us. But simultaneously, the awareness and awakening of buddhas and bodhisattvas is always present, never dying, ever available to help all beings.

SHAKYAMUNI'S FLOWER
AND THE MIND-TO-MIND TRANSMISSION

A further archetypal aspect of Shakyamuni's life especially central to the Zen branch of Mahayana is the legendary story of his "mind-to-mind" transmission of the "true dharma eye" to his disciple Mahakashyapa. While preaching to the assembly at Vulture Peak, the Buddha paused, and then silently held up a flower. All in the assembly were perplexed, except for Mahakashyapa, who smiled.

Shakyamuni acknowledged the response of Mahakashyapa, stating that he alone understood, and thereby received the Buddha's "true dharma eye treasury of the wondrous mind of nirvana." In the Zen tradition this tale is considered the first transmission of the teaching, and Mahakashyapa is considered the First Ancestor in the lineage. Although this pattern of transmission is not recorded in extant Indian writings, in China and the rest of East Asia it became the basis for lineage records tying contemporary masters back to the historical Buddha, and it is also the basis for the forms of Dharma transmission in the Zen tradition. This tradition particularly emphasized personal experience of awakening and the role of the teacher as both guide and as witness providing verification of the depth of the practitioner's realization. This experience is founded on mind-to-mind or face-to-face encounter with a mature master.

The Mahayana model for the teacher-student relationship also evidently draws on the bodhisattva teachings in sutras, for example the encounters of Sudhana with various teachers in the *Flower Ornament Sutra*. The relationship of practitioners to teachers, or to more experienced practitioners sometimes described as spiritual friends, can be seen as an important aspect of all bodhisattva practice, beyond the specific emphasis and ancestor-veneration rituals of the Zen lineages. All successors to the Buddhist teaching and the bodhisattva way are in some sense said to partake of mental attunement with Shakyamuni Buddha, and to continue and maintain the Buddha's awareness.

SIDDHARTHA GAUTAMA AND THE PARAMITAS

Although all bodhisattvas have some relation to each of the transcendent practices, the example of Shakyamuni as bodhisattva clearly emphasizes three of these perfections: effort, meditation, and wisdom.

Siddhartha's decision to leave the palace to dedicate himself to spiritual awakening, and his heroic effort during his six years of arduous practice before his enlightenment, are great examples of the transcendent practice of effort. We can appreciate his fasting and asceticism as effort and persistence. But his final taking of nourishment to adopt the Middle Way was also an example of marshaling energy for the sake of his effort to realize the end of suffering. His effort the night of his awakening, withstanding the assaults of Mara, further epitomizes heroic effort.

Siddhartha also exemplifies the perfection of meditation. He was master of the dhyana system, refining mental states to transcend desire and form. He further meditated to observe the twelvefold chain of causation, to understand the process of the creation and cessation of suffering, and simply to express and enjoy his insight. This meditation also continued to be his daily practice after his enlightenment.

In awakening to become the Buddha Shakyamuni, Siddhartha enacted the standard of wisdom and insight. He saw into and embodied the awakened buddha nature of all being, the emptiness of self-existence or estrangement, and the fullness of the interconnection of all creatures. He also was able to use his insight to develop ways of expressing and sharing this understanding and experience with the diversity of his many disciples. Shakyamuni demonstrated the relationship of these three perfections, as he used his great energy and heroic effort to persevere and perfect his meditation, thereby simultaneously perfecting his wisdom and understanding. Of course, speaking of Shakyamuni as the Buddha, rather than of Siddhartha's efforts as bodhisattva before his awakening, it is understood that all of the ten transcendent practices had been perfected.

EXEMPLARS OF THE SIDDHARTHA ARCHETYPE

There are no exemplars for the whole of buddhahood, except another buddha, but we can pose examples to clarify and illustrate particular aspects of the bodhisattva archetype demonstrated by Siddhartha on his way to awakening. To reiterate, the familiar persons cited in this and other chapters are

not here claimed to be incarnated "Buddhist" bodhisattvas in any sense. But each of them has done something that might be recognized especially as an example of bodhisattva activity, as have many ordinary, unknown people now and through the ages.

The main archetypal features posed by Siddhartha as bodhisattva may be summarized starting with the choice between worldly, material pursuits and spiritual concern and commitment. This choice is precipitated by an awakening to the suffering of the world and its creatures, including but not limited to oneself. The pivotal point in the story of Shakyamuni as bodhisattva is his home-leaving, abandoning his position and the comfort of a sheltering palace for the sake of his spiritual quest. Such home-leaving may be enacted in external situations, or symbolically and psychologically. This is followed by the archetypal quest for truth, featuring the great effort to undergo austerities and then the wisdom to find the balance of a middle way that makes perseverance and breakthrough possible.

Perhaps this is a startling example with which to commence, but in terms of abandoning kingship for spiritual values, Muhammad Ali is one of the best-known contemporary cases. As boxing's "heavyweight champion of the world," he first risked his title to change his name from Cassius Clay for the sake of his spiritual beliefs as a Muslim. The brash and colorful young boxer was already a controversial figure who had offended many establishment commentators by his lack of simulated modesty and by his pride in his skill, predicting his own victories in versified proclamations. We may recall the cocky pronouncement attributed in Buddhist legend to the infant Siddhartha soon after his birth, that "I alone am the World-Honored One." The young Ali similarly announced to the world, how "pretty" he was, and claimed, "I am the greatest."

Ali's adoption of Muslim beliefs and forms was highly unpopular. His faith was politically controversial, as it strongly upheld values of self-esteem for African Americans at a time when the civil rights movement was under threat. Ali's spiritual values were far from frivolous or fabricated. From early in his career up to the present, Ali has not forgotten his roots and the suffering of others. He frequently has used his financial resources and his social position to assist many altruistic projects, including the African American community, while avoiding unnecessary publicity and praise for his charitable endeavors.

Ali's renunciation of his "palace" was fully enacted when he refused to fight in what he, and many others, considered an unjust war in Vietnam.

Although he did not himself choose to abandon his title, Ali was stripped of his world championship by the boxing authorities in 1967 for claiming conscientious objection against the war. He did this at a time when protest of the war was still unpopular, and when his stand damaged his reputation in the African American community and threatened him with a long jail term. But Ali was adamant that he would rather go to jail than fight in what he insisted was not his war. He said that he had no desire or reason to go across the world and kill Vietnamese people who had done him no harm, adding, "No Viet Cong ever called me 'nigger.'"[2] Ali courageously persevered, and a United States Supreme Court ruling in his favor four years later allowed him to box again, and dramatically regain his title. Ali's affirmation of spiritual principles over worldly acclaim clearly exemplifies the important aspect of spiritual choice in the Siddhartha archetype.

Many had questioned Ali's stance on the Vietnam War because he was a professional fighter, and some may question the comparison of Ali, a boxer, to the Buddha. But we may remember that Shakyamuni, scion of the warrior caste, also was trained and accomplished in martial arts. After his enlightenment, the Buddha refused to counter, except nonviolently, when his former kingdom was invaded. Ali continues his caring involvement and genuine friendliness with people of all stations, even while dealing with his physically impairing Parkinson's syndrome. Ali has written about the theme of healing and he speaks to high school students from diverse backgrounds about the value of love and tolerance, and of overcoming the wounds of racial hatred and prejudice.

In examining the archetype of spiritual choice and renunciation, we can look to the example of another controversial figure of the Vietnam era, Daniel Ellsberg, who released the Pentagon Papers. Ellsberg had been a senior consultant for the Rand Corporation military think tank and an important civilian official in the Defense Department, possessing extremely restricted security clearances. Ellsberg's special expertise was command and control of nuclear weaponry, and he was privy to military knowledge sometimes shared by only a handful or so other people. A former marine company commander, Ellsberg authored the top-secret guidance to the Joint Chiefs of Staff for the strategic plans for nuclear war, operational through the early sixties. While working for the Defense Department, he had prepared a top-secret history and analysis of U.S. decision-making that demonstrated how several administrations had consistently lied about their

prosecution of the Vietnam War. Despite their own clear estimation that the war could not be successful, they nevertheless expanded the conflict, killing hundreds of thousands of innocent Indochinese civilians along with tens of thousands of American soldiers. Ellsberg released this study, which became known as the Pentagon Papers, to the *New York Times* in 1971.

Ellsberg has written about the seductions of power and the fear of losing it. Like him, many in the bureaucracy carrying out the Vietnam War came to abhor it, but were afraid of losing their comfortable jobs and worldly power. They continued to hope meekly that they could alter the situation from within the system. But Ellsberg had been exposed to the suffering in refugee camps outside Saigon during his service in Vietnam. He came to see how ongoing atrocities were supported and made possible by policies and practices of secrecy, which kept important information hidden from the public and from Congress.

After witnessing the truth of suffering in aged, sick, and dying persons, Prince Siddhartha observed a mendicant spiritual seeker and became determined to leave his palace to seek enlightenment for all beings. Similarly, Ellsberg met a young Indian woman in 1968 who was a dedicated student of the nonviolent and truth-telling teachings of Gandhi. Ellsberg was astonished, and his years of military calculations were unsettled by her clear articulation of a cogent theory of militant but nonviolent political action in which no human was treated as an "enemy" to be harmed, even though his actions and attitudes might be strongly opposed.

A year later Ellsberg sat in on a conference of pacifists and was greatly impressed as he listened to a bright, idealistic young American, a fellow Harvard grad, eloquently speaking of his hope and faith that those working for peace would persevere. Then the young man announced, to the surprise of his friends in the audience, that he was about to enter prison rather than participate in the murder in Vietnam. Deeply shaken, Ellsberg thought, "We are eating our young." At the time, Ellsberg had secret knowledge that President Nixon was about to covertly expand the war. Stunned and sobbing silently, Ellsberg staggered to a men's room down the hall from the conference room, and after an hour of convulsive weeping on the floor, asked himself calmly what he could do to stop the war now that he, too, was willing to go to jail. As a result of these encounters with nonviolent peace workers, Ellsberg felt compelled to leave the palaces of power and reveal the truth to the American people, regardless of the consequences to himself. We may view his determination to publish the Pentagon Papers as akin to Shakyamuni's

choice and decision to leave his palace and search for truth, performing whatever austerities might be required. Many brave people made sacrifices to protest the Vietnam War, but Ellsberg's stands out as one of the most dramatic and significant.

When Ellsberg decided to release the Pentagon Papers he firmly believed he would spend the rest of his life in prison and was willing to endure this eventuality. His original indictment indeed posed a maximum sentence of 115 years, and Ellsberg later became a central figure and widespread object of calumny during the Watergate investigations.

The release of the Pentagon Papers had an ultimately ruinous impact on the Nixon White House. Having conducted covert bombings of Cambodia, Nixon was secretly threatening to renew massive bombing of North Vietnam based on the strategy of trying to intimidate and terrorize the North Vietnamese government with indiscriminate mass murder of civilians. (During the Nixon administration, twice the bomb tonnage of all of World War II was dropped on Indochina.) Enraged by the release of the Pentagon Papers and concerned about keeping his policies secret, Nixon unleashed a campaign to blackmail Ellsberg into silence and prevent further revelations, especially to any prospective 1972 Democratic presidential opponent. All charges against Ellsberg were eventually dismissed by a federal district judge because of the prosecution's "pattern of governmental misconduct," beginning with a burglary of Ellsberg's psychiatrist's office (by the same team who later committed the Watergate burglary). This led to the convictions of a number of Nixon's top aides, which were a major factor in the impeachment proceedings against Nixon and his eventual resignation in 1973.

Since then, like Shakyamuni continuing his practice after his awakening, Ellsberg has continued his energetic practice of truth-telling in the interest of saving beings from war and nuclear holocaust. He was active in the late seventies in civil disobedience actions at the Rocky Flats plant in Colorado, where all triggers of nuclear weapons were manufactured. In those actions and the subsequent trials, Ellsberg called attention to the dangers of our nuclear policies, based in part on his classified knowledge. For example, our military contingency plans prominently include many scenarios for first use of nuclear weapons against countries without such weapons. Further, a large number of military officers at any time have been empowered, sometimes even without the president's knowledge, to give the go-ahead to launch nuclear warheads. Ellsberg persists in his efforts to awaken everyone to the folly of nuclear weapons, campaigning for their reduction and final abolition.

A more traditional kinship to the Siddhartha archetype is apparent in the life of Francis of Assisi, the thirteenth-century Christian saint. Francis was an ordinary youth, involved with fine clothes, frivolity, and sensual indulgence. He briefly became a soldier but was captured and shaken from complacency by prison and resulting sickness. After a series of religious experiences, Francis gave away his fine clothing and some of his family fortune to beggars and to the church, much to his father's displeasure. In his early twenties Francis, like Siddhartha, abandoned upper-class position and his family's material wealth to dedicate his life to spiritual practice and rigors.

Saint Francis matches the part of Siddhartha's story of following ascetic practices and fasting in the wilds of nature. Francis maintained his austere lifestyle even after his religious awakening. Like Shakyamuni, he shared his realization by founding an important order of monks and also an order of nuns. Francis's order stressed a lifestyle of simplicity, poverty, and contemplation; Shakyamuni and his order followed a simple, mendicant life with periods of intensive meditation. Saint Francis continues to be a great inspiration to many thanks to his joyful sincerity, sweetness, and loving relationship with birds and animals.

All Buddhist monks are formally considered home-leavers, but the story of Saint Francis's contemporary, the thirteenth-century Japanese Soto Zen founder, Eihei Dogen, particularly exemplifies the Siddhartha archetype. Dogen, whose voluminous writings are considered pinnacles of Zen philosophy and literature, also was born into a family of high nobility, probably descended from an emperor, and was trained for important political position. Like Siddhartha, however, he was awakened to the truth of suffering, in Dogen's case while seeing the incense rise at his mother's funeral when he was seven years old. In his early teens Dogen disappointed his noble relatives and abandoned his birthright of political leadership to enter the monkhood in the Tendai School. But later, in his twenties, like Siddhartha with his contemporary Indian religious teachers, Dogen apparently felt his spiritual questioning unsatisfied by all of the contemporary Japanese Buddhist teachers.

Dogen pursued his quest in an arduous, at that time physically perilous, journey to China. After feeling dissatisfied with a number of leading Chinese teachers, Dogen finally found his master, in whose monastery he trained diligently, determined not to leave until his quest was satisfied. Ultimately he had a deep awakening experience, before returning home to

Japan. After struggling to find an appropriate way to share his experience, like Shakyamuni who worked to find skillful means for effective teaching, Dogen was able to establish his own monastery and train successors in what has continued as the Soto lineage of Japanese Zen Buddhism. Dogen's writing exemplifies penetrating wisdom, and his teaching stresses meditation practice as an expression and celebration of awakening. As already noted, both wisdom and meditation were central practices of Shakyamuni.

The Siddhartha archetype is so fundamental to any bodhisattva practice that many of the various exemplars cited in the chapters to follow, to some extent or other, also partake of the spiritual choice, sacrifice, and quest of the Shakyamuni archetype, along with the other bodhisattva model they fully embody. Aside from celebrated cultural icons, famous saints, or heroic figures of myth, a great many common people, preferring to follow their spiritual pursuits unacclaimed, enact the archetype set by Siddhartha when they abandon concern with worldly fortune to work for the benefit of others, often in ordinary, unspectacular ways. These bodhisattvas are alive in the world, supporting all of us in our common efforts toward mutual awakening and well-being.

5 Manjushri
Prince of Wisdom

MASTER OF EMPTINESS AND WISDOM

MANJUSHRI IS the bodhisattva of wisdom and insight, penetrating into the fundamental emptiness, universal sameness, and true nature of all things. Manjushri, whose name means "noble, gentle one," sees into the essence of each phenomenal event. This essential nature is that not a thing has any fixed existence separate in itself, independent from the whole world around it. The work of wisdom is to see through the illusory self-other dichotomy, our imagined estrangement from our world. Studying the self in this light, Manjushri's flashing awareness realizes the deeper, vast quality of self, liberated from all our commonly unquestioned, fabricated characteristics.

With his relentless commitment to uncovering ultimate reality, Manjushri embodies and represents the paramita of prajna, the perfection of wisdom, both as a practice and as the body of sutras so named. Although Manjushri is especially associated with emptiness teaching and the Madhyamika branch of Mahayana teaching, he is not present in the earliest of the Prajnaparamita sutras. However, Manjushri is one of the most prominent bodhisattvas in all of the Mahayana sutras and is sometimes considered to be based on a historical person associated with Shakyamuni Buddha. One of the earliest bodhisattvas, Manjushri was popular in India by the fourth century, if not earlier, and was included in the first depictions of a bodhisattva pantheon in the fifth and sixth centuries. Images of Manjushri appeared in Japan by the early eighth century.

Insight involves going within, seeing the fundamental. This energy exemplified by Manjushri is about pulling wisdom out of the depths of oneself, about being an open channel for the awakening of buddhahood to express

itself. Manjushri's wisdom arises not from external knowledge or accomplishment, but out of concentrated inner vision. This wisdom is not based on analysis or calculation, although it may be helpful to investigate it in terms of intellectual analysis as an afterthought, and Manjushri often does so for the sake of beings. However, Manjushri's wisdom is not acquired, but an inalienable endowment always available to us, awaiting our settling into and uncovering of this deeper awareness.

Observing Manjushri's insight into emptiness, one can recognize a wider perspective into the ephemeral nonreality of our cherished views and objectives. Developing such nonattachment can be a great relief from the pressures of the world of striving and desire. Manjushri's wisdom is not just another thing, some new toy with which to play. Rather, it is a tool for seeing through our unexamined ignorance.

ICONOGRAPHY OF MANJUSHRI

Iconographically, Manjushri often rides a lion, the most kingly of animals, representing Manjushri's princely nobility and fearlessness. The seat on which Shakyamuni as Buddha sits is also called a lion throne, and the Buddha's utterances are often described as lion's roars. Manjushri's lion mount usually appears calm and stately rather than ferocious or menacing. Usually appearing as youthful, Manjushri himself has a long, flowing mane of hair, which is sometimes tied up in five topknots, representing the five-peaked holy mountain in northern China linked with him.

Manjushri wields a *vajra* sword to cut through the entanglements of ignorance, conquering all doubt and confusion. Sometimes held over his head ready to strike, sometimes set erect on a lotus flower by his side or held upright by Manjushri, his sword is a symbol in Mahayana literature for discriminating insight and knowledge, and for slicing through all discriminations and their snares. Manjushri's sword can cut things into two—or cut things into one. It can take life or give it. The path of wisdom demands such a sword because our self-created obstacles of ignorance are so persistent and intractable.

Along with the sword, which is generally held in his right hand, Manjushri often carries a scroll or text in his left hand. Sometimes the sutra scroll, often considered to represent the Prajnaparamita texts, rests atop Manjushri's head. While the sword and wisdom text are his two most characteristic attributes, images of Manjushri do not always possess them, as

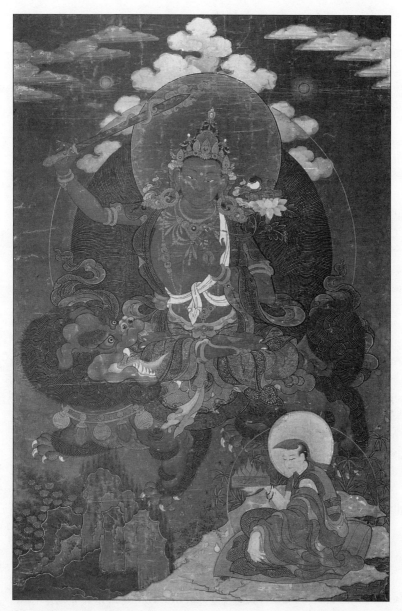

Manjushri on lion, Tibet, 18th century

he may instead hold a lotus flower, a jewel, or a small teaching scepter. Generally, most Nepalese and Tibetan Manjushri depictions carry the sword, whereas in many East Asian images the sword is absent.

THE YOUNG PRINCE OF WISDOM

Manjushri is usually depicted as a young prince, about sixteen years old, reflecting purity and innocence. He is sometimes referred to as Manjushri Kumarabhuta; the latter name, meaning "to become youthful," has been interpreted as "chaste youth," and is also a term used for monastic bodhisattvas. The youthful aspect of the archetype signifies the fact that striking wisdom, and insight into the essential, often are seen in child prodigies. There are many cases of youthful brilliance, of children sparkling with insight into some particular realm of art or intellect. For instance, Mozart while still a child was already composing and playing sublime music that still moves and inspires audiences.

Unusual child prodigies aside, many "ordinary" children often have refreshing clarity or express insight into familiar situations. As we all know, "Kids say the darnedest things." They can amuse or astonish us with their interpretations of the world's goings-on, while adults stagnate in their set perceptions. In Hans Christian Andersen's popular story "The Emperor's New Clothes," the unaffected child is the only one who sees through the vanity and emptiness of the emperor's illusory garments to the naked truth. Moreover, the child is not timid about declaring what he sees. Similarly, the youthful Manjushri perceives and declaims the essential emptiness of all fashioned appearances and pretensions, no matter how fancy or hyped such fabrications may seem.

Manjushri's youth signifies that his wisdom is not acquired based on experience or long years of study, but is immanent and ever available. As we shall see, his archetypal youthfulness can also become a source of humor, as Manjushri has been mocked in some stories for his cocky cleverness, sometimes viewed as arrogance.

MANJUSHRI AS SACRED MONK
OF THE MEDITATION HALLS

Manjushri sits enshrined on the center altar of Zen meditation halls, encouraging deep introspection and the awakening of insight. Thus he represents a primary aspect of Buddhist meditation, penetrating into the essence and cutting off all distractions and delusions. Meditation can be the context in which insight comes forth, and Manjushri embodies the samadhi (concentration) that is not separate from arising wisdom. Strictly speaking, Bud-

dhist meditation is not done in order to acquire wisdom as a goal. Rather, settling into the self and deepening awareness of physical and mental phenomena as they already are is itself an expression of this wisdom, and allows it to emerge and become more evident.

Manjushri's place in the meditation hall also represents his vow to embody for all beings purity and discipline, as well as wisdom. Discipline and ethical conduct function as spiritual housecleaning, preconditions to intensive meditation. Manjushri was also particularly revered in the Discipline School (*Ritsu* in Japanese), which studied the early vinaya texts with their monastic codes of conduct and discussions of the precepts. This Discipline School was important in establishing monastic standards for East Asian Buddhism.

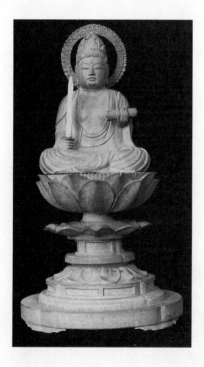

Meditation hall Manjushri, Japanese style

Further reflecting his designation as a "monastic" bodhisattva, some of the modern images of Manjushri on the altars of Japanese meditation halls depict him as a simple shaved-headed monk without sword or scroll, calmly sitting sidesaddle on a lion, or else cross-legged on a cushion, rather than as

the standard decorated bodhisattva figure with headdress and ornaments. Such meditation hall images are referred to as "the sacred monk" (*Shoso* Manjushri in Japanese), as he represents the model monk encouraging all the practitioners.

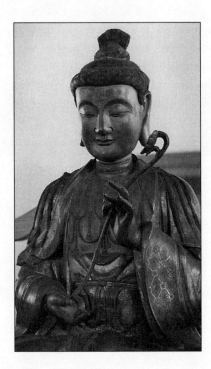

Manjushri with teaching scepter, China

ILLUMINATING LANGUAGE TO UNTANGLE DELUSION

One of Manjushri's foremost roles is as bodhisattva of poetry, oratory, writing, and all the uses of language. Manjushri has an intricate relationship and involvement with language, one of the primary catalysts of human ignorance and delusion. The patterns of our conventional thought processes are established and learned through our languages. Our sense of alienation is strengthened and inculcated through the syntax that separates subject and object. Mentally absorbing this subject-verb-object grammar, we come to see ourselves as agents acting on a dead world of objects, or we see ourselves as dead, powerless objects being acted upon and victimized by external, sovereign agents. We fail to recognize that the whole world is alive,

vibrant, totally interconnected, informed, and dancing with prajna. Manjushri works to reveal our enslavement by language, and to liberate language and use it to express the deeper realities.

Manjushri is the main interlocutor in many sutras, eloquently posing questions to the Buddha on behalf of the assembly, and eliciting responses from Shakyamuni to clarify the essence of the teaching. Manjushri is sometimes called Manjughosha, a name meaning "Sweet-Sounding One" or "Melodious-Voiced One," and which is described as a distinct aspect of Manjushri in early Indian iconography. Manjushri is spoken of in sutras as master of speech and most outstanding of orators, as well as the master of words. The great fourteenth-century Tibetan teacher Tsongkhapa praised the power of Manjushri's voice thus: "Melody of your speech like a sphere of music…. Whose ear it enters, it takes away their sickness, their old age, and their death. Your speech is pleasant, gentle, charming, heart-stirring, harmonious, its sweetness is pure stainless clear light."[1]

In his inquiries and assertions, Manjushri often elucidates the inner meaning of language, using the negations of the rhetorical style of emptiness teaching to break down reified patterns of thought and language that reinforce ignorance and block insight. Much of his discourse in the sutras involves unpacking the forms of linguistic delusion. Manjushri liberates language by showing how it can be used to express nondual understanding without being caught by its confusions. His language in some sutras foreshadows the use of "turning words" as pivots of awakening teaching in Zen koan literature. In the penetrating, investigative spirit of Manjushri, the later Zen masters used language in unusual, stimulating ways to elicit awakening, uttering living words and exposing dead words.

Manjushri plays significant roles in the *Lotus* and *Flower Ornament Sutras*, as well as in many of the Prajnaparamita sutras. He also appears in many of the other sutras, signifying bodhisattva wisdom generally, without adding any further material that might be seen as especially contributing to an archetypal characterization. However, in the *Maharatnakuta* "Great Jewel Heap" collection of sutras, Manjushri is especially featured and delineated in *Manjushri's Discourse on the Paramita of Wisdom* and *The Prediction of Manjushri's Attainment of Buddhahood*.

In his *Discourse on the Paramita of Wisdom*, Manjushri arrives to see the Buddha and inspires a gathering of the assembly in order to share his contemplation of the Buddha, and the nature of the "Thus Come Ones," or *tathagatas*, as buddhas are also called. The following excerpt from this

discourse, giving the flavor of Manjushri's orations, begins with the Buddha questioning Manjushri:

> "How should one abide in the paramita of wisdom when cultivating it?"
>
> Manjushri answered, "Abiding in no dharma is abiding in the paramita of wisdom."
>
> The Buddha asked Manjushri further, "Why is abiding in no dharma called abiding in the paramita of wisdom?"
>
> Manjushri answered, "Because to have no notion of abiding is to abide in the paramita of wisdom."
>
> The Buddha asked Manjushri further, "If one thus abides in the paramita of wisdom, will his good roots increase or decrease?"
>
> Manjushri answered, "If one thus abides in the paramita of wisdom, his good roots will not increase or decrease, nor will any dharma; nor will the paramita of wisdom increase or decrease in nature or characteristic.
>
> "World-Honored One, one who thus cultivates the paramita of wisdom will not reject the dharmas of ordinary people nor cling to the dharma of saints and sages. Why? Because in the light of the paramita of wisdom, there are no dharmas to cling to or reject.
>
> "Moreover, one who cultivates the paramita of wisdom in this way will not delight in nirvana or detest samsara. Why? Because he realizes there is no samsara, let alone rejection of it; and no nirvana, let alone attachment to it.... World-Honored One, to see that no dharma arises or ceases is to cultivate the paramita of wisdom.... To see that no dharma increases or decreases is to cultivate the paramita of wisdom.... To aspire to nothing and to see that nothing can be grasped is to cultivate the paramita of wisdom....
>
> "Furthermore, if a person, when cultivating the paramita of wisdom, does not see any paramita of wisdom, and finds neither any Buddha-dharma to grasp nor any dharmas of ordinary people to reject, that person is really cultivating the paramita of wisdom."[2]

In this discussion, Manjushri cuts through our conventional conceptions of and attachments to abiding, increase and decrease, ordinary and holy, nirvana and samsara, arising and ceasing, aspiring, and grasping. Experiencing personally and clearly the perfection of wisdom that Manjushri

expounds is about seeing through, and being liberated from, all limited views about these common snares of consciousness.

In reality, there is no safe haven to abide in, and nobody to do the abiding. There is no ordinary to shun, and no holiness to achieve. Although we live in the ceaseless production of the illusion of birth and death, in reality there is nothing independent to arise or cease. There is nothing at all to grasp, and also no grasping for us to suppress or seek to exterminate. Such is the truth of Manjushri.

THE PREDICTION OF MANJUSHRI'S ATTAINMENT OF BUDDHAHOOD

In the relatively short sutra, *The Prediction of Manjushri's Attainment of Buddhahood*, one of the assembled bodhisattvas inquires as to when Manjushri will attain supreme enlightenment and what his resulting buddha land will be like. Manjushri diverts the question, asking rhetorically, and in detail, whether such items as form, the nature of form, the psychic constituents, or empty space can seek or attain enlightenment, and whether there can be any person to be enlightened apart from these qualities. Later Manjushri declares that he does "not urge a sentient beings to progress toward enlightenment…because sentient beings are nonexistent and devoid of self-entity…. Enlightenment and sentient beings are equal and not different from each other…. Equality is emptiness. In emptiness, there is nothing to seek."[3] Manjushri undercuts all of our fabricated notions and delusions about enlightenment, which may lead us into futile self-seeking activity in the name of spirituality.

In the same sutra, Shakyamuni Buddha finally suggests that Manjushri may inform the inquiring bodhisattvas as to what kind of vows Manjushri will adorn his buddha land with, "so that the bodhisattvas hearing those vows will resolve to fulfill them also."[4] Manjushri expounds his vow not to attain supreme enlightenment himself until after the enlightenments of an astronomical number of specific sentient beings, whose awakenings he foresees. He also describes his vow that bodhisattvas in his buddha land will offer any food or clothing they receive to all needy beings, exemplifying Manjushri's particular affinity for the destitute and homeless.

Manjushri again avers that he does not seek enlightenment, "Because Manjushri is no other than enlightenment and vice versa…. 'Manjushri' is only an arbitrary name and so is supreme 'enlightenment.'"[5] Nevertheless,

Shakyamuni reveals that Manjushri has been practicing intently with such a vow for innumerable aeons, and will eventually be the Buddha named "Universal Sight," with a buddha land named "Wish-Fulfilling Accumulation of Perfect Purity."

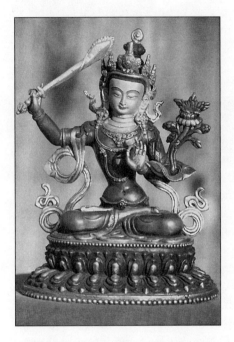

Manjushri, Nepal

MYTHIC QUALITIES AND HISTORICAL INCARNATIONS

In popular Nepalese mythology, Manjushri is considered the founder of Nepal's civilization. One legend is that a Buddhist deity sat on a lotus in the middle of a lake up in the Himalaya Mountains that was filled with aquatic monsters. To give devotees more access to the deity, Manjushri used his sword to open a channel for the lake to drain south into India, uncovering what is now the land of Nepal. Another story is that Manjushri appeared as a wandering mendicant monk who introduced Buddhism to Nepal.

Manjushri is appreciated as the bodhisattva of science, investigating the nature of reality to deepen our understanding of the world. Many devotees have venerated Manjushri hoping for increased intellect, eloquence, or memory for understanding sutras. He is still popularly invoked by Asian students facing difficult examinations.

Historically, great scholarly leaders have been considered incarnations of Manjushri. An example is the brilliant fourteenth-century Tibetan master Tsongkhapa, who was greatly learned, wrote prolific commentaries on the teachings, and founded the Gelugpa School of Tibetan Buddhism, known for its scholarship and systematic presentation of the teaching. One of the towering personages of all Buddhist history, Tsongkhapa himself appeared as Manjushri to other high Tibetan lamas of his day, and his body appeared to his disciples as the youthful Manjushri after he passed away.

In Japan Prince Shotoku, the late-sixth-century patron and devotee instrumental in establishing Japanese Buddhism, was an intellectual giant revered as an incarnation of Manjushri. A legendary figure, the myth of Shotoku includes his receiving a magical jewel from Manjushri at Mount Wutai in China. Son of the first Buddhist emperor of Japan, Prince Shotoku became regent of the recently unified nation of Japan when only nineteen and is still venerated in Japan today, often with images that emphasize his youthfulness. He wrote extensive commentaries on the *Queen Shrimala*, *Vimalakirti*, and *Lotus Sutras* and also wrote the first constitution of Japan. Prince Shotoku's commitment to ethical conduct as well as wisdom is reflected in his deathbed quote from the *Dhammapada*, an early Buddhist text beloved by all Buddhists: "Avoid evil, undertake good, purify the mind: this is the teaching of the buddhas."

THE PRAJNAPARAMITA GODDESS: MOTHER AND TEACHER OF BUDDHAS

An early figure we may associate with Manjushri is Prajnaparamita, depicted as a female deity or bodhisattva. She is referred to as the mother of all the buddhas. Prajnaparamita Bodhisattva often sits cross-legged on a white lotus, appearing majestic and dignified with a golden yellow body. In her radiance, Prajnaparamita dispels all darkness and distress. She also bestows wisdom upon those who venerate her.

While the Prajnaparamita Goddess is the mother of all buddhas, Manjushri, as the spokesperson for the perfection of wisdom, is considered the teacher of all the buddhas, training and preparing them to attain enlightened insight. Although eternally a youthful prince, Manjushri is spoken of as the teacher of the ancient, primordial seven buddhas that culminate with Shakyamuni Buddha. Manjushri is sometimes referred to as teacher of all

bodhisattvas as well as all the buddhas, since his insight into emptiness is the entryway necessary to all bodhisattva and buddha practice. Only when we personally experience the openness and lack of clinging taught by Manjushri do we truly enter into awakening spiritual practice. In line with his primary role as a spiritual progenitor and his identification with the Prajnaparamita Goddess, Manjushri is described in some sutras as both the father and mother of bodhisattvas, as well as their teacher or spiritual friend.

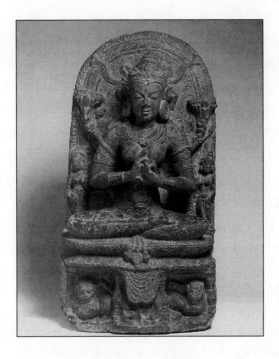

Prajnaparamita Goddess
Bodhisattva, India,
9th century

MOUNT WUTAI AND MANJUSHRI'S UNEXPECTED MANIFESTATIONS

Manjushri was one of the first bodhisattva figures to inspire a "cult" of veneration. Mount Wutai (Five Terrace Mountain) in Shansi Province in northern China is one of the four of China's ancient holy mountains that are associated with major bodhisattva figures. Mount Wutai is traditionally considered the mountain of Manjushri, to which many pilgrims have traveled seeking visions of him. Mount Wutai was known as Manjushri's abode from early in Mahayana history, and was famous even to Indian devotees, some

of whom traveled to the north of China (nearly as far as modern Beijing) to visit there. One ancient myth about Manjushri's birth is that Shakyamuni Buddha emitted a golden light ray from his forehead that reached and pierced a tree at the base of Mount Wutai, from which sprang a lotus within which Manjushri was born.

Mount Wutai's location in north China reflects Manjushri's popularity among the nomadic peoples north of China proper, who must have felt affinity as warriors with Manjushri's sword. The Mongols converted primarily to a form of Tibetan Buddhism, which accorded with their native shamanic beliefs, while they were conquering China and eventually establishing the Yuan dynasty in the thirteenth century. The first Yuan emperor, Kublai Khan, grandson of the great conqueror Ghengis, was posthumously considered an incarnation of Manjushri, and all Mongolian Buddhists desired to be buried on Mount Wutai.

Through their contact with the Mongols, the nomadic Ruzhen people also adopted Tibetan Buddhism, and came to revere Manjushri so much that they later took the name Manchu before they in turn conquered China in the seventeenth century. The early Manchu emperors, who were great devotees of Manjushri and sometimes were considered incarnations of the bodhisattva of wisdom, made frequent pilgrimages to Mount Wutai and founded new temples there.

Many entertaining stories are told of pilgrims to Mount Wutai encountering Manjushri in quite unexpected forms. Often he masquerades as a beggar to guide, and test, pilgrims. Only after proceeding up the mountain might the pilgrims realize that the ragged, unwashed, homeless person they had encountered on the trail was Manjushri himself in disguise. Depending on how they had treated such beggars, the pilgrims would perhaps be worthy of a vision of the bodhisattva in his glorious form. Whenever we encounter a homeless beggar we might wonder if this is Manjushri incognito.

One tradition is that Manjushri guides all pilgrims who come to Mount Wutai. The great modern Chinese monk Xuyun, who died in 1959 at the remarkable age of 120, describes a pilgrimage to Mount Wutai in his colorful autobiography, *Empty Cloud* (which is the meaning of his dharma name). Xuyun survived beatings and torture by the government in 1916, and again in 1951 by the Communists, who were perhaps preparing for the Tibetans.

Xuyun made his lengthy pilgrimage to Mount Wutai in his forties, piously vowing to seek good rebirth for his mother, who had died giving birth to Xuyun, and for his father, who had also died young. As he walked, at every

third step Xuyun made full prostrations on the ground in the direction of his destination, a traditional pilgrim practice. Once he was snowed in during a blizzard, and later he contracted malaria. On both occasions Xuyun was saved from death by a kindly wandering tramp named Wenji, who said he was from Mount Wutai. He gave Xuyun useful advice about the route, and later accompanied him some of the way, carrying his baggage while Xuyun did his prostrations.

By the time Xuyun finally reached Wutai, nearly three years after his original vow, he felt his mind bright, clear, and calm. When he told his story at a temple on Mount Wutai, including being saved by the vagabond Wenji, an elderly monk there was delighted, stating that Xuyun had been saved by a manifestation of Manjushri, whose name is pronounced similarly, Wenshu in Chinese (*Monju* in Japanese).

Another story tells of a great feast offered by a wealthy patron at a temple on Mount Wutai. Manjushri emphasizes the sameness of all beings and the emptiness of class distinctions, so these monks opened the feast to the public. But this openness was annoying to the donor, who wanted to gain personal merit by feeding only the monks, not the poor and homeless who arrived. When a ragged, pregnant beggar woman asked for a second helping for her child the patron indignantly refused, whereupon the woman said she would eat nothing, and departed. As she exited the hall, the beggar woman was suddenly transformed into Manjushri, surrounded by bodhisattvas filling the temple with radiance. All those at the feast fell to their knees and wept in repentance. Since then temple feasts at Mount Wutai are always open to the public, and nobody is refused a second serving.

TALES OF MANJUSHRI'S LEAKING

Manjushri is a central figure in a number of important Zen koans, including the first case in one of the major koan collections, *The Book of Serenity*. In this story Manjushri seems to be acting as one of the ceremonial attendants in the lecture hall. After pounding the gavel to signal the arrival of Shakyamuni Buddha at his lecture seat, Manjushri announces, "Clearly observe the Dharma of the King of Dharma [Shakyamuni]; the Dharma of the King of Dharma is Thus."[6] Thereupon the Buddha has nothing more to do than to step down and depart in silence.

Manjushri here points out the stark suchness of reality as it is, and the

inadequacy of language to express and explain it. Just to witness silently the truth is completion. But Manjushri seems to orate frequently and at great length about the failure of verbal expression. The verse commentary to this story by the Chinese Zen master Tiantong Hongzhi goes:

> *The unique breeze of reality—do you see?*
> *Continuously creation runs her loom and shuttle,*
> *Weaving the ancient brocade, incorporating the forms of spring,*
> *But nothing can be done about Manjushri's leaking.*[7]

Reality is indeed a subtle web, an ancient brocade, magnificent in its richness and all-inclusive of arising forms. This fertile web of suchness may be expressed or pointed to poetically. But here Manjushri's proclamation is described as "leaking," an image that refers to a technical term (*ashrava* in Sanskrit, also translated as "outflow") that describes deluded actions resulting from mental defilements and attachments. The comment about Manjushri's leaking reflects a criticism of this Manjushri character (especially prevalent in the developing classical Zen tradition) as a bit of a "smart-ass kid," who sometimes shows off and does not know when to shut up—although in Zen, criticism may be ironic praise, and vice versa.

I recall Katagiri Roshi, the late founder of the Minnesota Zen Meditation Center, saying in a lecture during a *sesshin* (intensive meditation retreat) that when you go outside and see a beautiful flower, or a sunset, or any other wondrous sight, if you say, "Wow!" that is already too much. Such splendor is full in and of itself, needing no comment. And yet, noble Manjushri persists in spewing forth his superfluous eloquence, challenging and inciting us to see for ourselves, insisting that we awaken. Nothing can be done to stop Manjushri's leaking.

Another famous, related story about Manjushri is his debate with Vimalakirti. At a meeting of numerous bodhisattvas at the great layman Vimalakirti's home, Vimalakirti asks that they each describe their entry into the teaching of nonduality. After many fine expressions of the meaning of nonduality in various contexts, Manjushri announces that all the previous speeches were themselves conditioned by linguistic limitations and were subtly dualistic. When the prince turns to Vimalakirti and asks for his views, Vimalakirti just maintains silence, demonstrating the truth that Manjushri had been verbally declaiming. All of Manjushri's leakings are

simply commentaries on silence. And indeed, Manjushri does not stop him-
self from verbally acclaiming Vimalakirti's thunderous silence.

In another Zen story, while the chief cook of a temple on Mount Wutai was
busy making lunch, Manjushri repeatedly appeared sitting above the rice
pot. This chief cook, who later became a noted master, finally hit Manjushri
with his stirring spoon and drove him away, saying, "Even if old man
Shakyamuni came, I would also hit him."[8] In Zen temples the position of
chief cook is highly esteemed. This story denotes the priority of taking care
of everyday life as practice, beyond attention to Manjushri's rhetoric and
understanding. Caring for the details of daily life is sometimes seen as more
important than spending time in studying sutras or in concentration in the
meditation hall, and many monks, perhaps including this chief cook, have been
encouraged to abandon any preference for meditation over ordinary work.

In the story in case 42 of the *Gateless Barrier*, another primary collection of
Zen koans, Manjushri arrives to visit Shakyamuni right at the end of a con-
ference of buddhas. All the buddhas have departed, but a young woman
remains sitting in deep samadhi right next to Shakyamuni's seat. Manjushri
asks why this young woman merits a place that Manjushri himself cannot
take. Buddha tells Manjushri to arouse her from meditation and ask for him-
self. Manjushri circles the woman three times and snaps his fingers, then
exerts all his supernatural powers, including transporting her to the Brah-
man heaven, but Manjushri is unable to bring the woman out of her
samadhi.

Shakyamuni declares that even a hundred thousand Manjushris could not
arouse the young woman, but that a beginner bodhisattva dwelling deep
beneath the ground, whose name means "Ensnared Light" or "Deluded
Understanding," will be able to bring the woman out of her samadhi. There-
upon this bodhisattva appears and bows to Shakyamuni and then snaps his
fingers before the woman, who immediately emerges from her meditation.

This story has many aspects, not the least of which is exposing prejudice
against women, even in Manjushri, who seems to be a bit jealous of the
meditating woman, who is apparently a buddha. Although Manjushri is
teacher of all the buddhas, in this situation the woman is completely obliv-
ious of him. One possible interpretation is that the woman responds
instantly when there is a need for her presence and awareness, when she
has something to share. She is immediately available to a deluded, novice

bodhisattva. This story, and the previous ones, point out the limitations as well as the character of the Manjushri archetype. Manjushri is ever fearless and unashamed about inquiring into the dharma, but he also has no real need to speak to the woman, as he is a bodhisattva of the highest stage, almost equal to a buddha, even though he was not invited to the buddhas' conference.

ASSOCIATED FIGURES: SARASVATI

Each of the major archetypal bodhisattva figures has a context of relationships to many other figures in Mahayana myth and cosmology, who include deities, spirits, guardians, and buddhas, along with myriad other bodhisattvas. Examining briefly some of these associated figures for the bodhisattvas will help clarify the milieu in which they have functioned historically in Mahayana lore and cultic activity, and may shed more light on the range of their archetypal character. A number of other figures in the vast Mahayana pantheon are associated to varying extents with Manjushri.

Originally derived from a river goddess in the ancient Indian Vedic texts, Sarasvati became the goddess of eloquent speech, rhetoric, scholarship, and intuitive wisdom. Given these realms, when she was adopted into Buddhism as a protective deity, naturally she came to be loosely associated as a counterpart to Manjushri as they share a combination of interests in language, speech, sound, insight, and intellectual activity. Sarasvati's mantra, *Om vagishvari mum*, was adopted into Manjushri devotion.

Sarasvati is regarded as a muse of learning and the arts, especially music, and is very popular as a folk deity. Many artists and musicians regard her as an inspirational figure. She is depicted with grace and serenity, often holding a stringed musical instrument. Sometimes she rides a peacock and is considered to grant fortune, longevity, and progeny. In East Asia she became one of the Seven Gods of Fortune, and has remained popular in Japan, where she is named Benzai Ten.

YAMANTAKA

In the complex, fantastic Tibetan Buddhist iconography, Manjushri appears in an idiosyncratic, wrathful manifestation as Yamantaka, who embodies total, all-consuming rage and the ultimate encounter with death. Yamantaka is depicted in horrific form with nine heads, thirty-four arms, and sixteen

legs, each of which symbolically represents a branch of Buddha's teaching, and all together express the total mobilization of enlightened energies and facilities required to meet death.

The myth behind the Yamantaka image is that Manjushri went down to hell to confront and conquer Yama, the lord of death in Indian mythology, who has the head of a water buffalo. Manjushri as Yamantaka took the same shape with his main head as a water buffalo and successfully confronted Yama, the archetype of mortality and all limitation. Faced with the boundlessness of emptiness and vast openness presented by Manjushri, Yama, Death incarnate, saw himself reflected in endless infinity. Death was scared to death by death and acquiesced to the boundless life of Manjushri's wisdom. Tibetan practitioners, while in meditation, visualize the figure of Manjushri as Yamantaka as a means of facing death and overcoming the fear and anger it arouses.

MANJUSHRI AND THE PARAMITAS

The transcendent practices most emphasized by the Manjushri archetype are wisdom, meditation, and discipline or ethical conduct. In Manjushri we more clearly see how these perfections are interrelated and how they support each other.

Manjushri fulfills his role as spokesperson for wisdom and insight with nobility, youthful vigor, and even playfulness, taking on humble guises to demonstrate nonattachment to appearances and convention. By taking center stage in the meditation hall, Manjushri also shows how wisdom emerges simultaneously with the concentration, introspection, and dignity of intensive meditation. Intent samadhi is a form or posture for perfecting wisdom. And insight into unity, sameness, or universal emptiness and interconnection is the content, or the nature, of concentrated meditation. When we concentrate and continuously look within to see what is essential or most important to us in our situation, we are activating the meditation of Manjushri. This steady looking within, settling into our own deepest intention, can lead us to our own inner wisdom.

Manjushri's position as a prince symbolizes the nobility of upright conduct. His vow of purity and his discipline show the role of ethical conduct as a basis for meditation and wisdom. The latter, in turn, help make clear the value of discipline, and strengthen and intensify the development of

uprightness. Confirmed in our own intention, we naturally do our best to act in a wholesome, dignified manner, even if that may sometimes involve being a beggar. Doing our best to conduct ourselves uprightly in our everyday situations allows more mental space for our natural insight to arise.

EXEMPLARS OF THE MANJUSHRI ARCHETYPE

In looking for familiar exemplars of Manjushri, we can note central features of the archetype he presents. Manjushri exhibits penetrating brilliance or intellect, with insight into the essence of existence in general or insight into the heart of some particular mode of expression. One of his main tools is eloquence and the skillful use of language, although he may sometimes verge on verbosity. Always he shines with energetic, youthful brilliance. With his focus on the teaching of emptiness and the obstructions we face from holding on to fixed views or doctrines, Manjushri avoids being pinned down to any given form and takes on new shapes to dispel attachments. He readily covers his brilliance in humble appearances to guide and test beings.

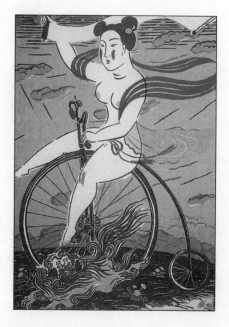

Manjushri goddess on bicycle

Albert Einstein is a classic example of the Manjushri archetype. Perhaps all atomic physicists might be included here, seeing into the elemental nature of matter, but Einstein's theory of relativity is particularly resonant. The teaching of *shunyata*, or "emptiness," expounded by Manjushri has also been translated as "relativity." The emptiness or absence of any isolated, inherent self-identity in all things may be expressed in terms of seeing into the fundamental interrelatedness, or relativity, of all things. Einstein's famous theory, and most of his central work showing the interrelation of matter and energy, was produced when he was young, further fitting the model of Manjushri's youthful insight.

In his later years, "pilgrims" often came to visit Einstein at Princeton. They often found the great man dressed shabbily, with tattered clothing, reminiscent of Manjushri as a beggar. He once received an award at a ceremony and was noticed to be wearing different-colored socks. My father had a framed photograph on his study wall of Einstein wearing an old gray sweater, with a ribbon across the bottom corner of the picture. When framing the picture, the photographer had seen fit to use the ribbon to cover up a large hole visible in the sweater, considering it inappropriate for Einstein to be seen in a ragged garment.

Einstein was a deeply spiritual man, who saw "cosmic religious feeling" as "the strongest and noblest incitement to scientific research."[9] We may hear echoes of Manjushri's emptiness teaching in some of Einstein's perceptive writings about "cosmic" religion, which he considered the highest development of all religions: "The individual feels the nothingness of human desires and aims and the sublimity and marvelous order which reveal themselves both in nature and in the world of thought. He looks upon individual existence as a sort of prison and wants to experience the universe as a single significant whole."[10] Manjushri too looks for the underlying principle and sees the illusion of isolated "individual existence" as the main obstruction to the experience of open, unified awareness.

Einstein's oft-quoted remark after the first use at Hiroshima of the atomic bomb that he helped create was that "Everything has changed except our way of thinking." It is precisely the changing of beings' ways of thinking that might be defined as the essence of Manjushri Bodhisattva's work, cutting through attachments to reified modes of thought about our lives and the world.

❖

Like Manjushri, the Irish writer James Joyce, in his brilliant dismembering of the English language, and playful, original usage of the sounds and patterns of words and phrases, brings penetrating insight into our linguistic habits of consciousness and cognition. However, Joyce's masterworks, *Ulysses* and *Finnegan's Wake*, are so complex, intricate, and packed with literary allusions that even with guidebooks it is difficult for readers to fathom fully the multiple levels of meaning embedded in his work. Although not easily accessible to understanding based on our usual conceptual discriminations, Joyce's writing, especially *Finnegans Wake*, often is unexpectedly humorous and evocative when read aloud. In this sense Joyce's writing is like the sutras in which Manjushri is featured, which are more often recited for their impact on mental states than dissected analytically. *Ulysses*, Joyce's profound epic of spiritual journey structured around detailed depictions of its main characters' consciousnesses during their activities and convergences throughout one single day in Dublin, also exemplifies Manjushri's penetrating insight into the essence of everyday, mundane awareness.

As Manjushri is the teacher of buddhas, Joyce's greatest effect might be as "teacher of writers," given the many subsequent writers whom he deeply influenced. The complexity of some of Joyce's own work may also be characteristic, a limitation or challenge of the Manjushri archetype, analogous to the difficulty of the rhetoric of Manjushri's emptiness teaching.

Gertrude Stein is another example of a writer deconstructing our usual sense of language in the interest of revealing deeper realities. She not only juggles normal grammar and syntax, but also plays with our sense of meaning and logic with frequent use of non sequitur. This is Manjushri's vital use of language itself to show us deeper realities beyond the reach of linguistic conventions. Stein attempted to show "things as they are," in some works virtually abandoning narrative. She believed that the simplified stringing together of experiences in narrative plots was illusory, secondary to pure experience itself. Instead of the illusions, she sought fundamental principles of awareness, as Manjushri seeks to penetrate to the essence. Like Manjushri the teacher of buddhas, sitting on the central altar of meditation halls, Stein's linguistic experimentation had considerable influence on the coterie of distinguished writers who gathered around her in her Paris salon.

Manjushri would certainly agree with Stein that "there's no there there," and not only in reference to the city of Oakland, but to all abodes. However,

instead of "A rose is a rose is a rose," Manjushri would perhaps say, "A rose is no rose is a rose."

Bob Dylan, the rock singer–songwriter–poet, has exhibited the brilliance and eloquence of Manjushri by writing powerful, penetrating lyrics expressing the problems of injustice in society, as well as the personal pains of love and loss in the human condition. He is especially known for his early work, the brilliant, complex, and evocative lyrics of his twenties, reminiscent of Manjushri's youthfulness. Dylan sang about staying "Forever Young," and in his mature and later work he has continued to produce brilliant songs, albeit somewhat less prolifically. The quantity of his masterpieces and the range of their content are awesome. Dylan's frequent radical shifts of style and subject matter show his unwillingness to be tied by audience or critics to any particular expectation or preconception of some limited "message," just as Manjushri cuts through all cherished views and doctrines in the Buddha's assembly.

Although Dylan may be considered a great poet, the poignancy of his work is oral as much as written. Despite his oft-caricatured, sometimes nasal voice, Dylan's brilliance is often keenest and most evocative in the phrasing and intonations with which he sings his lyrics. Similarly known for the verbal nature of his discourses and inquiries in the sutras, Manjushri is called Melodious-Voiced One.

Like Manjushri, Dylan often has used the rhetoric of negation to cut through psychological and social delusions. In an interview in 1965, one of his early periods of peak creativity, when asked about how one can live amid the madness and cruelty of the world, Dylan said, "I don't know what you do, but all I can do is cast aside all the things *not* to do. I don't know where it's at, all I know is where it's *not* at."[11] Many of his songs employ this negating method, whether describing a failed relationship in "It Ain't Me, Babe," or when portraying a successful relationship in "If Not for You," in which love negates and overcomes an assortment of anguishes. Even "All I Really Want to Do," a song about the friendship Dylan seeks with an ideal lover, is basically a catalog of the exploitative interactions he does not want. "It's All Over Now Baby Blue" powerfully evokes the experience of awakening and letting go, leaving "steppingstones" behind, when Manjushri's flashing sword cuts through all assumptions about the world and the very sky is folding under you. Manjushri and other masters of emptiness teaching such as Nagarjuna warn about the extreme dangers of attachment to emptiness.

So, too, does Dylan sing of the perils of excessive immersion in emptiness in his song, "Too Much of Nothing."

Dylan's religious concerns have been continuously expressed in his use of Judeo-Christian symbolism in his work as well as in his personal Jewish and Christian practices, and clearly he has explored, and articulated in his songs, the profound depths of his own spiritual inquiries. Manjushri's concern with ethics is exemplified by Dylan in his many songs about contemporary injustices, whether of persons wrongfully imprisoned, or "masters of war" not held accountable for true crimes.

Dylan's intuitive understanding of fundamental spiritual dialectics, also elaborated in the Mahayana path that Manjushri expounds, may be gleaned in many lines from his songs. "The country music station plays soft, but there's nothing, really nothing, to turn off"[12] is an incisive expression of the reality of every form as empty and open, with no fixed reality "to turn off" or avoid. The clear, open truth is ever present in the background voices and laments. Forms need not be obliterated to find their emptiness. Dylan also celebrates the suchness and value as well as the emptiness of each form, for example singing, "In the fury of the moment I can see the Master's hand, in every leaf that trembles, in every grain of sand."[13] Another Dylan line, "Are birds free from the chains of the skyway?"[14] is a haunting, Zen-like utterance, appropriately phrased as a question, penetrating the gossamer web of causation and mutual conditioning in which we are enmeshed, even while we hear the "chimes of freedom."

Demonstrating Manjushri's role in cutting through the bondage of delusions, Gloria Steinem has used her insight to astutely and cleverly expose gender inequities in modern society through her popular writings and editing of *Ms.* magazine. As one of the leaders of the feminist movement, she helped many see through the delusions of entrenched sexual stereotypes and role models and the suffering they occasion. With her composure and quick wit, Steinem has undercut people's set, unquestioned assumptions and prejudices in her writing and public speaking. Her exposure of these preconceptions resembles in methodology Manjushri's penetrating insight and dismantling of fixed notions.

One of Steinem's books of writings on the language of sexual oppression is titled, appropriately enough in this context, *Moving Beyond Words*. In many of her writings, Steinem has enacted Manjushri's role as protector and progenitor, in her case for feminists, by celebrating the courage and

insight of other women speaking out or standing up for their rights and understandings. In her deliberate activist campaigns to change legal systems and enact legislation to support women, Steinem perhaps also represents aspects of the Samantabhadra archetype. But as an educator using wit and humor, skill with words, her positive manner and charm, and ever-youthful energy, Steinem clearly embodies many of Manjushri's archetypal qualities.

Like Steinem, Margaret Mead exposed false cultural norms and assumptions. Instrumental in establishing modern anthropology, Mead called on Western culture to acknowledge the value and wisdom of supposedly primitive indigenous peoples and to appreciate global cultural diversity. Her work helped people see beyond reified attitudes about the world and human nature and history. She engaged the role of Manjushri by clarifying the emptiness of absolute truth in cultural norms and mores through the exploration of diverse cultures. Mead studied the anthropology of Native Americans as well as that of remote natives of Samoa and applied her findings to people in her own culture.

Margaret Mead possessed the intellect and insight of Manjushri in her academic writing and her position as a professor. But also like Manjushri, she readily adopted more humble guise in her many accessible books and in articles for *Redbook* and other popular magazines. She was determined to spread her message by any means available, leaking information about a wider view of humanity, sometimes to the dismay of her staid academic colleagues.

Mead was a free-spirited, independent woman, willing to make changes in her life situation. Her brilliance showed early in her career, as she is perhaps best known for her early work in Samoa and New Guinea, and her study of the varied possibilities of adolescence. Although her early work, which has been challenged and debated by some since her death, remains controversial, there is no question that Margaret Mead helped introduce contemporary methodologies and standards in anthropology and opened a broader sense of human potential.

In his fable *The Prince and the Pauper*, Mark Twain gives us another vision of the motif of a prince masquerading as a ragged beggar, which we can use to illuminate this aspect of Manjushri. In Twain's story, we have the twist of a commoner also masquerading as the prince after the two lads change places. The motivation of Twain's prince is not initially the same as Man-

jushri's, which is to test the awareness and conduct of his subjects, but the prince's experience in the slums of London gets similar results. Twain's prince poses as a beggar initially as a lark, seeking adventure and companionship. He ends up learning empathy for his subjects and compassion toward their suffering, which he later puts into action when he regains his position and is crowned king. From this we can infer that Manjushri's disguised aspect is a humanizing element in his archetype. His willingness to step down from his lofty position and rhetoric allows him to meet others and ultimately express his wisdom more effectively. Of course, it is also congruent with his essential message of not holding to any particular notion or social position as real or permanent.

In surveying these exemplars of the Manjushri archetype, we may achieve a better sense of the wisdom aspects of our own spiritual work and life. We activate this Manjushri quality when we focus and concentrate ourselves to bring forth our deepest insight into the nature of reality and of the ephemeral. Manjushri is further manifested when we articulate our insight to share it with others. We can recognize Manjushri when this insight appears along with youthful, creative energy, no matter our age. But the wisdom can be more usefully expressed when we are willing to share it humbly, disguised in everyday forms.

6

Samantabhadra
Functioning in the World

SAMANTABHADRA is the bodhisattva of enlightening activity in the world, representing the shining function of wisdom. Samantabhadra also embodies the luminous web of the interconnectedness of all beings and the radiant visions that express it. His name means "Universal Virtue" or "Worthy," and is pronounced *Puxian* in Chinese, *Fugen* in Japanese.

Samantabhadra and Manjushri are often paired as attendants on either side of Shakyamuni Buddha, with Manjushri on his lion representing the essence of wisdom, and Samantabhadra, mounted on an elephant, representing the application of wisdom actively benefiting the world.

The primary scriptural source for Samantabhadra is the *Flower Ornament Sutra*, for which he is the principal bodhisattva. Thus he represents the elaborate teachings on the array of practical activities of bodhisattvas, both of this sutra and of the profound Chinese Huayan School, which developed from it. (This sutra is called *Avatamsaka* in Sanskrit, *Huayan* in Chinese, *Kegon* in Japanese.) The diversity of beneficial expressions of bodhisattvas in the world, and spectacular visions of the interconnectedness of the ecosystems of the entire universe, are Samantabhadra's province. He is featured as well in the last chapter of the *Lotus Sutra* as a protector of that sutra and its devotees.

THE PHYSICAL PRESENCE AND ICONOGRAPHY OF SAMANTABHADRA

The short *Sutra on Contemplation of Practices of Samantabhadra Bodhisattva*, which is considered a closing sutra to the *Lotus Sutra*, presents a visualization

exercise about Samantabhadra. According to this visualization, Samanta-bhadra sits on a lotus mounted on the back of a six-tusked, seven-legged magical snowy white elephant (although in statuary the elephant is usually depicted in somewhat more conventional fashion). With every majestic step of the elephant's stately gait, dharma wheels containing white lotuses spring up beneath its feet as they are about to touch the ground. Samantabhadra riding majestically on his slow mount has a feeling of calm, deliberate activity, imbued with clear, considered intention and dignity.

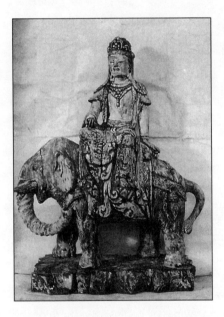

Samantabhadra, China

Samantabhadra is particularly radiant. Otherwise his person is usually similar iconographically to general bodhisattva figures, adorned with the jeweled ornaments, long, flowing hair and robes, and decorative headdress or topknot that derive from the princely class in early India. In East Asia he sometimes holds his hands up before him with palms joined, a sign of respect called *gassho* in Japanese. He may instead hold a lotus, a wish-fulfilling jewel, a sutra scroll, a short teaching staff, or in South or Southeast Asia a sword. Some forms of Samantabhadra have twenty arms holding implements to help beings. But this image of Samantabhadra, reminiscent of Avalokiteshvara's one thousand arms, is much less common than the multi-armed Avalokiteshvara.

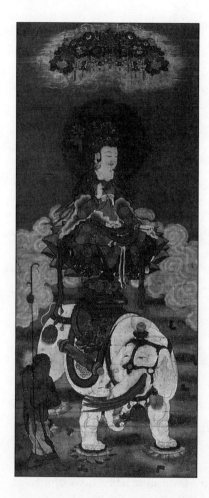

Lotus Sutra *Samantabhadra,*
Japan, circa 13th–14th centuries

Although Samantabhadra himself usually appears serene and poised but lacking in affect, his elephants are often quite expressive, even wildly hilarious with amazing grins. Some images depict Samantabhadra riding on multiple elephants, three, four, or even fifty, or on single elephants with multiple heads. Along with dragons, elephants are common symbols in Buddhism for enlightened practice and awareness. In Indian lore elephants commonly signify royal wealth and strength; in Buddhism the elephant's association with sovereignty is extended to include wisdom and knowledge. Samantabhadra's elephant's six tusks are said to represent the first six perfections, or the purification of the six senses. Sometimes riderless but laughing elephants are

seen as guardians of the gateways of temple buildings, suggesting Samantabhadra without his visible presence.

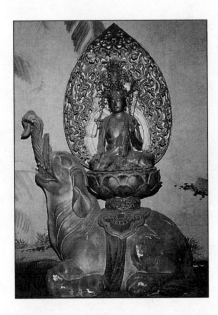

Samantabhadra, Japan, 18th century

The long final book of the *Flower Ornament Sutra*, the *Gandavyuha*, or "Entry into the Realm of Reality," describes the spiritual journey of the pilgrim Sudhana. At the culmination of the *Gandavyuha*, after meeting fifty-two other spiritual guides, Sudhana wishes to meet Samantabhadra. After he develops "a mind as vast as space and free from all attachments...immersed in the ocean of all enlightened teachings,"[1] Sudhana is finally able to behold Samantabhadra, sitting on a jeweled lotus flower in front of the cosmic "reality body" Buddha Vairochana.

From every pore of Samantabhadra's body emanate clouds of light beams that relieve the suffering of beings and increase the joy of bodhisattvas everywhere. Sudhana sees in every pore and from every part of Samantabhadra's body all the beings and entities of this world, and of all the worlds throughout every direction in vast space, throughout the whole range of past, future, and present. In every world apprehended through seeing the person of Samantabhadra, Sudhana also sees the awakening and activity of myriad buddhas and assemblies of bodhisattvas, and sees that this

same vision is seen in every one of those worlds, and that all of these worlds and events are seen distinctly, just by seeing Samantabhadra.

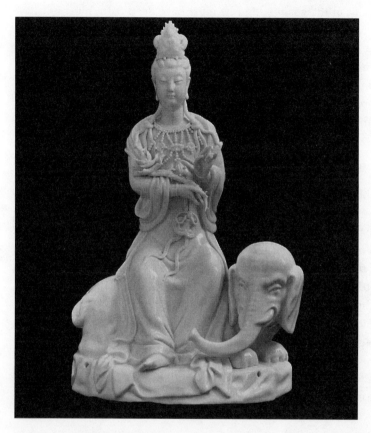

Samantabhadra, China

Given such an awesome vision of the true form of Samantabhadra, it is not surprising that Samantabhadra is difficult to encounter. No mere iconographic elements can capture such a spectacle. So it is appropriate that of all the major bodhisattva figures, images of Samantabhadra are the most rare in Mahayana temples. The sutras specify that to see Samantabhadra is extremely unusual and difficult, the product of great development and concerted efforts at awakening practice.

In the "Ten Concentrations" chapter of the *Flower Ornament Sutra*, a

bodhisattva named Universal Eye engages in practices in order to witness Universal Virtue (Samantabhadra). Universal Eye is told by the Buddha that to visualize Samantabhadra he must first realize that Samantabhadra is omnipresent in the cosmos, and he must have deep faith, must not have attachments to anything, must enter nondual true reality, and must practice the same undertakings as Samantabhadra. To his great delight, Universal Eye eventually sees Samantabhadra, a vision accompanied by rain showers of dazzling ornaments. Seeing Samantabhadra is thus extremely fortunate, and ensures great enlightening insight and awareness. Even just to hear the name Samantabhadra is said to be highly auspicious.

SAMANTABHADRA'S VOWS

Samantabhadra is particularly known for his set of ten vows, which have significant implications for his archetypal character. The ten are venerating buddhas; praising buddhas; making offerings to buddhas; confessing one's own past misdeeds; rejoicing in the happiness of others; requesting buddhas to teach; requesting buddhas not to enter nirvana; studying the Dharma in order to teach it; benefiting all beings; and transferring one's merit to others.

Samantabhadra's first three vows, venerating, praising, and making offerings to buddhas, show the aspect of bodhisattva practice of devotion to awakening and to those who have actualized such awareness. Samantabhadra's devotional sensibility arises out of the bodhisattva's humility and heartfelt gratitude. When first observing Buddhist devotees making full prostrations in homage to buddha or bodhisattva images, Westerners are often disconcerted or disturbed. We have as our first Judeo-Christian commandment and taboo the injunction not to bow down to idols or carved images. Indeed, this prohibition seems to reflect appropriately an unhealthy and dangerous aspect of the Western psyche that tends to seek and create idols, and thereupon abandon personal responsibility in their service. It is healthy to appreciate heroes, to allow ourselves to be inspired by exemplars of awakened activity and awareness. But we Westerners seem to want to believe in, and yearn for, "perfected masters."' We hear the word "enlightenment" and think its teachers are perfect and superhuman beings who can do no wrong.

This attitude of idolatry has occasionally been a problem as Buddhist teachings have been introduced to the West. Students have projected inappropriate, inhuman power on teachers, rather than seeing them simply as

worthy spiritual friends who can share their greater experience. Spiritual teachers, in turn, thus have the responsibility to reveal their humanness to students and not be fooled by students' unrealistic projections that are mixed with their appreciation.

Images of buddhas or bodhisattvas are fundamentally understood as representations of awakened qualities within our own selves, and within all beings. That is what is bowed down to. This is true not only for statues, but also for living teachers, who may or may not be appreciated as individual people. Teachers are venerated especially for expressing the awakened quality possible for all of us, and for representing the tradition that has maintained this teaching. This vow of Samantabhadra does not suggest that exemplars or guides be venerated for their personality quirks or charisma.

In his devotion, Samantabhadra not only venerates buddhas, he also vows to praise them, and the marvel and virtue of their awakening activity, in order to encourage and benefit others. Samantabhadra spreads the news about the presence of buddhas and the possibility of enlightenment. He further makes offerings to buddhas, providing them with useful gifts and with the practical offering of his own life activity and dedication in whatever way that may be helpful.

Buddhist legend stresses the importance of the spirit of offering, rather than the quality or quantity of richness of the offering. Sincere offerings to a buddha of a piece of fruit, or by a child of a ball of dirt, have been highly praised and considered the cause of great resulting benefits. These examples are from the legend of the benevolent third-century B.C.E. Indian king Ashoka. After uniting much of northern India through bloody warfare, Ashoka repented and became a peaceful and virtuous patron of the Buddhist community. According to the *Sutra of King Ashoka*, he had donated so much to spiritual communities when he was aged that his ministers forbade further gifts, so that one day when some monks passed by, all Ashoka could offer was his partially eaten mango. This gift was said to guarantee Ashoka's future buddhahood. In a former life, as a young child, Ashoka was supposed to have sincerely given Shakyamuni Buddha a mud pie. The Buddha gratefully accepted the child's offering and took it back to add to the sand being used to construct a wall of his monastery, resulting in Ashoka's later kingship.

Offerings to buddha may include donations to support and sustain Buddhist temples and training centers. Traditionally patrons have supported monks to help them pursue intensive practices. But with Samantabhadra's

devotional attitude toward all of creation, we can also offer buddha a beautiful sunset, the drifting clouds, a field of wildflowers, a baby's smile, or our efforts to act with kindness. We can offer the nourishment to buddha as we eat an orange.

Samantabhadra's fourth vow is to confess his own past misdeeds. Throughout numerous past lives, even such a great bodhisattva has erred and contributed to causing suffering in various ways. Samantabhadra has the humility to realize and acknowledge this. We can only awaken to our open, clear, radiant nature by examining and acknowledging the obstructions and self-graspings of our conditioning that inhibit this deeper reality. Traditional Buddhist rituals have included various "confession" ceremonies, either to teachers or before assemblies, as well as individual practices that help us acknowledge to ourselves particular personal blockages. Modern practices derived from the traditional ceremonies include group responses to individual sangha members' accounts of their personal problems as well as group recitations of general acknowledgements such as, "All my ancient twisted karma, from beginningless greed, hate, and delusion; born through body, speech, and mind; I now fully avow." As we openly acknowledge our failings, they may lose their power, and we can see how to not be caught by them.

In the *Sutra on Contemplation of Practices of Samantabhadra Bodhisattva*, the elaborate visualization exercise to witness Samantabhadra and his elephant in all their glory must be preceded by repentance practices, which vary from a day, to twenty-one days, up to numbers of lifetimes, depending on the practitioner's karmic obstructions. These repentance practices include reading and reciting of sutras, seeing all people as buddhas, and treating all beings as if they were one's parents. This is followed by an increasingly subtle process of purification of the senses. As we acknowledge our limitations and harmful acts, we clear the way to communion with Universal Virtue. These repentance practices were considered important and were followed by practitioners in medieval China who saw Samantabhadra as the bodhisattva to whom one confessed.

Samantabhadra's fifth vow is rejoicing in the happiness of others, and in others' virtues. Seeing others enjoy their lives and develop their capacity for bringing joy to others is what truly gives Samantabhadra his greatest pleasure. When a bodhisattva realizes that she is ultimately not separate from others, her sincerest wish is simply that all beings may be happy.

Of course, it is not always so easy to be happy with others' good for-

tune. Often we feel rather envious: *Why couldn't that happen to me? I try so much harder, and that person who is so mean, stupid, inconsiderate* (whatever critique) *has all the luck.* Such feelings are to be expected when we view others as "other," outside, and estranged from ourselves and our interests and well-being. So Samantabhadra has as one of his vows to genuinely be happy for others who are happy, regardless of superficial discriminations and judgments about whether they "deserve" their good fortune or not. This vow also includes seeing and enjoying the virtuous acts and good qualities of others, and not only their limitations, on which we might all too easily dwell. When we adopt this vow to truly appreciate the happiness and goodness of others, we are doing Samantabhadra's practice and immediately dispense with all jealousy.

Samantabhadra's sixth and seventh vows are requesting buddhas to teach and not to enter nirvana. Even more than the first three vows, these vows stress the value of a buddha's presence in the world, because of its fragility. When Shakyamuni Buddha was first awakened it is said that he thought nobody would be able to understand what he had realized, and that he might as well pass away into nirvana right then. A buddha realizes that this world, as it is, completely and wondrously expresses perfection and is a beautiful buddha land. The whole environment of the world actualizes this simultaneously with the buddha. But many beings existing in the world enmeshed in the cycle of causation may be unable as yet to apprehend this, due to their own ignorance, craving, and aggression.

Nevertheless, some beings are capable of understanding and developing spiritually upon hearing a buddha's teaching. The story tells that this is what the Indian deity Brahma said to Shakyamuni Buddha after his great awakening, convincing him to remain in the world in order to find ways to teach others. Samantabhadra vows to repeat this entreaty to all buddhas, recognizing that buddhas may only share their wisdom and compassion with those willing and ready to accept it. Similarly, all Buddhist students must actually request the teaching, demonstrating sincere desire to follow spiritual practice, in order to fully receive it from a teacher.

These two vows suggest the importance to Samantabhadra of spiritual discipleship, and the central role in the work of awakening of the apprentice-mentor relationship. Samantabhadra models himself on the teacher as mentor, and, in turn, becomes a mentor to others. Such relationships, so prevalent in East Asian cultures in the traditions, forms, and lineages of aesthetics and craftsmanship, as well as in spiritual training, are cared for

with great attention. One example of the role of the mentor or spiritual friend in the *Flower Ornament Sutra* is in Sudhana's pilgrimage to fifty-two spiritual friends, culminating with Samantabhadra. Probably the tradition of apprenticeship, which remains strong and familiar in East Asian society, allows Asians to respect and venerate human spiritual teachers without succumbing to the idolatrous abdication of personal responsibility that we face in our practice in the West when leaders are unrealistically glorified.

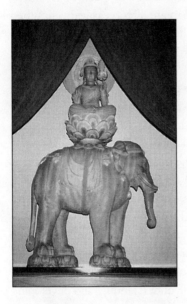

Samantabhadra, Japan

Samantabhadra's eighth vow is to study the Buddhist dharma in order to teach it himself. Samantabhadra reads, recites, ponders, and questions the sutras and the traditional writings from spiritual masters in order to be ever more fully in accord with awakened compassion and wisdom. Furthermore, Samantabhadra finds ways to share his study with others, either by expounding the teaching explicitly, or by expressing it in his daily activity and bearing in a way that allows other students to inquire and learn about the practice. Samantabhadra commits to keeping alive in the world the traditions of spiritual teaching. But the dharma Samantabhadra studies includes teachings not only from sutras, but available in everyday activity, in upright sitting, and from lotus blossoms, sunsets, and moonlight reflected on the ocean, as well as in fear and anxiety, and from old age, sickness, and death. Samantabhadra vows to share the depths and the wonder of all of life's teaching.

Samantabhadra's ninth and tenth vows, benefiting all beings and transferring one's merit to others, are the natural consequences of the fifth vow of rejoicing in the happiness of all beings. Carrying out the ninth vow, Samantabhadra does whatever is necessary to help beings, taking on complex roles in social settings for the sake of those who are suffering. This vow of beneficence is the basis for Samantabhadra's manifold appearances in the world. It implies helping in personal situations, but also recognizing the systemic problems of society that may produce suffering and finding means of facilitating necessary changes.

Samantabhadra's tenth vow of transferring merit has a technical meaning that is common to all bodhisattva practice. Developed bodhisattvas have the special power to extend the merit accrued from their own insight and compassionate activities to other beings. This is enacted in Mahayana ritual with dedications chanted after all sutra chanting or ceremonies to extend the benefits that result from any spiritual practice unto all beings. Blessings may also be transferred to specific, named persons. In these dedication chants, all buddhas and bodhisattvas are asked to extend their wisdom and compassion to all beings, but particularly to the sick for their recovery, or to those who have passed away for their fortunate rebirth, that the deceased may find their place in the way of awakening.

More generally, the transferring of merit indicates that Samantabhadra vows not to practice merely in order to acquire personal well-being or benefits. Meditation, chanting, and other spiritual practices may have positive effects (some of which have been verified by modern science) although none are guaranteed in all cases. Some practitioners notice side effects such as stress reduction and relaxation, increased energy, greater patience or endurance, less sleep needed, or a general sense of health or integration in one's life. Desire for these benefits is often the initial impetus that brings people to practice. Samantabhadra's tenth vow means that he does not practice hoping to achieve such results. If they occur that is fine, but always Samantabhadra "transfers" these advantages by using them to help sustain beneficial work in the world for others. Transferring the merit of bodhisattva practice helps dissolve the barriers between ourselves and others, and between the buddhas and all beings. All practitioners take on this vow of transferring merit when they practice with the attitude of extending its benefits to others.

The sixteenth-century Chinese Zen master Zibo said that if you fulfill just one of Samantabhadra's vows, "you will achieve enlightenment without a

doubt. How much the more so if you attain to them all!"[2] In the middle of our everyday activity in the world, amid difficulties in our workplace or family, with coworkers, children, or spouses, mindfully recalling these ten vows can be a great help. Reciting or remembering these vows allows us to engage in our ordinary life in a way that activates our awakened, beneficial nature.

SAMANTABHADRA'S SAMADHIS

As the preeminent bodhisattva of the *Flower Ornament Sutra*, Samantabhadra represents this teaching's exalted, visionary approach to enlightening awareness and expresses such vision by enacting the heightened intensity of concentrated states of mind. These concentration states, or samadhis, are also meditation instructions that demonstrate the dynamic, dialectical interplay between phenomena and the universal, which is elaborated in the systematic philosophy of the Chinese Huayan School. In his identification with so many wondrous samadhis, Samantabhadra reveals himself as the visionary bodhisattva who unveils the integration of all beings with the totality of the universe.

The "ocean seal" or "ocean reflector" samadhi is considered the fundamental consciousness of the *Avatamsaka*, which Shakyamuni Buddha realized immediately upon his enlightenment, and in which he proclaimed the whole *Flower Ornament Sutra*. This samadhi is thus also associated with Samantabhadra. The ocean reflector samadhi is illuminated consciousness like the surface of the ocean, fully reflecting everything in the cosmos, confirming and sealing it with authenticity. The winds of delusions cause the waves of phenomena to arise on the surface of the ocean, forming thoughts and perceptions, but as soon as the mind settles and the water is calm and clear, this ocean-mirror awareness again reflects perfectly.

In the ocean-mirror metaphor, all things are images equally reflected in the ocean without obstructing or impinging on each other. Moreover, each phenomenon is an image of the whole that can reflect all other entities. Thus this awareness embodies the fundamental nature of reality and mind. In the dialectical philosophy of Huayan, aptly illustrated in the ocean seal samadhi, the mutual interpenetration of all things with totality, and of all things with each other, is the essential nature of reality. Although a description of a buddha's consciousness, it is also the inherent quality of all consciousness.

In the *Flower Ornament Sutra* chapter "Meditation of Bodhisattva Universally Good," Samantabhadra enters the concentration or samadhi called

"the immanent body of the illuminator of thusness." This samadhi is described as being in all awakened ones, as containing all worlds in the universe, and as producing all other concentration states. It contains the teachings and liberations of all buddhas and the knowledge of all bodhisattvas, and develops enlightened virtues and vows.

At the time that Samantabhadra entered the samadhi of the immanent body of the illuminator of thusness, he saw vast numbers of buddhas in multitudinous worlds in all directions, and also saw buddhas within every atom in all of those worlds. In front of each one of these buddhas sat other Samantabhadra Bodhisattvas who immediately also entered into the samadhi of the immanent body of the illuminator of thusness. The buddhas in all the myriad realms thereupon praised each Samantabhadra Bodhisattva for their great enlightening abilities, fostered by the power of the cosmic, absolute Buddha Vairochana. Then the buddhas bestowed upon every Samantabhadra omniscient knowledge of all the different worlds and their workings, and their appropriate enlightening teachings.

When this had transpired in each of the many worlds and in all of the atoms in those worlds, all of the buddhas reached out with their right hands and patted each of the Samantabhadras in all the realms on the head. This amazing, mind-boggling scene is the content of this primary samadhi of Samantabhadra. As Samantabhadra arose from this samadhi, all of the Universal Virtue Bodhisattvas arose in every world, and all of the worlds trembled. Gentle rains of beautiful clouds and jewels, many with specific described qualities, then fell profusely upon all bodhisattvas everywhere, bestowing enlightening knowledge, techniques for teaching, and splendid illumination.

The marvelous description given in the sutra of Samantabhadra's samadhi presents a display of the holographic quality of the reality of the bodhisattva realm. This account of the true nature of the universe and of the buddha work dramatizes the glorious vision of Samantabhadra. As the panoramic awareness of various samadhis of Samantabhadra is presented in the sutra in effusive detail, the reader may partake of this intoxicating and elevating consciousness.

Samantabhadra enters many other samadhis that express vast, holographic visions with the totality of reality inherent in each part and particle as they are revealed. For example, early in the "Entry into the Realm of Reality," before Sudhana begins his pilgrimage, Samantabhadra elucidates the "lion emergence" samadhi, revealing to the assembled bodhisattvas the

vast array of buddhas, lands, enlightening beings, powers of samadhis, and manifestations of teachings, from past, present, and future, that all exist within the oceanic buddha lands on a single hair tip, and on every hair tip.

SAMANTABHADRA'S VISION: THE LIVELY ENVIRONMENT

Surveying the samadhis and the vows of Samantabhadra, we begin to recognize the vast, panoramic vision of reality that he expresses and displays. Samantabhadra's inspiring and dazzling vision of the universal awakened nature of reality especially emphasizes the interrelatedness of all phenomena, and the relation of all phenomena with the ultimate truth or emptiness of all things. In the holographic aspect of his samadhis, each part replicates the whole, and yet does not interfere with any other part. This is the reality described in the *Flower Ornament* simile of Indra's net, with each jewel in the vast net fully reflecting all other jewels from its own position.

Samantabhadra's vision of the way things are is prescriptive as well as descriptive. It may be true that each part of the universe intimately reflects the whole, but this also includes and depends on the vital presence of bodhisattva practice and the crucial aspiration for universal enlightenment. This interpenetrating reality of all things is only realized and manifested in the context of concentrated awareness dedicated to the luminous awakening and well-being of the whole. The universal vision cannot be apprehended by one who sees the self as fundamentally at war with others, "looking out for number one" at the expense of others who must be bested. Only when we see that we are all in it together, and invigorate our intention to live constructively in that light, can we see each one as truly integral to the whole.

Samantabhadra's name means universal virtue or goodness, but he is not an ineffectual "goody-goody" or naïve "do-gooder," just trying to be a good boy for its own sake, or out of some sense of obligation. The aesthetic, wondrous quality of his vision illustrates that Samantabhadra performs bodhisattva activity because it is beautiful. To be in accord with enlightened truth, aligned with all buddhas and bodhisattvas, is simply the most pleasing and joyful of lifestyles for Samantabhadra. His ongoing effort is to further adorn and beautify the bodhisattva path, helping others find the calm, deep radiance within which enlightening, helpful work is not a chore, but the most splendid way of living.

One striking aspect of Samantabhadra's vision, present in other Mahayana sutras but most glowingly abundant in the *Flower Ornament*, is the teach-

ing role of inanimate objects. The *Flower Ornament* lands, with their jeweled trees, lakes, clouds, palaces, light beams, and of course flowers, are very much alive in their function of demonstrating and awakening beings to the luminous reality of interconnectedness and openness. The world is not a collection of dead objects. In pure buddha lands, including even this world of ours, every single thing is vitally joined in the enlightening work of bodhisattvas.

There are obvious ecological implications to Samantabhadra's teaching, such that we may designate him the bodhisattva of environmentalism. When we see the interrelatedness of our world, we recognize that clear-cutting the rain forests of the Amazon depletes the oxygen available for our own lungs. Allowing the mass extinction of species, even of unknown insects or tropical plants, impedes the diversity and richness of all life on the planet. Healing medicines that may have been discovered in recently extinct flora will not be available, but also the radiance of the whole fabric of the web of life fades. When each flower, each jeweled tree, each lake, each rock, each bird is a liberating ornament illuminating the bodhisattva work, we appreciate the bodhisattva vow to uphold and maintain all things with delicate care and attentiveness. The world is an intricate, sensitive system in which all parts are integral to the whole, and in which our own beneficial activity is vital. Samantabhadra's active application of wisdom is centered on guarding and caring for the world, as expressed most directly in his vows to share the dharma, to benefit beings, and to transfer his own merit.

THE MOUNTAIN OF SAMANTABHADRA

Mount Omei, rising like a cone from the high plateaus of Sichuan Province in western China, is the holy mountain and principal pilgrimage site of Samantabhadra. It has been home to many temples and continues as a monastic training center even today. Over the centuries, many pilgrims to beautiful Omei have reported miraculous visions amid its hazy heights. Colorful balls of phosphorescent light have especially been noted floating in the mist or below the peaks at night, said to be lanterns emanated by Samantabhadra as offerings to the Way.

Mount Omei is one of the four sacred mountains of the bodhisattvas in China along with those of Manjushri, Avalokiteshvara, and Kshitigarbha. Samantabhadra images also appear prominently at Mount Wutai, the mountain primarily dedicated to Manjushri. Of the four mountains, Mount Omei was especially a favorite inspirational spot for poetry, and

many of the famous Chinese poets penned verses there. This is fitting considering Samantabhadra's archetypal visionary qualities. As an example, one of the greatest of Chinese poets, the famed eleventh-century writer Su Dongpo, was born and raised in a town at the foot of Mount Omei. A deeply insightful student of Chan Buddhism who was also a busy government administrator sometimes holding important national positions, Su Dongpo wrote some of his verses upon visits to Mount Omei.

SAMANTABHADRA HIDDEN IN THE WORLD

Although Samantabhadra is omnipresent in all places and times, even in every atom, he is especially hard to encounter explicitly, as is apparent from the elaborate visualization exercises required to see him. He often acts beneficially while hidden in worldly roles. Such "hidden practice" has been a colorful motif in Buddhist history, as many great masters have spent time living incognito in the bustle of the marketplace or humbly "under a bridge." Dongshan, ninth-century founder of the Soto Zen lineage in China, advised his successors, "Hide your practice, serving secretly, as if a fool, like an imbecile."[3] Practicing within, while not being identified as a bodhisattva, nurtures the practitioner's developing skill and capacity, along with allowing more effective helping work in many situations.

One of the more colorful examples in Asian folklore of Samantabhadra hidden in worldly roles is the twelfth-century Japanese courtesan Eguchi, who lived in what is now Osaka. She is said to have been an incarnation of Samantabhadra, using the passions and her charms to enlighten men and teach impermanence. She has been depicted as a geisha sitting on a white elephant like Samantabhadra's. Later she became the heroine of a Noh play based on an anecdote in which, out of kindness, she refused lodging to the famed monk-poet Saigyo in order to protect his reputation.

Hidden practice is important to the Samantabhadra archetype, anonymously occupying ordinary roles in society to do bodhisattva work and inspire others to do likewise. He is willing to see the workings of the world and act, discreetly when possible, transforming social systems in order to help beings. Samantabhadra is generative, inspiring. New Samantabhadras appear in every atom. And Samantabhadra's presence as an example produces more bodhisattvas, like a Tom Sawyer inviting others to fence painting.

The *Flower Ornament Sutra* presents a variety of lessons on how to put the Samantabhadra archetype into practice. In the chapter called "Practices of

Samantabhadra," the Bodhisattva declares that buddhas appear in the world only because beings, in their ignorance, are attached to conceptions of self and possessiveness and need spiritual assistance. Samantabhadra warns against anger at "other bodhisattvas," as he inclusively defines us all. He calls such anger the greatest mistake possible, because each angry feeling creates millions of severe obstacles when we hold on to these feelings or act on them. Samantabhadra instead encourages a series of practices as antidotes: knowing the endlessness of the multitude of realms; an attitude of not abandoning beings; seeing all as buddhas; profound devotion to enlightening practices; and retaining space-like, impartial mind without attachments. We may well imagine the usefulness such practices as impartiality hold for people working for transformation amid the contentiousness of worldly institutions.

A large catalog of specific practices for mindful attitudes is listed in the chapter called "Purifying Practices." They are offered by Manjushri as instructions in how to emulate Samantabhadra as a guide and to fulfill his vows, while engaging in a variety of ordinary as well as religious activities. Given in verse form, these practices use the occasion of everyday sights and actions as reminders of spiritual purpose: Upon seeing a bridge, wish that all beings carry everyone across to liberation; going to sleep, wish that all beings attain physical ease and undisturbed minds; coming to a door, wish that all beings enter all doors of buddhas' teachings; seeing the sick, wish that all beings know the emptiness of the body and abandon contention; seeing a flower, wish that all beings' spiritual powers would blossom. Such diverse activities are included as brushing teeth, washing the face, or bathing; approaching uphill, downhill, winding, or straight roads; seeing happy or suffering people; seeing forests, rivers, or gardens; entering a monastery; or observing mendicants, soldiers, or kings. Many of these verses have been adopted as daily chants in the Buddhist monastic tradition, and have been adapted for contemporary use by modern teachers.

ASSOCIATED FIGURES:
VAIROCHANA BUDDHA AND VAJRASATTVA

As we have seen, in the *Flower Ornament Sutra* Samantabhadra is closely associated with Vairochana Buddha (Dainichi Nyorai in Japanese), whose name means "Great Illumination." Vairochana is the main buddha of this sutra, in whose assembly the visions of the sutra transpire, and whom Samanta-

bhadra sits before. Vairochana is considered a dharmakaya, or reality body buddha, the absolute quality of buddha, whose brilliant body is itself identical to and coextensive with the totality of the universe. He corresponds as a cosmic buddha to the historically incarnated buddha, Shakyamuni. Vairochana Buddha speaks in the *Flower Ornament Sutra* only through the voices of bodhisattvas, who are inspired by lights emitted by Vairochana. This especially includes Samantabhadra, who is often described as an emanation of Vairochana. Thus Vairochana is likened to the great dazzling illumination of the sun. One chapter in the *Flower Ornament Sutra* describes Vairochana's preparatory study with former buddhas and the excellent realizations he thus attained in a previous incarnated life as a prince named Light of Great Power.

Vairochana is sometimes depicted iconographically with his body covered with buddhas, or surrounded by them on his background nimbus. His body may also be imprinted with cosmic symbols such as the sun, the moon, and the cosmic Mount Sumeru. His vast, absolute nature may also be indicated by images of extraordinary size, such as the Great Buddha at the Kegon temple Todaiji in Nara, Japan, which is the largest bronze statue in the world.

In the Tibetan esoteric systems, a buddha named Samantabhadra Buddha is also considered a primordial dharmakaya buddha like Vairochana. In another of the complex, numerous tantric systems, one of a group of five bliss realm buddhas is also named Samantabhadra. But these tantric Samantabhadra Buddhas are understood by most sources as completely different figures from the Bodhisattva Samantabhadra whom we are discussing as a major bodhisattva archetype.

However, according to Vajrayana sutras and commentaries popular in East Asia, the important tantric bodhisattva Vajrasattva (Adamantine or Diamond Being; Kongosatta in Japanese) is another form of Samantabhadra Bodhisattva. Vajrasattva is a tantric archetypal figure representing enlightening power and the purification of intention and vow. He especially emphasizes bodhichitta, the initial aspiration toward enlightenment. The teachings of Vairochana Buddha in the *Mahavairochana Sutra*, one of the central scriptures of East Asian Vajrayana, are given in response to questions from Vajrasattva. Vajrasattva's importance to tantric Buddhism is signified by his role as founder in its lineages, as he is said in many branches to have transmitted these teachings from Vairochana Buddha directly to historical human founders.

Iconographically, Vajrasattva usually sits cross-legged and holds raised in his right hand a vajra (a ritual thunderbolt implement) symbolizing the strength of vow, and in his left hand a vajra bell, usually held down on his hip, symbolizing compassionate immersion in samsara. Vajrasattva is the focus of tantric visualization and mantra ritual exercises that lead to mental identification and merging with the Vajrasattva figure. Vajrasattva usually has a serene expression in Tibetan Buddhism, and is only occasionally represented in wrathful manifestations. But in Japan, as Kongosatta, he often is depicted in wrathful form, frequently standing and crushing underfoot demons representing greed, hate, and delusion.

SAMANTABHADRA AND THE PARAMITAS

Samantabhadra emphasizes the transcendent practice of vow, as elaborated in his ten vows. His commitment to universal awakening, but also to numerous specific helpful activities, expresses an attitude and practice that we can emulate to find our own inner fulfillment. Each of his ten vows is a tool we can use to strengthen our personal vows and intentions. Samantabhadra's vows keep him active in the world, carrying out programs to transform society and its conditions in behalf of the development and awakening of beings.

Samantabhadra also embodies the tenth perfection of knowledge, having fully developed buddha-like awareness of the multiplicity of manifestations of the universal in diverse realms. Thus Samantabhadra can engage in many roles and situations, armed with his dedication to help develop and assist beings. As we practice vow and knowledge, our knowledge develops and we may begin to have access to capacities and skills for becoming more effective and more aware of wholeness.

Samantabhadra's practice of the perfection of meditation helps him to find the fulfillment of knowledge through the holographic awareness and visions it fosters. Such knowledge emerges simultaneously with the immersion in samadhi. But anyone who has done intensive meditation practice over a day, a week, or longer knows that it is also a forge that purifies, tests, and exposes one's self and illusion of self to oneself. This samadhi is fiery and not to be taken lightly. Samantabhadra's visualizations described in the *Flower Ornament Sutra* are not realized casually. It is said that all buddhas sit in the middle of fire. Being willing to remain upright and still in the middle of the searing flames of life and of our garbled karma and conditioning, we

can begin to settle into our deeper awareness which shows us the weave of our interconnections with all buddhas and sentient beings.

Another perfection especially embodied by Samantabhadra is the paramita of powers, the ninth paramita. Informed by his practice of the perfection of knowledge, as well as his skill in means, Samantabhadra has the capabilities to effect changes in the world, and in the hearts and minds of beings as appropriate. We have seen such powers in his ability to provide graphic displays of interconnectedness, in the dharanis and other protection he offers to beings, and in his effective beneficial work in the world. In the following accounts of examples of Samantabhadra from our own world, we will explore the variety of his powers and good works.

EXEMPLARS OF SAMANTABHADRA

Samantabhadra himself is hard to see, so it is ironic, and yet somehow remarkably appropriate, that exemplars of his beneficial workings in the world are especially numerous. Samantabhadra engaging in hidden practice is not apparent in his most majestic radiance, but he is evident everywhere in the world to those who look, in many roles and arenas. While it is sometimes difficult to find exemplars of aspects of the other archetypes, the problem with Samantabhadra is to select which few to describe of the very many readily available exemplars. Presenting more examples than for other archetypes is irresistible, providing a way of seeing the range of qualities of the Samantabhadra archetype.

Reviewing Samantabhadra's archetypal characteristics, we can focus first on his active work in the world, vowing to engage in situations that might be beneficial for beings. Historically in Asia, Samantabhadra has not been formally presented as a social or political activist (nor has any other archetypal bodhisattva figure). Yet in the context of the modern "Engaged Buddhism" movement, many Buddhists throughout the world are openly and actively addressing social issues and conflicts, but informed with Buddhist spiritual principles of wisdom and compassion. Thus, in examining the Samantabhadra archetype as it manifests in our time, we unavoidably must see the arenas of Samantabhadra's vows and work on behalf of beings in the world as including social systems and political institutions. The sutras make clear that Samantabhadra does not shy away from social conflict, although he may prefer to act behind the scenes whenever that may still be helpful. All of Samantabhadra's subtle and deliberate activity in the realm of

social structures and systems is ultimately aimed at the broadest scope of fostering universal awakening.

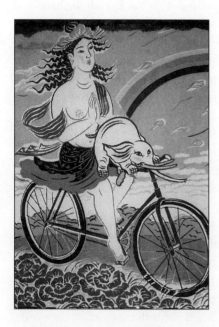

Samantabhadra goddess on bicycle

A second aspect of Samantabhadra, along with beneficial deeds, is vast, aesthetic vision, creatively expressing the larger picture of wholeness with a positive sense of awe, while encouraging the development of awakening as the vitalizing principle of that vision. This comprehensive vision is the source of hope and energy that sustains and informs Samantabhadra's constructive, liberative activities in society. Even while immersed in worldly missions, part of Samantabhadra's character is solitary and devotional, seeing all his activity as a simple offering to the vision of awakening. Many of Samantabhadra's exemplars, even while embroiled in social activism, have this humble, devotional attitude.

A third prominent quality of the archetype is Samantabhadra personally embodying vibrant presence and radiant dignity. His impressive, stately presence inspires and energizes others and helps them awaken to wider vision and to their own participation in productive activity in the world.

One eminent and dramatic example of Samantabhadra energy in the world today is the courageous Burmese leader Aung San Suu Kyi, winner of

the 1991 Nobel Peace Prize, who has spent many years imprisoned under house arrest in Rangoon. The daughter of the leader of the Burmese independence movement who was assasinated after World War II, Aung San Suu Kyi was living comfortably in England with her British husband and their two sons when she visited her mother in Burma in 1988. During this period, government police shot and killed thousands of demonstrators and many members of the burgeoning democracy movement. Suu Kyi resolved to address the political troubles of her homeland. She traveled the country speaking out strongly and vowing to fight the tyranny of the ruling military dictatorship. She was placed under house arrest, but after the political party she led, the National League for Democracy, overwhelmingly won the national elections held in 1990 in Burma, she should have become prime minister. Instead, the military junta ignored the election results and arrested and imprisoned most of the members of her party who had won election to parliament.

Through her long imprisonment, Aung San Suu Kyi was offered release if she would depart the country and abandon any participation in Burmese politics. But she refused, continuing to sacrifice her own freedom and the chance to be with her family in order to willingly stand up for her country's freedom. Thanks largely to the acclaim she received from around the world, Aung San Suu Kyi's house arrest was eventually withdrawn after many years. Because she refuses to abandon her active vow to speak out for democracy for her countrypeople, her life has been threatened numerous times, many members of her political party have been periodically arrested, and Aung San Suu Kyi herself remains in daily peril from the junta. However, her heroic courage and self-sacrifice have awakened the desire for social openness in her country, and she has inspired people all over the world.

Aung San Suu Kyi was raised in the Theravada Buddhism of Burma, and her husband was a scholar of Tibetan Buddhism. While reflecting her Buddhist practice, the vision behind her work is wide, inclusive, and obviously deeply personal, now informed by her contemplations during the many years under house arrest. She speaks of the importance of mutual tolerance and nonviolence for achieving peace and social justice, and has expressed the wish for reconciliation with the Burmese military, even while standing firmly for principles of democracy and actively working to affect change. Suu Kyi does not see any group of people as evil, but instead talks of the necessity for all people to be willing to learn and change, congruent with Samantabhadra's vision of the long-term development of beings. She

unhesitatingly says that her greatest joy is bringing happiness to others, echoing Samantabhadra's fifth vow. Aung San Suu Kyi's highly dignified bearing, piercing beauty, and calm but energetic inner presence are also reminiscent of Samantabhadra, and a source of her inspirational powers.

Dr. Martin Luther King, Jr., remains one of the great American exemplars of Samantabhadra in our time. We can see all the many brave people engaged in the civil rights movement in the 1960s as acting with the concern, courage, and resolve of Samantabhadra. But Dr. King has most fully come to symbolize and embody in the national consciousness the struggles for social justice of that movement. With his indomitable spirit and willingness to speak of the truth and suffering of many people, he bravely persevered while facing numerous arrests and threats, culminating in his assassination.

Dr. King's example encouraged and galvanized many to live and act with hope for a promised land of justice and equality, which he saw in the distance, even if he could not enter himself. He forged from his Baptist background and ministry a strong spiritual vision of a racially just world, with his vision still alive in our society. His celebrated dream of a just and harmonious "pure land," in which the very mountains and valleys ring out freedom, included a vision of all people fighting for human rights, with nonviolence and dignity but also determination.

The small though significant gains that have come out of the civil rights movement do not yet come close to matching Dr. King's dream. The situation of minorities in the United States is still very difficult; African American churches are being torched across the South as I write. But the message of hope and freedom he shared, and his courage to act and inspire others to act, endure and reverberate in the American heart.

Perhaps no figure in English literature more fully exemplifies the archetypal qualities of Samantabhadra than the British visionary poet and painter William Blake. A professional engraver, Blake used paintings to illustrate and adorn his visionary poetry, which is nearly as vast, comprehensive, and colorful as the *Flower Ornament Sutra* itself. Blake's illuminated poems are a monumental reworking of Western spirituality, imbued with joyful and profound spirit.

Blake was influenced by lore from England's druidic past, by the Greek and the Christian Gothic traditions, and by the more recent visionary Swedenborgian theology, which gave a philosophical context for profuse

visions of heavenly beings and spirits, and for the validity of inner spiritual states. Inspired by his own vivid, spiritual visions, Blake rewrote much of the Bible and sang his own complex, prophetic works like an Old Testament prophet. It is beyond the scope of this brief reference to describe Blake's elaborate and original mythos and cosmology, or analyze in detail how it does and does not correspond to Samantabhadra's vision. But even a few characteristics of Blake's work reveal some archetypal kinship to Samantabhadra and give us a wider sense of the bodhisattva of action and vision.

Congruent with Samantabhadra's wondrous visions and samadhis, Blake stressed the role of man's "poetic genius" and superordinary perceptions, that "He who sees the Infinite in all things, sees God."[4] And Blake was concerned not only with his inner life, but also with the human society in which he lived in the late eighteenth and early nineteenth centuries. He praised the American Revolution and the beginnings of the French Revolution, offering a visionary interpretation of the spirit of rebellion as celebrating nature in his long poem *America*. Many of his poems deplore contemporary incidents of slavery and oppression, and speak eloquently of the "Marks of weakness, marks of woe" among the poor of the nearby London slums. Blake opposed the "mind-forged manacles"[5] with his dream of a liberated England in his vision of Albion.

Blake championed imagination and concentrated, radiant visions, not unlike Samantabhadra's samadhi and visualizations. Blake said that at sunrise he did not merely see a round disk of fire like a coin, but he saw "an innumerable company of the Heavenly host crying, 'Holy, Holy, Holy is the Lord God Almighty.'"[6] He considered most fully real such a sun, shooting forth cavalcades of brilliant angels and choruses of hallelujahs, reminiscent of Samantabhadra's visions of bodhisattvas shining in every atom. Blake's vision of the sun also recalls the name of the *Flower Ornament*'s true body (dharmakaya) buddha Vairochana, whose name means "Great Illumination" and is translated in Japanese as Dainichi, meaning "Great Sun."

Blake's vast sense of universal inclusivity is expressed in his statement, "Every thing possible to be believed is an image of the truth."[7] His encouragement, "To see a world in a grain of sand, and a heaven in a wild flower"[8] illustrates the Huayan interpenetration of the universal and phenomenal. The following proverbs from Blake's *Marriage of Heaven and Hell* resonate intimately with Samantabhadra's call to action and holographic wonder. "Eternity is in love with the productions of time,"[9] reflects Samantabhadra's embodiment of the ultimate entering into works in the con-

ventional world. The purification of perceptions in Samantabhadra's vow of repentance and in some of his visualization exercises is echoed in Blake's, "If the doors of perception were cleansed every thing would appear to man as it is, infinite."[10] Blake's "One thought fills immensity"[11] and "Every thing that lives is Holy"[12] further illuminate the subtlety and glory of the *Flower Ornament* vision of the vast net of mutually reflecting, wondrous jewels.

Although Blake's voluminous and splendorous work was not highly regarded during his life, he was sustained in humble circumstances by his inner visions and samadhi, along with a loving wife and a few good friends and students. He died "in a most glorious manner,"[13] singing joyful hymns of the heavenly realms he beheld.

Mahatma Gandhi, the modern Indian apostle of nonviolent action and liberation, expresses many aspects of Samantabhadra. Far from being passive, Gandhi's nonviolent campaigns for social justice, freedom for all, and independence from colonial overseers demonstrated a deliberate, dignified approach to activism for benefiting the world, setting an example that has inspired and informed many other modern movements for social justice. With his focus on the power of truth, nonharmfulness, and love, Gandhi introduced into modern politics the possibility of political or social action and even revolution based on spiritual vision and values rather than material concerns. From his protests against racial inequity in South Africa to his national campaigns for Indian independence, Gandhi, always informed by his spiritual vision, used nonviolent tactics and maneuverings that dynamically exposed the nature of the oppression he was opposing. Gandhi's many specific campaigns of redress further illuminate Samantabhadra's practice of vow, as he indomitably enacted many limited, focused vows, all addressed to the ultimate context of liberation. He also personally underwent long fasts and austerities, as rigorous as the samadhi practices of Samantabhadra, for the sake of beings suffering oppression around him.

Gandhi was concerned with educating the British about the injustices they committed and also about their underlying decency, relating to them with firmness but respect. His strategy was not to vanquish his opponents, but to transform them by opening their hearts and minds. He was flexible and creative in his tactics, working with the present situation and calling off otherwise successful campaigns when they succumbed to factionalism or violence. Thus he followed Samantabhadra's criteria for

the multiplicity of activities as appropriate to bodhisattva work only when imbued with principles of compassion.

Gandhi was also adamant about the universality of his vision of freedom and dignity. His radical and unhesitant inclusion of untouchables in his community recalls Shakyamuni Buddha in Indian history. Gandhi insisted that he and his wife work side by side with untouchables to demonstrate opposition to this entrenched Indian prejudice.

Gandhi did not restrict his vision and activity to the larger political or social realms, but encouraged all to act locally within their ordinary situations. He attempted to foster a sustainable, appropriate economy by having Indians spin and wear homespun clothing, thereby incorporating the fundamental struggle for self-reliant but cooperative independence (and interdependence) into the very fabric of his people's everyday reality.

As the mother of the modern environmental movement, Rachel Carson is a prime example of Samantabhadra as environmental bodhisattva. Carson was an eminent marine biologist who poetically described the life of the ocean in *The Sea Around Us* and other best-selling books. She understood the ocean scientifically as an interconnected system, and was able to evocatively convey a vision of the mysteries and wonder of that world. She saw both science and her literary gifts as aimed at illuminating truth.

In accord with Samantabhadra's sense of action as being necessary to protect the world, Carson was not content merely to show a vision of how the ocean works, but began also to write about our responsibility to actively preserve the ocean from nuclear and other wastes. In her 1962 book *Silent Spring*, Rachel Carson was one of the first to widely warn the public of the dangers of toxic pollution from DDT and other pesticides. Carson and her book were aggressively vilified by the chemical industry, but she sparked an outcry that led to the banning of some pollutants and the beginning of some control and regulation of dangerous chemicals. Although we are still far from having gained protection from the spread and threat of poisonous waste in our environment, the awareness of the problem, which was initiated by Rachel Carson, continues to develop.

A different sort of environmental bodhisattva can be seen in folksinger Pete Seeger, who cheerfully has encouraged both global communication and environmental reclamation through his songs and music. In a long career,

ranging back to the forties, singing with Woody Guthrie, the Almanac Singers, and later the Weavers, Seeger has sung songs of hope and justice throughout the world and has helped to disseminate many grace-filled tunes and songs of freedom across cultural borders. Instrumental in the popularity of the folk music revival in the sixties, Seeger helped revive the banjo, was one of the founders of the Newport Folk Festival, and spread many now famous folk songs. A number of songs he wrote himself have endured, such as "If I Had a Hammer," "Where Have All the Flowers Gone?" and "Turn, Turn, Turn."

A friendly, unassuming presence who has been described as sweet and sparkly, Seeger has not shied away from difficulties. He confronted the House Un-American Activities Committee during the McCarthy witch-hunts of the fifties and was blacklisted for years from performances in many venues and in the mass media due to his persistent commitment to socially progressive views and efforts. Seeger has been an active advocate for the labor movement in the thirties, for free speech in the fifties, and for the civil rights and peace movements in the sixties and seventies. Through varied setbacks to efforts for social justice and openheartedness, Seeger has preserved a Samantabhadra-like inspiring vision of dedication and steadiness in fellowship with all beings. Seeger's radiant, infectious sense of hope and possibility is reflected in the ease with which he enlists audiences to sing along with him. He says of the work of activists today, "It's the job of artists and writers of all sorts to try and help people to see a thread of sense and logic through all this chaos."[14]

Seeger calls reading Carson's *Silent Spring* a turning point in his life. Since the late sixties, from his base on the Hudson River north of New York City, Seeger has sailed the sloop *Clearwater* up and down the river, singing songs, building community, and speaking out to promote clean water and ecological consciousness, demonstrating a continuation of Samantabhadra energy inspired by Rachel Carson. A prime example of the slogan "Think globally, act locally," the regional environmentalist movement Pete Seeger inspired has succeeded in its vow to clean up the Hudson River, to the point that the Hudson is no longer a "dead" river. One can now swim safely in large sections of the Hudson. The battle to stop chemical pollution continues. People on nearby waterways such as Long Island Sound have been encouraged to begin their own campaigns, continuing Rachel Carson's work against pollution of the oceans.

Jackie Robinson and his courage in integrating baseball show how Samantabhadra's work can be carried out very powerfully in a variety of social guises. The integration of baseball was an important example that radically transformed American society and made possible the later civil rights movement and Dr. King's work for racial and social justice. While probably not the most talented player overall in the Negro leagues at the time Branch Rickey chose him to integrate baseball, Jackie Robinson had Samantabhadra's qualities of fortitude, dignity, and experience, and his willingness to act, all of which were necessary for the situation. He had been a star in integrated college sports before graduating from UCLA. And Robinson had previously defied prejudice, being acquitted at a military court-martial after he had refused to move to the back of a Texas bus.

When he joined the Brooklyn Dodgers in 1947, Robinson promised their general manager, Branch Rickey, not to react to the inevitable hatred, threats, and racist virulence, even initially from his own teammates. Despite his own temper and competitive drive, Robinson remained silent and unshaken by the vicious abuse he received, fortified by his vow to integrate baseball. Robinson's dynamic, exciting play and his hitting, base running, and defensive skills led to his being named Rookie of the Year.

In 1949 Rickey finally gave Robinson permission to respond openly to the hatred and name-calling, and thereafter Robinson was a strong voice against discrimination in many arenas. Robinson's exciting presence also enlivened and transformed the game of baseball by bringing the more daring, lively style of the Negro League into the major leagues. His Dodgers, which included a number of other African American stars, were a dominant team during Robinson's ten-year career. Baseball prospered as a result and became a beacon of relative equality in the 1950s and early 1960s, when segregation was still legal and enforced in the South, where baseball teams held spring training. The African American players who followed Jackie Robinson into major league baseball for the following decade or two also had to partake of the courage of Samantabhadra.

Another baseball player who strongly embodied aspects of the Samantabhadra archetype was the enormously talented Roberto Clemente, whom I had the privilege of watching regularly while growing up in Pittsburgh. Clemente was an exceptional hitter, both for average and power, and an excellent fielder who defined outfield defense for a generation of ballplayers. A number of times Clemente used his amazing, lightninglike throwing

arm to toss out batters at first from his position in right field after they had singled and taken too wide a turn around first base. Among his victims was a dumbfounded Willie Mays.

But Clemente is considered a great hero for his charity as well as his athletic prowess. He did much to share his success as a ballplayer by setting up programs to help youth in his native Puerto Rico, without seeking fanfare or credit for his generosity.

Clemente died tragically and heroically on a 1972 New Year's Eve flight to Nicaragua to bring supplies to victims of a devastating earthquake. It would have been beneficence enough for someone in his position just to organize and finance such a relief flight. His willingness to leave his family on New Year's Eve to personally deliver help to another country and make sure it arrived in the right hands was characteristic of Samantabhadra's selfless work in the world. Poignantly, he died after finishing the previous season with his three-thousandth hit, an archetypal benchmark that defines the all-time great baseball hitters and remains Clemente's exact hit total, even in a career shortened by painful injuries as well as untimely death.

Beyond charitable works and his heroic death, Clemente most reflects Samantabhadra simply for his dynamic presence and pride in his own playing. Everything he did on the field was impressive and exciting, infused with his great vow and determination. He had the energy and bearing of a wild, but contained, stallion while waiting on deck to hit. Even when striking out, he was dramatic and full of flair. His was a constant intensity, as fiery and concentrated as any of Samantabhadra's samadhis. A few times after games I had the opportunity to witness how his dignified and energetic but friendly manner carried over off the field as well. This quality of inner dignity that aroused admiration in everyone who observed Clemente informs our sense of the Samantabhadra archetype of inspiring presence in the world. In Pittsburgh and Puerto Rico, Clemente is remembered simply as "the Great One," an apt translation of the Sanskrit epithet *mahasattva*, "great being," used customarily for bodhisattvas.

Thomas Edison with his numerous useful applications of inventions shows us another mode of Samantabhadra's archetypal activity. Edison's energetic persistence led to the invention of the phonograph, important initial developments in motion-picture projection and sound, the electric lightbulb, and the first power stations and other systems for making electric power widely available. Electric light transformed human experience, "enlightening" our

nights. With brilliance and industry on the physical, scientific plane, Edison directed his will and considerable powers of dedication to producing inventions that would be universally available and improve the quality of life. Samantabhadra likewise concerns himself with a variety of means for the material betterment of beings.

Edison established the first modern research laboratory, where he assembled talented engineers and scientists to develop applications for inventions. Although he certainly produced a number of inventions personally, Edison's brilliance and efforts involved refining ideas more than originating them. Nevertheless, Edison was a man of tremendous energy and stamina who worked tirelessly himself, and inspired those around him to maximize their own capacities. He studied diligently to help create new technologies that would find wide commercial and culturally transformative applications. Neither was he dissuaded from his commitment to new efforts at innovations by the spectacular failures that sometimes accompanied his great successes. (His failures included an attempt to develop widespread, affordable housing using concrete; a protracted program to magnetically separate iron ore; and efforts to develop low-cost rubber.)

In keeping with his famous quote, "Genius is one percent inspiration and ninety-nine percent perspiration," Edison was less a person of great insight than of indomitable persistence, reminiscent of Samantabhadra's deliberate but steady pace as contrasted to Manjushri's flashing brilliance. Edison also had a strong relationship to Samantabhadra's facility for samadhi states, as Edison possessed unusual powers of mental concentration, reportedly following numbers of trains of thought simultaneously in the process of managing the development of his new technologies.

Edison also offers us a negative example of Samantabhadra's warning never to hold on to anger at other enlightening beings. Edison demonstrated this failing dramatically and with archetypical irony, when his bitter rivalry with George Westinghouse led Edison to wage a campaign against Westinghouse's new alternating current, which competed with Edison's direct-current system. Edison arranged to have the electric chair use alternating current and initially named the "Westinghouse," in hopes of discrediting his rival. Edison opposed the newly invented electric chair as a defilement of electricity, rather than out of any principled opposition to capital punishment. Edison's rancor became a serious obstacle to him, at least for a while, as alternating current prevailed. Fortunately, Edison moved on to other areas to again develop constructive inventions.

Vincent van Gogh illuminated the world not with electricity but with paintings that capture a radiant vision of nature. The vibrancy of his landscapes and all their elements—cypresses, sunflowers, wheat fields, irises, farm huts, orchards, and sky—clearly reflect a samadhi-like intensity of perception imbued with Samantabhadra's sense of the interconnectedness of all things. It is remarkable simply that van Gogh could see this way, but even more marvelous that he was able to develop the skill to share his vision with us. Van Gogh included the paint in his jeweled landscape vision and illuminated every feature of the landscapes with a rich, thick texture of paint so that the whole scene and the brushstrokes themselves seem to glow. His paintings are offerings to awakening beings and vision.

We know from van Gogh's touching, philosophical letters to his brother that he had deep spiritual sensitivity and concern for the suffering of his fellow humans. His sympathetic portraits of the Dutch "potato eaters" and other working-class people expressed this concern. The young van Gogh considered following his father in the ministry, and he remained an ardent reader of the Bible. Later he came to think of himself as both a monk and a painter. Through his interest in Japanese painting, van Gogh came to have some awareness of Buddhism. He sent his friend Gauguin a self-portrait, depicting himself as an ascetic with close-cropped hair and a shimmering green aura. Van Gogh described this likeness of himself as "a simple monk worshipping the Eternal Buddha,"[15] which we might read as a reference to Vairochana Buddha, the buddha most closely associated with Samantabhadra.

In his solitary lifestyle, his renunciation of physical comforts out of dedication to his practice of painting, and his communion with nature while out painting landscapes, Vincent certainly experienced extraordinary samadhi-like bliss states and wondrous visions of totality, along with his human loneliness. Despite his own inner turmoil and doubts, van Gogh was able to produce paintings that continue to call to a wide audience with a vision of the world as alive, radiant, and precious in every detail.

Mayumi Oda is a Japanese artist who has lived most of her adult life in California. A prolific painter, she is a longtime Zen and Tibetan Buddhist practitioner. Her works have been displayed in museums and exhibitions worldwide. She paints bright-hued visions of everyday life, for example vegetables or flowers growing in the garden. But she is probably best known for her playful and colorful paintings of buxom, seminude goddesses in various contemporary and everyday settings, including a number of paintings of

some of our bodhisattvas as goddesses. Paintings by Mayumi of Manjushri, Samantabhadra, Avalokiteshvara, Jizo, and Maitreya are featured among the pictures in each of those chapters of this book.

When she visited Japan in 1991, Mayumi learned about her country's reckless nuclear-energy program featuring the reprocessing, global transport, and production of plutonium. The Japanese plutonium program included the new fast-breeder reactor grotesquely misnamed Monju after Manjushri, as well as another nuclear reactor nearby named Fugen, or Samantabhadra. The fastbreeder technologies have been abandoned by most other countries as too dangerous, but Japanese policymakers imagine that plutonium can fulfill their energy needs. Mayumi was aghast when she learned about this from a Japanese environmentalist friend.

Mayumi visited a shrine in Japan dedicated to the goddess of the arts, Sarasvati, called Benzai Ten in Japanese, and asked what she could do. Meditating on the next New Year's Day, Mayumi heard a voice saying, "Stop the plutonium" and "Help will be provided on the way." Knowing that the Japanese authorities are more susceptible to pressure from overseas, Mayumi and some friends in California founded Plutonium Free Future, dedicated to opposing the Japanese plutonium policy and to global abolition of all uses of plutonium.

Like Samantabhadra, Mayumi has applied her artistic vision to necessary activism in the world. And help has appeared, from scientists as well as from other artists. She has used sales of her art to support Plutonium Free Future, which helped publicize the first shipment of reprocessed plutonium from France to Japan at the end of 1992. Global demonstrations resulted, forcing the Japanese to seriously reconsider their policies. Due to a significant "accident," the Monju plant was at least temporarily shut down. But Japan's perilous nuclear programs have continued, with attempts to use their plutonium stockpile. Mayumi energetically continues with both her art and her antinuclear work. As she is interested in supporting visions of positive alternatives, Mayumi has also been active in promoting use of safer renewable energy sources such as solar, both in Japan and worldwide.

There are so many readily apparent Samantabhadra exemplars that it is hard to refrain from citing more. The variety of all of these different exemplars of Samantabhadra, acting beneficially and supporting awakening in the world, allow us a glimpse of the full range and splendor of Samantabhadra himself.

7
Avalokiteshvara (Guanyin, Kannon)
Heart of Compassion

AVALOKITESHVARA, the bodhisattva of compassion, is the most popular of all bodhisattvas. Avalokiteshvara is named Chenrezig in Tibet, the "Goddess of Mercy" Guanyin in China, Quan Am in Vietnam, Kwanseum in Korea, and Kannon, Kanzeon, or Kanjizai in Japan. (I will use these names interchangeably with Avalokiteshvara, except when the implications of a particular rendition are being considered.) The Sanskrit name can be translated as "Gazing Lord" or "Lord of What Is Seen." Another interpretation, more common in East Asia, could be translated as "Regarder of the Cries of the World" and "Perceiver of Sounds," which are the meanings represented by Guanyin, Kanzeon, and Kannon. We will explore these etymologies and their significance as teachings about compassion in this chapter.

Avalokiteshvara assumes so many different forms, has so many different closely associated figures, and takes on such varied coloration in new cultures, that we might understand this complex bodhisattva as a whole assemblage of archetypes of spiritual life. This bodhisattva may appear as female, male, or androgynous. Several complete books have been written just about Avalokiteshvara in one or another of her forms. Nevertheless, I will explore somewhat more briefly the range of primary aspects of Avalokiteshvara to see how we might use this archetypal model to find compassion in our own lives. All the various forms of Avalokiteshvara are emblematic of compassion (*karuna* in Sanskrit). They express the gentle, responsive, empathetic, or helpful qualities of compassion.

THE COMPLEX ICONOGRAPHY OF AVALOKITESHVARA

Iconographically, Avalokiteshvara is protean, fluid. Sometimes male, some-
times female, Avalokiteshvara appears in more diverse forms or personae
than any other bodhisattva. Accordingly, we may appropriately refer to
Avalokiteshvara as either her or him. The colorful variety of Avalokitesh-
vara's forms is itself part of her message of compassion, as compassion
takes on any form that might be beneficial to beings. Each of these forms
may also show us another aspect of the compassionate character of Avalo-
kiteshvara.

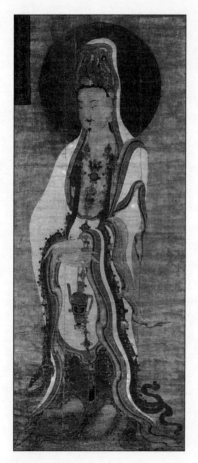

Kwanseum, Korea,
17th century

There are six or seven primary forms of the Avalokiteshvara figure. The
original form of the bodhisattva was designated later (after the other forms

emerged) as Sacred or Honorable Avalokiteshvara (Arya Avalokiteshvara in Sanskrit, Sho Kannon in Japanese). Elegant and simpler than other manifestations, with a single face and two hands, Sho Kannon holds a lotus or a vase in one hand, while the other hand is held out in the mudra, or gesture, for allaying fear or for offering. This Sacred Avalokiteshvara Bodhisattva dates at least as far back as the *Lotus Sutra*, which was first committed to writing in the first century C.E., and early conceptions of Avalokiteshvara date back to the third century B.C.E. The Sacred Avalokiteshvara might be identified with the lotus-bearer form discussed below among the thirty-three manifestations of Guanyin.

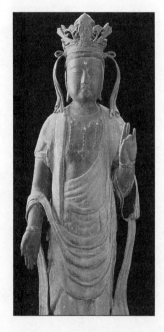

Kannon, Japan

Scholarly speculations on the origins of Avalokiteshvara as a Mahayana bodhisattva range from suggestions of Persian antecedents to the theory that Avalokiteshvara was a personification of Shakyamuni's compassionate gaze. Some forms of Avalokiteshvara are thought to be derived from forms of the Indian deity Shiva. Other scholarly speculation attributes her historical origin to ancient sun-worship cults.

The second form is Eleven-Faced Avalokiteshvara (Ekadashamukha in Sanskrit, Juichimen Kannon in Japanese). In sculptures the eleven faces are

depicted set like a crown of smaller heads above the figure's main head. Sometimes the main head is counted as one of the eleven; sometimes there are eleven others. The most common configuration of the eleven heads counts the main head and includes three small faces to the front, three to the left, and three to the right. The three faces in front are usually smiling kindly, the three to the figure's left (as we face it) are wrathful and scowling, directed at those beings who require stern guidance to awaken, and the three to the right have fangs to strongly protect the faithful. A head of Amitabha Buddha, set above the others, is considered the eleventh face.

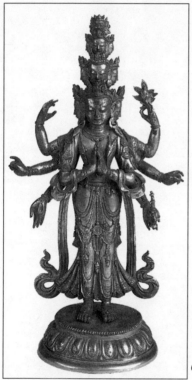

Chenrezig, Tibet, 18th century

These eleven heads sometimes appear on other manifestations of Avalokiteshvara, especially on the thousand-armed Avalokiteshvara. A variation on the head arrangement appears for Chenrezig, the common Tibetan form of Avalokiteshvara. In addition to a varying number of arms, Chenrezig

features the eleven heads towering in three tiers of three heads (in slightly decreasing size as they ascend), topped by a wrathful head, and above that, Amitabha Buddha's head.

Figures of Amitabha (Amida in Japanese) are characteristically either sitting or standing in the headdress of many of the different forms of Avalokiteshvara, and sometimes over each of the ten other faces of Juichimen Kannon. Avalokiteshvara is considered an emanation of Amitabha, said to have sprung full-blown from Amitabha's head. Mindful remembrance of Amida Buddha through the chanting of his name is probably the most prevalent form of Buddhism in modern East Asia, and Avalokiteshvara has a central role in this tradition's sutras and devotional practice. Avalokiteshvara often appears at Amitabha's side as his attendant, as he does the liberative work of Amitabha Buddha in the world and helps lead beings to Amitabha's Pure Land.

Various symbolic meanings are attributed to the eleven heads. For example, they may represent the ten stages of bodhisattva development, expounded in the *Flower Ornament Sutra*, with the final stage of buddhahood crowning them. But the preeminent story about the Eleven-Faced Avalokiteshvara describes how the bodhisattva saved all the many suffering beings from out of the samsaric realms of birth and death. As she was carrying them into the Pure Land of liberation she looked back and beheld all the spaces in samsara being filled again by new beings, and her head split apart in grief. After this happened ten times, Amitabha provided a new head. With the aid of a final buddha's head, Avalokiteshvara was able to continue and sustain her liberative work. Another version is that Avalokiteshvara's head split into ten pieces simultaneously, each of which Amitabha restored to completion, adding his own head.

This story of Eleven-Faced Kannon reveals important aspects of bodhisattvic compassion. The eleven heads allow different mental perspectives, visual viewpoints, and varying attitudes with which to skillfully offer compassion to the vast diversity of creatures. But most powerful is the image of Avalokiteshvara's head-sundering grief at the sight of suffering beings. Although with eleven heads he may contain this grief, the power and sincerity of his caring for the suffering of beings is the starting point of this compassion.

The third form, Thousand-Armed Avalokiteshvara (Sahasrabhuja in Sanskrit, Senju Kannon in Japanese), is perhaps the most renowned an metaphorically pregnant representation of Avalokiteshvara. This figure's

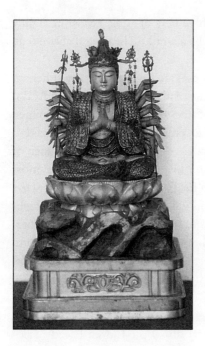

Multi-armed Kannon,
Japan, circa 12th century

thousand arms are sometimes depicted symbolically, with twenty arms on each side, each of the forty representing arms functioning in twenty-five realms. But many paintings and statues actually include one thousand arms, flowing like a nimbus fanning out on either side of the torso. In addition to the hands outstretched at his sides, one pair of hands usually is joined palm to palm at chest height in the gesture of respect (*gassho* in Japanese). Another pair of hands is often held together low at the abdomen, palms up in the meditation gesture or sometimes holding a medicine or begging bowl. In Japan one can still see large, magnificent examples of such statues, some seated, some standing. Each of these thousand hands has an eye in its palm, so Senju Kannon has a thousand eyes as well as hands.

Many of the hands hold tools and implements, including dharma wheels, lotuses, buddhas, jewels embodying the sun and moon, as well as ropes, axes, swords, mirrors, rosaries, vases, conches, books, willow branches, bows, and arrows. These thousand hands and eyes represent Avalokiteshvara's practice of skillful means, compassionately assisting beings by whatever methods would be effective, using whatever comes to hand as a tool. Some implications of the thousand arms and their implements, which may

also be held by others of the manifestations of Avalokiteshvara, will be discussed further below.

The fourth form is Horse-Headed Avalokiteshvara (Hayagriva in Sanskrit, Bato Kannon in Japanese), who appears as a fierce, wrathful figure, usually with a horse head depicted in his headdress, and with three faces and six or eight arms. In this manifestation Avalokiteshvara expresses compassion with an angry, terrifying visage for whoever needs such incitement to awaken or be helped.

Many dynamic protective figures, often ferocious and powerful, appear around Buddhist temples, often paired on either side of the main gate, or guarding other passageways or the buddhas and bodhisattvas. When touring the vivid Japanese Buddhist sculptures in the ancient temples in Nara and Kyoto, I was stunned by the fierce guardian and protector figures. After the impressive impact of that opening, I could begin to deeply appreciate the more sublime and serene disciple, bodhisattva, and buddha figures.

Most of the wrathful guardian figures have been adopted from native spirits and deities in the different Asian cultures where the Buddhist teachings have spread. Converted to the spiritual practice of awakening, they now serve as protectors and guardians of practitioners. But they also help the bodhisattvas in their liberative work striking through the selfish grasping, petty dislikes, and clouds of confusion of those who might thereafter be awakened to their own spiritual intention and path. Aside from Horse-Headed Avalokiteshvara, the bodhisattva archetypal figures examined in this book do not generally manifest in wrathful aspects in East Asian iconography. However, as an exception within the elaborate Tibetan Buddhist pantheon (along with the wrathful Yamantaka form of Manjushri described in the chapter on that bodhisattva), Avalokiteshvara manifests as the wrathful protector Mahakala. Mahakala, a fierce, large black figure with an enormous head, is covered with grisly ornaments including skulls and serpents showing his determination to redeem even the most incorrigible, and treads underfoot all horrific, negative impediments to enlightenment.

The specialized Tibetan iconography aside, Horse-Headed Avalokiteshvara is only one of the many wrathful guardian images in Mahayana Buddhism, but is perhaps the one most closely associated with the major bodhisattvas. Horse-Headed Avalokiteshvara generally imparts his own fearlessness to others. He is naturally considered a protector of animals, signified by his horse-head crest. Although as humans we may be most

concerned about the spiritual development of people, the bodhisattva's compassion encompasses all beings, including animals.

Probably a formal manifestation developed later than many of the others, the first recorded mention of Horse-Headed Avalokiteshvara as an object of devotion is in the early eighth-century translation of the *Mahavairochana Sutra* into Chinese. He may have derived in part from a similar Indian deity associated with Vishnu.

The fifth form is Avalokiteshvara Turning the Wish-Fulfilling Gem (called Chintamani Chakra Avalokiteshvara in Sanskrit, Nyoirin Kannon in Japanese). This manifestation of the bodhisattva usually perches on a lotus blossom pedestal. He sits informally in the posture of royal ease, often with his right knee raised and foot flat on the pedestal. One arm rests on the knee with the hand resting against his cheek, in introspective contemplation. Nyoirin Kannon often has six arms, although the number varies from two to twelve. A left arm (when there are more than two) rests in balance flat against his pedestal. One of the hands holds a wish-fulfilling gem, with which this bodhisattva can grant the wish of any being. Forms of Nyoirin Kannon, or others in similar posture, sometimes sit on a rocky base or in a cave grotto, perhaps gazing into a pool.

Part of the compassionate work of a bodhisattva is simply to give beings what they want. The frustration of basic material needs often blocks the deeper work of liberation, the bodhisattva's ultimate concern. Starving beings usually cannot attend to spiritual matters. The bodhisattva of compassion may also grant someone's wish as a means of cultivating that being's affinity with the practice of awakening. To be granted one's wish provides the experience of generosity, which can be contagious, encouraging caring for others and the loss of self-centered concerns. This manifestation of Avalokiteshvara, granting beings their desires with his magical jewel, also conveys a sense of kindness and relief with his relaxed, though dignified, bearing.

The Mahayana sutras frequently encourage their listeners to perform worthy and wholesome practices because of the great merit and benefits to be accrued. The extent of such benefit, material as well as spiritual, is spoken of in terms of astronomical, mind-boggling quantities and images, such as the number of grains of sand in as many Ganges Rivers as there are grains of sand in one of those Ganges Rivers. Embedded in such cosmic images of vast fortune and blessings are occasional glimpses of the emptiness and

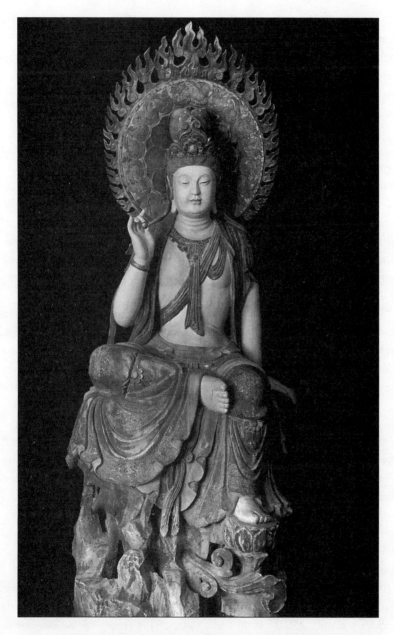

Nyoirin Kannon, "Turning the Wish-Fulfilling Gem," Japan

illusoriness of all notions of gain and benefit. And yet, the bodhisattva does not flinch from responding to the simple needs of beings in ways that will help gradually lead those benefited to their own awakening practice, beyond any fears of the truths of emptiness and universal interconnectedness. Such simple satisfaction of desires is particularly the kind of practice of Avalokiteshvara with Wish-Fulfilling Gem.

The sixth form is Chunda Avalokiteshvara in Sanskrit or Juntei Kannon in Japanese. *Juntei* means roughly, "carry or handle appropriately." Chunda Avalokiteshvara is specifically female, one-faced with three eyes and as many as eighteen arms. Dating back at least to the second century C.E., Chunda first appeared independently as an embodiment of one of a series of early dharanis. Chunda's blessing-bestowing mantra is *Om chale chule chunde svaha*. She remains an independent figure in South and Southeast Asia, where she is not associated with Avalokiteshvara but is considered an emanation of Vairochana Buddha.

Chunda Avalokiteshvara is primarily known as the mother of buddhas, and is thereby associated with the bodhisattva goddess of wisdom, Prajnaparamita, also thought of as mother of buddhas. The manifestation as Chunda points to the maternal aspect of Avalokiteshvara, and may perhaps be the source of the Chinese feminization of Avalokiteshvara as Guanyin. In China, as Guanyin, Avalokiteshvara is almost always female, while in other cultures Avalokiteshvara may be either male or female, with Chunda always representing the bodhisattva's feminine and maternal qualities. As Avalokiteshvara sees all beings with compassion, and as potential buddhas, Chunda Avalokiteshvara sees all beings as her own children to be nurtured and protected.

These six manifestations often are presented as a complete set, but they are sometimes joined by a seventh form, Unfailing Rope or Lasso Avalokiteshvara (Amoghapasha in Sanskrit, Fukukenjaku Kannon in Japanese). His face is sometimes painted red, and he usually has six or eight arms, one hand holding a rope or noose, others holding other implements that may include a lotus, a monk's staff, and a rosary. This aspect of Avalokiteshvara embodies the unfailing power of the bodhisattva, capable of saving even the most difficult, incorrigible creatures steeped in resistance to wholesomeness. Using his rope as an implement, Fukukenjaku Kannon captures and tethers beings until he can bring them to the other shore of liberation. In

some tantric texts he is said to liberate beings especially upon their deaths, delivering them to auspicious buddha fields. By the ninth century Amogha-pasha had received a large, independent, devotional following in northeast India. This cultic interest spread as far as Japan, and Java in Indonesia, where the Mahayana was then the dominant religion.

Kitchen Kannon

THE IMPLEMENTS OF SKILLFUL MEANS

A number of specific implements are traditionally considered attributes of Avalokiteshvara. These are carried in the hands of Thousand-Armed Avalo-kiteshvara, and sometimes by other forms of the bodhisattva. The function of the rope and the wish-fulfilling jewel have already been described. Dharma wheels indicate the dissemination of liberative teaching. The vase contains water bestowing love and virtue, or sometimes a nectar granting immortality. The willow branch drives away sickness. The ax gives protection against oppressive authorities. The mirror signifies prajna, or wisdom. The rosary is used to call upon the buddhas to give succor, or to welcome one into the Pure Land. The conch summons heavenly and beneficent spirits. A palatial pavilion signifies abiding in the dwellings of buddhas

throughout lifetimes. White lotuses indicate attainment of merit; blue lotuses rebirth in a Pure Land; red lotuses rebirth in heavenly realms; purple lotuses the beholding of bodhisattvas. Other traditional attributes include hooks, monks' staffs, sutra books, vajras (small "adamantine" three- or five-pronged scepters), vajra bells, clubs, daggers, clouds, bowls of fruit or jewels, bows and arrows, and sun or moon disks.

All of these traditional implements and their functions have been expounded in traditional texts such as the *Sutra on the Great Compassionate Heart Dharani* (see below). Some of these instruments have their own mantras and visualization exercises, and are venerated in their own right. But the range of Avalokiteshvara's attributes indicates the more practical principle of the compassionate use of whatever everyday implement comes to hand for the benefit of beings.

As Avalokiteshvara/Kanzeon/Chenrezig takes her role in Western Mahayana practice, we are sure to see new, updated implements of bodhisattva work in her hands. In the Zen tradition the position of head cook, who must mindfully attend to all of the complex affairs of the community's kitchen, is considered especially important. Therefore particularly appropriate is Mayumi Oda's modern picture of Avalokiteshvara as a cook, wearing a chef's hat with an image of Amida Buddha on it, in her many hands holding such objects as a frying pan, a spatula, a whisk, a serving fork, and a lemon. As Western culture gradually adapts to bodhisattva iconography, will we perhaps see Thousand-Armed Avalokiteshvara holding electric lightbulbs, video cameras, cell phones, guitars, stethoscopes, basketballs, compact discs, microscopes, skate boards, laptop computers, palm pilots, and DVDs?

THE LOTUS SUTRA KANZEON CHAPTER

Avalokiteshvara is especially associated with the *Lotus Sutra*. In the most commonly known Chinese version, translated from Sanskrit by the great Central Asian translator Kumarajiva in 406, the twenty-fifth chapter of the sutra is called "The Universal Gateway of the Bodhisattva Regarder of the Sounds of the World." This chapter about Avalokiteshvara is often considered a separate short sutra.

The *Lotus Sutra* particularly emphasizes the beneficial practice of skillful means, and Avalokiteshvara/Kanzeon is the premier embodiment of this compassionate activity. According to his chapter of the sutra, Kanzeon answers the calls of all in need, and appears in whatever form will be help-

ful to beings in a particular situation. In the sutra, Shakyamuni Buddha promises that if you simply call out her name, wherever you are, Kanzeon, Regarder of the Sounds of the World, will come to you. When surrounded by fire, when about to be swept away in a torrential river, when about to be murdered, when bound in prison, if you just call out and mindfully evoke the name of Regarder of the Sounds of the World, you will be delivered from danger. This compassion and salvation is for everyone and is not limited to the virtuous or worthy. The sutra specifies that prisoners who call Kanzeon's name will be freed from their chains, with no mention as to whether or not they are guilty. This compassion includes all classes. One sutra passage speaks of a caravan of merchants laden with jewels or cash on a treacherous road in a district full of violent bandits. If just one of the group remembers the name of the bodhisattva and encourages them to call it out, they will all be protected.

We might understand this promise by reflecting that to call upon the spirit of compassion and patient awareness in the midst of danger could easily be calming and induce one to activate one's own awareness of compassion, with beneficial results. Thus the devotional act may give rise to transformative cultivation practice. But there is the unmistakable sense, both in this sutra about Avalokiteshvara and in the way it has been regarded and treasured through much of East Asia for sixteen hundred years, that this bodhisattva also exists as an "external" force or presence. In some manner she offers her mysterious guidance and protection to those with faith.

The sutra continues by saying that for those who are lustful, or who are enraged with anger, or who are confused with foolishness, if they simply mindfully evoke the name of the Regarder of the World's Cries, then they will be freed from these afflictions. If a woman seeking to bear children gives offerings and respect to Kanzeon, she will have a son if she prefers, one who will be virtuous and wise. Or if the mother wishes to have a daughter it will be so, with a daughter gracious and virtuous, who will be loved and respected. This promise has helped make Avalokiteshvara/Guanyin/Kanzeon particularly popular and beloved over the centuries by women.

The concluding verse summary of the *Kanzeon Sutra* chapter of the *Lotus Sutra* is still chanted daily in Chinese and Japanese Zen temples. It reiterates that when faced with danger, simply by constant mindfulness of Kanzeon's power and virtue, one will be saved from fire, from drowning in the ocean, from violent attackers or predatory or poisonous animals, from imprisonment, execution, or other terrors.

This verse chanted daily in Asian temples has yet to be adopted into the liturgy of most Western Buddhist centers. Many Westerners who came to Buddhist practice in the sixties and seventies wanted some pure meditation technique, or therapeutic practice, and may feel that to call on the bodhisattva of compassion sounds too much like Judeo-Christian prayer. Calling out the name of some mythical bodhisattva may seem superstitious or primitive to "sophisticated" Westerners.

One traditional tendency of Buddhist practitioners, especially notable among some Zen people, is to rely on one's own ability at performing spiritual exercises. But Japanese Pure Land devotees, who venerate Kanzeon as an attendant of Amida Buddha, believe that it is impossible for anyone except perhaps the most exceptional to acquire significant spiritual achievement by relying solely on her own strength, intellect, or yogic prowess. Moreover, even gifted adepts may simultaneously exert themselves in meditation, and trust and rely humbly in the kindness and power of Kanzeon Bodhisattva, or more generally in the spirit of bodhisattva awareness.

One practice period that I attended at Tassajara, a monastery in the remote Monterey mountains in California patterned in many ways on Japanese Soto Zen monastic practice, was also attended by a Japanese monk who had trained extensively and held important positions at Eiheiji, the strict Japanese Soto Zen headquarters monastery. Near the end of the three-month intensive practice period, I asked him what he missed most at Tassajara from Eiheiji. He might have mentioned the monks sleeping all night in the meditation hall rather than in separate cabins, the more formal eating practice, the Japanese language (English was very difficult for him), the intensity and rigor of the Japanese monks' meditation practice, or any of a number of chants and ceremonies that we omit. But he immediately responded that the one thing he most missed was daily chanting of this portion of the *Lotus Sutra* about devotion to Kanzeon and the bodhisattva's saving powers.

In this teaching from the *Lotus Sutra*, Avalokiteshvara hears the cries of suffering beings in need and simply responds unconditionally. There is something warm and comforting in hearing about this, and in chanting it regularly. The last lines of the closing verse, "Eyes of compassion, observing sentient beings, assemble an immeasurable ocean of blessings,"[1] have been cherished as a practical Mahayana motto. This points to the activity of unconditional acceptance and compassion. To see each being, from insect

to human, whether family or "foe," from a viewpoint of care and sympathy is highly recommended and auspicious.

Because of his association with the *Lotus Sutra*, Avalokiteshvara is associated doctrinally with the important Tiantai (in Japanese, Tendai) School, the Chinese scholastic school of Buddhism that systematically incorporated all of the major Indian Buddhist teachings as skillful means. Of course, Avalokiteshvara is venerated by all Mahayana schools, and especially in Japan by the Zen, Pure Land, and Nichiren Schools, which developed out of the Tendai School.

THE THIRTY-THREE MANIFESTATIONS
OF AVALOKITESHVARA

If the seven forms of Avalokiteshvara previously described were not elaborate enough, there have also been systems of 8, 15, 25, 28, 32, 33, 38, 40, and 108 manifestations of Avalokiteshvara, all expressing the limitless nature and range of the bodhisattva's compassion. The various arrangements of manifestations do overlap, but they coexist happily even in their differences. In seemingly endless elaboration, the forms in each of these systems often include numerous, sometimes subtle, variations or subforms.

One of the primary iconographic systems in East Asia depicts thirty-three different forms of Avalokiteshvara, developed from an enumeration in the *Lotus Sutra* of thirty-three manifestations, including beings from supernatural realms and varying by social position and spiritual power in accord with the spiritual needs of beings encountered. Although the identifications among the thirty-three manifestations have changed and evolved in different eras, most East Asian systems have been arranged around that number. The following are brief descriptions of a number of the more intriguing of the thirty-three aspects of Guanyin in the most prominent system as it evolved in China.

White-Robed Guanyin is seated upon a white lotus and also holds a white lotus, symbolizing purity. Perhaps derived from Arya or Chunda Avalokiteshvara, White-Robed Guanyin became especially popular beginning in the tenth or eleventh century as the predominant, female form of Guanyin in China. Her image in white porcelain wearing a long, flowing robe is familiar from Chinese restaurants and remains ubiquitous in Chinese temples and homes, representing the feminine, maternal nature of Avalokiteshvara's

compassion. While Avalokiteshvara reflects female as well as male aspects in all Buddhist cultures, in China she is predominantly feminine (as White-Robed Guanyin, and also in most of the other Guanyin forms). The feminization of Guanyin in China probably reflects native Chinese spiritual sensibilities. The majority of native Chinese deities are female, and Taoist and Confucian principles associate serving and benefiting others with yin, female, or maternal virtues.

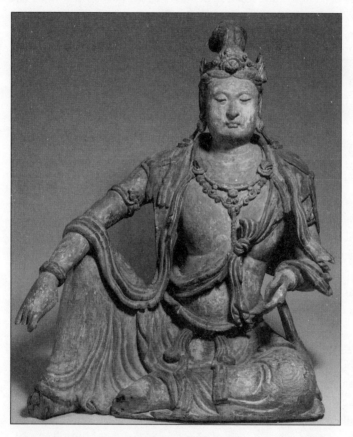

Guanyin in royal-ease pose, China, 12th century

In another manifestation, Guanyin Holding a Willow Branch vows to cure illness. Interestingly, modern pharmacologists have discovered an aspirin-like compound in willow bark. Dragon-Head Guanyin rides on a dragon, a symbol of enlightenment in Asia. One–Leaf Guanyin sits on a

single leaf floating on the waters, meditating and protecting those who fall into the ocean depths. Moon-Water Guanyin, who meditates by gazing at the reflection of the moon in water, and Rock-Cave Guanyin, who sits in a cave to protect beings from the poisonous snakes who live there, both have some resemblance in posture and bearing to Wish-Fulfilling Gem Avalokiteshvara, one of the seven major manifestations described above, and may perhaps be derivative forms.

Fish-Basket Guanyin is based on Lingzhao, the daughter of the famed eighth-century Chan adept Layman Pang who was a great practitioner in her own right, and who made her living selling bamboo baskets. Calming Guanyin protects sailors by calming seas and saving the shipwrecked. Leaf-Robed Guanyin offers protection from pestilence, insects, and illness, and grants longevity. Pure-Water Guanyin carries a water vase in her left hand to symbolize purification. Lotus-Holding Guanyin, carrying a lotus to symbolize bodhisattva vow, is one of the earliest forms of Avalokiteshvara (referred to by some modern scholars starting in the nineteenth century as Padmapani Bodhisattva), sometimes identified with the first of the seven major forms, Arya Avalokiteshvara.

Extending-Life Guanyin and her gift of longevity are honored with a short ten-line *Sutra for Protecting Life* (*Enmei Jukku Kannon Kyo* in Japanese) still chanted daily in Zen temples. It invokes and evokes causal affinity with buddha, dharma, and sangha, and the chanters' mindfulness of Kanzeon Bodhisattva throughout the day from morning to evening. This sutra concludes by saying that such mindfulness comes forth with, and is not separate from, the universal buddha mind. Its text, almost as emblematic of compassion in East Asia as is Avalokiteshvara's mantra *Om mani padme hum* in Tibet, is chanted in Sino-Japanese:

Kanzeon / Namu Butsu, / Yo Butsu U In, / Yo Butsu U En, /
Bu Po So En, / Jo Raku Ga Jo, / Cho Nen Kanzeon, / Bo Nen
Kanzeon, / Nen Nen Ju Shin Ki, / Nen Nen Fu Ri Shin.

Blue-Necked Guanyin is venerated in Avalokiteshvara's "Great Heart of Compassion Dharani" (*Daihi Shin Darani* in Japanese), still chanted daily in Zen temples. This figure is thought to be modeled after a legendary form of the Indian deity Shiva, who saved the world by swallowing the poison from the Lord of Serpents. The poison remained in Shiva's throat, producing a blue spot on his white throat.

Guanyin Called the Wife of Malang is based on the story of a beautiful young woman in China in 817. Besieged by suitors, she announced that she would marry whoever could memorize the Guanyin chapter of the *Lotus Sutra* in one night. When twenty suitors fulfilled this requirement, she asked that they learn the *Diamond Sutra* overnight. Ten remained, and she said she would marry the one who memorized the entire *Lotus Sutra* within three days. Only a young man named Malang succeeded in this feat. Just as the marriage ceremony was about to begin, the young woman collapsed and died. Shortly after the funeral an old priest appeared and had the grave opened, revealing only golden pieces of bone. After explaining that she had been a manifestation of Guanyin helping lead people to salvation, the priest vanished. Modern Western practitioners might well wonder why she could not have somehow continued her work after marriage. At any rate, the Chinese accounts record that the populace of that region became devoted to Guanyin thereafter.

Others of the thirty-three manifestations include Guanyin Holding a Sutra, Guanyin of Complete Light, Guanyin Viewing Waterfalls, Nonduality Guanyin, Fearless Guanyin, Guanyin of Oneness, and Clam Guanyin. The latter is based on events in Tang-dynasty China when an emperor (who reigned from 827 to 841) was unable to open a clam. After the emperor burned incense and prayed, the clam took human form, which a monk explained as a manifestation of Guanyin.

Of the many other forms of Guanyin not included in these thirty-three, also noteworthy and highly venerated is Child-Providing Guanyin, who gives pregnant women offspring of the desired gender (usually male in patriarchal China), based on the promise in the *Lotus Sutra* Avalokiteshvara chapter. She is called Koyasu Kannon in Japanese, *Koyasu* meaning "easy deliverance," as she is also believed to bestow that blessing on mothers. This Guanyin often holds a child and is sometimes accompanied by a dove. She is believed to derive originally from the Indian goddess Hariti, a mythological ogress and cannibal who devoured many children before being converted by Shakyamuni into a protectress of children and of the Dharma.

HEARING THE CRIES

One meaning of Avalokiteshvara's name is "Regarder of the World's Cries or Sounds," indicated in the Japanese name Kanzeon. A shortened form of this is Kannon (or the Chinese Guanyin), "Hearing or Regarding Sounds."

Avalokiteshvara is the one who calmly hears and considers all of the world's sounds of woe. This name implies that empathy and active listening are primary practices of compassion. Just to be present, to remain upright and aware in the face of suffering without needing to react reflexively, is compassion. Kanzeon acknowledges beings and their cries, and responds when appropriate or when it would be useful. Often, when we are troubled, what we most yearn for is this acceptance, to be heard and have our pain recognized. Such attentive presence may be more the essence of compassion than our attempts to problem-solve, to manipulate the world or our psyches in order to "fix" difficult situations.

This careful observation of the words and cries is the compassionate practice of counselors and therapists, empathetically giving their presence and paying attention to the conflicts and confusion of others. Considering all the many manifestations encompassed by Avalokiteshvara, however, we might also remember to carefully regard our own cries, the suffering of all the beings included within us. We cannot offer compassion to others if we cannot be compassionate, accepting, and forgiving of ourselves. We can hear and acknowledge our own feelings of fear, frustration, and anger with calm uprightness, rather than needing to react externally and act them out inappropriately.

Avalokiteshvara uses implements effectively as needed and responds with awareness and skill, but she also has a strong receptive component. We might see Avalokiteshvara as less an activist than Samantabhadra. Thinking of the majestic stately pace of his elephant, we can see Samantabhadra as deliberate, imbued with intention, using his knowledge to systematically change the conditions of the world when it would be beneficial. Avalokiteshvara is instead responsive without deliberation, simply meeting the immediate cries and needs of beings as they appear before her.

REACHING BACK AT MIDNIGHT

A number of old Zen teaching stories or koans relate dialogues between two Chinese monks from the ninth century, Daowu and Yunyan (Dogo and Ungan in Japanese), biological brothers who both became noted masters. In one story, recorded in *The Book of Serenity* (case 54) and in *The Blue Cliff Record* (case 89), the younger brother Yunyan asks what the bodhisattva of compassion does with so many hands and eyes, referring to the Thousand-Armed Avalokiteshvara. Daowu replies that it is "like reaching back for your

pillow in the middle of the night." Yunyan immediately understands and says that "all over the body is hands and eyes."[2] Daowu responds that "all over" is very good, but only expresses 80 percent. Then Daowu says, "Throughout the body" are hands and eyes.

This story shows us how Avalokiteshvara responds, how she functions in and beyond the empathetic, active listening of hearing the world's cries. The activity of compassion, the thousand hands and eyes, are likened to reaching back for your pillow in the middle of the night. This is a marvelous image for the natural, unpremeditated, uncalculating function of Avalokiteshvara. Even while sleeping, each hand has an eye in it. The hand feels for and sees its pillow. *The Book of Serenity* commentary says, "When reaching for a pillow at night, there's an eye in the hand; when eating there's an eye on the tongue, when recognizing people on hearing them speak there's an eye in the ears."[3] The thousand hands, endowed with their own awareness, open and receptive to the cries of the world and to shortages of pillows, see what to do with what is at hand. This is the faith and the wondrous activity of the Bodhisattva Kanzeon, Observant of the Sounds of the World.

The thirteenth-century Zen master Dogen in his commentary on this koan avers that "All over the body" and "Throughout the body" are both right, both complete. This is the wholehearted, fulfilled body of compassion. This body is not merely the physical being of a solitary bodhisattva, with eyes all over or throughout his hands, tongues, and ears. The koan commentary points out that the thousand arms of Avalokiteshvara are said only to symbolize eighty-four thousand arms. But the number of arms is incalculable, and manifold. In a deeper sense, hands and eyes are themselves the body (throughout and all over the body) of the cosmic buddha, the body of all material and all bodies. The entire universe is not other than Avalokiteshvara's myriad arms and eyes, reaching back for the comfort of their pillow to bestow compassion by sharing their pillow with all beings in loving embrace.

Even in the darkness of the unknown, groggy with sleep, the hand feels back to adjust the pillow. Zen symbolism often refers to the Mahayana dialectics of emptiness and form, and universal and particular, elaborated in the Huayan or *Flower Ornament Sutra* philosophy. In this symbolism, darkness is not only a matter of night or day, but represents the state of absolute totality and unification. Light may represent the world of assessments and differentiations, the endless distinct phenomena. The thousand hands reach

out from the emptiness of absolute unity, feeling around for pillows in the world of particular beings. We might see the pillows simply as comforters for all the suffering beings, to cushion the blows of the mundane world.

Another master quoted in *The Book of Serenity* commentary says, "'A thousand hands' illustrates the many-sidedness of guidance of the deluded and salvation of beings; 'a thousand eyes' illustrates the breadth of emanating light to illumine the darkness. If there were no sentient beings and no mundane turmoil, then not even a finger would remain, much less a thousand or ten thousand arms; not even an eyelid would be there, much less a thousand or ten thousand eyes."[4] Avalokiteshvara Bodhisattva exists amid the "mundane turmoil" only in order to help and awaken suffering beings. Thanks to their calls, his myriad arms reach back to find pillows in the middle of the night. We can further see the thousand hands as an image of sangha, or Mahayana community, with each person lending a hand with his own viewpoint and skill to the total body of universally awakening beings.

> *Reaching back at midnight,*
> *A thousand flowing hands and eyes*
> *Calmly hear all cries,*
> *And share their pillow with myriad beings.*

SELF-EXISTENCE AND AVALOKITESHVARA'S LIBERATION

Another Sino-Japanese version of the name Avalokiteshvara is Kanjizai (Guanzizai in Chinese), which has illuminating implications. *Kan* means "regard," "observe," "perceive," or "contemplate," the same as in Kanzeon or Kannon. *Jizai* as a compound has an interesting cluster of relevant meanings, whose etymology I will attempt to unravel. One meaning of *jizai* is "lord" or "sovereign." Kanjizai thus harkens back to what scholars believe was probably the primary Sanskrit meaning for the name Avalokiteshvara, "Lord Who Sees or Gazes," or one who sees in a sovereign manner.

Kannon, "Observer of Sounds" (elaborated as Kanzeon, "Observer of the Sounds of the World") is believed to be an interpretation of an alternate Sanskrit reading, which can be transliterated as Avalokitashvara. This latter meaning of the bodhisattva's name certainly has appropriate resonance and import to the practice of Mahayana compassion, as has been discussed. The version of the name as Kannon or Kanzeon also has been the predominant

interpretation among practitioners and devotees in East Asia for at least sixteen hundred years, going back to Kumarajiva and his *Lotus Sutra* translation. But Kanjizai, the secondary name (as used in East Asia), also has significant implications for our understanding of the bodhisattva of compassion.

In addition to "sovereign," the combined characters for *jizai* in Kanjizai have the implication of independence, appropriate to the position of a sovereign lord. This *jizai* also thus means "being free from resistance or obstructions," also "free from delusions." As a common, everyday word in Chinese and Japanese, the word (read in Japanese as) *jizai* means "freely" or "easily." So we could understand this Kanjizai as "Freely Observing," or as "Observing or Contemplating Freedom or Liberation."

But the freedom of *jizai* is further explicated by looking at its two constituent characters, *ji* and *zai*. *Ji* means "self," and *zai* means "existence." So we can see the freedom of jizai not as just another word for nothing left to lose, but in the very existence of the self. Kanjizai thus means literally "Contemplating Self-Existence," as well as "Contemplating Freedom." Combining these meanings we can see this aspect of the bodhisattva of compassion as contemplating the freedom of self-existence.

What is Kanjizai's self-existence? Of course, the fundamental Buddhist doctrine of emptiness, as usually expounded by Manjushri, means precisely that things are empty of inherent self-existence. So Avalokiteshvara as Kanjizai Bodhisattva contemplates self-existence, how the self exists, observes closely its workings, and realizes freedom in perceiving its emptiness. When we see that we are not separate from other beings, that nothing can exist separate and estranged, we recognize our common sameness. People are the same in having needs and desires. We all want to love, or to be loved, and we do imagine that we are solitary, isolated. But to truly realize the self, both the self's lack of inherent separate existence and as the larger Self of the interconnectedness of all beings, is what is called liberation.

This points to Avalokiteshvara's meditative realization as described in the beginning of the *Heart Sutra*. It is Kanjizai that is the name for the bodhisattva used in the *Prajnaparamita Heart Sutra*, the short text that is chanted daily in many Mahayana temples, and which is perhaps the best known Mahayana sutra. The *Heart Sutra* was probably constructed in China from Sanskrit sources under the influence of Xuanzang, the great seventh-century Chinese pilgrim and scholar, whose journey to India is the basis for the

great, colorful Chinese fable *Monkey*. Xuanzang (Hsuan-tsang in the old Chinese transliteration) returned to China and became a great translator. But unlike the earlier Kumarajiva, who had used the name Kanzeon for Avalokiteshvara, Xuanzang used the translation Kanjizai (or Guanzizai in Chinese).

The *Heart Sutra* starts with the Bodhisattva Avalokiteshvara practicing deeply the perfection of wisdom. Fully practicing this perfection, Kanjizai Bodhisattva, observing self-existence, perceived the essential emptiness of all things, and so was able to carry everyone beyond suffering. This is the great freedom and salvation of Kanjizai.

We can see the Kanjizai who recognizes this commonality as the fully realized, awakened aspect of Avalokiteshvara, and of compassion. Kanzeon, on one of the many other hands, is the instrumental, functioning aspect of Avalokiteshvara, who hears the suffering of the creatures of the world and responds by using the implements at hand to help nurture all the diverse beings to be able to realize this fundamental reality. Both sides of the bodhisattva of compassion are important and necessary. She hears, responds, and benefits beings as Kanzeon in order to help all realize the awakening to the nature of self of Kanjizai. The freedom of Kanjizai, and her clarity about the illusory nature of all isolation, in turn helps Kanzeon more effectively look at all the lonely people.

Kanjizai's practice of freedom through contemplating self-existence is further clarified in Dogen's often quoted lines, "To study the Way is to study the self. To study the self is to forget the self. To forget the self is to be awakened by all things, and the body and mind of self and others drop away."[5] To study the reality of spiritual life means intimately studying one's self. This can lead to letting go of self-obsession and to the clear awareness of the sounds of all beings. Thus we can awaken to our fundamental openness, clarity, and radiance. But the first, indispensable step is actually to study this self of ours that we usually take for granted. As Kanzeon does with the sounds of the world, Kanjizai clearly observes the self, listening to all of the sounds and inner beings of the self, with their fears, confusion, sadness, and pettiness. We must carefully and deliberately track our own intentions, desires, conditioned habit patterns, and actual everyday conduct, and take responsibility for them. As we thoroughly study the workings of our self, but with compassion, we can let go of the self and awaken to the deeper reality of all things.

MEDITATION ON SOUND

The meaning of Avalokiteshvara's name as Kanzeon, "Hearing the Cries of the World," also could be translated as "Hearing the World's Sounds." "Hearing Sounds" is the literal meaning of the names Guanyin and Kannon. Thus Avalokiteshvara has sometimes been associated with various meditation practices with sound as an object of concentration. Near the end of the *Lotus Sutra* chapter about Avalokiteshvara, it is recommended to maintain mindfulness on the sound of Avalokiteshvara as he listens to the world's sounds. Also recommended is mindful attention to the sound of the tides, ever surging in ebb and flow, which are likened to the pure voice of the Indian creator deity Brahma.

Avalokiteshvara's espousal of meditation on sound is most fully expressed in the *Shurangama Sutra* ("Heroic Advance"; Ryogonkyo in Japanese). This sutra, unlike the similarly named but older *Shurangama Samadhi Sutra*, is now generally accepted by scholars as a later Chinese work, but it was influential for many East Asian meditators. In this text various bodhisattvas describe the meditation practice that helped them to realization. Avalokiteshvara recommends concentration on sound as an object, and then turning the attention back to one's own hearing of sound, to realize the illusory nature of the imagined split of hearer as subject and sound as object. This practice is encouraged as an effective means of overcoming all dualistic delusions, not only of hearer-sound and subject-object. Through sustaining attention to sound, Avalokiteshvara states, dualistic notions of stillness and disturbance, and the arising and disappearance of states, as well as limited conceptions of attainment of emptiness or enlightenment, are all overcome.

After all the bodhisattvas have spoken, culminating with Avalokiteshvara, Manjushri recommends Avalokiteshvara's concentration on sound as most universally applicable and helpful for beings. Other senses such as smell, taste, touch, and thought are only intermittently available, whereas sound is constant. Further, sound can be perceived from all directions equally, whereas visual objects are limited, only seen in the direction eyed, and invisible through solid objects such as walls.

Another form of meditation on sound associated with Avalokiteshvara is mantra and dharani practice. The Sanskrit mantra of Avalokiteshvara, *Om mani padme hum*, remains highly popular, especially among Tibetan Buddhist practitioners. We can also link Avalokiteshvara to the popular East Asian

nembutsu chant, "Namu Amida Butsu," homage to Amida Buddha. The ten-line *Sutra of Kannon for Protecting Life,* mentioned in connection with the thirty-three manifestations of Guanyin, and the *Great Heart of Compassion Dharani* (also mentioned above), dedicated to Avalokiteshvara are chanted regularly in the Zen schools to invoke the spirit of compassion.

Various rhythmic instruments commonly signal scheduled events or accompany chanting at Buddhist temples and practice centers, helping to induce states of concentrated awareness. Practitioners playing gongs or bells may be instructed not to "strike" them, but kindly to "allow the bell to sound." Sound as a meditation object is also a mode of practice associated with listening to the voice of buddhas or dharma lecturers, as the spiritual meaning of words is often conveyed by the feeling tone of the speaker, more than by their cognitive sense.

As applied to everyday practice, we can pause briefly in the midst of our busy activities and just enjoy our personal experience of sound. Sound flows constantly, like the stream of a mountain valley. Even when living in a big city, we can stop and soak in the sound of the stream of traffic on a nearby highway. Turning our attention within to appreciate our hearing of the sound, the sound of sound itself, we can be refreshed by subtle inner sound and silence, and then just return to our work.

MOUNT POTALAKA
AND AVALOKITESHVARA PILGRIMAGE

Avalokiteshvara's sacred site is the island mountain Potalaka, Putoshan in Chinese. The mountain island is described in the *Gandavyuha Sutra,* in which the pilgrim Sudhana visits Avalokiteshvara on Potalaka, as composed of jewels and profusely adorned with trees, flowers, gardens, ponds, and streams. Avalokiteshvara declares to Sudhana that, after passing away, beings devoted to compassion will be reborn on this island, which Avalokiteshvara calls his buddha land, and thereby will come face-to-face with the buddhas of all worlds.

Potalaka has been identified with a number of Asian geographical sites, including three in India. The seventh-century pilgrim-scholar Xuanzang thought it was off the coast of Malaya, but also referred to a site in southern India. Mount Potalaka has most commonly been identified with a mountain island in the East China Sea off the coast near the southern port of Ningbo.

For Avalokiteshvara's mountain to be located on an island is quite appropriate, since many of her personae are associated with water as a symbol of mercy and compassion. For example, she often holds a vase of purifying or nourishing water, or floats on the ocean like One-Leaf Kannon, and a few of her forms sit on a rocky island. A four-sided pagoda at a temple on Putoshan Island identifies Kannon with the water element in an image on one of the sides. The images on the other sides identify Kshitigarbha with earth, Samantabhadra with the fire element, which forges activity emerging from concentration and vision, and Manjushri with air, characterized by inspiration.

Other Asian locales identified with Potalaka include the beautiful Potala structure in the Tibetan capital of Lhasa, the palace of the Dalai Lama since the seventeenth century, until his current exile enforced by the brutal invasion of the Chinese government. Since the Dalai Lama is considered an incarnation of Avalokiteshvara, his residence was naturally identified with Potalaka.

Several mountain sites in Japan have been designated as Potalaka, and a number of pilgrimage sites in different parts of Japan are sacred to Kannon. Many of these are built around routes to thirty-three temples or shrines, based on the thirty-three manifestations of Avalokiteshvara, and remain popular today.

FOLKLORE AND MIRACLE STORIES

A vast collection of folklore exists about the bodhisattva of compassion and her power and kindness. Many of the colorful stories from China and Japan, including accounts of seeming "miracles," provide names, places, and dates of events to which numbers of people bear witness. Whether or not we care to take these stories literally, their cumulative effect demonstrates the popular impact of the figure of Avalokiteshvara on the Mahayana sensibility. They also show some of the range of the beneficial deeds attributed to this bodhisattva. As archetypal representations of compassion, these stories indicate the breadth and skillfulness of the ideal of compassionate concern for suffering beings, and are an encouragement to cultivate calm, clear caring for others, and ourselves, in our own hearts and minds. A number of the thirty-three Guanyins described above derive from such stories from China; most of the following tales are from Japan.

An early ninth-century Japanese collection of stories tells of a monk from one of the Yogachara School temples of the old capital city Nara, who was hiking on beautiful Mount Yoshino, a sacred mountain inhabited by ascetic practitioners from very ancient times in Japan. A horse-chestnut tree had once been cut down there. It was intended as wood for carved images of the bodhisattvas, but had been abandoned soon after work began, and now the large log was laid over a stream as a bridge. As the monk started to cross the bridge he heard a voice from below him saying, "Ouch. Don't step on me."[6] Perplexed, the monk looked around until he went under the log and was awestruck to see the bodhisattva images that had begun to be carved in it. Deeply moved, the monk eventually was able to have the wood carved into a finished image of Kannon Bodhisattva, as well as images of Amida and Maitreya Buddha.

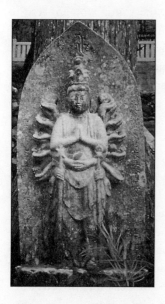

Cemetery Kannon, Mount Koya, Japan

This story suggests that upon the initial dedication of this tree to the representation of bodhisattvas, the very fiber of the wood had taken on this commitment to its enlightening role in a way that could not be deterred. At its heart, this bodhisattva compassion is not limited to the human realm. But this story is also about this monk, who was open and sensitive enough to hear cries of compassion, even from an old, dead tree.

❖

At least two distinct versions exist of an old Japanese story about a young, unmarried woman whose parents died suddenly. Once affluent, she was so reduced to poverty that all the servants left the house and she could barely provide food for herself. Devoted to Kannon, she sought relief, beseeching the Kannon image enshrined in a hall her parents had built behind the main house. The next day, or soon thereafter, a wealthy widower appeared and respectfully asked to marry her, to which she assented. Then he asked for food. Without any provisions with which to make dinner, the woman again prayed to Kannon. A maid from a nearby house appeared, saying they had heard she had guests, and offering a large chest of food, drink, and various delicacies. The young woman had nothing to offer to express her gratitude except a red shawl she was wearing, which the maid finally accepted and put on before departing.

The next day, after the successful dinner, the young woman went to return the dishes to the neighbors' house, but they insisted they did not know what she was talking about and had given no food. Confused, the young woman went back to her family shrine and saw the red shawl wrapped around the statue of Kannon, apparently the provider. One version records that the woman and her new husband went on to have a number of children and a very happy and full life.

The following story from China also attests to the power of trust in Avalo-kiteshvara's compassion, and her faithful response to the pleas of those in distress. A military commander named Sun Jingde in the Northern Wei dynasty of China (386-535), who was a devotee of Guanyin, was captured by an invading enemy and sentenced to execution. The night before his sentence was scheduled to be carried out, a Buddhist monk appeared in a dream and taught him to recite a sutra to Guanyin. Sun Jingde awoke and recited it a hundred times. The next morning the executioner broke swords three times when striking Sun Jingde's neck. Sun's amazed captors decided he was not supposed to be executed and released him. Returning home, Sun found that the Guanyin image on his home altar had three sword marks on its neck.

When the thirteenth-century Japanese Zen founder Dogen was twenty-three, he made a perilous voyage to China, seeking the answers to his spiritual questions. After realizing awakening and then training with a Chinese

teacher, he returned to Japan four years after his departure. During his homeward journey a great storm arose on the ocean. All the sailors and the other passengers feared being capsized by the huge waves. Amid the ocean spray, Dogen calmly sat on deck and chanted the chapter on Avalokiteshvara from the *Lotus Sutra*. After a while, Dogen had a vision of One-Leaf Kannon, one of the thirty-three manifestations previously described, riding on a leaf atop the waves. Dogen continued chanting, and, as predicted in the sutra, the waves calmed and the storm subsided. Dogen thereupon carved into the wooden planks of the boat the likeness of Kannon he had witnessed.

Later a priest at the temple where the boat landed in Japan made a rubbing and preserved this Kannon image. I heard this story when visiting the very humble remnants of that temple in the southern island of Kyushu. The temple caretakers kindly gave out copies of the image of One-Leaf Kannon supposedly carved by Dogen. Legends of the saving power of Kannon appear frequently in the biographies of great historical Buddhist teachers, emphasizing the teachers' own indebtedness to and faith in the universal path and compassion of the buddhas and bodhisattvas, rather than in their particular personal talent.

A story from early thirteenth-century Japan tells of a medicinal hot springs in a town called Tsukuma, in old Shinano Province (modern Nagano Prefecture), where a townsman had a dream in which a voice announced that Kannon would come to the town square the next day. The dreamer asked how he would know it was Kannon, and the voice described a scruffy, thirtyish warrior on horseback. After the townsman awoke and told his friends, everyone in the village was excited and gathered at the appointed time. When a samurai fitting the description arrived, all the people prostrated themselves to him. The astounded warrior demanded an explanation, but the townspeople just continued their prostrations until a priest finally told him about the dream. The samurai explained that he had fallen off his horse and injured himself and simply had come to the medicinal springs for healing. But the townspeople continued making prostrations to him.

After a while it finally occurred to the perplexed warrior that perhaps he actually was Kannon, and that he should become a monk. He discarded his weapons and was ordained, later becoming a disciple of a famous priest. This former warrior is not otherwise noted in history. Just to become an ordinary monk was enough to allow him to consider himself Kannon.

This story shows the strength of popular belief in dreams, as well as the power of Kannon. Such willingness to be guided and to change one's life because of someone else's dream may seem like extreme gullibility, but it also expresses an aspect of compassion that trusts in hearing when the world calls to us and that responds without hesitation. The samurai had come to the town for healing, and he was finally able to hear and receive the healing gift that was offered him, relinquishing his previous idea of his identity. We may note that intercession and guidance from the bodhisattva figures often is said to occur through visions in dreams.

Even attributes associated with Avalokiteshvara are capable of giving miraculous assistance to his devotees. A blind man devoted to Kannon used to sit begging at the gate of Yakushiji temple in Nara. His eyes were open but he could not see. He regularly meditated on, and chanted the name of, the light-emitting jewel of the sun, which is an implement held by one of the right arms of Thousand-Armed Avalokiteshvara. One day two strangers approached him and said, "In sympathy for you we have come to cure your eyes."[7] They treated his eyes and departed, and soon his eyes grew bright and he was able to see. Many stories of miraculous rescues or cures attest to the popular faith and reverence for Avalokiteshvara.

I have my own, modest story about Kanzeon. When I was twenty I had the opportunity to visit Japan and, traveling randomly, stopped to visit the historical capitals of Kyoto and Nara. At Kofukuji temple in Nara I was amazed by the powerful Buddhist statuary filling the large storehouse building. As already mentioned, I was first struck by the wrathful images, and then by the sublime buddhas and bodhisattvas, including a sixteen-foot-high Thousand-Armed Kannon. I staggered out of the storehouse in awe, and wandered around the Kofukuji complex with its large pagoda and herd of deer.

I came to an octagonal building housing an altar with a largish Amoghapasha or Fukukenjaku "Unfailing Rope" Kannon, who ropes and corrals difficult customers, which one viewed from in front of the building. As I turned away, an old woman offered incense and bowed deeply to the Kannon image. Suddenly, I felt that all the statues I had just seen were very much alive; this definitely was not just a museum. Twenty years later I was head monk for the three-month practice period at Tassajara monastery, where, for his first lecture, the head monk is supposed to relate how he per-

sonally came to practice. I said that if there was one time when I first became a Buddhist, it was when I saw that old woman sincerely bowing to that Kannon statue.

After that first visit to Kofukuji I had spent three months examining Buddhist statues and Zen gardens in Kyoto and Nara. I wished to be immersed in that spiritual world, but at the time I did not know that it was possible for an American to actually engage in Buddhist practice, so I returned to the States. Four years later I met a Japanese Soto Zen priest in New York City and began daily sitting meditation and formal Zen practice, eventually receiving priest ordination.

Several months after being head monk at Tassajara I returned to Japan for the first time in twenty years, to spend two years living in Kyoto co-translating old Zen texts with a Japanese priest. A month after arriving I returned to Kofukuji, twenty years to the month after my first visit. I came to the octagonal building with the Fukukenjaku Kannon, in which a special service with chanting by many Japanese priests was occurring. After joining the chanting for a while, I left and enjoyed the statuary in the storehouse building, and also the Great Buddha image of Vairochana at the nearby Todaiji temple. A month or two later I learned that, whereas previously when I had visited it the building with the Fukukenjaku Kannon had been open daily, nowadays it is closed and the statue sealed from sight. It is now open for viewing only one day each year, the day I just happened to return to see it after twenty years.

I do not know what significance, if any, to attribute to such a coincidence, or for that matter to all the miraculous folk stories about Avalokiteshvara. It is obvious that the capacity of compassion to hear and to respond runs deeper than what is imagined in conventional human logic and perceptions. I relate this personal experience as my way of expressing appreciation and testifying to any "mysterious assistance" that may have been imparted by Kanzeon.

Such "mysterious assistance" (*myoshi* in Japanese) is one traditional doctrinal basis for understanding the stories of miraculous activities of bodhisattvas. When devotees place themselves in an open space of mind, whether through meditation, chanting, prostration, or other practices, an energetic resonance with their environment that allows mutual benefit between themselves and surrounding beings can be created. In this context of openness and trust, the cosmic, archetypal bodhisattvas (whether understood as internal or external, energies or entities) may be able to intervene and help alleviate suffering.

ASSOCIATED FIGURES:
AMITABHA BUDDHA AND MAHASTAMAPRAPTA

A host of other figures in Mahayana Buddhism are associated with Avalo-
kiteshvara, none more closely than the popular cosmic Buddha Amitabha.
As mentioned previously, Avalokiteshvara is considered an emanation of
Amitabha. Avalokiteshvara is often depicted attending Amitabha, either as
one of sixteen bodhisattvas descending from the heavens to gather the spirit
of devotees as they die, or paired on either side of Amitabha.

The third of the three main *Pure Land Sutras*, referred to as the *Meditation
Sutra*, consists of meditations on Amitabha and his attendants Avalokitesh-
vara and Mahastamaprapta, including an elaborate visualization exercise
about Avalokiteshvara and how the bodhisattva conducts one to the Pure
Land of Amitabha.

Mahastamaprapta Bodhisattva (Seishi in Japanese) is Amitabha's atten-
dant, paired equally with Avalokiteshvara, although Mahastamaprapta is
rarely depicted by himself, and has never produced a cult following like that
of Avalokiteshvara. Mahastamaprapta's name means "one who has obtained
great strength." He represents Amitabha's wisdom, as Avalokiteshvara does
his compassion.

TARA

Tara, Avalokiteshvara's female counterpart, is sometimes said to be an ema-
nation of Avalokiteshvara created from one of his tears. She is widely ven-
erated in Tibet as the female bodhisattva of compassion. There are
twenty-one different forms of Tara Bodhisattva in Tibetan Buddhism, but
Green Tara and White Tara are by far the most predominant. The seventh-
century Tibetan king and great Buddhist patron Sengtsan Gampo had two
wives, from Nepal and China, who are considered embodiments of Green
and White Tara, respectively. White Tara sits in cross-legged lotus posture
with a third eye apparent in her forehead. She is dazzlingly radiant and grace-
ful, with eyes on her palms and the soles of her feet indicating her aware
generosity. She bestows peace, prosperity, long life, health, and good for-
tune. Green Tara sits graciously with her right leg extended down resting on
a lotus, head slightly tilted, and hands holding up lotus blossoms. Her ener-
getic sitting posture signifies the integration of wisdom and art.

Generally all the Taras are youthful and sensuous, clad in filmy robes with breasts exposed. One hand is usually extended in granting gesture, the other raised offering refuge. Tara Bodhisattva is attractive but dignified and serene, and many stories give her a playful, tomboy aspect, although White Tara is also seen as maternal, sometimes known as the Mother of Salvation.

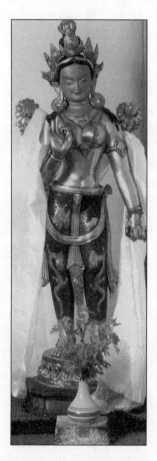

Tara, Tibet

In the Chinese system, where Guanyin herself is generally female, rather than being an independent figure, Tara in her white form is considered one of the thirty-three Guanyins. Inspired by Tibetan Buddhism, combined with interest in goddess and feminist spirituality, the image of Tara Bodhisattva has already gained popularity in the West.

MIAOSHAN

A highly popular Chinese legend depicting the origin of Guanyin is the dramatic story of a princess named Miaoshan. There are many elaborate variations on this fable, although none were compiled previous to the twelfth century. One simplified account is of Miaoshan as a daughter of an ancient king who has no sons, and who wishes to find her a suitable husband as heir to his throne. Like Shakyamuni, Miaoshan determines to enter the spiritual life against the king's wishes. She refuses to accept marriage and the match chosen by her father and runs off to a nearby monastery.

Miaoshan enjoys being in the monastery, although she is mistreated. In one account, the abbess of the nunnery is bribed by the king to give her harsh treatment and strenuous work. Regardless of all hardships, Miaoshan remains clear about her deep intention to help alleviate the suffering of beings. The king finally becomes enraged that his daughter has refused his bidding and orders the monastery burned to the ground. While many of her fellow residents perish in the flames, Miaoshan is miraculously rescued from the conflagration by guardian spirits who venerate her sincere practice and secrete her on Guanyin's remote Putoshan Island.

Miaoshan realizes that her father, the king, will reap the karmic consequences of his murderous acts. The king indeed becomes afflicted with a mysterious, life-threatening ailment that puzzles all of his physicians. A mysterious messenger appears, who declares that the king can be cured by taking a medicine compounded from the eyes and arms of someone virtuous who gives them ungrudgingly. The messenger claims to be able to obtain these. On her distant island, Miaoshan unhesitatingly tears off her arms and plucks out her eyes to send for the king's cure. Upon taking the medicine the king is healed, and he decides to make a pilgrimage to his unknown benefactor.

Arriving at the island, the king recognizes his daughter, now armless and blind, and is deeply moved and repents his misdeeds. Miaoshan then reveals her thousand hands and eyes and her true, or in some accounts future, identity as Avalokiteshvara. Amid all of its miraculous aspects, this tale emphasizes the purity and sincerity of Miaoshan, her generosity, and the skillful means and supernatural powers that she develops during the story. As a myth about the origin of Avalokiteshvara, it emphasizes her dedication to saving beings as well as her familiar archetypal qualities. The enduring popularity of the Miaoshan story also contributed to, and exemplifies, the Chinese process of feminization of Avalokiteshvara as Guanyin.

CLASSICAL INCARNATIONS OF AVALOKITESHVARA:
THE DALAI LAMA AND BODHIDHARMA

Both Bodhidharma, the founder of Chan/Zen in China, and the Tibetan Buddhist spiritual leader, His Holiness the Dalai Lama, are formally considered incarnations of Avalokiteshvara. The person of the Dalai Lama is considered to have been reincarnated over generations, and historically has been venerated as an embodiment of Avalokiteshvara since the fifth Dalai Lama in the seventeenth century. The current, fourteenth Dalai Lama will be discussed below as a modern exemplar of the bodhisattva of compassion.

The association of the legendary Bodhidharma as Avalokiteshvara is given in a story stressing his sternness, revealing the "tough love" side of compassion. This is the first story in the classic Zen koan anthology, *The Blue Cliff Record*, and is the second case in *The Book of Serenity*. Although scholars question the historicity of many parts of the Bodhidharma legend, there is no question about its role as one of the most prominent teaching stories in the Zen tradition.

Bodhidharma was a great Buddhist master from India who arrived at the court of Emperor Wu of Liang in southern China in the sixth century C.E. Emperor Wu, a great patron of Buddhism and a sincere devotee, had sponsored many new monasteries and sutra translations, and the ordination of many monks. The emperor asked the newly arrived Bodhidharma what merit he had accrued by all these good works, a not unreasonable, if immodest, question considering the blessings promised by many Mahayana sutras for such activities. Bodhidharma unhesitatingly replied, "No merit." Startled, the emperor asked, "What is the highest meaning of the sacred truth?" Bodhidharma said, "Vast emptiness, nothing holy." The emperor asked, "Who is this facing me?" Bodhidharma said, "I don't know." The story states that the emperor did not understand. Bodhidharma then departed, and crossed the Yangze River to the kingdom of Wei in northern China.

Emperor Wu asked his spiritual adviser, Master Zhi, about Bodhidharma. Master Zhi said that this Indian monk was the Great Being Avalokiteshvara transmitting the Buddha Mind Seal. The emperor felt regretful, and wanted to send attendants to bring Bodhidharma back. But Master Zhi said, "Don't say you will send someone to fetch him back. Even if everyone in the whole country were to go after him, he still wouldn't return."[8] The crux of the story, especially for our examination of Avalokiteshvara as an archetype, is how Bodhidharma's seeming abandonment of Emperor Wu and his

kingdom can be regarded as a response of the bodhisattva of compassion. One conventional view of compassion, as well as the image of Kanzeon's immediate, universal response to sufferers in the *Lotus Sutra*, is of unconditional helpfulness. But Bodhidharma's strictness stands as a warning against some interpretation of this helpfulness as being an ineffective, "sentimental" compassion. Bodhidharma may have seen that Emperor Wu was grasping after spiritual gain and was not ready to receive the teachings Bodhidharma had to offer. Perhaps his nonreturning was the most compassionate way to awaken the emperor to a deeper reality.

Bodhidharma's story continues with even more severity. After leaving Emperor Wu, Bodhidharma sat wall-gazing in a cave in northern China for nine years. A Chinese monk came to study with him, but Bodhidharma ignored him and just kept sitting in meditation. The monk stood outside the cave all night in the snow. The next morning Bodhidharma still said that the monk was not serious enough for training, and continued to sit and ignore him. Finally, according to the tale, the monk cut off his own arm and handed it to Bodhidharma to prove his sincerity, recalling Miaoshan's sacrifice for her father. Bodhidharma thereupon accepted the monk, who eventually became the Second Ancestor in the Chinese Chan/Zen lineage. From fairly early on, historians noted that the Second Ancestor actually had lost his arm prior to his meeting Bodhidharma during an encounter with bandits. And yet the old legend remained a powerful image in Zen history of the sacrifice and intensity required for training in that tradition.

Bodhidharma's responses to Emperor Wu seem to focus on teachings of emptiness, nonattachment, and selflessness, which might more commonly be associated with Manjushri than Avalokiteshvara. But Avalokiteshvara may manifest precisely in the strictness of Bodhidharma's appropriate "tough love." The ultimate compassion for bodhisattvas is helping all beings to thorough awakening and self-realization. In this way Bodhidharma may be seen as embodying the aspect of Avalokiteshvara as Kanjizai, the observer of self-existence and its emptiness, who bestows compassion more by liberated example than by responding directly to individual needs and suffering. Indeed, the example of Bodhidharma has inspired the strenuous efforts of sincere dharma practitioners for nearly fifteen hundred years.

AVALOKITESHVARA AND THE PARAMITAS

In reviewing the complex and numerous archetypal aspects and folk stories surrounding Avalokiteshvara, we might try to incorporate a number of key elements in our own activity. The very diversity of manifestations of Avalokiteshvara, as well as the range of implements in her thousand hands, indicates the importance of skillful means directed to the diversity of suffering beings. We can use this principle by being willing to vary our approach to different people and developing sensitivity to the true needs of others. Of course this implies the empathetic listening of Kanzeon, carefully and patiently considering the cries of beings, and also the subtler sounds around us.

Another element of this archetype of compassion is simply immediate, unconditional response. Responding unhesitatingly with whatever comes to hand, trusting our best intention, can help develop the skillfulness that actually helps in the situations that confront us. This responsiveness can be informed and deepened by also acknowledging the liberated Karijizai aspect of the Avalokiteshvara archetype. By intimately studying how we ourselves exist, by settling in and seeing that we are not separate from others, we can be free to respond when and how it would be useful. We can leave things alone as did Bodhidharma, without reacting unconsciously from prejudices or the reflexes of conditioning.

Translating these archetypal elements to the ten transcendent practices, we can identify the paramitas most emphasized by Avalokiteshvara as generosity, skillful means, patience, and powers. The generosity of Avalokiteshvara is in his natural, unconditional responsiveness, just reaching back in the night. Although reflecting the immediacy of his impulse to be there when one just calls his name, this responsiveness is also informed by the fulfillment of self-examination, of intimate awareness of how the self exists. The perfection of generosity is not static, but develops and unfolds as it is called upon. Giving leads to more complete giving. We learn generosity by being generous.

Avalokiteshvara's generosity and giving are interwoven with her practice of skillful means. Although an accumulation of tools may be involved in the perfection of appropriate methodology, the image of the Thousand-Armed Avalokiteshvara implies that the implements are numerous, and already at hand. Such proficiency is a matter less of acquiring knowledge and technology than of intuition and practice, of learning to use whatever may come to hand in a helpful way and trusting our own intention and responses.

The paramita of patience is relevant because we must also realize the limits of our current practices of generosity and skillfulness in order for them to develop. This is the patience of simply observing and contemplating the activities or sounds of the world. We see such patience in Kanjizai's contemplation of self-existence, and in Bodhidharma sitting like a wall for nine years. This patience is not passive, unconscious waiting, but rather an active, ready attention to our life.

Kannon goddess

The transcendent practice of powers is most fully embodied by Avalokiteshvara in the many stories about his miraculous assistance of people in distress. Not only does Avalokiteshvara respond generously and skillfully, but he has extraordinary powers to apply to diverse situations. The persistent application of skillful giving of itself seems to naturally bring forth such unusual capacities. These endowments may not be a function of magic, but of clarified intention reflecting the needs of the beings before us.

EXEMPLARS OF AVALOKITESHVARA

His Holiness the Dalai Lama, an "official" incarnation of Avalokiteshvara, is well known for his promotion of world peace and his nonviolent work against the Chinese oppression of the Tibetans, for which he won the Nobel Peace Prize in 1989. As spiritual leader of the Tibetan people and political leader of the Tibetans in exile, the Dalai Lama has been remarkable for his determination not only to speak out for Tibet, but also not to demonize the Chinese people, speaking of them sympathetically as fellow beings who also will be inexorably impacted by their government's brutality against the Tibetans and its ecological devastation of the Tibetan landscape.

In his lectures and teaching around the world, the Dalai Lama appears not as a leader, but simply as a humble monk. His gentleness, humor, and ready kindness are apparent. When listening to the Dalai Lama speak, his sound, tone, and presence are as notable as the content of what is said. This does not come across in written transcripts, or even tapes, but clearly reflects the archetypal aspect of Avalokiteshvara's relationship to sound.

We can see Avalokiteshvara's attention to skillful means in the Dalai Lama's interest and study of modern science. He has said that Buddhism should revise its ancient cosmological teachings to accord with modern knowledge. His concern with tools and instruments, reminiscent of the implements of Avalokiteshvara, is evident in his avocation as a mechanic. Even as a youth he was fascinated by how things work, for example taking apart watches and putting them back together.

Like Avalokiteshvara observantly hearing the sounds of the world's beings, the Dalai Lama listens very attentively to people, carefully and buoyantly. With his broad concern, he has carried out open dialogues with diverse peoples about their attitudes and traditional spiritualities. After participating in a cross-cultural dialogue between the Dalai Lama and a number of Jewish scholars and rabbis, the orthodox Jewish teacher Rabbi Zalman Schachter said of His Holiness the Dalai Lama, "There were times I was close to tears just from the intensity of his listening."[9]

The Dalai Lama says that all the world's spiritual traditions are useful for people with different dispositions, and the basis of his own religion is simply kindness. In the face of the increasingly brutal holocaust being inflicted on Tibet, the Dalai Lama speaks of the power of truth to ultimately gain world support and change the situation, and the importance of the Tibetans' setting a successful example of nonviolence to create resolution. He finds

his source of hope in the fundamental gentleness of human nature. He points out that in our time more and more people are aware and sincerely concerned about the situations and suffering of other peoples around the world, partly thanks to global communications media. As the people of our planet begin to more clearly hear and consider the cries of the world, compassion and generous response will increase.

Albert Schweitzer, another Nobel Peace Prize winner, was multitalented, seemingly endowed with a thousand hands like Avalokiteshvara. A trained and accomplished biblical scholar, philosopher, and concert pianist and organist, Schweitzer became a physician in order to minister to people in need in Africa. He personally constructed a hospital and leper village in Gabon, in what was then French Equatorial Africa. While continuing medical mission work throughout his life, Schweitzer also studied religious philosophy and was often in respectful disagreement with the orthodox dogmas of his European missionary neighbors.

Schweitzer wrote clearly of the centrality of compassion to our humanity, "The purpose of life is to serve and to show compassion and the will to help others. Only then have we become true human beings."[10] Echoing the bodhisattva vow, Schweitzer was also definite about the universality of compassion, about "reverence for life" and the necessity to care for all beings. "Ethics are complete, profound, and alive *only* when addressed to all living beings. Only then are we in spiritual connection to the world. Any philosophy not respecting this, not based on the indefinite totality of life, is bound to disappear."[11]

In accord with Avalokiteshvara's relationship to sound and harmony, Schweitzer loved playing the organ, especially the sublime spiritual music of Johann Sebastian Bach, about whom he wrote an important biography. Schweitzer also personally helped construct organs and gave concert tours on trips back to Europe to raise funds for his African hospital.

Visitors to Schweitzer's hospital noted that he lived very simply, carrying out personally the everyday, necessary physical chores, responding in whatever way was needed to maintain the facilities of his hospital and care for his patients. Schweitzer stated that he kept in his heart as a motto one word: service.

Perhaps the single contemporary person most often associated with the virtue of compassion is Mother Teresa. Many have been inspired by the

story of this petite, Albanian-born nun's simple and clear dedication. While working as a schoolteacher in India, she was suddenly and unwaveringly called to care for the poorest of the poor in the slums of Calcutta. At first she took on this mission by herself, abandoning all personal comfort or security to put herself in the midst of others' extreme suffering. She spoke of her contemplation and response to the cries of the world in terms of Jesus' choosing to be present in the meek, the hungry, the sick, and the homeless, and her own commitment to respond to their needs. She envisioned cleaning maggots from the infested wounds of homeless beggars as joyful cleansing of the body of Christ.

Eventually an order of nuns gathered around Mother Teresa, ministering to the poorest of the poor. Now her order has spread through many countries of the world. When she first brought her sisters to American cities, some people were offended and asked why she didn't stay in impoverished countries like India. Instead of talking about the homeless increasingly filling American cities, Mother Teresa responded that Americans are impoverished spiritually, all are lonely and starved for love. She spoke of our need for spiritual values, of our need to give service and caring to those who are suffering. In recent years, some criticized Mother Teresa for not addressing the systematic social causes of suffering and also for accepting financial support from some donors with otherwise questionable conduct. She resolutely replied that her calling was not to analyze social systems and economic ideologies. Rather, she responded personally and individually to those she saw suffering most desperately, who were still too weak to be taught how to feed and care for themselves. She said she was happy to accept generosity and support for her work without making discriminations about the givers.

Mother Teresa's approach—responding personally and immediately to suffering while not addressing underlying societal factors—reflects a characteristic of the Avalokiteshvara archetype. Avalokiteshvara responds directly without hesitation, reaching back in the dark of night to care and comfort. She usually does not engage in the struggles of political or social activists, unlike Samantabhadra, who takes on such diverse roles within the social system in order to improve conditions or inspire, benefit, and awaken others.

Mother Teresa may only be problematic as an example of Avolokiteshvara inasmuch as she seemed larger than life, capable of saintliness beyond the reach of ordinary humans. We may feel that we cannot express bodhisattvic

compassion unless we are also such a saint. But Mother Teresa herself said that everyone can be a saint. The compassion represented by Avalokiteshvara is especially the province of ordinary people in everyday situations.

An exemplar of the Avalokiteshvara archetype in my personal experience is Mrs. Mitsu Suzuki, the widow of Shunryu Suzuki Roshi, the founder of the San Francisco Zen Center. Mrs. Suzuki, who in 1961 moved to San Francisco to be with her husband at his Japanese-American temple, is herself a quietly important figure in the still-short history of American Zen. For more than twenty years after her husband died in 1971, Mrs. Suzuki stayed on, living at the Zen Center he had established with his American meditation students. Although she did not finally return to Japan for more than thirty years, America remained a strange country to her and English a difficult language. But she amiably remained as a quiet presence and much-loved guide and example to several generations of Zen students.

Mrs. Suzuki would never have thought of trying to impose her views or opinions, but kindly and clearly embodied simple principles of compassion and generosity, even through difficulties that embroiled the Zen Center community. Her example helped many of us stay focused on the real work during stressful times. Throughout, she remained cheerful. I recall her daily vigorous walking exercises down the halls of the residence building, widely swinging her arms and smiling at the bemused students as they passed.

Mrs. Suzuki has a keen sense of the Japanese aesthetic, a contemplative sensibility that is inextricably linked to Zen practice, and which she expresses as a fine haiku poet. Some of her haiku, which have appeared in Japanese journals, have also been translated and published in English. These short poems are concentrated distillations of immediate experience. The following examples might be seen as descriptions of Avalokiteshvara, simply but carefully observing the sounds and doings of her world and herself:

> *Disturbing matters continue*
> *I hear bird songs*
> *absent-mindedly.*

> *Clear winter day*
> *sound of waves*
> *solitary life.*

Listening to
my grandchild's love story
I cut a huge melon.[12]

Mrs. Suzuki expresses the strict side of Zen compassion. She helped train and refine Zen students while acting as a teacher of the Way of Tea, commonly referred to as "tea ceremony." Suzuki Roshi had suggested she take up tea practice, and it became a vehicle for her to share the background of his teaching after he was gone. Mrs. Suzuki used tea and the sensitive handling of its many traditional utensils as skillful means, frequently demonstrating "tough love" in her sharp-tongued criticism of students' lack of attentiveness to the details of the tea-making forms and choreography. Her lessons helped many Zen students expand their sense of presence and learn to care for their everyday surroundings.

This tea practice has evolved over the centuries in Japan to foster awareness and respectful consideration for others in the simple act of kindly preparing, serving, and drinking a cup of tea. Along with the tea itself, the Way of Tea encompasses the practice and appreciation of many everyday handicrafts, such as flower arranging, garden design, pottery, and calligraphy, which have been widely absorbed into Japanese daily life as gentle expressions of spirituality.

In addition to tea, Mrs. Suzuki taught some students the Japanese way of sewing formal tea ceremony garments and meditation robes. One student especially recalls Mrs. Suzuki's hands as "small and very well kept. When she picks something up, even if it's as seemingly insignificant as a pin, her hands and the object seem to know each other. The way a pin or a piece of fabric is held becomes a teaching in such hands."[13] Just in the dimension of such ordinary activities with traditional implements, Mrs. Suzuki was able to teach her students the heart of kindness, and with (Kannon-like) supple hands of compassion, assembled an ocean of blessing.

The compassion of Avalokiteshvara is manifested in our world by many common people. "Random acts of kindness" are performed quietly in response to everyday situations. One of my earlier memories, from when I was about three years old and traveling with my family, is of a man I didn't know, perhaps a professional associate of my father's. He noticed that my shoes were untied and bent down and tied them for me. Something about this simple action touched me such that I recalled the kindness much later.

8 Kshitigarbha (Jizo)
Monk As Earth Mother

THE HISTORICAL ORIGINS
AND IMPACT OF KSHITIGARBHA

KSHITIGARBHA is of lesser importance in terms of philosophical doctrine than the other bodhisattva archetypes. He appears in Tibet and in India simply as one of the many bodhisattvas in the intricate Vajrayana mandalas that depict aspects of awakened mind. But as the Mahayana spread through Central Asia and into China and Japan, Kshitigarbha came to rival even Avalokiteshvara in popularity, thanks largely to his fertile relationship to the earth and his shamanic protection of the deceased and of hell dwellers.

The *Sutra of the Past Vows of Kshitigarbha Bodhisattva*, which remains popular in East Asia, is by far our most extensive source of early teachings about Kshitigarbha. It is said to have been translated into Chinese in the seventh century, around the time that Jizo's popularity began to increase. Some modern scholars theorize that this sutra, which is available in English translation, was actually compiled in Central Asia or China, possibly not until the tenth or eleventh century. This *Sutra of the Past Vows of Kshitigarbha Bodhisattva* provides many details of the character of Kshitigarbha and the nature of his bodhisattva work. It includes colorful stories from the past lives of Kshitigarbha that led to his strong vow to remain in the world, saving beings in all realms until Maitreya's arrival as the next buddha.

Kshitigarbha is called Dizang in Chinese, and Jizo in Japanese. In modern Japan Jizo is still highly venerated as a protector of children and travelers and as a guide to the afterlife. Jizo is especially prominent as the protector of the spirits of aborted fetuses and deceased children. Since he is such an important figure in contemporary Japan—and has a much smaller

role in India and earlier Mahayana—I will generally refer to him by his Japanese name Jizo, rather than the Sanskrit Kshitigarbha.

In English Jizo means "Earth Storehouse" or "Earth Womb." In many ways Jizo relates to the ground and to our earth. Although usually depicted as a male monk in Japanese tradition, we might conceive of Jizo symbolically as the earth mother bodhisattva. In accord with his name "Earth Womb," Jizo expresses many aspects of mothering, as well as of male nurturing and protective functions.

ICONOGRAPHY OF JIZO

Iconographically, Jizo usually appears as a shaved-head monk, with a staff in one hand and a wish-fulfilling gem in the other. The traditional monk's staff dates back to Shakyamuni Buddha's order in India. It has six metal rings at the top (symbolizing the six realms discussed below), which jangle as the monk walks, announcing his presence, warding off predators, and scaring away small animals that might inadvertently be crushed underfoot. In early statues, instead of carrying this staff, Jizo often held his hand in either the mudra (gesture) of giving, with open hand extended, or the mudra of fearlessness, with arm held up, palm facing forward, to calm and reassure.

Of all the archetypes, Jizo is perhaps the most fixed in iconographic form. Variants are fairly rare. Sometimes in India and China he wears, along with his monk's robe, the ornamentation and headdress of a typical princely bodhisattva, rather than the shaved head of a monk, which is almost universal in Japanese Jizo images. In many Indian and Tibetan images Kshitigarbha does not appear as a monk, although he has been depicted as a monk ever since Central Asian images appeared, with the early spread of the Mahayana. In some Central Asian and Korean images, Jizo as a monk wears a cloth kerchief on his shaved head, as monks commonly do when traveling. In Japanese statues beginning in the Kamakura period (thirteenth and fourteenth centuries), Jizo is usually a monk with a youthful appearance, perhaps in recognition of his particular association with children.

Jizo (as Dizang) remained prevalent in Chinese temples into the twentieth century, with special halls housing his image, although statues are not set out along the roadside as they are in Japan. In contemporary Japan small stone Jizo statues appear frequently alone or in clusters at temples, and also individually, often in small shrines, along many city streets as well as country roadsides to protect travelers. Stone Jizos are often placed at crossroads,

riverbanks, on the seashore, and at other transitional spaces. Often these stone Jizos are given red cloth bibs as offerings to the spirits of deceased children. These red bibs became so popular in Japan that now they are put on the statues of other Buddhist figures besides Jizo.

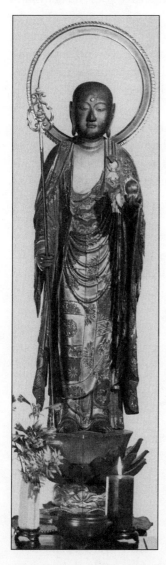

Jizo, Japan, circa 13th–14th centuries

THE SIX REALMS

Traditionally Jizo is guardian of and guide to the underworld and the intermediate state between births, especially benefiting those in the hell realms. As friend to those in hell, Jizo loyally stands by and comforts the tortured, the wretched, and the afflicted. But along with his sojourns in hell, Jizo is also ever present in the other five of the six realms or worldly destinies that are delineated in Buddhist cosmology. These realms are described as the physical situations in which beings are incarnated during the endless rounds of rebirth due to the implacable cause and effect of the workings of karma. But the six realms are also a major Mahayana psychological teaching, and can be understood as the basic mental states that might be experienced by any of us during the course of a week or even a day. Since Jizo does bodhisattva work to help beings in all six of the realms, I will describe these six as the locus of Jizo's practice.

The six realms are: the heavenly beings; the titans or angry, ambitious deities; humans, considered the most auspicious realm for practice and realization of awakening; animals; hungry ghosts; and the hell realms. These realms are not permanent, eternal destinies, as in the Western concepts of heaven and hell, although

some beings may remain in the Buddhist hell realm for a very long time indeed.

The heavenly beings (*devas* in Sanskrit) have a delight-filled, carefree existence in their home among the clouds in the sky. But since they are constantly being entertained with pleasures and are spared pain and hardships, it is very difficult for these devas to awaken to spiritual practice for the benefit of others. We might relate this state to our own experiences of bliss, the glimpses of the ecstatic we may fondly recall. The heavenly beings have long, pleasant life spans. However, they are still subject to the consequences of worldly cause and effect, and eventually a day comes when they look in the mirror and see a gray hair. This sign of the onslaught of aging is a tragic calamity, signaling the imminent demise of the heavenly beings. Their resulting destiny may well be the hell realms, since the loss of their pleasant existence is likely to cause great resistance and desperate, futile clutching to hold on to their heavenly status. Such a mentality paves the road to hell. However, there are also sincere devotees who are said to abide for a time in the heavenly realms in order to help prepare themselves for deeper spiritual practice and to return to the other realms with bodhisattvic intention and commitment. This is the original idea behind the popular desire for rebirth in the Western Paradise of Amitabha Buddha in Pure Land schools.

The second realm is that of angry, fighting deities (*ashuras* in Sanskrit), powerful but ambitious titanic characters who are jealous of those in more lofty heavens above them. We may liken this state to that of a successful wealthy executive who can only think of having even more power and material possessions, too engrossed in business conquests to enjoy the simple wonders of just being alive.

The human realm, the third, is considered highly auspicious because it is the most likely domain from which to set out on the path of spiritual awakening. Thanks to Jizo's aid and intervention, some beings from the other five realms also have a chance of awakening to spiritual practice. Humans are subject to greed, anger, and confusion, to dissatisfaction, dis-ease, and restlessness, and we humans frequently have a vague nagging sense of nausea and anxiety. Although aware of suffering, humans are not so beleaguered with misery as those in the three lower realms. Thus they may more readily arouse concern for all beings and act to help others. It is as rare and auspicious to be born as a human being as it would be for a sea turtle who sticks his head up into the air from the ocean depths once every hundred years to accidentally put his head through a life preserver that has been floating on

the surface of the ocean. To be truly and simply human is the ultimate worldly goal.

Animals, in the fourth realm, live in a swirl of appetite and fear. We can recognize this beastlike state in those people who alternate between craving and satisfaction and in their fight-or-flight responses to perceived physical threats.

Hungry ghosts (*pretas* in Sanskrit), the fifth realm, are restless spirits in a miserable state of constant hunger. They are depicted as frustrated beings with large stomachs and tiny, needlelike throats, who can never swallow enough food. They are shown eating excrement, and it is said that for them water tastes like pus. We may recognize an element of such desperate hunger and hopeless dissatisfaction in North American consumerist culture. To the extent that an economy is predicated on the cancerous necessity for boundless growth, people may become conditioned by television commercials and many other artful stimuli to want more and more, to go out and buy the latest model or the newest fashion or toy. This may be likened to the mind-set of hungry ghosts. East Asian ceremonies featuring Jizo are dedicated to feeding and finally satisfying the hungry spirits in order to pacify them and to encourage them to take up awakening practice for all.

The sixth, or hell, realm contains many beings tortured in various grim settings. Some medieval Japanese images of the Buddhist hells resemble medieval European depictions of fire and brimstone. Hellish horned demons push the afflicted into fiery pits or cauldrons. Other hell precincts within the sixth realm are icy cold, or show those residing there being shredded by sharp swords. But sometimes Jizo is also shown in hell, saving those who suffer. In the *Sutra of the Past Vows of Kshitigarbha Bodhisattva*, Jizo speaks knowingly of eighteen great hells and five hundred secondary ones, with another hundred thousand hells, each with distinct names, all arranged inside a ring of mountains, reminiscent of the strata of hells found in Dante's *Inferno*. Jizo also graphically describes the agonizing torments of occupants of the various hells. For example, "Iron eagles peck at the offenders' eyes…. Long nails are driven into all their limbs. Their tongues are pulled out and plowed through. Their guts are pulled out, sawed, and chopped apart. Molten brass is poured into their mouths."[1] Such tortures continue, since their subjects are restored to a state where they must experience the same or another hell realm anew.

One system of Buddhist cosmology describes eight burning hells, eight freezing hells, and three isolated hells, including Avichi, the (nearly) endless

hell reserved for self-serving perverters of Buddhist teaching and destroyers of spiritual community. Like the other five realms, hell is both a destiny where beings may be reborn in other lives, and also a psychological state that we can arrive at in this life as a consequence of our unwholesome actions. Jizo particularly studies these hells, working tirelessly to release beings from such suffering.

Many stories and parables in Buddhist folklore describe the different realms both as actual destinies we should fear, and as psychological states that are always available to us. The great seventeenth-century Japanese Rinzai Zen master Hakuin was once approached by a samurai warrior who asked Hakuin to explain heaven and hell to him. Hakuin looked up at the samurai and asked disdainfully, "How could a stupid, oafish ignoramus like you possibly understand such things?" The samurai started to draw his sword and Hakuin chided, "So, you have a sword. It's probably as dull as your head!" In a rage, the proud warrior pulled out his sword intending to cut off Hakuin's head.

Hakuin stated calmly, "This is the gateway to hell."

The startled samurai stopped and, with appreciation for Hakuin's cool demeanor, sheathed his sword.

"This is the gateway to heaven," said Hakuin softly.

A popular fable describes hell as a room in which a bunch of angry, emaciated people sit around a banquet table. On the round banquet table is piled a wonderful feast, with many platters of the most delicious-smelling foods that one can imagine. Strapped to the forearms of the famished people sitting around this table in hell are four-foot-long forks and spoons, so no matter how they try, they cannot get any food into their mouths.

Heaven, on the other hand, is a room in which jovial, well-fed people sit around a banquet table that is piled high with a wonderful feast, with many platters of the most delicious-smelling foods that one can imagine. Strapped to the forearms of the happy people sitting around this table in heaven are four-foot-long forks and spoons—and the people are feeding one another across the table.

JIZO'S VOW

Jizo's powerful vow is to be present for all suffering beings in all six realms. In many temples, and along roadsides, appear groupings of six Jizo statues, one for each realm. Jizo is everywhere, but is particularly known, and

appreciated, for being present to aid hungry ghosts and beings in hell.

In the *Sutra of the Past Vows of Kshitigarbha Bodhisattva*, Shakyamuni Buddha explains the background and quality of Kshitigarbha's vow. Jizo has been enacting his vow to help save all beings for an inconceivable, cosmically vast span of time and vows to continue until the arrival of Maitreya Bodhisattva as the next historical buddha. Included in the sutra are stories about four of Jizo's previous lives, in the remotely distant past before he became Kshitigarbha Bodhisattva, during which he was inspired to give rise to this great vow.

The sutra also delineates the benefits and guardianship that Jizo vows to bestow upon beings in need. Jizo has liberated countless beings over many ages and set them on the path to full awakening, and vows to remain in the world for the benefit of those still suffering. Jizo helps liberate diverse beings by warning them of the unfortunate consequences of their particular misconducts. Those who venerate or make offerings to Jizo, create images of him, or recite his sutra or his name are assured of the assistance promised by his vows. Included are such benefits as increased intelligence and memory, abundant food and drink, happy families, a kind heart, success in their pursuits, protection from disease, robbers, fire, and flood, and, ultimately, the realization of buddhahood.

Because of his vow to remain present with beings in all the realms, Jizo is very close and accessible to all of us. This closeness is a feeling held by many East Asian Buddhists and accounts for his special popularity. In addition to saving beings from hell, Jizo is thought to conduct deceased beings into the pure lands, or paradise realms. Dating back to early Chinese depictions of Amitabha Buddha, Kshitigarbha is shown as one of the bodhisattvas in this Buddha's retinue, and Tang dynasty Chinese writings feature Kshitigarbha as a priest inhabiting his own palace within Amitabha's Pure Land. From ancient to contemporary times in Japan as well, Jizo is sometimes depicted helping beings to Amida's Pure Land along with Kannon Bodhisattva. Stone Jizo images often have been erected on grave monuments, not only to protect the deceased from hells but to help conduct them into pure lands and heavenly realms.

JIZO AS EARTH MOTHER/EARTH DAUGHTER

The rich relationship of Jizo, the Earth Womb Bodhisattva, to the earth mother archetype is revealed in two of the past-life stories in the *Sutra of the*

Past Vows of Kshitigarbha Bodhisattva, which give a fascinating twist to the Greek myth of Demeter, the maternal Goddess of Grain, and her daughter Persephone, Queen of the Underworld.

In both stories, Jizo is the daughter of a woman destined for hell after death. In the first story, the daughter is a Brahman woman whose recently deceased mother had been full of skeptical doubt, had ridiculed spiritual practice, and had recklessly ignored the consequences of her own conduct. The Brahman woman is filled with grief and concern for her mother's spirit, and meditates deeply, with arduous bone-breaking intensity, concentrating on an image of the buddha of her era. She finally hears the voice of that buddha, who transports her down to the hell realms, where she witnesses various local tortures. But she learns from one of the hell guardians that her efforts have saved her mother, who has already departed from hell to heavenly realms, where the mother's spirit will prepare for spiritual practice.

In the second story the daughter, named Bright Eyes, is also concerned about her deceased mother, who relished eating animal flesh and also regularly spoke ill of others. Bright Eyes is advised by an awakened arhat disciple to make offerings to the current buddha, which she does. She is granted a vision of the mother's experiences in hell. Thanks to Bright Eye's intervention, her mother's spirit is reborn to a lowly housemaid as a son destined to die as a child, rather than being reborn in hell. After Bright Eye's further entreaties and solemn vows to deliver all beings from hell from then onward, the mother is assured of new rebirths that will lead to her own spiritual awakening.

Desiring her mother's liberation, each daughter sincerely vows to work to benefit all suffering beings throughout the future. Both daughters arrive in hell to learn that through their dedication and sincerity not only are their mothers saved, but so are all beings then in hell. The deep vows of the Brahman woman and then of Bright Eyes to continue their liberating work for all who suffer, lead to their becoming Jizo Bodhisattva.

These "past life" stories of Jizo as a daughter, grieving for and rescuing her mother from hell, intriguingly reverse the story of Demeter, Greek Goddess of Grain, associated with the earth and agriculture. In the old myth, Demeter's daughter Persephone is kidnapped by Hades, King of the Underworld. Demeter is grief-stricken, and refuses to perform her work of endowing the world with fertility and harvest. In order to restore food to the world, which has become barren, the gods finally send the messenger god Hermes down to hell, the underworld of Hades, to rescue Persephone. She

ends up coming back for two-thirds of the year, but spending part of the year down below as Queen of the Underworld, during which period winter reigns above as Demeter goes into retreat.

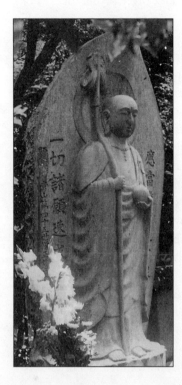

Memorial Jizo, Japan

Whereas Demeter is an earth-mother figure, rescuing her daughter from hell, Jizo has been a kind of earth daughter, going down to rescue her mother. The delivery of Persephone saves the earth and its people from the famine brought on by Demeter's grief and refusal of her duties. The delivery of the mothers of the Brahman woman and of Bright Eyes similarly saved all the other beings then in the hells. In seeing Jizo as an "earth daughter" caring for all suffering beings, we may recall the Buddhist practice of seeing all sentient beings as one's mother. One parallel in the Greek story is that the daughter goddess Persephone returns below to spend part of her year as the Queen of the Underworld, sharing her presence with the beings in hell.

Tibetans believe that we have all lived so many lives that every single person we pass in the street was in some former life either our parent or child.

"Seeing all beings as our mother" is recommended in traditional Asian Buddhist cultures. We come into existence in each moment totally mutually dependent, and interdependent, with all phenomena. Thus all beings are like our mothers, helping give us birth, and are worthy of our love.

The stories of Jizo as earth daughter and the popular veneration of Jizo at cemeteries and memorial sites in East Asian countries reflect primary Confucian virtues of filial piety that were absorbed and developed in East Asian Buddhism. This filial concern is also apparent in Indian Buddhist roots and relates to issues of family practice mentioned in the discussion of Shakyamuni's bodhisattva career. Jizo as the archetypal monk emphasizes that Buddhist home-leaving does not necessitate the abandonment of family members as beings unworthy of compassionate care. In fact charity, compassion, and liberative work begin at home. In the very first sentence of the *Sutra of the Past Vows of Kshitigarbha Bodhisattva*, Shakyamuni Buddha is said to be expounding this teaching especially for the benefit of the spirit of his mother, the Lady Maya, who died seven days after giving birth to Shakyamuni, and who arrives from her place in the heavenly realms to join the assembly. In the course of the sutra the Lady Maya questions Kshitigarbha about the nature of the various hell realms, giving him the opportunity to warn beings of the retributions for misdeeds.

This relationship of Jizo to family values has developed and strengthened in the history of Japanese Buddhism. Family ancestral memorials, often graced by stone Jizo images, are erected at a particular temple, and that temple becomes the locus of family worship and spiritual identity.

JIZO AS PROTECTOR OF WOMEN AND CHILDREN

The discussion of earth mothers and daughters indicates Jizo's special relationship with the feminine. One benefit of invoking Jizo mentioned in the sutra is that women who wish it will be reborn as men, and women who like being women will in future births be attractive and in good social standing (where they are less likely to be oppressed). This in part reflects the historical prejudice against women in Asian patriarchal societies, which at times influenced Buddhist writings and institutions (although such prejudice is certainly not an essential part of any worthy spiritual teaching). But Jizo's promise to help women may also be taken as a simple recognition of the unfortunate hardships and social obstacles facing women who wish to engage in spiritual practice.

Jizo's role as a protector of women dates back to the *Sutra of the Past Vows* and appears throughout East Asian history up to the present. Many medieval Japanese nuns were especially devoted to Jizo. Though most Japanese Buddhist sculpture included robes as part of the carving, one genre of medieval Japanese Jizo statues were carved as naked, then covered with cloth robes. Modern scholars have discovered that a number of these "naked" Jizos, commissioned by nuns, were anatomically female under their robes, apparently in secret affirmation of the enlightening capacity of women, and of the feminine side of the conventionally male Jizo archetype.

Jizo has continued to have a special relationship with women, sometimes as a healing figure for women's ailments, and also as protector of children in Japan, which was not a feature of Kshitigarbha in China. A whole class of Jizo images is considered to help bring an easy childbirth. In modern Japan Jizo is much revered by women and has gained prominence in ceremonies to aid the spirits of abortions and deceased children.

Jizo is popularly considered a guardian of travelers and children in Japan, and many statues of the bodhisattva are set at crossroads, riverbanks, and seashores, all liminal or transitional spaces. Jizo is said to guide people across the "river of three crossings," the passage between this world and the afterlives. In a myth native to Japan, Jizo appears at the *Sai no Kawara*, or Sai riverbank, where many children are blocked from crossing into new rebirths, particularly those who have died by the age of seven—considered to be an age of initiation in Japan as well as Europe. These young children are said to be stacking pebbles to try to build a crossing, but the piles are repeatedly knocked over by demons. Jizo is said to arrive at such crossings and help guide the children across the river to the next life. The stone mounds also symbolically represent Buddhist memorial stupas, traditionally built to develop merit, thereby acting as spiritual as well as physical bridges. Stone piles are often seen near Jizo statues, created by relatives to assist the child spirits.

Historically, the roadside stone Jizos seem to have supplanted old phallic stones that were part of native Japanese animist traditions, and which also had stones piled before them. As they weather and their features fade, some upright stone Jizo statues indeed have phallic overtones. Thus, in popular Japanese religion, Jizo has had a complex of blessings to offer to women devotees as required, including fostering fertility as well as easing childbirth and protecting deceased children and abortions.

Cemeteries behind Japanese temples house many stone Jizos, which often have red bibs around their necks and are surrounded by toys and candy left in commemoration of and for the benefit of the spirits of specific deceased children and aborted fetuses. Ceremonies for the spirits of aborted children, *mizuko* "water children" ceremonies, have become a big business at some temples in Japan, where abortion has been accepted as a major form of birth control. In these ceremonies the mothers and sometimes the fathers and siblings of aborted fetuses petition Jizo to help aid the child spirits to find peace and happy rebirths. The fetus is acknowledged as a living being and given respect and spiritual assistance, even though circumstances led the mother to choose abortion. Thus abortion has not become such a polarizing issue for Japanese Buddhism as it has for contemporary Christianity, although some Western observers have questioned whether such ceremonies have helped rationalize easy acceptance of abortion.

JIZO AND THE EARTH SPIRITS

Creation and veneration of images of Jizo are praised as beneficial and responsive to specific petitions. This is also true for other bodhisattvas, especially Avalokiteshvara, a practice reflecting the prominent role of prayer in popular Buddhism. Such prayer can be understood both as humbly seeking succor from Jizo as a force in the world, and as aligning oneself inwardly with the intention and spirit of Jizo.

In the *Sutra of the Past Vows*, there appears a protective earth spirit named Firm-and-Stable, who guards the land. The Buddha states that it is through this earth spirit's power that all vegetation and minerals come forth from the ground. His role seems analogous to that of Demeter in Greek mythology. Out of great appreciation for Jizo and his vow, Firm-and-Stable promises support to all those in the present or future who enshrine and venerate images of Jizo. He mentions such benefits as fertile lands, long life, protection from floods, fires, robbery, and nightmares, and many conditions for arousing sagehood.

The earth spirit's assistance to Jizo, the Earth Womb Bodhisattva, is reminiscent of the earth, or an earth goddess, testifying to Shakyamuni's awakening under the bodhi tree when he was challenged by Mara. Some scholars believe that the figure of Kshitigarbha originally derives from Prithvi, the Vedic Goddess of the Earth. This again highlights bodhisattva practice as earth-based spirituality, valuing the ground of this very world and life rather

than some other, idealized state of being or some otherworldly locus or goal of practice.

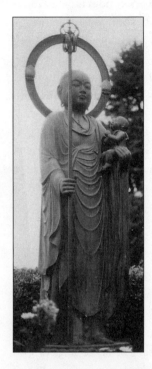

Jizo with child, Japan

THE TEN KINGS OF HELL

Kshitigarbha's relation to the earth, and its hell depths, was further depicted in China, and in early Japanese Buddhism, in Jizo's relationship with Yama (in Japanese Emma), the Indian God of Hell. Chinese Buddhism adapted Yama to an early Chinese Taoist myth of a god of the underworld assisted by ten judges, who keep records of arriving beings' past misdeeds and help assign them their places in the hells. A Taoist-influenced Chinese text from before the tenth century, called the *Sutra of the Ten Kings*, and a group of popular writings developed from it, depict this aspect of Kshitigarbha. In this Chinese folklore, Kshitigarbha was sometimes considered to be one of these ten judges, and sometimes even as another form of Yama himself. Although he appears in these texts as one of the group of fierce hell guardians, or even as the ruler of hell, Kshitigarbha simultaneously manifests as a priest mitigating the hell occupants' plights. In China and Heian

period Japan (ninth to eleventh centuries), Jizo images were often shown together with fierce images of Yama. This aspect of Jizo's relation to the earth and the underworld, as stern judge of people's conduct, never interfered with Jizo's predominant, benevolent role of working to save beings. The ten underworld kings motif did not develop as a major factor in Jizo's role in Japan.

In the *Sutra of the Past Vows of Kshitigarbha Bodhisattva,* Yama and his many assistant "ghost kings" appear expressing their appreciation of Kshitigarbha. They wonder at the obstinacy of beings who, due to the stubbornness of negative, unwholesome habits, continue in misconduct leading to the hell realms. But Yama and the ghost kings, inspired by Jizo, promise to aid and lessen the burdens of any of the hell-bound beings who may have ever taken on spiritual practices by reciting sutras or venerating buddhas or bodhisattvas.

JIZO AS SHAMAN

Jizo Bodhisattva's guidance of beings in the afterlife, his journeying to different realms to help beings, and his relationship to the earth all exemplify Jizo's role as a shaman, a word deriving from a Siberian people's word for spirit healers. Shamanism as an anthropological and religious term has been defined in a great variety of ways, but most basically refers to healers who journey to other psychic or spirit realms, above and below, usually on behalf of beings in need. Shamanism is a major feature of the native, primal religions in much of the world. Like Jizo, shamans are often described as psychopomps, a technical religious term for those who guide beings into afterlife realms. Shamans also use the protection and assistance of various earth spirits—animals, totems, herbs, and dream beings—just as Jizo is aided by the earth spirit Firm-and-Stable.

Indigenous, earth-based spirituality universally honors the power and beneficence of the natural world and expresses gratitude and wonder for all elements that support life. Animals and plants as well as geographical features such as mountains, forests, and particular rocks and trees are honored as independent spirit beings and forces, interrelated with the whole.

The shamanic undercurrent was incorporated into Buddhism from native traditions throughout Asia, including India, Tibet, Mongolia, China, Korea, Japan, and Southeast Asia. Jizo, the Earth Womb Bodhisattva, has incorporated this native shamanism into his archetypal qualities. Shamanic, native

spirituality is also a feature of Native American traditions. It is not surprising that Jizo is finding popularity among Buddhist practitioners in North America, where native spirituality was still widely practiced until only a century or so ago, and is reemerging as an influence on many contemporary spiritual seekers.

Shamans are sometimes referred to as "wounded healers." Such shamans are individuals who have suffered deeply, plunged into their own inner abyss, and awakened to a calling to care for others. In his past-life stories of the daughters going down into hell for their mothers, Jizo suffered and witnessed the torments of hell. After learning of the success of her strenuous efforts on behalf of her mother and of the other hell beings, the Brahman woman, the first daughter who goes down into hell, declares that she will not live much longer. After arising from her successful concentrations to save her mother, she had fallen down, breaking all her limbs. Similarly, many traditional shamans undergo visions in which they are torn apart or otherwise physically shattered. As an archetype, the wounded healer remains prominent even in our post-shamanic worldview, apparent among many modern psychotherapists, social workers, and teachers who draw on their own severe experiences of suffering to help others.

Some, but not all, traditional shamans are also priests or monks. Although monastic communities in most societies developed later than shamanic traditions, Jizo's persona as a monk may also be related to his helping and shamanic functions. As a priest, Jizo ministers to the needs of those confronting death. Indeed, the primary activity of many contemporary Japanese Buddhist priests is to conduct funerals and regular memorial services for the departed.

OBON CEREMONIES

Obon ceremonies (in Sanskrit *ullambana*) are held in mid-August in Japan and, until recently, were performed in China as well. These ceremonies are thought to date back to a community ritual that Shakyamuni Buddha initiated for the benefit of his disciple Maudgalyayana's mother, who had become a hungry ghost. This ritual was then transformed so as to benefit all beings in unfortunate realms. During the several-week period of these ceremonies, all the spirits of the dead are said to return to this realm, and prayers and offerings are made for them and for all unquiet spirits. Foremost among these rituals is the *segaki* "hungry-ghost-feeding" ceremony, per-

formed in order to propitiate hungry ghosts and restless spirits. Many special dharanis are chanted to appease and satisfy the spirits, and abundant food is offered on the altar to feed the hungry ghosts. Obon is by far the busiest time of year for all Japanese Buddhist priests, as they go to the homes of all their parishioners, as well as to cemeteries, to chant for the benefit of deceased family ancestors. The *Sutra of the Past Vows of Kshitigarbha Bodhisattva* is recited as part of these ceremonies.

Smiling Jizo, Japan

According to old Chinese texts from the Ten Kings tradition, a ceremony said to commemorate Dizang's (Jizo's) birthday is held at the end of the ullambana period to seal up the hells. In Kyoto, toward the end of the regular Obon period, special Jizo Obon ceremonies are still conducted to protect and guide children. For several days, distinctive pavilions with Jizo altars are erected on every block or two. Priests come to perform beneficial chants, including the *Sutra of the Past Vows*, as children gather around. There are also games the children play, and candy and cake for them to eat. In many ways this festive time for children parallels our Halloween, as it is

also the time when strange spirits are being sent back to their weird realms.

The house where I lived for two years in Kyoto, between a large temple complex and its cemetery, was on a block where the children had all grown and departed; most of the residents were elderly women or couples. But Jizo Obon was still a cherished custom. For two or three days a table and altar were set up between our house and the one next door, adorned with bunting and banners, cookies and treats, a number of small Jizo figures, and a specific stone Jizo figure borrowed from a grouping of buddhas just inside the cemetery on the other side of the house. Although no children still lived on the block, several grandchildren visited and played games at the Jizo altar.

On the last night of Jizo Obon, an American friend and I joined about ten women from the block around the altar, chatting and telling stories. Then we passed a long, thousand-bead rosary around the circle, everyone holding part of the large circle of beads as they flowed through our fingers, while we all chanted "Namu Amida Butsu" a thousand times. Veneration of Amida Buddha and Jizo naturally fit together in the combination of practices. Afterward we enjoyed the treats left for Jizo. While the sense of the event was to maintain the tradition of veneration of ancestral spirits and protection of children, the feeling was of pleasure, playfulness, and friendliness, all informed with the intimate presence of Jizo Bodhisattva.

JIZO PILGRIMAGES AND FOLKLORE

Jiuhua Shan "Nine Blossom Mountain" in Anhui Province in south-central China is the sacred mountain of Jizo, or Dizang, to use his Chinese name. Jiuhua Mountain is an important monastic center and remains a prominent destination of pilgrims to the present day. It was venerated as the site of Dizang at least from the ninth century, when a large community gathered there around a Korean Buddhist monk, Jin Qiaojue, who came to be regarded as an incarnation of Dizang, and was referred to as Jin Dizang, combining his first name with that of the bodhisattva.

In Japan there are also many Jizo worship sites and pilgrimages. The eastern hills along the southern part of the city of Kyoto have historically been a major site for burial grounds. Many popular Jizo images are enshrined at temples in the area, especially visited during the August Obon ceremonies. During Obon there is also a popular pilgrimage, dating back to the twelfth century, to six Jizo statues set at traditional entry gates around Kyoto.

❖

East Asia has a rich folklore about Jizo, and many stories feature unusual, "miraculous" events. An old Japanese tale tells about an elderly peasant couple enduring a severe winter. On the day before the New Year celebration, the grandest day of the year, the wife gave the husband some cloth she had woven to sell at the market in town. He was unable to find any buyers, but in the late afternoon encountered a hat seller who also had not made any sales, and the husband exchanged his cloth for five straw hats.

Pilgrimage altar Jizo, Kyoto, Japan

As the husband trudged home, a snowstorm arrived. He came upon six stone Jizo statues by the roadside nearly covered with falling snow. Feeling bad for Jizo, whom the old couple venerated, the husband brushed off the statues and placed the five hats on the statues, using his own hat to cover the sixth Jizo. Then he returned home. The old couple calmly went to bed hungry, but were awakened by the jangling of the rings on monks' staffs, chanting voices, and a thump on their doorstep. They found a large bundle of

food and other provisions, and saw six Jizo-like monks walking away in the distance. This story exemplifies the common feeling of the closeness of Jizo, especially for the humble and those in need.

A number of narratives tell of specific persons saved from hell by Jizo, sometimes revealed after revivals following apparent deaths, or in the dreams of associates of the deceased. Because of some expression of faith in Jizo during their lives, they are rescued from hell. In addition to being a guide to the afterlife and a savior of hell dwellers, Jizo has developed other beneficial roles in popular Japanese lore. Most prominent is as healer, with Jizo statues at certain temples known as being helpful for particular maladies, including measles, boils, headaches, and ear problems. Jizo is especially known as a physician for women. Prayer to Jizo is considered beneficial during pregnancy to ease and protect childbirth, and also for protection during early childhood.

A whole genre of Jizo stories involves Jizo taking the place of devotees who face danger or hardships. The statue at the Mibudera temple in Kyoto is celebrated for miraculously giving aid, such as on one occasion when it warned temple occupants in their dreams of a fire, thereby allowing them to awaken and extinguish the blaze. A fourteenth-century chronicle tells of a member of an unsuccessful rebellion who was saved by this Jizo image, which appeared as a priest when the soldier came to take sanctuary in the temple. The priest gave the soldier a rosary and sutra and took his sword. When the enemy soldiers arrived shortly thereafter they found the rebel calmly reading a sutra, and instead took the priest holding the bloody sword and bound him and threw him into prison. The next morning the priest had disappeared from his cell, but when the Jizo shrine was opened they saw the Jizo image tied up with ropes. Filled with awe and repentance, the soldiers all decided to become monks.

Some Jizo statues are said to aid laborers, taking on the down-to-earth manual work of others when needed, especially farmers and those working in the soil. One story tells of a hard-pressed farmer praying to Jizo for help during a difficult harvest. Upon awakening the next morning the farmer found a critical part of his task finished, and the lower legs of the neighborhood stone Jizo all muddied, apparently from working the fields. Some of the stories in which Jizo substitutes for others are rather amusing. In a temple on Mount Koya, the sacred mountain of the Shingon School, the abbot told a laborer that he must arise very early and shovel away the snow

before a Jizo image carved by the school's great founder Kukai, or Kobo Daishi, because Jizo rose early every morning and went out to save suffering beings. One morning the servant gruffly expressed the wish that just once Jizo might shovel the snow for himself. The next morning the servant awoke to find the snow already cleared from the garden and snowy footprints on the veranda of the Jizo hall leading back to the room where the image was housed.

One of the older Japanese tales provides a charming depiction of the value of faith in Jizo. A devout, aged nun heard talk that Jizo walked about daily at dawn, and she began roaming the area herself in hopes of seeing him. A con man observed her and inquired why she was out in the cold. When he heard of her mission, the man promised the nun he would show her where Jizo was if she gave him some money. The naïve nun gladly assented, and the trickster took her to the house of some townspeople he knew who had a ten-year-old son named Jizo. They said that Jizo was out but would soon return. The old nun happily gave the con man her silk outer robe and stayed to wait for the boy, much to the perplexity of the parents. When the lad arrived the parents said, "This is Jizo," and the nun was overcome and prostrated herself in adoration. When she looked up, the youth, playing idly with a stick, scratched his forehead, which split open, revealing the radiant countenance of Jizo Bodhisattva. Tears of joy streamed down the nun's cheeks, and she immediately passed away into the Pure Land. This story is an early example of the Japanese association of Jizo with children, and the common people's feeling of the proximity and sympathy of Jizo.

JIZO AS CONQUERING WARRIOR

As preeminent guide to the afterlife and benefactor of those facing hell, Jizo was considered by medieval Japanese samurai a protector of soldiers, whose profession it is to face death in battle and who especially risk going to hell through their activities. Many famous Japanese warriors revered Jizo based on folk stories of soldiers being protected or aided in battle by Jizo-like priest figures. A cult of a warrior Jizo figure developed in ninth-century Japan and became popular among the samurai during the civil wars of the sixteenth century. Celebrated especially among the severe, mountain ascetic Shugendo practitioners as well as the samurai, a figure called Shogun "Victorious Army" Jizo was venerated. This Shogun Jizo was depicted clad

in warrior armor over priest robes, usually riding a horse. (This word *shogun* is somewhat different from the military-ruler shoguns, those who gained power over Japan at the beginning of the seventeenth century.)

The warrior Jizo exemplifies the varied circumstances to which Kshitigarbha has been applied. This armored figure of Jizo has not survived into modern Japan, and need not be regarded as a major aspect of the Jizo archetype. But even the Shogun Jizo was considered to protect against fires and other calamities, and to be especially helpful to women in childbirth. He was also said to bring peace, albeit sometimes by vanquishing the wicked in battle.

THE SPACE WOMB BODHISATTVA

A much less celebrated but complementary bodhisattva figure associated with Kshitigarbha is Akashagarbha (in Japanese Kokuzo), the Space Womb Bodhisattva. Sometimes Jizo and Kokuzo images appear as attendant bodhisattvas on either side of the Healing Buddha, a popular cosmic buddha figure (called Bhaisajyaguru in Sanskrit, Yakushi Nyorai in Japanese). Akashagarbha represents the principle of space or emptiness as opposed to Jizo's earthiness or ground-centeredness. This space is considered the fifth element in traditional Buddhist cosmology, after earth, water, fire, and air. As an element it is characterized by various positive attributes, such as the absence of all obstacles to awakening.

Akashagarbha is depicted with a wish-fulfilling gem on top of his head or in his hand, as he grants the wishes of beings who take on purification practices and acknowledge and repent their past unwholesome actions. Akashagarbha was highly venerated by mountain ascetic groups, who performed visualization exercises focused on him. He is mentioned in the *Sutra of the Past Vows of Kshitigarbha Bodhisattva*, where he asks Shakyamuni Buddha to elaborate the benefits to be derived from devotion to Kshitigarbha.

JIZO AND THE PARAMITAS

The transcendent practices emphasized by Jizo are vow, discipline or ethical conduct, powers, and effort. As already described, Jizo is especially venerated for his strong, longtime vow to save beings in even the most horrific situations. Jizo has been enacting this vow for an inconceivably vast time

period and will continue to do so until the arrival of Maitreya as the next Buddha. He is always present in all realms to help all of us. We can activate this aspect of Jizo in our practice when we commit ourselves to remain present with those in desperate situations, calmly and sympathetically witnessing their plight and giving assistance when or if we can.

Jizo's commitment to the second paramita—ethics, morality, or discipline—is apparent in his persona as a monk, embodying ideal standards of purity and discipline. A major aspect of Jizo's liberative work is to educate people to the consequences of their actions. In his sutra he warns the assembly against misdeeds and their resulting unfortunate destinies as he catalogs the horrors of the numerous different hells and the actions that lead beings to them. The Earth Womb Bodhisattva also recommends beneficial spiritual practices and enumerates their positive outcomes, both in the temporary benefits of heavenly realms and also in the deeper qualities of an awakening, compassionate lifestyle. When we study our responsibility for the consequences of our deeds and share this study with others, we are extending the ethical concern of Jizo.

Jizo exhibits the perfection of powers in his effectiveness in liberating beings, as in the pictures of Jizo lifting beings out of hell. He offers numerous beneficial practices, through venerating his images or sutra, or through recitations of his name or his mantra, *On ka ka kabi sanmaei sowaka* in Japanese, which is said to help beings in need. Furthermore, he remains present with beings stuck in hell, waiting for an opportunity to help out when their causal conditions for suffering have been sufficiently expiated. In the many folk stories in which Jizo substitutes for others in hardships, he shows his power to perform the toils of others, and even to accept their tortures.

While all the bodhisattvas are involved with all of the ten perfections, the other paramita that seems particularly demonstrated by Jizo is effort. Jizo Bodhisattva works hard. He endures the fires of hell for the sake of helping beings. Perhaps this quality of Jizo as a hard worker, with a straightforward, down-to-earth style and practice, is what makes him one of the most beloved of the bodhisattvas.

EXEMPLARS OF JIZO

In reflecting on the archetypal qualities of the Earth Womb Bodhisattva and how they might be envisioned in our own culture, I conceive of the modern exemplars of Jizo as those willing to witness with dignity our con-

temporary hells, willing to testify, despite their dread and grief, to these horrors. With this steady presence, they are sometimes even able to help the afflicted, or at least in some sense redeem their suffering.

I think of Elie Wiesel, the 1986 Nobel Peace Prize winner, in his role as witness to the Nazi Holocaust. Wiesel has written many powerful books that attest to the horrors suffered by Jews during World War II. As a teenager in Auschwitz and then Buchenwald, Wiesel, like Jizo, beheld the torments of hell.

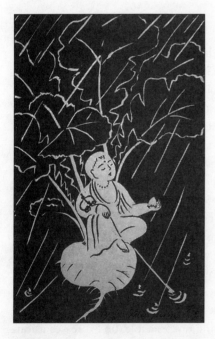

Jizo goddess

In *One Generation After*, amid graphic descriptions of the concentration camp atrocities, Wiesel expresses the importance of this witnessing:

> Rejected by mankind, the condemned do not go so far as to reject it in turn. Their faith in history remains unshaken, and one may well wonder why. They do not despair. The proof: they persist in sur-viving—not only to survive, but to testify.
>
> The victims elect to become witnesses.

On his way to the mass grave, the historian Simon Dubnow exhorts the Jews of Riga, his companions in misfortune: "Open your eyes and ears, remember every detail, every name, every sigh! The color of the clouds, the hissing of the wind in the trees, the executioner's every gesture: the one who survives must forget nothing!"

In Buchenwald, I attended several "literary" evenings and listened to anonymous poets reciting verses I was too young to understand. They did not write them for me, for us, but for others, those on the outside and those yet unborn.

There was then a veritable passion to testify for the future, against death and oblivion, a passion conveyed by every possible means of expression.[2]

Wiesel testifies to the horrors with vivid images he etches on our hearts: a young, wide-eyed Jewish boy, hands above his head in surrender, surrounded by Nazi soldiers with rifles aimed, about to shoot him; "children with bloated heads like old men, and old men with childlike emaciated bodies";[3] pregnant women hanging from trees; young Jewish mothers, naked, attempting to modestly cover themselves as they are herded with their children, also naked but well behaved, into the gas chambers. Wiesel reflects on these terrible scenes, unsurpassed in horror by any of Jizo's visions of hell. Wiesel considers what they mean about us as humans and how we can understand and withstand such cruelty, and discusses the details of the individual moral choices that led to such consequences.

Through his witness Wiesel redeems the suffering of the residents of the hell camps, standing by them as Jizo would, and also warns us about our own worst capacities and our need for watchfulness. Through Wiesel, we can see Jizo's liberative work in hell as simply remaining present, humanity intact, willing to view the extremes of cruelty and suffering. Without attempting to issue explanations for the unspeakable, he expresses astonishment and perplexity, and the fullness of grief. Furthermore, by relating the concentration camp victims' own "passion to testify," he allows us to see them, too, as exemplars of Jizo, calling to us.

As witness to the Holocaust, Wiesel has continued observing and speaking of other horrors and violations of human rights since the World War II era, in places like Southeast Asia, Nicaragua, and South Africa. He helped call attention to the plight of Jews in the old Soviet Union, journeying Jizo-like to that realm of suffering to report and give comfort. After surviving the

Nazi Holocaust, Wiesel vowed to remain silent for ten years. He felt he had to wait, perhaps purifying himself like Jizo's past-life daughters waiting to enter their mothers' hells, before he could finally find appropriate words to bear witness.

The works of Toni Morrison, winner of the 1993 Nobel Prize for literature, depict the horrors and the spiritual struggles faced by African Americans. Morrison has written several novels that subtly and movingly describe her characters' plight amid hellish circumstances of slavery and racism. Her masterpiece, *Beloved*, is most notable as an example of the Jizo archetype, as it deals with mourning and reclaiming the spirit of a murdered child. In this story, set in Ohio after the Civil War in the early 1870s, Sethe, a former slave, and her daughter, Denver, live in a house that is frightfully haunted and visited by the spirit of Sethe's other daughter, killed when not yet two years old, the one word "Beloved" now etched on her tombstone.

The book reveals, with great poignancy and vitality, the dreadful conditions that led to the infant's death. We see through the eyes of Sethe's lover, Paul, the calamities on the road to escape from slavery.

> During, before and after the War he had seen Negroes so stunned, or hungry, or tired or bereft it was a wonder they recalled or said anything. Who, like him, had hidden in caves and fought owls for food; who, like him, stole from pigs; who, like him, slept in trees in the day and walked by night; who, like him, had buried themselves in slop and jumped in wells to avoid regulators, patrollers, veterans, hill men, posses and merrymakers. Once he met a Negro about fourteen years old who lived by himself in the woods and said he couldn't remember living anywhere else. He saw a witless colored woman jailed and hanged for stealing ducks she believed were her own babies.[4]

As the characters are able to face their situations and acknowledge the dead child's spirit, their own suffering is eventually recognized and accepted, although it is uncertain whether Beloved's spirit is finally pacified. To reveal significant plot elements might impair the drama of Morrison's tale. But as Morrison eloquently allows us to see and share in what has happened to Sethe, the reader comes to understand her fierce determination to defend her children from the hell of slavery. We as readers are also immersed in her hellish experience. Along with protecting children, Jizo's work of witnessing

to hell is in the forefront of the lives of all the many characters attempting to deal with the ghosts of their own slavery. Witnessing these ghosts, the reader sees how they still haunt our society today.

The mother and daughters in *Beloved* struggle to understand how they are hell-bound and by what means they can help each other, much like the passionately caring earth daughters and mothers described in Jizo's past lives in the sutra. Sethe and her daughters travel across the borders of life and death like Jizo, haunting each other and witnessing the shifting hells, and sometimes maybe even saving each other from further horror.

Thomas Merton, the Trappist monk and inspiring writer who was instrumental in developing interfaith dialogue between Buddhist and Catholic monastics (and dedicated practitioners from many other spiritual traditions), has illuminated the aspect of Jizo as archetypal monk. In an informal talk in Calcutta in 1968, during the trip to Asia in which he was accidentally and tragically electrocuted, Merton expressed his view of the monastic vocation in the sense in which it is common to all religions. Merton elaborates on the monastic as the committed "marginal person," outside the mundane world of society, but concerned for the ultimate spiritual state of all beings. For Merton a monk is "a marginal person who withdraws deliberately to the margin of society,"[5] thereby seeking to deepen the essence of human experience in himself and for all people. Merton describes how monks are intentionally irrelevant as they traverse the usual bounds of life.

> The marginal man accepts the basic irrelevance of the human condition, an irrelevance which is manifested above all by the fact of death. The marginal person, the monk, the displaced person, the prisoner, all these people live in the presence of death, which calls into question the meaning of life.... The office of the monk or the marginal person, the meditative person or the poet is to go beyond death even in this life, to go beyond the dichotomy of life and death and to be, therefore, a *witness* to life [italics added].[6]

Merton's monk is marginal, on the fringes, outside and irrelevant to the common stream of social goals and conventions, just as Jizo stays present in the rounds of the six destinies without being caught by any of them. Jizo Bodhisattva appears as a monk because, as Merton clarifies, a monk's job is to stand witness to all life and death from a place that transcends their

boundaries. The ideal monk, like Jizo, crosses back and forth over the border between life and death, returning to the liminal, transitional spaces while remaining clear and observant of the fundamental meaning of whatever may be experienced.

Merton clarifies the essential humility of the monk. Monks are not *better* than ordinary people in the world. Monks do not possess an unusual "capacity to love others greatly." They understand that "our capacity for love is limited. And it has to be completed with the capacity to be loved, to accept love from others, to want to be loved by others, to admit our loneliness and to live with our loneliness because everybody is lonely."[7] We might see in this humility of the archetypal monk the humble aspect of the monk Jizo, the Earth Womb Bodhisattva, who is down-to-earth, concerned with common people, and also greatly beloved by Mahayana devotees.

Thich Nhat Hanh, the Vietnamese Zen master now a popular teacher in the West, exemplifies Jizo as a monk working for peace in the midst of war. In the early sixties, during the hell of the Vietnam War, the Vietnamese monk Thich Nhat Hanh founded the School of Youth for Social Service, whose students worked on social service projects to help peasants in South Vietnam. The students were committed to nonviolence and hoped to encourage peace and reconciliation. But in the context of colliding forces determined to escalate conflict, Thich Nhat Hanh and his colleagues were seen as threats and were attacked by both sides. Many of Thich Nhat Hanh's students and friends were killed. He traveled to the United States, hoping to help stop the war. Although he made a strong impression on many, especially on spiritual leaders such as Martin Luther King, Jr., the war raged on, and Nhat Hanh was forced to remain in exile or face certain death upon returning to his homeland.

Today, long after the end of the active fighting in Vietnam, Thich Nhat Hanh still works for peace from his new home in southern France and during visits to America and elsewhere. A prolific writer, he has spread the Mahayana teachings of wisdom and compassion, helping many people find inner peace in a troubling, violent world. Many of his friends, family, and fellow monks and nuns have been killed or tortured. Nhat Hanh works to help Buddhist leaders in Vietnam currently imprisoned and undergoing torture, and Vietnamese refugees still living in peril. Having witnessed intense suffering and the horrors of wartime, Thich Nhat Hanh maintains a demeanor that is amazingly and genuinely serene, calm, and gentle. He encourages

his audiences to smile, to enjoy their breathing, to enjoy restful walking meditation, and to slow down all the unnecessary hurry and busyness in their lives. He emphasizes the smile on the face of buddha and bodhisattva images, and the joyfulness of connecting with the underlying unity of the buddha nature available when we can stay present in our lives right now.

Like Jizo, who remains present to help liberate beings in all situations, Thich Nhat Hanh sees clearly, with compassion and kindness, the consciousness of all suffering beings, whether victims or aggressors. Nhat Hanh sees that taking sides, and labeling some as "the enemy," only perpetuates the hell realms created when we imagine ourselves separate and unrelated to others. Jizo Bodhisattva does not reject anybody. All beings are deeply, inextricably interconnected in interbeing, or as Thich Nhat Hanh says, "We interare," appearing together in this web of mutual causation, of dependent co-arising that is the true nature of our lives.

Thich Nhat Hanh also conducts workshops for people from many contemporary realms—writers and artists trying to express deeper visions of reality, social activists facing burnout from the stress and difficulty of their helping work, American veterans of the Vietnam War still suffering from harsh physical and psychic wounds, and recently even world political leaders. Though identified with socially engaged Buddhism, Nhat Hanh rarely speaks directly of political issues, but always encourages people to find and express their own inner peace in mindfulness of the present moment and in gratitude for what is wondrous in our present experience.

Jizo Bodhisattva's monkish commitment and vow to witness to the suffering of beings has been enacted in various ways, not only by formally or officially ordained monks. An example of the modern monk in our own North American culture is the dedication and intensity of the great jazz musicians. I am most deeply inspired by the work of John Coltrane, but a large number of other jazz adepts, such as Charlie Parker, Bud Powell, Lester Young, Charles Mingus, Thelonius Monk, McCoy Tyner, and Pharaoh Sanders (to name only a few), exemplify Jizo in their monklike commitment to their art and its spirit. Marginal to much of mainstream culture and working amid an often hellish milieu of racial discrimination, poverty, and, all too frequently, drug addiction, these pioneers have extracted music from inner realms to testify powerfully to spiritual truth and beauty.

Coltrane, a great master in this tradition, persevered through lack of critical appreciation and his own demons (including use of heroin and alcohol)

to create a pioneering application of harmonics and rhythm in highly vision-
ary music. Inspired by African and Asian musical traditions as well as read-
ings ranging from Islam to Kabbalah and from Plato to Krishnamurti,
Coltrane sang his own inner heart and glory, for example in his classic hymn
"A Love Supreme." His music can be considered a unique expression of
universal vision and wonder, more in the mode of the Samantabhadra
archetype. However, the inner depths Coltrane explored to bring forth his
spiritual sense of sound, with its ferociously energetic, angular improvisa-
tions, reflect as well the dedication of Jizo to persistent witness of the truth
and raw beauty of awakening, arising even out of the hellish. Coltrane was
concerned with "new sounds to imagine; new feelings to get at...so that
we can see more clearly what we are. In that way we can give those who lis-
ten the essence, the best of what we are."[8]

Many American Buddhist practitioners have turned their attention to wit-
nessing our society's hells. As the AIDS epidemic spread in the 1980s, many
took on hospice work, becoming companions for the dying. The Zen Hos-
pice Program, initiated at the San Francisco Zen Center, trains people to
work as hospice volunteers for anyone terminally ill, in homes or in hospi-
tals. At the Hartford Street Zen Center in San Francisco's largely gay Cas-
tro district, Zen priest and teacher Issan Dorsey established a hospice to
care for many of his own students and their friends as they succumbed to
AIDS-related diseases. Before Issan's own death from AIDS, his temple
(now named Issanji after him) expanded into the building next door to
include a functioning hospice facility along with its meditation hall.

Witnessing for and assisting dying people clearly reflects the traditional
and central Buddhist concern for the "great matter of life and death." Stay-
ing present to face the dying process has greatly deepened the wisdom and
commitment of the hospice workers, as well as helping people pass on with
dignity and awareness, in an atmosphere of love and kindness. These hos-
pice projects contributed significantly to the critical needs of caring for vic-
tims of the AIDS plague, expressing Jizo's vow by tending to the hellish,
wasting conditions of AIDS victims.

Many hells exist in our world today. In many countries brutal torture con-
tinues as a regular practice. Jizo's work is carried out by Amnesty Interna-
tional and many other organizations and individuals devoted to monitoring
human rights violations throughout the planet and ministering to the victims
of torture. Jizo is present and much needed in our world.

Other "hell realms" of people on the fringes of our society's dreams and enterprise include the worlds of the imprisoned, the homeless, and the inner-city poor. Another example of someone expressing the practice spirit of Jizo by aiding such people is my friend Frank. Frank and I began meditation practice around the same time in New York City with a Japanese Soto Zen priest. Several years later I moved to California, but continued to be inspired by Frank and his work. Since our teacher retired in the mid-1980s, Frank has continued intensive daily meditation on his own.

Frank is a social worker employed by New York City, for a long time assigned to Harlem. His job at times has included working to rehabilitate prostitutes and drug addicts, frequently in extremely dangerous neighborhoods. Frank sometimes befriends his clients. One such client was a young, pregnant woman with an addiction problem and a remarkably difficult family situation. Frank, without family or children of his own, fell in love with his client's new daughter when she was born. With the biological father long gone from the scene, Frank ended up becoming godfather to the infant as well as to her older sister. For many years now he has spent most of every weekend with the family, acting as father to the two young girls and encouraging wholesome developments for those in the extended family whenever it has been possible.

I envision Frank, with his commitment to care for these girls and in all of his dedicated work, as a Jizo-like presence protecting children and helping diverse beings in hellish situations. Frank himself scoffs at the notion of his implementing formal bodhisattva vows and feels that his own life has been enriched immeasurably from the connection with his goddaughters. He attributes his ability to confront the great challenges of their situation joyfully, with his "most wholesome totality," not to any virtue of his own, but simply to the energy emerging from meditation practice.

9
Maitreya
Bodhisattva As Future Buddha

SHAKYAMUNI BUDDHA predicted that his disciple Maitreya would become the next incarnated Buddha in the distant future. Awaiting his destiny as the future Buddha, the Bodhisattva Maitreya now sits nearby in Tushita Heaven, one of the blissful meditation domains in our own realm of desire, contemplating how to save all suffering beings. Maitreya Bodhisattva may appear in our world incarnated as a bodhisattva, and also is sometimes depicted as the future Maitreya Buddha. He awakens our hopes for the future and our responsibility to the generations to follow. Maitreya's call concerning the future has rich implications for the present, which we will further consider after exploring some of the traditional components of the complex Maitreya archetype.

The legend of Maitreya has a long, elaborate history. Aside from Shakyamuni himself, Maitreya was the first bodhisattva to be venerated and recounted in Buddhist sutras. Maitreya (Metteya in Pali) is documented in the Pali suttas of the Theravada tradition as well as in the Sanskrit Mahayana sutras, and Metteya/Maitreya has continued to be an important figure throughout both Theravada and Mahayana history. He is sometimes called Ajita "Unconquered," his given name, as his more customary name, Maitreya, is by some accounts a family name. Maitreya is transliterated Milo in Chinese, Miroku in Japanese.

The many different references to Maitreya give conflicting descriptions, but some indicate that Maitreya may have been based on a historical disciple of Shakyamuni, possibly either a son of King Ajatasattu of Magadha, a son of the king of Varanasi, a disciple of a South Indian Brahman sent to

study with the Buddha, or the son of a rich merchant. Many of the accounts of Maitreya are of a novice, or relatively junior disciple. In some versions of the story, other disciples were perplexed when Ajita was predicted as the next future Buddha, as he was not particularly distinguished for his wisdom or rigorous practice, and indeed seemed a bit naive, even foolish.

But Maitreya, whose name means "Loving One," had a caring and generous character. The Metta "loving-kindness" after which Maitreya (Metteya) is named is a traditional Buddhist mindfulness practice in which the practitioner emanates good wishes and loving thoughts toward particular beings. Although the eventual aim of such practice is to mentally bestow blessing on all beings, beginners are advised to start with family and other intimates, for whom loving thoughts are already present. Gradually these thoughts can then be extended to unknown beings and finally, perhaps, even toward one's supposed enemies. Such generous, loving wishes, generally more directed and focused than Avalokiteshvara's immediate responsive compassion, and less deliberate than Samantabhadra's intentional, beneficial efforts in the world, are central to the Maitreya archetype.

Based on the sutras and early commentaries, the amount of time that will pass between Shakyamuni's prediction of Maitreya's buddhahood and his final arrival at that state varies widely. Current estimates of Maitreya's final enlightenment range from 7.5 billion years, to 30,000 years in the future, to the date 4456 C.E.

According to later Mahayana writings, Shakyamuni's great disciple Mahakashyapa, also considered the First Ancestor in the Chan/Zen lineage, is waiting in a meditative state of suspended animation, encased in a cave on Kukkutpada, or Cock's-foot Mountain, deep in the Himalayas. When Maitreya appears as a Buddha, it is said that Mahakashyapa will arise from his meditation and present Maitreya with Shakyamuni's robe and bowls, celebrating Maitreya as the new Buddha. Mahakashyapa waiting for Maitreya was a popular motif in East Asian Maitreya lore.

SPECULATIONS ABOUT MAITREYA'S ORIGINS

In the early sutras committed to writing a few centuries after Shakyamuni's death, and in the commentaries that followed, Maitreya developed as a figure who represented a future golden age of enlightenment. Scholars have debated the origins of Maitreya, speculating about the influence of Zoroastrianism on Buddhism. With its savior figure Saoshyant, who is predicted to

appear in the future to welcome a paradise of eternal happiness, Zoroastrian thought certainly influenced all Mideastern religions and may perhaps have influenced the development of the Maitreya story. Zoroastrianism, in turn, may have been influenced by the Maitreya figure and other Mahayana ideas.

Historically we need not see Maitreya as arising from non-Indian sources, as early Indian religions (such as Jainism) spoke of future great spiritual or even savior figures. More relevant are the early Buddhist concepts of many buddhas over the ages, before and after Shakyamuni. Other buddhas preceded Shakyamuni, even prior to the six buddhas commonly designated in the Mahayana as coming before the seventh buddha of our age, Shakyamuni. And other buddhas will follow, even after Maitreya Buddha.

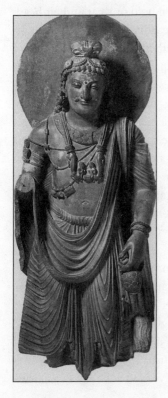

Maitreya Bodhisattva, Gandhara,
circa 2nd–3rd centuries

ICONOGRAPHY OF MAITREYA

Statues of Maitreya are among the earliest Buddhist images. Maitreya was already a popular figure during the second century C.E., when the Gandharan

images of Shakyamuni appeared in northwest India and then Central Asia. Maitreya images under Hellenistic influence and with European features followed shortly after those of Shakyamuni. Maitreya was thus probably the first bodhisattva figure to be venerated, and as his images circulated in central Asia, he was thought of as a patron of missionaries, who were actively spreading the teachings there. Iconographically, Maitreya is sometimes depicted as a Buddha in the future, sometimes as a bodhisattva. Huge stone statues of him were built along the trade routes in central Asia and northwest China, often on borders to show that the new country would become a future buddha field. The two huge stone buddha statues in Afghanistan that were destroyed by the Taliban government in 2001 were Maitreyas dating back to the third and fourth centuries.

North and East Asian Maitreya images often hold or wear in their headdress a stupa, a reliquary originally containing bones or ashes of Shakyamuni. Later stupas came to contain relics of other great Buddhist teachers, or images of buddhas or bodhisattvas. The stupa has a complex symbolism, with ascending portions of the structure representing earth, water, air, fire, consciousness, and space. The East Asian pagoda is an architectural adaptation of the stupa, with the same symbolic elements. Maitreya is the only bodhisattva commonly holding a stupa, but he may instead hold a dharma wheel, a medicine jar, a golden vase containing nectar, or a lotus. In Tibetan images the stupa is in Maitreya's crown, and in Korean images the stupa is often on top of his head, sometimes on a large square platform.

Maitreya often is depicted as a bodhisattva in Tushita Heaven contemplating suffering beings. He is usually sitting on a throne with one or both legs down, in what is sometimes referred to as Western style, fingers to his chin as if in thought. The Japanese images in this form, which appeared early in Japanese Buddhism and some of which were brought from Korea, are among the most famous Buddhist statues in the world. They make a striking contrast to Rodin's *The Thinker*, analogous in pose but different in feeling and tone. Whereas the Western thinker is contorted and tense in his pondering, seated Maitreya sits more upright, usually with a delicate, graceful quality, concentrated, emotionally suggestive, and wistfully thoughtful, but still usually serene.

Perhaps the most famous example of this contemplative Maitreya is the statue at the Koryuji Temple in Kyoto, one of the earliest Buddhist temples in Japan. Near this famous, serene Maitreya image sits a smaller statue called "Weeping Maitreya," sitting in the same pose, with fingers to cheek, but

leaning forward and clearly crying over the suffering of beings in this age before his arrival in the world as a buddha.

Some sutras describe Maitreya in his abode in the meditation heavens as attended by heavenly musicians and maidens. These are sometimes depicted as small figures sitting or floating above and around Maitreya on the halo behind him. Adding to the complexities of his iconography, Maitreya is also sometimes depicted seated on a white cow, similarly to Manjushri on his lion and Samantabhadra on his elephant.

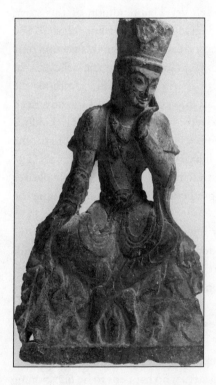

*Maitreya Bodhisattva, Northern
Wei dynasty, China, 6th century*

MAITREYA IN EARLY BUDDHISM AND THE THERAVADA

The Mahavastu, a Pali text of the Mahasanghika School, an early precursor of the Mahayana, was one of the earliest sources to give a comprehensive account of Maitreya and his past lives, also listing future buddhas that would follow Maitreya. Generally emphasized is the very long period, fraught with various setbacks over numerous lifetimes, that would pass between Maitreya's first thought of enlightenment and his future buddhahood.

Although mention of Metteya (Maitreya) in the early Pali suttas is casual rather than extensive, in the postcanonical Theravada tradition and literature, he gradually assumed a prominent place. One popular story featuring Metteya deals with a gift of two lengths of cloth to Shakyamuni by Mahaprajapati Gautami, the foster mother of Siddhartha Gautama as a child. In the version that appears in Pali texts around the sixth century c.e., the Buddha asks her to instead offer the cloth to the sangha, or community. After hearing an erudite discourse by the monk Ajita, she offers the cloth to him, and he, in turn, makes it into canopies for the Buddha's chamber.

However, in a popular nineteenth-century Thai rendition of this story, Gautami feels slighted that the Buddha will not accept her offering. She offers it to the senior monks, but all decline except Ajita, in this version only a junior novice. The Buddha observes Gautami weeping; she believes that Ajita's lowliness proves her own lack of merit. The Buddha summons the assembly and throws his alms bowl up into the clouds. All the advanced disciples with their powers are unable to retrieve the bowl, but at the Buddha's suggestion, young Ajita asks that, if he is truly leading a spiritual life for the sake of enlightenment, may the Buddha's bowl descend to his hands. The bowl immediately lands in Ajita's outstretched palms, which greatly pleases Gautami and leads to Shakyamuni's prediction that Ajita will become the future Buddha Metteya.

Here Maitreya appears as a rather humble, inexperienced disciple, his virtues not apparent even while he is actually preparing to be the next buddha. The extensive accounts of Maitreya's background and future buddhahood in the later Theravada traditions include such details as his future enlightenment sitting under a "dragon flower" tree and subsequent discourses to dragon-flower assemblies, a prominent motif in Maitreya imagery.

In early Mahayana sutras Maitreya appears, like Manjushri and numerous others, as the particular generic bodhisattva who happens to be questioning the Buddha to elicit some point of teaching. But occasionally specific qualities of Maitreya emerge. For example, in the *Perfection of Wisdom in Eight Thousand Lines*, Maitreya declares to Shakyamuni's disciple Subhuti that of all beneficial activity, the most excellent is the work of a bodhisattva when it is founded on dedication and rejoicing or jubilation, qualities characteristic of the Maitreya archetype.

MAHAYANA AMBIVALENCE TO MAITREYA

Maitreya appears in a highly ambivalent light in some of the early Mahayana sutras. In the very first chapter of the *Lotus Sutra*, Shakyamuni Buddha emits a light from between his eyebrows that puzzles Maitreya, who questions Manjushri. Manjushri reminds Maitreya that in a remotely past buddha land, they had witnessed a similar light emitting from a previous buddha, a light that had heralded the teaching of the *Lotus Sutra* on behalf of that buddha by a bodhisattva named Fine Luster, none other than Manjushri himself.

Among Fine Luster's eight hundred disciples, one named Fame-Seeker Bodhisattva was actually Maitreya in a former life. This Bodhisattva Fame-Seeker was named thus because he craved personal profit and advantage; although he read and memorized numerous sutras, he derived no benefit and quickly forgot most of them. Although Maitreya, at least in his past life, is thus dishonored by his former teacher Manjushri, the bodhisattva of wisdom goes on to say that the slothful Fame-Seeker also did many kind deeds. These allowed him to train with numerous buddhas over many lifetimes until now he was finally the Bodhisattva Maitreya, destined to be the next buddha.

Although the *Lotus Sutra* opens with Manjushri's rather dim view of Maitreya's distant past, the final chapter of the *Lotus Sutra*, delineating Samantabhadra's protection of students of the sutra, offers a more positive view of Maitreya and his future. Samantabhadra certifies that those who read the *Lotus Sutra* and understand its import will be reborn in Maitreya's Tushita Heaven. Samantabhadra describes this realm as highly meritorious and beneficial, as Maitreya abides there already possessing the marks of a buddha, accompanied by a retinue of bodhisattvas and goddesses.

The evolving visualization practices aimed at rebirth in Maitreya's heaven were ultimately dedicated to one's own progress toward awakening in the universally beneficial bodhisattva path. But the pleasures of Maitreya's abode are sometimes emphasized as an enticement to practice—which seems to be somewhat the case in Samantabhadra's description. In the early Mahayana, Maitreya is at times depicted less as an active benefactor of suffering beings (like Samantabhadra, Avalokiteshvara, or Kshitigarbha) and more as someone simply waiting around to be the next buddha. Perhaps this reflects disparagement of the origins of Metteya in the pre-Mahayana, Theravada suttas. A minor scripture, the *Sutra of the Lion's Roar of Maitreya*, states explicitly that desire to see the future buddha is a Hinayana defilement, in other words, is merely self-serving.

MAITREYA AND THE YOGACHARA

In the development of Mahayana doctrine, Maitreya as bodhisattva is most closely associated with the Yogachara teachings and their study of consciousness and psychology. From his vantage in the meditation heaven, Maitreya contemplates the phenomenology of consciousness and perception, deeply considering how to save all the confused and suffering beings, thereby seeking to fulfill his destiny as a fully awakened buddha.

Most prominent of all the Yogachara teachers were the great fourth- to fifth-century Indian Buddhist philosophers, the brothers Asanga and Vasubandhu. Vasubandhu wrote the *Abhidharma kosha*, an important proto-Mahayana commentary on the early Abhidharma analytical system of psychology. He was later converted by his older brother Asanga to the Yogachara School and wrote important Yogachara commentaries. Vasubandhu is also honored in the Zen lineage as one of its Ancestors in India.

A number of important Yogachara texts are traditionally attributed to Asanga, although sometimes they have been viewed as written by Maitreya himself. Asanga's works include the *Yogachara bhumi*, "Grounds (or Stages) of Yogic Practice," which includes the *Bodhisattva bhumi*, "Stages of the Bodhisattvas." Asanga also compiled the so-called Five Books of Maitreya, which include the *Abhisamayalankara*, a summary of the *Perfection of Wisdom in Twenty-five Thousand Lines*. Modern scholars attribute some of these texts to Asanga and some to a teacher named Maitreyanatha, whose name means "Devotee of Maitreya." It is not clear whether this Maitreyanatha was Asanga's teacher or perhaps is another name for Asanga himself. A number of Yogachara teachers apparently took the name Maitreya, or variations on it, as their Buddhist name. Traditionally, Maitreya is said to have magically transported Asanga to the Tushita Heaven, where he gave Asanga Yogachara sutras and these other commentary texts. This may indicate that visions of Maitreya Bodhisattva inspired or revealed the texts to Asanga, or to some other devotee of Maitreya, who committed them to writing.

The legendary teaching story about Asanga's relationship to Maitreya is a quite colorful representation of the fullness of the loving-kindness that characterizes Maitreya. Asanga spent twelve years in solitary meditation in a cave in the Himalayas, doing practices involving visualization of, or devotion to, Maitreya. After twelve years of intense practice without any evident result, Asanga departed his cave feeling discouraged. As he approached a

town he encountered a dog whose lower body was being eaten by worms. Struck with sympathetic concern, Asanga realized that removing the worms would kill them, but that leaving them would lead to the dog's death. Immediately Asanga decided to cut some flesh from his own body to feed the worms and remove them from the dog. He went to the town and traded his monk's staff for a knife, then returned to the dog.

After cutting some flesh from his thigh, Asanga thought that if he picked the worms off the dog with his hands they might also die. So he determined to remove the worms from the dog with his tongue. At the moment he was about to proceed, the dog vanished, transformed into Maitreya in all his radiance. Overwhelmed with tears, Asanga asked why Maitreya appeared now, when Asanga had abandoned hope of seeing him, and had never manifested through all of Asanga's meditative exertions. Maitreya answered that he had been near Asanga from the beginning, but Asanga's conditioning had made him unable to see. But thanks to Asanga's kindness to the dog and the worms, he was now able to behold Maitreya.

Maitreya asked Asanga to carry him on his shoulders into the town. Asanga did so gladly, although the townspeople could only see Asanga carrying a smelly, infested mongrel. Asanga was then offered any wish by the brightly glowing Maitreya, and Asanga asked for guidance on how to disseminate the Mahayana teachings. Thereupon Asanga was transported directly to Maitreya's Tushita Heaven, where he engaged in study with Maitreya. Sometime thereafter, Asanga returned to the human realm and established a monastic training center where he wrote down what he had learned. Legend has it that he would give teachings at the monastery by day and return to Tushita Heaven each night to study Yogachara treatises.

Maitreya's approval of Asanga's kindness toward the dog as well as the worms is a vivid example of Maitreya's unconditional love. Such concern for even the humblest of creatures may be seen as a quality of Maitreya, which is echoed in some of his exemplars.

MAITREYA VISUALIZATION

Before Amida Buddha and his Western Pure Land became the dominant object of devotion in East Asian Mahayana Buddhism, many groups focused on visualization exercises designed to bring rebirth in Maitreya's heavenly realm. According to Buddhist cosmology, Maitreya's realm is even closer than the pure lands of cosmic buddhas such as Amida, since Mai-

treya's meditation heaven, attainable via visualizations, is still within this realm of human desire. In Buddhist cosmology the universe consists of three realms, the realm of desire, in Sanskrit *kamadhatu;* the realm of form, or *rupadhatu;* and the formless realm, or *arupyadhatu.* From the time they first ascend the traditional Indian dhyana system to experience the form and formless realms beyond desire, meditation adepts already are too lofty to arrive at Maitreya's heaven. From this viewpoint, visualization of Maitreya was an accessible practice, especially appropriate for people who did not have the time or yogic skill to perform more advanced meditation practices.

Devotees sought to visualize in detail, while in samadhi, their own presence with Maitreya in his Tushita Heaven, thereby arriving in that realm either in this body, or in some future rebirth. Such Mahayana visualization practice is similar to Vajrayana practices, but the tantric visualizations involve explicitly seeing oneself as the bodhisattva figure envisioned, while the Mahayana practices aim for a more general affinity with the bodhisattva and his qualities.

Elaborate Mahayana visualization practices for Samantabhadra as described in sutras such as the *Flower Ornament* and the *Lotus* are mentioned in chapter 6, although these exercises seem too demanding to ever have been very popular, and historically there has never been widespread cultic activity around Samantabhadra. Visualization exercises involving Manjushri did achieve some popularity among early Mahayana practitioners. But visualization practices that were directed at Maitreya in Tushita Heaven were clearly more prevalent in East Asia than visualizations for any other bodhisattva figure. Practice aimed at arriving up in Maitreya's heaven are described in terms of the motif of Maitreya's ascent, as opposed to his descent to the world, either in human incarnations or upon his buddhahood.

Many great Buddhist teachers hoped to be reborn in Maitreya's heaven. One of these was the great early seventh-century Chinese scholar-monk Xuanzang, founder of the Chinese Yogachara School, whose translation of Avalokiteshvara as Kanjizai is mentioned in chapter 7. Xuanzang is famous for his sixteen–year pilgrimage to India, where he visited many Buddhist sacred sites and monasteries. Once Xuanzang was a passenger on a large boat sailing down the Ganges River, when it was attacked by pirates. After capturing the boat and taking all the passengers' valuables, the pirates decided that Xuanzang, with his calm, dignified manner, would be ideal for the annual human sacrifice to their deity.

Xuanzang, realizing he could not dissuade the pirates, asked only for a little time to quiet his mind before they used their swords on him. He con-

centrated his mind on Tushita Heaven, reflecting mindfully on Maitreya. He vowed to be reborn there so that he could learn teachings from Maitreya and perfect his wisdom, thereafter to be reborn in this world in order to teach these pirates to abandon evil and practice virtue. Then Xuanzang would propagate the teaching and benefit all beings.

While his executioners waited, Xuanzang silently offered homage to all buddhas and sat mindfully with thoughts fixed on Maitreya. Xuanzang visualized the ascent of the heavens until reaching the palace and throne of Maitreya, by which point he was so rapt in bliss that he had no awareness of the pirates and their sacrificial altar. Suddenly a powerful storm arose, uprooting trees and capsizing all the boats. The pirates fearfully reconsidered their sacrifice. Xuanzang, who had been oblivious of the storm, returned to ordinary awareness, whereupon the pirates repented and begged forgiveness, and finally received the Buddhist precepts. Xuanzang eventually returned to China, translated many Mahayana texts into Chinese, and wrote important commentaries, especially on the Yogachara texts associated with Maitreya.

Some visualization exercises focusing on Maitreya were centered on and aimed at the goal of rebirth on earth at the time of Maitreya's future buddhahood, rather than rebirth in Maitreya's heaven. But clearly the ideal aim of the practice, at least in Xuanzang's case, which became a model for other Maitreya devotees, was ultimately to find auspicious rebirths for the sake of more fully returning to the beneficial bodhisattva work in this world, even before Maitreya's advent.

From the fifth through the eighth centuries these Maitreya visualization practices were popular in China and spread throughout East Asia. Such concentration exercises, along with repentance for having fallen short of Maitreya's loving-kindness, were integral to the practice of many, probably the great majority, of Maitreya devotees. By the sixth century, interest in Amida Buddha and his Pure Land began to develop. While Maitreya devotionalism had always occurred in conjunction with practices concerning the other bodhisattva figures, Amida devotees came to see Amida Buddha's Pure Land as the superior, sole focus of their spiritual aspirations. From about the ninth century, devotion to Amida and to practices of entry into his Western Pure Land supplanted in popularity the practices aimed at Tushita Heaven and Maitreya, although cult activities surrounding Maitreya sporadically returned to prominence.

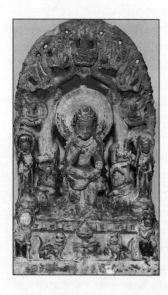

Maitreya Bodhisattva stele,
China, dated 551

BODHISATTVA AS THE NOT-YET BUDDHA:
AWAKENING THE FUTURE

The paradoxical quality of spiritual awareness—the exalted and timeless intersecting with the ordinary and temporal—is especially pregnant in the situation of Maitreya. Maitreya the future Buddha is defined as the bodhisattva who is not yet a buddha. As such he embodies the unfulfilled aspect of the bodhisattva. He is caught in not presently being what everyone knows he is promised to become. He is a mere shadow of his future self.

In the sutra named after him, the layman Vimalakirti (see chapter 10) devastatingly criticizes and challenges the entire notion of Maitreya's future buddhahood. Maitreya is reluctant to visit Vimalakirti on his sickbed when requested to do so by Shakyamuni Buddha. Maitreya relates that one day Vimalakirti dropped by in Maitreya's Tushita Heaven, interrupted a colloquium among the resident deities, and queried Maitreya about his understanding of the nature and meaning of his next birth, in which it was predicted he would become the Buddha. In the discussion, Vimalakirti asserted that the idea of buddhahood existing in a next birth was false because, in reality, the three times are merely a conventional fiction; we are born, age, die, and transmigrate in a single moment. This predicted birth could not be in the past, which is already finished. If in the present, it does not abide. If only in the future, it will never arrive.

Furthermore, ultimately there can be no prophecy of something that does not already exist, nor can there be any personal, private attainment of a truly perfect enlightenment. A buddha's enlightenment is the realization of all beings, who attain ultimate liberation together and simultaneously with a buddha. Enlightenment is all-pervading, like the vastness of space. So the notion of Maitreya alone attaining such a state in some imagined future time is simply nonsensical. To establish discriminations about an enlightenment as existing in a future, or actually existent at any "when," is a delusion. Maitreya relates that Vimalakirti warned him not to mislead the heavenly beings who listened to him with false notions and discriminations about enlightenment. Silenced by this discourse, Maitreya was unable to respond to Vimalakirti's challenge.

Vimalakirti's position in this argument, refuting conventional views of time (as well as any view of enlightenment itself), is only one of a number of complex theories of time and history implied in Buddhist philosophy and literature. Contemplating Maitreya's position as undergraduate bodhisattva, only one future life away from ascendancy to buddhahood, requires us to consider the nature of temporality.

The dominant view in traditional East Asian culture sees the world as devolving. In this view contemporary people cannot live up to the virtue and genius of the old sages and masters or the benevolent ancient emperors. An important Buddhist theory of history, especially influential in Japan around the eleventh through fourteenth centuries, held that the Dharma had gone through three ages of decline until the final age, when true practice and enlightenment had vanished and only the shell of the teaching remained. The decadent final age (*Mappo* in Japanese) was believed to have already arrived, although this theory was not universally accepted.

A related, fantastical theory more directly associated with Maitreya was that the human life span was gradually decreasing. It had once been tens of thousands of years long and would ultimately last a mere decade, after which the life span would again increase. Maitreya was supposed to appear when the life span again reached its maximum.

These negative views of history are contrary to the popular modern Western view of history as a march of progress, driven by the wonders of science and technology, which will eventually solve all problems and give us a perfect understanding of the universe. Of course, even in the West we have begun to lose faith in the total omnipotence of science and materialism, and to recognize the fallibility and limitations of human rationality. We

are also familiar with negative Western views of modernity, which seek to hearken back to a perhaps mythic past haven of family-based moral values and decency in our culture.

A positive spiritual outlook on history is implied in the Mahayana view of sangha, the communal monastic institution, as an agency for the development and perfection of beings. The basic direction for bodhisattva effort is the vow, ideally enacted by spiritual institutions in the world, to encourage all beings toward realization of the truth of universal awakening. This can be seen as a historical goal that might be gradually realized or approached, as well as an omnipresent, timeless intention.

Echoing Vimalakirti's critique of Maitreya's attention to the future, much of Buddhist practice and teaching emphasizes the importance of presence, engaging the current situation with full awareness. This is sometimes expressed in terms of the timeless eternal. Another possibility is the Japanese Zen master Dogen's encouragement of the practice of "Being Time," involving the total, existential attention to and examination of the multidimensional richness of time, reenvisioning time but without trying to escape or deny the consequences of time as passing. Our life is always in dynamic process. In this understanding, time does not exist as some inflexible, external container, but is the vital expression and enactment of our own being right now. Time does not exist separate from our own presence. The complexity of time is expressed in such Mahayana teachings as the ten times of Huayan philosophy. These are the past, present, and future of the past; the past, present, and future of the present; and the past, present, and future of the future. The tenth time is the combination of the previous nine.

As a bodhisattva representing and sponsored by the future, Maitreya invites us to reenvision and reinhabit time itself. Buddha's view of time sees all times as included in the immediate present, here and now. Just as the bodhisattva path includes all beings, it includes all times in the present time of being. But Maitreya forces us to consider the historical as well as the existential future, and the relationship and implications of the future to our present situation. Maitreya calls us from the promise of the future to revitalize our concern for future generations (as well as for our own future rebirths).

Some messianic Maitreya worshipers have seen his advent as close at hand; some calculations estimate his arrival at 7.5 billion years after Shakyamuni's passing. But Maitreya has always inspired hopes and dreams for the future and therefore has drawn attention to the inadequacies and frailties of the present.

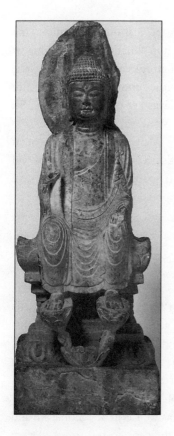

Maitreya Buddha, China, dated 675

MAITREYA AS MESSIAH

The Maitreya archetype has a quasi-messianic component, the promise that he will herald a climactic new golden age. However, as a messiah he is not equivalent to the Christian Jesus. Maitreya will be simply one of a long series of future buddhas existing throughout the seemingly infinite reaches of time in this and other universes. He does not present the finality and eternality of the Christ.

Because Buddhists believe that one's merit affects future rebirths, they have been concerned with conduct. Some early Indian laypeople, and especially Maitreya devotees, kept "merit books" describing their virtuous deeds, which were read to them on their deathbed to help purify their thoughts before dying and thus make the next rebirth a propitious one. But these rebirths are seen as an endless round leading to buddhahood, instead of leading to a single fixed, everlasting damnation or beatitude.

Maitreya has been a Buddhist symbol of hope, inspiring yearnings for a future utopian era. Mahayana believers, caught in situations of suffering or in societies filled with cruelty, have sought Maitreya's arrival on this world, and hoped to sojourn in his heavenly realm, either immediately or in future births. Some rocks and shrines in the Himalayas are covered with graffiti scrawls, both old and new, pleading, "Come, Maitreya, come."

The messianic yearnings engendered by Maitreya have often been expressed in worship and devotion. One traditional view is that Maitreya will appear only when the world is ready for him. If we each purify ourselves we will become worthy of Maitreya's beneficent presence in the future.

THE WHITE LOTUS:
POLITICAL IMPLICATIONS OF THE MESSIANIC

The centrality of Maitreya's relationship to issues of temporality suggests the relevance of the history of the Maitreya figure, which indeed reveals the scope and implications of the messianic aspect of the future Buddha. Early accounts of Maitreya's buddhahood indicate that he will extend his buddha field when the world has already become pure and wholesome, unlike Shakyamuni's awakening, which occurred at a time seen as a downswing in some Buddhist theories of history. Messianic yearnings inspired by Maitreya were expressed in the political arena as well as in devotionalism and visualization practices. Some felt that it was their job to reform or perfect society, after which Maitreya could appear. Others believed that Maitreya himself would appear as a great political leader or warrior to revolutionize the world and claim his buddhahood.

Some rulers sought to bolster their power by claiming to be messengers or leaders designated to prepare the world for Maitreya, or even incarnations of him. For example, Empress Wu, the powerful and controversial Chinese ruler from 685 to 705, countered the strong Chinese prejudice for submissiveness of women when she took active governance. She justified her imperial dominance by proclaiming that she was an incarnation of Maitreya Bodhisattva, and she energetically supported Buddhism and built many temples, some with large Maitreya statues.

Yearning for Maitreya also fed millenarian tendencies, especially in China, where Taoist and other pre-Buddhist mythology foretold an apocalyptic new age. Attempting to prepare the world for Maitreya's arrival, some devotees engaged in political activity against the established power structure,

sometimes revolutionary. Activist Maitreya cults were especially prevalent in fifth- and sixth-century China. Unsuccessful armed uprisings in Maitreya's name reoccurred sporadically, with significant examples in the seventh, eleventh, and early nineteenth centuries.

These millenarian movements came to be collectively designated as the White Lotus Society. Dating back to a lay Buddhist group in the early fifth century, the White Lotus movement encompassed diverse associations and communal groups that persisted at least into the mid-nineteenth century. Some advocated devotional practices or strict attention to ethical community conduct to ensure survival into the new Maitreyan age. Others were active proponents of social justice and change.

Along with Maitreya worship, these groups were strongly inspired by popular Taoist beliefs, including devotion to the Eternal Mother goddess. She was considered the progenitress of all human beings, who originally had been buddhas and immortals but had gone astray and forgotten their true nature because they were seduced by worldly gain. So the Eternal Mother vowed to save all of her children, with Maitreya sometimes seen as her messenger. Another influence beginning in Tang dynasty China was Manichaeism, whose followers believed in a historical battle between the forces of light and darkness, with the Prince of Light predicted to triumph in a final age.

The syncretist White Lotus folk movements, devoted at least in part to Maitreya, maintained an underground populist tradition and network throughout Chinese history, appealing often to disenfranchised peasants and itinerant townsmen. Its members included monks and laypeople who followed some traditional Buddhist ceremonial and repentance practices, recited sutras, and meditated. Within their sectarian organizations and small community associations, they practiced relative equality of the sexes, which was highly subversive in patriarchal Chinese society, especially as women, along with laymen, often attained positions of authority within the organizations. Many of the groups had hereditary leaderships as part of the teaching lineages that transmitted and maintained their traditions.

Some of the White Lotus cults pursued reformist activities on behalf of the underprivileged and oppressed, including public works projects. But all the White Lotus groups remained outside or opposed to the establishment, and were often outlawed. Even if not actively seeking to create it, they at the least proclaimed Maitreya's imminent descent, heralded by apocalyptic conflagrations, which would overcome the current political powers, seen as corrupt and degenerate, and would introduce a highly improved new age of

peace and egalitarianism. In response, the White Lotus groups were understandably feared and at times ruthlessly persecuted by the authorities of the changing dynasties, and the official dynastic histories hardly give sympathetic or full accounts of the varied White Lotus activities and beliefs.

In the middle of the fourteenth century these millenarian cults, after their long clandestine presence, secretly gathered their energies and collaborated to play a crucial role, while often invoking the name of Maitreya, among the forces that overthrew the Yuan (Mongol) dynasty. Some of the millenarian Maitreyan groups even established wide liberated zones of populist political control for about a decade. When the new Ming government consolidated power, the peasant-born founder of the new dynasty, a former Maitreya devotee himself, again outlawed and forcefully suppressed all groups espousing the coming of Maitreya.

The social activist, sometimes progressive aspect of the Maitreya archetype, hoping to create social conditions for Maitreya's buddhahood, definitely has been a minority feature, not followed by all Maitreya devotees. But increased knowledge from historians about the varied beliefs, activities, and communal organizations of the Chinese Maitreya activists may be of interest to modern socially engaged Buddhists, also attempting to apply Mahayana principles to problems and inequities connected with social structures.

HOTEI AS MAITREYA

In China Maitreya is nearly synonymous with his supposed incarnation as the historical tenth-century Chinese Zen monk Budai, whose Japanese name, Hotei, may be more familiar in the West. Chinese images of Budai, or Hotei, are frequently labeled simply "Maitreya" (Milo in Chinese) such that in popular Chinese awareness they are virtually identical. Hotei is legendary as a wandering sage with supernatural powers who spent his time in village streets rather than in the security of temples. His image is recognizable as the disheveled, fat, jolly "laughing buddha" whose statue is seen in many Chinese restaurants and in all Chinese Buddhist temples.

Hotei

Hotei's name means "cloth bag," as he carried a sack full of candies and toys to give to children, with whom he is often depicted in play. This scruffy Buddhist Santa Claus expands our view of Maitreya's warmth and loving-kindness. Hotei's fat belly and affinity with children reflects yet another aspect of Maitreya in popular folk religion, that of a fertility deity. Maitreya was sometimes prayed to by those who wanted children, especially in Korea.

The ten ox-herding pictures in the Zen tradition depict stages of deepening practice and awakening in terms of the metaphor of searching for and then taming an ox. The final picture, after the ox has been forgotten and spiritual practice is integrated with caring for the world, is called "returning to the marketplace with empty, bliss-bestowing hands." Most versions of the tenth picture show fat, laughing Hotei with his sack over his back, greeting a townsman.

In one story about Hotei that attests to his wisdom, he was stopped on the street by a monk of more orthodox appearance (possibly critical of Hotei's flamboyance), who questioned Hotei as to the fundamental meaning of the Buddha's teaching. Hotei immediately dropped his sack. The monk then asked about the actualization of the teaching. Hotei picked up his sack and went on his way.

Other stories describe Hotei as a dependable prognosticator of the weather, precipitation reliably according with the extent of his garb, whether or not he was wearing shoes or head cover. It is said that just before he passed away, Hotei recited a poem that expressed his regret that even though Maitreya sometimes appears in the world, he is unrecognized by people of the time. This led to the association of Hotei with Maitreya that has endured ever since.

HISTORICAL INCARNATIONS: MAHASATTVA FU AND RYOKAN

Along with claims by political rulers to being incarnations of Maitreya, other popular figures, more in the mode of Hotei, have been so designated. Mahasattva "Great Being" Fu was a sixth-century Chinese layman and teacher who claimed to have descended from Maitreya's Tushita Heaven and came to be widely regarded as an incarnation of Maitreya. A contemporary of the Chan/Zen founder Bodhidharma, discussed as an incarnation of Avalokiteshvara, Fu's life story is equally enriched with legend.

Fu attracted many students to his dharma lectures. Living in a time of great hardships and famines for the peasants, on three different occasions Fu sold all of his possessions to feed the local villagers and often also fasted to give away his food to the needy. In 548 he protested the government's treatment of the poor, initiating a campaign that in some ways foreshadowed Gandhi, by engaging in a long hunger fast that Fu announced he would finish with a fiery self-immolation as an offering to benefit all suffering beings. At the culmination of his fast, many of his followers asked to burn themselves in his place; others burned fingers or cut off ears as offerings, sold themselves as slaves, or engaged in other ascetic extremes, finally persuading the Mahasattva to abandon his plan. Until his death in 569, Fu and his disciples worked in the fields to feed the hungry. He also personally maintained arduous ascetic practices dedicated to universal well-being, and he held large devotional meetings where he lectured about liberation and chanted invocations to bless the poor.

Ryokan, the Japanese Zen monk and spiritual poet (1758–1831), is not traditionally considered a formal incarnation of Maitreya, but his life is a remarkably complete expression of an East Asian tradition of iconoclastic

but kindly hermit poet-monks, which includes Hotei and clearly exemplifies Maitreya. Ryokan was fully trained in a Soto Zen monastery, but instead of becoming a temple priest and teaching formally, he returned to live a hermit's life of meditation in a hut near his home village and made his modest livelihood via mendicant practice in nearby towns. Still a deeply beloved figure in Japan today, Ryokan chose the spiritual name Daigu, or "Great Fool," although he was well read, intelligent, a skilled meditator, and an elegant calligrapher whose brushwork was already treasured in his own time.

Perhaps best known for his kindly foolishness and play with children, Ryokan always carried balls or other toys in his robe sleeves and frequently broke from begging rounds to join in neighborhood children's games. Once, playing hide-and-seek, Ryokan hid in a barn. It got late and the children were all called to dinner. The next morning upon opening the barn, the surprised farmer asked Ryokan what he was doing. Ryokan said "Shh! Be quiet. The children will hear." Ryokan may have been so absorbed in samadhi that he was unaware of the night's passage, but such foolishness matches and illuminates Maitreya's naiveté and charming innocence.

Ryokan cared for even humble creatures. When he came out to sun himself before his hut in the morning, he would carefully pick the lice out of his robe and gently place them on a nearby rock. When he was finished he would just as carefully place them back in his robe. A famed Western scholar of Japanese literature, after telling this story, stated that no Westerner could take seriously such a person. However, Ryokan's loving care even for insects, echoing Asanga's concern for the dog and worms, illustrates the full extent of Maitreya's loving-kindness.

A more comfortably "human" example of his loving-kindness practice occurred when a relative asked Ryokan's help in dealing with his son, who was becoming a delinquent. Ryokan visited the family and stayed the night without saying anything to the son. The next morning as he prepared to depart, Ryokan asked the boy's help in tying up his sandals. As the lad looked up from doing so, he saw a tear roll down Ryokan's cheek. Nothing was said, but from that time the boy completely reformed. The easy camaraderie with children and attention to young people shown by Maitreyan figures such as Ryokan and Hotei is another form of Maitreya's concern for the future, in the next generation.

Ryokan's extraordinary legacy of poetry intimately captures the sincerity and simplicity of the way of life of some Maitreya devotees. For example:

Without desire everything is sufficient.
With seeking myriad things are impoverished.
Plain vegetables can soothe hunger.
A patched robe is enough to cover this bent old body.
Alone I hike with a deer.
Cheerfully I sing with village children.
The stream beneath the cliff cleanses my ears.
The pine on the mountain top fits my heart.[1]

MAITREYA FOLKLORE AND SACRED MOUNTAINS: KOREA AND JAPAN

Maitreya is particularly important in Korea, as Buddhism was introduced from China at a time when Maitreya veneration was at its peak. Beginning in the fifth century, an association of noble (male) youth developed in Korea called the Hwarang, who were devoted to Maitreya, and some of whom were considered his incarnations. They were affiliated with monasteries but also with the military as national defenders, and reflected strong shamanic and Confucian as well as Buddhist roots. The Hwarang trained in music and dance for elegant ceremonies, but also as ardent warriors who sacrificed themselves heroically on battlefields during the early history of Korea's warring kingdoms. After Korea was unified in the late seventh century, the Hwarang relinquished their military role and focused on the shamanic and ceremonial. These youthful devotees may have been models for the pensive, delicate Maitreya images that were exported to Japan.

Maitreya has often appeared in the role of protector in Korea. He has been a popular fertility figure, supposed to guarantee the sons much desired in Korea's traditional patriarchal culture. Maitreya has been incorporated into Korean shamanism, and thanks to his fertility powers is currently venerated in Korea primarily by women. In Korea and in Japan many small cults have arisen that claim some allegiance to Maitreya.

In Japan, from the first introduction of Buddhism in the seventh century through the cultural heyday of the aristocratic Kyoto court in the Heian era of the ninth through eleventh centuries, Maitreya was of prime importance as an object of devotion. Maitreya's messianic ideal and the utopian yearnings for rebirth in Maitreya's heavenly realm, or on earth after his buddhahood, were readily conflated with native Japanese veneration of sacred

spirits and particular mountains. Whereas Maitreya was not strongly asso-
ciated with sacred mountains of China, as were Manjushri, Samantabhadra,
Avalokiteshvara, and Kshitigarbha, Maitreya had an honored place at vari-
ous sacred mountains in Japan.

The Maitreya mountain cults have been supported by the *yamabushi*, or
mountain ascetics, who combined native mountain worship with practices
of Shingon, the Japanese branch of the Vajrayana that dominated the Japan-
ese Heian period and was founded by the brilliant ninth-century monk
Kukai. Also known as Kobo Daishi, Kukai is a legendary culture hero in
Japan, famed as a masterful sculptor, artist, meditator, and engineer of many
beneficial public works projects, who moreover is said to have invented the
Japanese syllabary alphabet. Kukai also was devoted to Maitreya. As he was
dying in 835, Kukai stated that he would be reborn with Maitreya in the
Tushita Heaven and then would return at the time of Maitreya's buddha-
hood, in 56 million years. Kukai's body remains enshrined at a temple on
sacred Mount Koya, home of the remote monastic headquarters he estab-
lished, and which at times since has been envisioned as Maitreya's Pure
Land. Still today, many Japanese pilgrims visit Kukai's mausoleum on Mount
Koya. In all Buddhist countries the location of a great many monastic train-
ing centers in remote mountains like Mount Koya in part represents the
urge to wait out the turmoil of the world until Maitreya's emergence. Over
the centuries, Japanese Maitreya-related mountain sects have developed
around Mount Koya, Mount Yoshino south of Nara, and Mount Fuji. With
mostly peasant followings, and supportive of reforms during frequent peri-
ods of hardship, these groups were devotional, not actively revolutionary,
believing in the power of Maitreya's descent and the natural correction and
mending of the world.

A unique strand of Japanese worship is the image of Maitreya's treasure
ship, which some groups believe will land on the shore of Japan from Mai-
treya's heavenly realm in the east laden with rice. Influenced by native Japan-
ese shamanism and agrarian mythology, this belief has inspired enduring
local cult activities in eastern Japan, featuring ceremonial dances and songs
to solicit the blessings of Miroku (the Japanese name for Maitreya). Thus in
Japan, Maitreya sometimes has become more of a deity of rice and abun-
dance than a future buddha.

New religious sects keep arising in modern Japan, including a group
whose leader declared himself an incarnation of Maitreya in 1928. A con-
temporary lay group emphasizing moral training and devotion follows a

Maitreya Sutra compiled from older sources in the 1960s, and has created a training and pilgrimage center called Mirokusan "Maitreya Mountain."

MAITREYA AND THE PARAMITAS

The transcendent practices emphasized by Maitreya are patience, meditation, and generosity. As he sits waiting, either for worldly conditions to ripen or perhaps for his own realization to fully mature, Maitreya in some sense epitomizes the practice of patience. Seeing Maitreya wait for a future buddhahood thousands of years or more in the future, we view his patience as unavoidable. His future has been prophesied. He has no choice but to wait, although he may incarnate in the world in various congenial forms during the intervening period. We can learn from Maitreya that patience is not something we have any choice about.

Learning patience is a matter of finding peace and balance with the unresolved or unsatisfactory when there is nothing that can be done except to wait it out. Of course some situations allow us to take positive, constructive actions to help improve or alleviate conditions, although such actions also usually involve patience. But when we can do nothing, or cannot yet see how to act, it may be helpful to follow Maitreya's model of contemplative consideration, waiting patiently.

Maitreya's meditation concentrates on the study of self, examination of the nature of consciousness for the sake of discovering the cause of suffering and the mental conditions for full awakening. This practice of the meditation paramita acts as a support for Maitreya's practice of patience. To become intrigued and absorbed in the yogic study of reality, consciousness, and the way things work together is a productive mode of waiting patiently. Thus Maitreya, in his waiting, deeply contemplates the arising, falling, and interactions of phenomena, especially including his own mental processes as they interact with the world. The clarity and self-knowledge from this contemplative awareness are naturally strong supports for all the other transcendent practices, allowing fuller generosity and skillfulness.

Maitreya's approach to the practice of generosity is based on loving-kindness and devotion. Maitreya simply wishes happiness to all beings, extending sweet, loving thoughts to all. In such a mental field, his intention clarified by his meditation, he naturally gives what he can.

EXEMPLARS OF MAITREYA

The complex Maitreya archetype has three major strands. The first is looking to the future, recognizing the unfulfilled potential of our own time or being, and envisioning a better one. This may mean hoping for an auspicious rebirth in Maitreya's heaven, or on earth during Maitreya's buddhahood, or it even may manifest as political activity aimed at preparing this world for the advent of Maitreya's golden age.

The second aspect is the deliberate, introspective study of consciousness. This is yogic psychology, studying oneself to try to understand the workings of the mind and thereby help end the suffering of beings.

A third strand of the Maitreya archetype is loving-kindness. Maitreya expresses love actively going out into the world. This energy is more intentional and directed than the responsive, caring compassion of Avalokiteshvara, with her empathetic listening and immediate response.

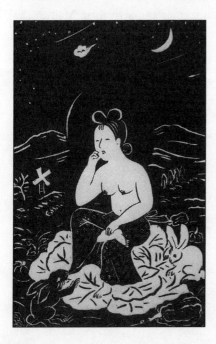

Maitreya Goddess

The outpouring of concern for loving-kindness in the sixties counterculture, with a call for a new age of peace and love, represented Maitreya energy. Among youth of that time, there was a strong sense of imminent possibility:

of new modes of living, thinking, loving, of bringing kindness and compassion into the political realm, or of "dropping out" to form new, "enlightened" small communities. Despite the hedonistic excesses that occurred, and the harm this caused to some individuals, many of the ideals, values, and new perspectives supported by the sixties counterculture have had lasting, positive impacts on the social landscape. The cry in the midst of America's Vietnam experience to "Make love, not war," and the call for flower power and sexual liberation, echo the hopes and idealism as well as some of the innocence and naïveté we might note in the millennial followers of Maitreya in ancient China. The counterculture's explorations of new dimensions of consciousness, initially via psychedelics, but then with yoga, meditation, and shamanic practices, also fit the Maitreya archetype.

The counterculture's relationship to a "vision of the future Buddha" is depicted in a poem about Maitreya written in 1967 by the fine American Zen poet Lew Welch. Welch was a close associate of Beat poets Gary Snyder, Allen Ginsberg, and Philip Whalen, all strongly influenced by Mahayana ideas. This poem, excerpted below, imagines the arrival of Maitreya as imminent:

Maitreya Poem

At last, in America,
Maitreya, the coming Buddha
will be our leader, and,
at last, will not be powerful, and
will not be alone...
Take it as a simple prophecy.
Look into the cleared eyes of so many thousands,
young, and think:

Maybe that one?
That one?
That one?...

Look out. (The secret is looking Out.)
And never forgetting there are
phoney ones, and lost ones, and foolish ones,
know this:
Maitreya walks our streets right now.
(each one is one. There are many of them.)

Look out. For him, for
her, for
them, for
these will break America as
Christ cracked Rome
　　　(and just tonight
　　　another one
　　　　　got born!)[2]

Welch's hopeful poem sees the potentiality of everyone as future buddha, sees the buddha nature in all beings. The doctrine of seeing everyone as a future buddha was associated with branches of Yogachara teaching. It might be seen as the converse of the practice suggested by the Jizo archetype, of seeing all beings as one's own past mother. In the shadow of the vision of new possibilities is the critique of things as they are—in the case of the sixties, during the civil rights movement and Vietnam War—of the failure and hypocrisies of the American dream, and the need for change and reform.

Out of the sixties flower-child mix came various aspects of Maitreya energy, including radical political activism displaying the sociopolitical expression of the messianic. Abbie Hoffman was a brilliant example of political activism grounded in Maitreya-like, new-age vision. Based in his experience of the psychedelic counterculture as well as of the social activism of the civil rights movement, Hoffman specialized in outrageous, attention-capturing events aimed at provoking the public to new, radical perceptions and possibilities. Hoffman was a longtime dedicated organizer against the Vietnam War and later on behalf of environmental protection. Hoffman is best known as one of the "Chicago Seven," who led antiwar demonstrations at the 1968 Democratic convention. Previously Hoffman had briefly closed down the New York Stock Exchange by throwing one-dollar bills from the gallery, resulting in a chaotic grab for single bills by the brokers, thus lampooning the operating factor of shortsighted greed. Some of Hoffman's satiric guerrilla theater escapades exemplified aspects of the trickster quality of Vimalakirti as well as Maitreya's foolishness, but his idealism and sense of imminent social revolution echo the Maitreyan activists.

The more dominant, less political image of Maitreya, studying the nature of consciousness to benefit beings, is evident among many prominent sixties counterculture figures, for example in the career of Ram Dass. In his for-

mer identity as Richard Alpert, Ram Dass was a Harvard psychologist researching the effects of LSD with his colleague Timothy Leary. Ram Dass abandoned his academic position and middle-class identity to pursue expansion of consciousness, initially through psychoactive drugs. But later, through his pilgrimages to India and practice with his guru there, Ram Dass redirected his explorations toward Hinduism and a variety of other spiritual approaches to the study of consciousness. His book, *Be Here Now*, was a popular inspiration and preparatory guidebook inviting post-hippie involvement in a wide range of Eastern religions and yogic practices, and encouraged the emerging New Age spiritual movement.

Ram Dass's teachings have included exercises ranging from Sufi to American Vipassana Buddhist practices, and more recently he has engaged in dialogues investigating his Jewish roots. Such eclectic inclusiveness echoes the popular Maitreya figures of China and Japan with their Taoist and native shamanic associations. Although all the bodhisattva figures have interacted with native cultural traditions, this eclecticism seems especially prominent in the openhearted figure of Maitreya.

Ram Dass also embodies Maitreya's loving-kindness in his extensive work on behalf of helping programs such as the Seva Foundation. Seva, from a Sanskrit word for service, offers medical assistance to people with blindness and other health problems in economically disadvantaged countries such as Nepal, India, Tibet, Guatemala, and Mexico, and also has programs on Native American reservations.

In his many writings, Ram Dass has given practical advice to help those engaged in varieties of healing work avoid stress and burnout. A popular lecturer, Ram Dass often speaks directly of loving-kindness practices, and his cheerful, humorous, sweet demeanor provides us with an image of what Hotei might look like in a contemporary context.

The Beats of the fifties and the hippies of the sixties were a continuation of a long tradition in America, which includes meditative and communal aspects of the Maitreya archetype that date back to the nineteenth-century Transcendentalists. An early exemplar of this tradition is Henry David Thoreau, whose writings and concerns about right livelihood, in its deepest sense, are still relevant and inspiring today. In his contemplations by Walden Pond, and his dedication to social justice and responsibility, Thoreau thoroughly expressed aspects of the Maitreya archetype.

Thoreaus musing as he sits in front of his Walden shack reminds us of

contemplative Maitreya, or of Ryokan sunning himself by his hermitage. Thoreau's attentive and illuminating observations of the surrounding flora and fauna, even to the workings of ants, is reminiscent of Maitreya's loving concern for all beings. We witness the loving-kindness and foolish joy of Maitreya in Thoreau's rejoicing at the simple wonders of the natural world, and in his practices to simplify his life.

Thoreau's writings against slavery and his public act of civil disobedience in opposition to the United States's imperialism in the Mexican War inspired both Gandhi and Martin Luther King, Jr. But Thoreau did not adopt a Samantabhadra-like programmatic activism that was part of a collective campaign for change; rather, his brief sojourn in jail was more an independent, idealistic statement, aimed at provoking in others a vision of other possible social modes, perhaps to be actualized in a just, Maitreyan future.

Thoreau's contemplations give us insight into Maitreya's view of time and future. For example, in a famous passage in the concluding chapter of *Walden*, Thoreau speaks of hearing a different drummer, and keeping pace to the music one hears, however long maturation should take. This is followed by a parable of an artist who sought perfection. The artist wanted to make a staff and was so resolute and engrossed in looking through the forest for the perfect stick to work from that he escaped time and achieved perpetual youth. By the time he had shaped and then smoothed the staff, dynasties had faded, the polestar had changed, and whole cycles of universes had come and gone. When the staff was finished, he had produced a whole new system of creation, and the time elapsed seemed no more to him than a single thought of the creator deity Brahma. His art was pure and the result wonderful. This parable of Thoreau's is a possible illustration of how time might look to Maitreya in Tushita Heaven, as he perfects his awareness while the passing ages of the history of man wait for his ascendancy to buddhahood and descent to the human world.

Another remarkably apt Maitreya exemplar is John Chapman, better known in legend as Johnny Appleseed. Chapman wandered around western Pennsylvania, Ohio, and Indiana in the first half of the nineteenth century planting and cultivating apple-tree nurseries and orchards. The Johnny Appleseed legend, firmly rooted in the historical Chapman, tells of a frontier folk character noted for courage and physical endurance as well as many eccentricities. With long, flowing hair and a scraggly beard, he was usually barefoot, with ragged, secondhand garb and a variety of improvised headgear, includ-

ing a tin mush pan. His apparel often consisted of a gunnysack with holes cut out for neck and arms (which may have been similar in material to the sack that Hotei carried, and for which Hotei was named). Chapman stayed with the many frontier families whom he befriended, and otherwise he rarely had any fixed abode. At home and happy in the wilderness, he slept in hollow logs or makeshift sheds when he was out planting his nurseries. Chapman foresaw the future needs of Euro-American agrarian expansion and made his voluntarily modest livelihood planting a profuse chain of apple nurseries in areas of Ohio and Indiana beyond the frontier in preparation for the advance of new settlers.

Although he often appeared as a homeless vagabond, like Hotei, Chapman was also an avid missionary of the Swedenborgian New Church and propagated Swedenborg's visionary spiritual beliefs among settlers along with his apple trees. Much of the historical record of Chapman is through his correspondence with contemporary Swedenborgians, whose theological principles and doctrines were among the most intellectually sophisticated and complex of the time. Chapman preached and passed out mystical tracts to many often-mystified settlers who were nevertheless grateful for his apple trees. Despite the jokes and teasing Chapman's preaching sometimes occasioned, he was instrumental in establishing a significant New Church presence in frontier Ohio.

Like Hotei, Chapman was a great favorite of children, with whom he enjoyed playing and telling stories. He frequently gave material assistance to frontier families in distress, giving away his apple saplings to those who could not afford to pay. Many tales relate Chapman's extreme kindness to wild animals, including nursing an injured wolf; carefully extricating from his pant leg without injury a yellow jacket that was stinging him; and deeply mourning a rattlesnake he killed unintentionally after it bit him. Chapman was highly unusual in his place and time for being a strict vegetarian, common among Maitreyans.

Chapman did not exhibit conventional Euro-American attitudes of acquisitiveness toward land. He was notably careless and unconcerned about registering claims of ownership to the locations where he planted his many apple nurseries (to which he was entitled by American law), apparently feeling, like the natives, that the land was open, free, and not to be possessed. Indeed, Chapman had mutual friendship with and respect for his Indian neighbors, who appreciated his generous character, spiritual disposition, and ability to enjoy the wilds of the woods.

Aside from his Hotei-like qualities of ragged, eccentric appearance, kind-hearted generosity, and love of children, Chapman archetypally exemplifies Maitreya simply in his primary commitment to planting trees. Trees are revered in Buddhism, from Shakyamuni Buddha's awakening under the bodhi tree, to his implementation of tree-planting in India. An old Zen story about the great, dynamic Chinese master Linji (Rinzai in Japanese) tells of his frequent planting of pines and cedars at the monastery where he trained. His teacher, Huangbo (mentioned in the section on powers in chapter 3), asked Linji "for what purpose he planted so many pines deep in the remote mountains" at their temple (where perhaps nobody would ever notice the trees). Linji replied that it was as an adornment "for the mountain gate" of the monastery and also "to make a guidepost for later generations."[3]

For humans, planting trees is a quintessential act of caring for future generations, an emblem of Maitreya's concern for the future. Some of the trees that Chapman had planted were still cherished a century after his death. In our own age of clear-cutting and widespread global deforestation, Johnny Appleseed's devotion to planting trees for the future is increasingly relevant.

A modern example of the contemplative side of the Maitreya archetype is Carl Jung, who studied consciousness and psychology from the perspective of spiritual healing and awakening. While all investigators of human psychology bear some relation to the contemplative image of Maitreya pondering humanity, Jung has particular relevance to this archetype. Although he worked empirically as a scientist, Jung's concern with the inner psychic process, his own as well as that of others, was passionate. Jung also articulated the archetypal approach within psychology, which is employed in this book to help access the bodhisattva figures and their teachings. He saw the psyche as religious in nature, spontaneously producing images with spiritual significance. Alongside his allegiance to Christianity, Jung studied a variety of Eastern philosophies and religions, beginning the ongoing process of Western analysis and practice of Eastern disciplines in integration with psychological and therapeutic orientations.

Jung saw his psychoanalytic process as guided by the future. He promoted the synthetic-prospective method, in which the analyst works with the client to create a container for the psyche to realize its full potential and future possibilities. This involves developing access to the collective unconscious as constellated in the client's particular psyche. Jung saw everyone as

both inhabiting and containing this collective or universal unconscious, which contains the individual's potentialities for the future. This has parallels, although inexact, with the Yogachara School theory of the *alaya vijnana* or universal storehouse consciousness, which is espoused by Maitreya. Jung's collective unconscious is largely a means or metaphor for recognizing common human patterns of psychic motifs and imagery, and how we each express or react to them. The Yogachara storehouse consciousness theory focuses more on the process of causality, or karma, in our individual conditioning. The storehouse consciousness and its working describes the impact of our conduct in affecting the variety of predispositions, wholesome and unwholesome, embedded in our deeper consciousness. How we choose to strengthen or let go of these tendencies in turn shapes and presents our potentiality.

In the process Jung advocated and called "individuation," individuals fulfill their deeper selves, gradually free themselves from conditioning, and develop integration and wholeness in accord with their own potential, which was implicit in their lives all along. Jung came to believe in his later work that, with the personal maturing of the individuation process, the whole of society and of reality is integrated in Unas Mundas, the unified world, which fosters balance and harmony. This social aspect of Jung's vision resonates with the Maitreyan forecast of a harmonious new age of enlightenment.

Joanna Macy is an American Buddhist scholar and teacher whose practice roots are mostly Theravadin. She has worked with monks in Sri Lanka in an effective, village-based social-development movement initiated by Buddhist activists. She also has done extensive Tibetan Buddhist practice after working with lamas in Tibetan refugee camps, leading to a visit to teachers in Tibet. As a scholar, she has expressed Buddhist teaching and psychology in terms of contemporary Western systems-theory philosophy. Macy also has been an active spokesperson in the Deep Ecology movement. In all of her work, Joanna Macy is quite powerfully bringing the truth and depths of Maitreya's contemplation of the future to bear on crucial dilemmas in our present world.

Dr. Macy has worked extensively on nuclear-related issues, including leading workshops to help people face the unconscious despair that has deeply affected human psyches concurrent with the modern apocalyptic threat from nuclear weapons, treating and seeking to heal our society's denial of this reality. She also has studied the issue of nuclear waste and the nearly

inconceivable extents of time involved in its toxicity. Scientists estimate that the nuclear wastes created in the last fifty years will remain deadly for tens and hundreds of thousands of years, longer even than most of the pre-dicted dates for Maitreya's arrival. (The radioactive nickel in reactor cores will be lethal for 2 million or 3 million years!)

In examining the issue of nuclear waste, our generation's most lasting physical legacy to this planet and its beings, Macy discovered that the poli-cymakers responsible have planned burial of the wastes underground in unretrievable storage containers made of materials that will inevitably crumble and leak long ages before the toxicity expires. This reckless disre-gard for future generations of life seems to be based on a failure of imagi-nation to conceive of the durations of time involved, or even to care about the future. Contemplating the extents of Maitreyan future time, Macy, in consultation with scientists and social thinkers, has proposed that all nuclear wastes be buried in monitorable, retrievable storage, so that leaks can be spotted and repaired, and so that the nuclear materials can be retrieved should the technology ever be devised to neutralize the waste.

Given such vast lengths of time, a new concept of attentive nuclear guardianship is also required, one that can be sustained over periods beyond our current view of history. In accord with the fundamentally positive out-look of Maitreya and the promise of his future age of awakened harmony, Joanna Macy has used the dilemma of nuclear waste to offer a positive, hopeful vision of a long-term human future based on guardianship of our world with clear, spiritual awareness. Macy's insight and faith are that we can acknowledge and use this peril to our species as an opportunity for con-sciously taking responsibility for our world and our own garbage, and for liv-ing in a more caring, intentional manner.

Macy initiated the Nuclear Guardianship Project to help promote con-sideration of nuclear waste issues and the long-term guardianship required. This has led to increased consciousness, among nuclear planners as well as others, of the vast time spans that need to be considered. Macy has intro-duced the term "deep time," borrowed from Deep Ecology, to talk about the vast dimensions of time we must reckon with to ensure guardianship and that we may also need to consider in anticipating Maitreya's arrival.

In workshops on deep time and future generations, Macy encourages some participants to imagine and envision themselves as beings from specific future times and places, and then to dialogue with the other partic-ipants, who represent this time. Together these future and present persons

imagine and discuss issues of concern between the present and future. The personal relationship that Macy seeks to develop with beings of the future suggests an aspect of Maitreya's meditations as he awaits his buddhahood, contemplations that surely include intimate consideration of the beings he will save and embrace in his buddha field.

Macy emphasizes the fact that every being who will ever live on earth is present here and now. This is true as a biological certainty, as all future life will collectively be produced from the DNA of present creatures. We might also consider how the awareness of future beings will evolve in some fashion from our current thoughts, worldviews, and paradigms. Maitreya, the bodhisattva as the unfulfilled, potential buddha, demands that we consider the future spiritually, historically, and even practically. Joanna Macy is a clear contemporary example of such courageous, unflinching contemplation in her profound considerations of the future and in her activism on behalf of future generations.

The consideration of the future encouraged by Joanna Macy and other exemplars of the Maitreya archetype has important implications for the present, perhaps even more crucially than for the future. In the light of Vimalakirti's criticism of Maitreya as being attached to an illusory future realm, we can see that the interest in the future inspired by Maitreya really concerns our own present awareness and conduct. Maitreya's vast future is part of our present and awareness of it enriches and deepens our present. The fullness of the future can inform our current contemplations, as it did for Thoreau and for Jung. The future can also inspire our present activity and practice, as it did for Johnny Appleseed, whose generous tree planting encouraged his contemporaries and bequeathed a guidepost for future generations.

10 Vimalakirti
The Thunderous Silence
of the Unsurpassed Layman

THE RELIGIOUS STATUS
AND ICONOGRAPHY OF VIMALAKIRTI

VIMALAKIRTI, the legendary hero of a sutra that became popular in China and Japan, is depicted therein as a wealthy lay disciple and patron of Shakyamuni Buddha whose wisdom and eloquence surpassed that of all of the other disciples and bodhisattvas. He is featured in the *Vimalakirti Nirdesha Sutra*, "The Sutra of Displays [or Teachings] of Vimalakirti," one of the older Mahayana sutras, dating back at least to the first or second century C.E. Vimalakirti's name means "undefiled fame or glory," and he is also sometimes known as the Golden Grain Tathagata. His name is commonly transliterated as Weimojie in Chinese, and Yuima (short for Yuimakitsu) in Japanese.

Vimalakirti differs from the other bodhisattvas considered as archetypes in this book. Aside from the sutra in which he is featured, there is only brief mention of him in several other minor Mahayana scriptures and commentaries. Unlike Manjushri, Samantabhadra, Avalokiteshvara, or Jizo, Vimalakirti is not a cosmic, mythic bodhisattva, but is depicted in the sutra as a historical lay follower of Shakyamuni who lived in the town of Vaishali in northeastern India (although in terms of modern historical studies there is no basis for believing he was an actual historical disciple of the Buddha, as were Shariputra or Subhuti, for example). Vimalakirti and his sutra are not central to any school of Buddhism. He does not appear in tantric mandalas and his image is not so commonly venerated on temple altars.

However, Vimalakirti's sutra is highly entertaining spiritual literature and was very influential, especially in East Asia. Key scenes from the sutra

depicting Vimalakirti were popular in early Chinese Buddhist cave statuary and memorial steles. Vimalakirti has been the subject of sculpture and painting in China and Japan, although his image is much less common than the bodhisattva figures we have already discussed. Vimalakirti is portrayed as an ordinary layman of Shakyamuni's era in India, with flowing white layman's robes and a soft cloth hat, and often with a long beard. He is shown seated, sometimes leaning on an armrest, suggesting the illness that initiates the drama of the sutra.

To speak at all of the usual representations of Vimalakirti in terms of iconography is ironic. As a layman unerringly critical of the monastic disciples of Shakyamuni and of the usually celebrated bodhisattvas, Vimalakirti represents the iconoclastic side of Mahayana Buddhism. Vimalakirti's teaching is about seeing through the trappings of religion to the spiritual heart of the wonder of reality. Vimalakirti playfully and magically demonstrates that this truth is always available to people and is not dependent on priestly intercession or hierarchical status, either worldly or spiritual.

PRACTICE AND WEALTH IN THE MIDST OF THE WORLD

Vimalakirti practiced as a layman amid the delusions of the world, without getting ensnared by them. In the sutra he is introduced in the most lofty terms as having mastered the perfection of wisdom along with tolerance, eloquence, incantational powers, and subtle knowledges. Moreover, he was expert in liberative techniques and skill, understanding the thoughts and actions of beings and expressing the teaching to all as appropriate.

Endowed with great material wealth and appearing to live as befitted his class at the time, Vimalakirti used his riches to sustain the impoverished. Although he had a wife, a son, a harem, and servants, he lived simply as a religious devotee, abstaining from all sensual indulgence. He entered many different realms inhabited by varied social classes, from gambling dens and taverns to upper-class financial exchanges, engaging in trade although uninterested in his own personal profit. He discussed and understood worldly philosophies and sciences, but always was in accord with Buddha's teaching. Vimalakirti entered brothels to talk about the folly of sexual misconduct and educate the young women, and entered bars to lead drunkards to right mindfulness.

Aligned with ordinary people because he appreciated worldly excellence, Vimalakirti also was honored by deities for revealing the limitations of their

divinity. Vimalakirti served as a government official in order to protect beings, always acting in harmony with the law, while using his position to reverse the attachments of rulers to the power of their sovereignty. Vimalakirti appeared as the most skillful in each of his sundry endeavors, while constantly awakening and benefiting the beings he encountered.

This image of Vimalakirti as thoroughly engaged in the world while expressing the deep power of spiritual liberation became popular in China as a model for literati, officials, and Confucian gentlemen who wished to engage in Buddhist practice while still remaining in their worldly positions. Even if very few could maintain the level of nonattachment espoused by Vimalakirti, they acknowledged the ideal he represented.

Generally, Vimalakirti in all his activities embodies the Mahayana view of being in the world but not of it, as Vimalakirti fulfills liberative work without being trapped or fettered by worldly desires or attachments. But a central point of the *Vimalakirti Sutra* is that the bodhisattva can *only* awaken in the context of intimate contact and involvement with the follies and passions of the world and its beings.

The relationship of bodhisattvas to delusion is elaborated by Vimalakirti later in the sutra, when he introduces the disciples to teachings about inconceivable liberation and the nature of the "family" of the buddhas or of a tathagata, the "one who comes and goes in thusness." Bodhisattvas can develop only through fully entering, before transcending, the turbulent seas of passions and delusions. Vimalakirti asserts that bodhisattvas find their way by engaging in false actions. The bodhisattva proceeds, for example, by feeling no malice, hostility, or hatred while committing the five deadly misdeeds. (These five deadly sins lead immediately to hell. They are killing one's father, mother, or a saint, disrupting the sangha, or intentionally wounding a buddha.) Among further examples, the bodhisattva follows the modes of craving without any attachment to enjoyment of desires, follows the activities of hatred without feeling any anger, follows the manner of the rich without acquisitiveness and with frequent recollection of impermanence, manifests the effects of sickness while having conquered all fear of death, and displays the behaviors of passion while remaining utterly dispassionate and pure.

Shakyamuni's disciple Mahakashyapa absorbs this teaching and laments that the purified arhats like himself can never become fully enlightened because, having cut off all desire and passion, they do not have occasion to

arouse the aspiration for the universal awakening of all beings (bodhichitta). Perhaps with a bit of hyperbole, but with a clear sense of the importance of humility, Mahakashyapa says, "Only those guilty of the five deadly sins can conceive the spirit of enlightenment and can attain buddhahood."[1] Only with such a full immersion in delusion and the ways of the world, at least empathetically if not in karmic deed, can bodhisattvas fully conquer their own passions and have concern for all other misguided beings.

Some later expositions of the Mahayana affirm that even the purified, faultless arhats may eventually activate bodhichitta, arousing concern for "lesser" beings, and also serving as inspirations for some people. But Vimalakirti emphasizes that the fundamental aspiration emerges out of immersion in the ordinary world of desire, like lotus blossoms growing out of the mire of a swamp.

CRITIC OF DISCIPLES AND BODHISATTVAS

In the realm of spiritual teaching and practice, Vimalakirti is the expert practitioner as critic, affording disciples and bodhisattvas the opportunity to develop their practice through his critiques. This quality is revealed in the sutra when Shakyamuni Buddha, knowing telepathically that Vimalakirti is sick in bed, asks his disciples to call on the layman and inquire after his health, a familiar activity for monks ministering to the laity.

One by one the Buddha's disciples express their reluctance to visit Vimalakirti. It transpires that each of them in his previous encounter has been criticized in detail by Vimalakirti, who has exposed flaws in the disciples' understanding or practice, specifically on points in which each was most accomplished and respected. Disclosing these incidents to Shakyamuni, the disciples relate that after Vimalakirti's rebukes they were intimidated and rendered silent, unable to respond.

For example: Shariputra, a leader among Shakyamuni's disciples, is sitting beneath a tree in silent retreat, so Vimalakirti discusses true contemplation as not abandoning ordinary behavior and people; Mahakashyapa, who is on begging rounds when seen by Vimalakirti, is admonished not to be partial by avoiding the houses of the wealthy, but to allow all to eliminate their materialism—Mahakashyapa is further instructed by Vimalakirti to maintain equanimity with whatever is offered; Rahula, Shakyamuni's son who renounced a kingdom for monkhood, is asked by some young gentlemen about the benefits and virtues of renunciation. As Rahula expounds on

the value of renunciation, Vimalakirti intrudes to point out that true renunciation forsakes all benefits.

Another bodhisattva named Jagatimdhara tells of being approached by Mara, the evil tempter spirit, in disguise as Shakra, king of the Indian gods, and accompanied by twelve thousand heavenly maidens. Mara offers the maidens as servants to Jagatimdhara, who hastily refuses the offering as unfitting, since he is a monk bodhisattva, vowed to celibacy. Vimalakirti abruptly shows up and reveals to Jagatimdhara that this is not Shakra but Mara tempting him. Vimalakirti thereupon requests the maidens for himself from Mara, who is intimidated by the layman and his power. Vimalakirti takes and educates these daughters of gods, leading them to arouse the thought of universal enlightenment and develop bodhisattva qualities. When Mara later demands their return, Vimalakirti complies only after instructing the maidens on how to sustain their illumination and spread it, even after they return to Mara's palace.

Shakyamuni requests a visit to the ailing Vimalakirti from his most generous patron Sudatta, also known as Anathapindada, who funded the first Buddhist monastery at Jetavana. Sudatta's reluctance derives from a great offering ceremony Sudatta previously performed, donating many material gifts to religious devotees and to the poor. On the seventh day of this offering, Vimalakirti, himself a rich philanthropist, appeared to discourse on the genuine meaning of wealth and generosity. He chided Sudatta for mere material donations, explicating that true offerings develop living beings endlessly in the dharma and consist of such factors of enlightenment as love, joy, morality, and meditation on emptiness.

Throughout the stories of Vimalakirti's exchanges with the great disciples and bodhisattvas, Vimalakirti upsets all conventional views of spiritual activity, luminously revealing the inner vitality of awakened awareness and activity. In Vimalakirti's criticism of his fellow practitioners, we might see the workings of spiritual community or sangha. Receiving and offering such feedback is our way of developing and clarifying our own bodhisattva practice. We grow, together with our dharma sisters and brothers, through the painful process of exposing and letting go of our cherished notions of self, including pride in our own supposed spiritual accomplishments.

At the end of the chapter on inconceivable liberation, the disciple Mahakashyapa is discouraged by the knowledge that he is a purified arhat unable to receive this liberation available to those immersed in the world. But Vimalakirti tells him that only one who is a bodhisattva can be hassled

or harassed by another bodhisattva. Nobody, not even an arhat, would be subjected to the scathing criticism of Vimalakirti or any other enlightening being if he were not recognized as being on the bodhisattva path himself. When we take on bodhisattva practice, whoever appears as our critic or enemy, or presents us with problems, is actually our spiritual friend, helping us shed obstructions and make progress on our path.

Vimalakirti's critiques express his special commitment to lay practice as a bodhisattva model. Many of his comments and admonitions involve the tendency of the disciples to withdraw from engagement with the ordinary world. He criticizes priestly roles and religious trappings for masking inauthenticity of practice or interfering with the full development of spiritual potential of common people. Vimalakirti upholds the value of the universally available personal experience as the true criterion of spiritual teaching, understood in the light of the insubstantiality of all views and designations.

VIMALAKIRTI'S ILLNESS: THE INVALID AS HEALER

As we have seen, the drama of Vimalakirti's sutra is impelled by his illness. Vimalakirti uses the opportunity provided by his ailment to expose the fundamental nature of disease in the seemingly endless, rat-race cycles of our world, and to advocate nondualistic attitudes that are conducive to spiritual health and well-being. Vimalakirti's relationship to disease is as patient rather than physician, and he cultivates self-healing. Thus Vimalakirti's archetype features the image of the invalid as liberating bodhisattva, treating all beings' fundamental afflictions.

When Manjushri finally arrives to ask about Vimalakirti's infirmity, the layman eschews all conventional diagnoses, but replies that his sickness derives from ignorance and the thirst for existence and will last until all living beings are free from sickness. These ills are part of the nature of living in the world. With their vow to benefit all beings, bodhisattvas become sick due to their compassion and love for others who are sick.

Manjushri inquires as to how a bodhisattva should console another bodhisattva who is sick. Giving instructions in how to turn illness into spiritual teaching, Vimalakirti suggests that a bodhisattva should tell another bodhisattva that the body is impermanent, but without encouraging renunciation or disgust. Although the body is miserable, one should not seek comfort in cessation. The sick bodhisattva should repent past misdeeds, but not out of vain and self-serving hopes of expiating their effects. Sickness should be

used to encourage empathy for all living beings and their beginningless suffering, so that one might learn to heal all disease and thus become joyful.

Vimalakirti elaborates: An ailing bodhisattva may manage his mind by considering that sickness arises from passions, which result from illusory mental fabrications. The body being a mere construction of conditioned factors, there is ultimately no essential thing that is sick. Sickness may be dispersed with the elimination of egoism and possessiveness, which rely on discriminations of self and other. By recognizing through one's own suffering the misery of all beings, the bodhisattva may accurately contemplate beings and resolve to heal them.

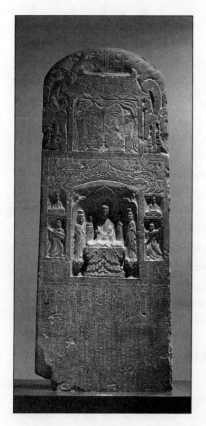

*Votive stele with upper scene
of Vimalakirti debating Manjushri,
China, dated 549*

Finally, by realizing the ultimate nonexistence and unreality of all beings, oneself included, a bodhisattva may express compassion without indulging in a sentimental compassion based on emotional attachments and passions,

which are debilitating and lead to burnout. Such attachments, Vimalakirti warns, will lead a bodhisattva to avoid contact with suffering beings and feel aversion toward further rebirths, thus falling into the antithesis of bodhisattva intention. Instead, one may effectively care for the sicknesses of self and of all others when not caught up in indulging the mind, or in trying to control the mind.

By taking his sickness as a metaphor of the condition of life in the world, Vimalakirti demonstrates his own personal nonattachment and presents an example of using all the events of our life, including misfortunes, to further the awakening of all. While not necessarily concerned with eliminating his individual illness, Vimalakirti transcends it by applying his awareness to treat the fundamental sickness of all being.

VIMALAKIRTI'S ROOM

When Manjushri fearlessly agrees to visit Vimalakirti and engage him in dialogue, all of the disciples and bodhisattvas, including those who had declined to visit him themselves, suddenly decide they want to go and observe this spectacle. Manjushri arrives accompanied not only by the main disciples and bodhisattvas, but by an entourage including a great many heavenly and other extraordinary beings, all eager to witness the conversation of these two bodhisattvas renowned for their wisdom.

Vimalakirti with his special powers is aware of their impending arrival and magically transforms his single-room house into emptiness. His room becomes empty of all furnishings save his sickbed. Although the room is small, all the myriad bodhisattvas, disciples, and spirits miraculously are able to find space in it. In the course of their conversation about sickness, Vimalakirti tells Manjushri that his room is empty because all buddha fields are empty, and that all buddha fields are empty even of emptiness, because all imaginings and views are empty.

After Vimalakirti's discussion about his illness, the disciple Shariputra wonders where all of Vimalakirti's guests will sit, since there are no chairs in the room. Knowing Shariputra's thoughts, Vimalakirti asks him if he came for the dharma, or for a place to sit. Shariputra, always the target of Vimalakirti's sharp tongue, avows that he came for the dharma, not for a chair. Vimalakirti chastises Shariputra, saying that one truly interested in the dharma of buddhas is not concerned about his own body, much less a chair.

Vimalakirti proceeds to again undercut usual views of the teaching as

being no more than illusory views, and to show up all attempts to appropriate dharma as merely an object. For example, he says, "The dharma is not an object. He who pursues objects is not interested in the dharma, but is interested in objects. The dharma is without acceptance or rejection. He who holds on to things or lets go of things is not interested in the dharma but is interested in holding and letting go."[2] Further, to seek association with dharma is not dharma, but mere interest in association.

Vimalakirti then asks Manjushri, with his experience of millions of different buddha fields in all directions, where the very best lion-throne chairs are. Manjushri unhesitatingly mentions a buddha field, many buddha fields distant in the east, which has the most splendid thrones, each 102,000 miles high. Vimalakirti instantly concentrates his mind so that the buddha of that distant buddha field sends 3.2 million of those thrones, which all land in the house of Vimalakirti. They all fit inside Vimalakirti's room, without interfering with or impinging upon each other, the room, the town of Vaishali, the land of India, or the world. After the great bodhisattvas fit themselves on the thrones, Vimalakirti teaches the novice bodhisattvas and even the disciples in his room to extend themselves so that everyone can take a seat.

In the seventh century C.E., the *Vimalakirti Sutra* was so highly valued in China that a Chinese imperial envoy made a pilgrimage to the supposed site of Vimalakirti's house in northern India to measure the ruined foundations of the room where this miraculous scene was supposed to have transpired. While the Indians had little concern for history, and took this literature of the inconceivable as allegorical, it seems that the Chinese, with their great concern for history and lineage, credited more literal readings. The ruins that were shown to the envoy were one square *zhang*, or *fangzhang*, which is almost exactly ten feet square, and thereafter Vimalakirti's room was referred to by this term throughout East Asia.

Vimalakirti's room size established the model for all Chan/Zen abbots' quarters, which are still named *fangzhang* in Chinese, or *hojo* in Japanese, after Vimalakirti's room. Of course not all abbots' quarters have been a mere ten feet square, even though formally designated fangzhang or hojo. In modern Chinese and Japanese, this term is still used for the person and the title of a monastery abbot, as well as for his residence.

The image of Vimalakirti's room transformed to the chamber of a Zen abbot or teacher established a significant paradigm in the Zen tradition. Disciples enter the teacher's room, the inner chamber, for training and testing in private interviews. These encounters may involve "dharma combat,"

dialogues as challenging and profound as those between Manjushri and Vimalakirti, as in the *Vimalakirti Sutra* possibly involving nonverbal as well as vocal elements. Such encounters may also end with the student and his flaws in understanding or practice as exposed as Shakyamuni's disciples were by Vimalakirti, and many Zen students have felt similar reluctance to enter the room. In any event, this small, inner chamber inspired by Vimalakirti is where the heart of the teaching and its realization may be expressed or revealed.

TRICKSTER OF THE INCONCEIVABLE

With the arrival in his room of the gigantic lion thrones, Vimalakirti goes beyond the bodhisattva as wealthy philanthropist mixing in worldly realms, beyond the bodhisattva as iconoclastic layman and critic of other bodhi-sattvas, beyond the bodhisattva as expounder of the paradoxical qualities of emptiness, and beyond the bodhisattva as invalid healer. Now we see Vimalakirti as magician. Along with his other attributes, Vimalakirti is a wonder-worker trickster who upsets all familiar preconceptions, not only with his eloquent and incisive critiques of the disciples, but also with spec-tacular magical displays.

Of course, all of the cosmic bodhisattva figures have extraordinary pow-ers. Manjushri appears as a beggar or manifests other visions to test his devotees. Samantabhadra in his samadhi has startling and awesome holo-graphic visions of interconnectedness. Avalokiteshvara takes on myriad forms to perform miraculous deeds, saving people from perils such as drowning or execution. Kshitigarbha travels to hellish realms to save the inhabitants. Maitreya's infinitely vast towers within an immensely vast tower in the *Gandavyuha Sutra* are even more impressive than Vimalakirti's huge lion thrones. But Vimalakirti, while still seeming to be an ordinary man of the world, performs his marvels with panache, achieving specific effects on people's awareness. Vimalakirti displays the startling realm of emptiness— teaching with special theatricality to express the bodhisattva quality of inconceivable liberation. He is a kind of entertainer, creating spectacles to educate his audience into deeper understanding and experience of the true, wondrous nature of reality.

After seating his audience in their vast lion thrones, Vimalakirti informs Shariputra of the liberation called inconceivable, which defies our usual sense and perceptions of form and dimension. This inconceivability is a

key principle for Vimalakirti. Near the end of the sutra, Shakyamuni Buddha even gives as another name for the *Vimalakirti Sutra* the "Dharma of Inconceivable Liberation." The endless depths of reality are far beyond the limitations of our intellectual or perceptual capacities. We cannot possibly comprehend in full either the relative or ultimate truth of any entity or event. Vimalakirti encourages us to develop ever more subtle acceptance of the fact of the ungraspability and non-arising of all phenomena. This patience implies an ongoing process of opening up to new possibilities and to the freshness of experience, of entering strange new worlds where none have gone before.

*Vimalakirti holding
a galaxy; adapted from
a sutra illustration, China*

Within this inconceivable realm, as described or demonstrated by Vimalakirti, bodhisattvas can place the vast, cosmic king of mountains, Mount Sumeru, into a mustard seed without shrinking the mountain or expanding the seed. A bodhisattva in this realm can pour all the oceans into a pore of her skin without disturbing any of the fish or other creatures dwelling in the ocean. A bodhisattva living in the inconceivable may pick up a whole galaxy in his hand, toss it like a boomerang around the universe, then put it back in its place, without disturbing any of the beings therein. These maneuvers can be seen by the affected beings, but only by those who will be inspired and led into training in the bodhisattva disciplines by witnessing these miracles.

Vimalakirti's marvels are not for showmanship, but only for the purpose of awakening all beings. He tells Shariputra that a bodhisattva living in inconceivable liberation can transform himself or any other being into a divine spirit, a sage, a bodhisattva, or even into a buddha. Vimalakirti performs his miraculous displays as a master of liberative technique, using his powers appropriately to help beings develop according to their own potential on the given occasion.

Vimalakirti informs Shariputra that this inconceivable teaching he has described is only an encapsulated form of an immeasurably vast teaching. The lengthy *Avatamsaka* or *Flower Ornament Sutra* discussed in the chapter on Samantabhadra (and more than fifteen hundred pages in English translation) is also only a short version of the vast inconceivable lore represented by Vimalakirti. Vimalakirti encompasses this teaching of wonder and awe together with the teaching of emptiness and insight mastered by Manjushri.

THE GODDESS AND THE SEXISM OF SHARIPUTRA

Throughout the sutra, Vimalakirti performs various tricks, some miraculous, others subtle transformations of our usual worldview and expectations. But Vimalakirti leaves one of the most dramatic tricks in the sutra to a colleague, a highly skillful goddess bodhisattva who is never named, but who has been living with Vimalakirti in his house for twelve years.

The scene begins with Vimalakirti instructing Manjushri on the illusory nature of all beings, and how a bodhisattva nevertheless generates great loving-kindness toward them. A bodhisattva desires to teach the dharma he has realized. He produces loving-kindness that is truly a refuge for beings, that is serene because free of grasping, that accords with reality and is free of passions. The bodhisattva's love does not get caught or warped by dualistic discriminations between self and other.

Upon hearing Vimalakirti's responses to Manjushri about the essential reality and function of the bodhisattvas' love, this goddess friend of Vimalakirti manifests herself in material form and, full of delight, showers beautiful heavenly blossoms on the bodhisattvas and great disciples. The flowers fall to the ground from the bodies of the bodhisattvas, but stick to the disciples, much to Shariputra's consternation. As Shariputra unsuccessfully tries to shake or brush the flowers away, he complains that wearing flowers or other ornaments is improper for monks. The goddess reprimands Shariputra, saying that flowers are free of conceptualizations and discrimi-

nations and are thus proper, whereas the disciples themselves are full of improper conceptualizations. The flowers do not stick to the bodhisattvas, who have dispelled such fabricated discriminations and are not afraid of worldly sensations, forms, and beauty.

Impressed by the goddess, Shariputra asks how long she has been in Vimalakirti's room. She in turn asks Shariputra how long he has been liberated. Shariputra remains silent for a while, finally muttering that liberation is inexpressible, so he does not know what to say. She responds that liberation is the nature of every syllable and not apart from language, as liberation is the sameness of all entities. She tells him that to see liberation as the freedom from desire, hatred, and confusion, as Shariputra does, is just pride and distraction. The true nature of desire, hatred, and confusion is itself liberation.

Shariputra is now overwhelmed by the goddess and her sharp wit. He respectfully asks her what level of achievement she has realized or obtained. The goddess avows to the disciple that she has attained nothing, that to claim any attainment is only pride. She merely expresses whatever teaching would be useful to beings.

Shariputra inquires about Vimalakirti and his teaching, and the goddess responds that in her twelve years living in Vimalakirti's room, she has heard only about loving-kindness and the inconceivable quality of buddhas. She describes various wonders in Vimalakirti's house, including a constant golden light, beautiful music that conveys the reality of buddha teaching, and the experience of those who enter and then are no longer troubled by passions.

Thoroughly undone by the brilliance of this goddess, Shariputra asks her why she does not transform herself into a man. While this question would be astonishingly rude in contemporary cultural contexts, Shariputra is echoing the prevalent prejudice in early Buddhism, which held that a woman is incapable of becoming a buddha. In exceptional cases, when a woman became sufficiently adept and spiritually proficient, she might transform herself into a man and then would be qualified to become a buddha. Such prejudice has nothing to do with the philosophy or teaching of spiritual awakening and Mahayana Buddhism, which holds that all beings are imbued with buddha nature. Rather, it is a reflection of the patriarchal culture that has dominated Asian as well as European history for the past few millennia.

Various attempts were made in the Mahayana Buddhist tradition to undercut prejudice against women's spiritual qualities. The goddess tells

Shariputra that she has sought to identify in herself some essential "female nature," but has failed to find it. She receives Shariputra's agreement that if a magician produced a mirage of a woman she would not really exist and that Shariputra would not ask such an illusory woman about changing her gender. The goddess states that in the same way, all things only exist as illusions.

Then Shariputra is put to the test. Using her magical powers, the goddess performs an instant double sex-change operation. She is transformed into Shariputra, and he finds himself in her body. Shariputra is shocked and distraught to find himself a woman, and he admits that he does not know how to change back into a man. The goddess explains to Shariputra that the gender distinction is not ultimately real, that the Buddha has said that beings are not, in essence, limited to being either male or female.

The goddess then changes Shariputra and herself back to their previous forms. She clarifies that just like Shariputra's temporary femininity, which he neither produced nor could transform, all qualities, including gender, are not in reality created. Women appear as women without being limited to being only women, which supposedly would disqualify them for buddhahood. We could infer the same applies to males, as exemplified by Shariputra's experience. Similarly, she points out, the perfect enlightenment of a buddha is simply a conventional distinction, not a fixed or manufacturable, actual condition.

As the scene ends, Vimalakirti reveals to Shariputra that this goddess has served billions of buddhas, has fulfilled all her vows, and has achieved complete acceptance of the unconditioned nature of all things. She can play freely with superpowers and knowledges and goes where she desires in order to mature beings.

VIMALAKIRTI'S SILENCE

The inconceivable is most fully elaborated in the famous, climactic scene in which Vimalakirti suggests that the assembled bodhisattvas expound their own entryway into full awareness of the reality of nonduality. Then thirty-one bodhisattvas, not including any of the primary bodhisattvas we have discussed, present an illuminating seminar on the multifaceted aspects of nonduality. Such dualities as good and bad, saintly and profane, and birth and death are taken for granted and presumed real in our conventional management of our lives. The nondual awareness discussed by the bodhisattvas

and Vimalakirti is important because our sense of estrangement and suffering arises and our lives become fragmented with these unquestioned habits of dualistic discrimination.

Each bodhisattva gives a brief but penetrating account of some apparent dichotomy or polarity, the transcendence or reconciliation of which was their personal entry into nondual awareness. For example, one describes freedom from calculations of happiness and misery. Another describes equanimity about all conceptions of the immaculate and impure. Another describes distraction and attention as not separate in the mental process. Another declares that self and selflessness have no duality, since there is no fixed self to be made selfless. Another states that knowledge is of the same nature as ignorance, but ignorance is itself unknowable.

Manjushri then congratulates all of the bodhisattvas on their fine explanations, but declares that all of their statements have been themselves dualistic. All syntactical formulations, including this one, are unavoidably tinged with dualistic presuppositions. Manjushri says that the entrance into nonduality is not to express, proclaim, designate, or say anything. Manjushri then turns to Vimalakirti and asks him to expound the principle of the entry into nonduality.

Vimalakirti remains silent.

This is widely referred to as Vimalakirti's thunderous silence. Manjushri applauds the layman, proclaiming that Vimalakirti has indeed demonstrated the entrance into nonduality, beyond all sounds, syllables, and conceptions. All the explanations, including Manjushri's praise of Vimalakirti, are, at best, dualistic commentaries on the silence provided by Vimalakirti.

Vimalakirti's silence is a prime example of the Zen-like fullness of expression and communication that simultaneously demonstrates the limitations of language. This silence is dynamically expressive and illuminating performance art, not the tepid hesitation of Shariputra's silence when asked by the goddess to speak of liberation.

Both *The Blue Cliff Record* and *Book of Serenity* koan collections contain the story of this colloquium on nonduality. *The Blue Cliff Record* rendition ends before Vimalakirti's silence, but after Manjushri's question to Vimalakirti, the commentator Xuedou instead says, "What did Vimalakirti say?" Then he adds, "Completely exposed."[3] Just as words can be meaningless, silence sometimes speaks volumes.

The introduction to the case in *The Book of Serenity* says, "Even if one's

eloquence is unhindered, there's a time when one can't open one's mouth."[4] In a poem in his recorded sayings, Tiantong Hongzhi, the verse commentator of *The Book of Serenity*, says, "The motto for becoming genuine is that nothing is gained by speaking. The goodness of Vimalakirti enters the gate of nonduality."[5] When we do not even subtly seek gain, either in our speaking or nonspeaking, we can genuinely meet this thunderous silence.

Vimalakirti's Silence; painting by
Zen Master Hakuin, 18th century

ASSOCIATED FIGURES: AKSHOBHYA BUDDHA

Vimalakirti is said to have originally come from Abhirati (literally "intense delight"), the buddha field of Akshobhya Buddha in the east, having arrived in this world in order to save beings. When this is disclosed to the assembly near the end of the *Vimalakirti Sutra*, they all yearn to witness this buddha land. Although beings in Akshobhya's pure land are of a vastly greater stature than those in our world, Vimalakirti, without rising from his sickbed, uses his psychic powers in accord with the inconceivable to bring the entire Abhirati universe into the palm of his right hand as a luminous orb. Neither that world nor this are in any way impeded by this occurrence, but the members of the assembly are inspired, by clearly beholding the splendors of Abhirati, to ripen their practice and dedication to the Way. Thereafter Vimalakirti replaces the Abhirati realm exactly as it had been.

This Akshobhya Buddha is the buddha to the east, as Amitabha is the buddha to the west in a primary Vajrayana system, which has Vairochana Buddha in the center, and buddhas named Amoghasiddhi and Ratnasambhava to the north and south. Each of the five presides over a family of buddhas and bodhisattvas. Akshobhya was a particularly popular figure in the historical development of Buddhism in northeastern India, probably leading to his cosmological association with the eastern direction. Akshobhya, which means "immovable" or "imperturbable," became a buddha after resolutely following his vow as a bodhisattva never to be angry or disgusted with any being.

WANG WEI AND LAYMAN PANG

Vimalakirti became a celebrated figure in China, and an explicit model for Chinese lay practitioners. One example is the early eighth-century official Wang Wei, generally regarded as one of the greatest of Chinese poets, although he was also much appreciated by his contemporaries as a painter and musician. Noted for the direct imagery and the deceptive simplicity of his nature verses, reminiscent of landscape paintings, Wang Wei was a dedicated Buddhist practitioner, and much of his poetry is deeply impregnated with Taoist and Buddhist metaphysical and spiritual overtones. Wang Wei explicitly identified himself with Vimalakirti, taking the spiritual name Mojie, which, together with his family name Wei, becomes Weimojie, the Chinese transliteration of the name Vimalakirti. Like Vimalakirti, Wang Wei

served in the government, his career as an official alternating between major cabinet ministry positions, periods of political exile, and voluntary seclusions in meditative hermitages.

Vimalakirti's model of the enlightened layman was matched in China by the famed Chan practitioner known as Layman Pang. His wife, son, and daughter were also noted practitioners, especially his daughter Lingzhao, the model for Fish Basket Guanyin, previously mentioned as one of the thirty-three manifestations of Avalokiteshvara in China. Layman Pang especially treasured the *Vimalakirti Sutra*. After Pang's awakening his teacher asked if he wanted to don black robes and become a monk, but Pang chose to remain a layman, emulating Vimalakirti. Layman Pang is described and depicted wearing white householder or layman's robes like Vimalakirti.

When his teacher asked Layman Pang about his daily activity, Pang responded that he did nothing special, but was naturally harmonious, neither grasping nor rejecting anything. Then Layman Pang uttered the famous line that his supernatural powers and wondrous activity were simply carrying water and chopping firewood. Layman Pang thus became the Chan/Zen model for seeing all the miraculous activity of Vimalakirti as incorporated nondualistically into common, everyday work activities.

Vimalakirti became a model for literati in Japan as well as China, for example inspiring the thirteenth-century masterpiece "Record of the Ten-Foot-Square Hut" by Kamo no Chomei. In this journal, the author eloquently described the natural and man-made catastrophes afflicting the society around him, and recounted his renunciation of worldly attachments to live in a small, secluded hut patterned literally after Vimalakirti's famed room. Ironically, Vimalakirti's ten-foot-square room had become in East Asia a model for reclusion and meditative withdrawal from the suffering of the mundane world, as opposed to Vimalakirti's beneficial practices while thoroughly immersed in the world.

VIMALAKIRTI AND THE PARAMITAS

The transcendent practices most emphasized by Vimalakirti are knowledge, powers, wisdom, and skillful means. Repeatedly in the sutra Vimalakirti exhibits awareness of the workings of the mind, as when he knows the assembly is coming to visit him with Manjushri, and when he sees Sharipu-

tra's desire for a chair. His knowledge is also revealed in his encounters with the disciples and bodhisattvas. He clearly sees the subtle attachments and prejudices of the great disciples and bodhisattvas and knows how to fully reveal and counteract their predispositions. Vimalakirti's perfection of knowledge is also apparent in his skillful involvement with worldly realms. He uses his knowledge of the world to perform beneficial actions and develop beings as thoroughly as possible along the bodhisattva path.

Vimalakirti displays his perfection of powers extravagantly, but always to help specific beings. He demonstrates the inconceivable teachings, for example fitting myriad immense thrones into his small room, for the sake of awakening Shariputra and the other disciples from their limited views of practice and awakening. While Vimalakirti miraculously displays the paramita of powers as readily as any other bodhisattva, he is simultaneously most intricately engaged in the ordinary affairs of the world. It is fitting that Layman Pang, modeling himself after Vimalakirti, would articulate the perfection of miraculous powers as everyday activities.

Like Manjushri, Vimalakirti practices the perfection of wisdom through his eloquent expositions on the emptiness of all formulations and fixed views. Vimalakirti sees the inner meaning of spiritual reality and reveals its fullest implementation even to purified arhats and seasoned bodhisattvas. Vimalakirti even surpasses the bodhisattva of wisdom Manjushri by proclaiming the ultimate insight in his thunderous silence.

Vimalakirti practices skillful means in his diverse activities in society. Supported by his knowledge and wisdom, he mixes with a wide range of beings and is said to be among the most skillful in each realm, thereby gaining the opportunity to skillfully expound liberative teaching.

EXEMPLARS OF VIMALAKIRTI

It is revealing to compare Vimalakirti with two bodhisattvas discussed previously, with whom he especially shares qualities. Vimalakirti eloquently expounds the emptiness teaching associated with Manjushri, but Vimalakirti is perhaps less didactic than the prince of wisdom, revealing the teachings through marvelous, theatrical tricks or displays, and in silence, as well as through eloquent orations.

Vimalakirti enters many spheres of society as does Samantabhadra, but in a less programmatic way, without Samantabhadra's sense of a particular mission or benevolent aim. All the varied milieus are simply where

Vimalakirti lives. And right in the many realms of the marketplace he naturally expresses the inconceivable awakening also expressed in Samantabhadra's visions. But whereas Samantabhadra may be exemplified by different individuals, each occupying one of many diverse worldly roles, each exemplar of Vimalakirti enters many realms and arenas within his or her own one life. Vimalakirti thus fits the image of the renaissance man, at home in many roles and with multiple interests.

Vimalakirti has many modes. He is the iconoclastic critic of all spiritual pretension, showing adept practitioners where they are caught by subtle attachments. He is the wealthy philanthropist acting benevolently and mixing unhesitantly throughout society, in the very middle of its ethical ambiguities. He is the invalid as teacher, using his malady to demonstrate and educate about the underlying dis-ease that separates us from our fundamental health and wholeness. Finally, Vimalakirti is the trickster magician, playing with our consciousness with miracles and mind-boggling powers to liberate us from false notions of the world, and of liberation itself. The following persons, likely exemplars of Vimalakirti's qualities, may clarify one or more aspects of Vimalakirti's enlightening character and strategy. None, in and of him or herself, will display the whole of Vimalakirti's vast range.

Thomas Jefferson was the quintessential rennaissance man, with his wide interests and considerable talents in architecture, the sciences, music, linguistics, and philosophy, and with his construction of many practical, helpful inventions. Among his many other activities, the sutra mentions Vimalakirti visiting schools to educate children. Jefferson was also an innovator in education, establishing public school systems in order to make education more generally available, and founding the University of Virginia. Like Vimalakirti a wealthy landowner, Jefferson lamentably was also a slave owner—although (at least in his early career) he unsuccessfully made attempts to abolish slavery and to stop its spread in the United States—and finally freed some of his own slaves upon his death.

We may see qualities of Samantabhadra the benefactor as well as of Vimalakirti in Jefferson's establishment of democratic principles through his political activities, even before being elected president of the United States, especially in his drafting of the Declaration of Independence and his persistent promotion of the Bill of Rights. Jefferson's affirmation that "the price of liberty is eternal vigilance" and his vow of "eternal hostility against every form of tyranny over the mind of man" echo the rigor of Vimalakirti's

relentless inquiry into the attachments and dualistic conceptualizations that obstruct liberation.

Jefferson's "enlightenment" was the rationality of the emerging science of Europe, and he remained current on the latest intellectual developments on the continent. Deeply interested in religion, Jefferson extracted from the Gospels his own edited "Jefferson Bible" for his personal study and inspiration. Jefferson firmly believed that God had created the human mind free, able to find its own way through reason and inherent moral sense. In his selections from the Bible, he eliminated all references to the supernatural, miracles, and the resurrection, which Jefferson saw as later accretions and mystifications intended to obscure Jesus' true greatness and wisdom. Instead Jefferson portrayed Jesus as a uniquely gifted practical, moral, but completely human teacher. This might at first seem diametrically opposite to Vimalakirti's inconceivable teachings and miraculous displays, but Jefferson, like the enlightened Buddhist layman, was attempting to reclaim religious authority and value from the priestly class, or in Vimalakirti's case from the purified monks, and to return religion to the province of everyone's personal experience. In this sense Jefferson exemplifies the aspect of Vimalakirti as critic of religious elitism, pretension, and prejudice.

Jefferson adamantly championed religious tolerance and vision and was largely responsible for establishing the principle of separation of church and state in the United States, as he opposed the efforts of church institutions to seize official state dominion. Jefferson's Virginia Statute for Establishing Religious Freedom was a milestone legislative act. Along with the Declaration of Independence and the founding of the University of Virginia, Jefferson treasured the religious freedom act as one of his three greatest accomplishments, which he asked to be memorialized on his tombstone instead of mention of his presidency. Jefferson was not opposed to religious expression in the public realm, but rather to any government sponsorship and partiality toward an exclusive, sanctioned vision of religious truth, which might inhibit people's independent exercise of their own divine sense, their own inherent insight and wisdom. Congruent with Mahayana inclusivity and skillful means, and with Vimalakirti's wide-ranging realms of activity, Jefferson espoused tolerance of a diversity of religious expressions and understandings as the basis for healthy social morality.

Obviously there are vast differences between the cultural worldview of sixth-century B.C.E. northern India and that of late eighteenth-century Virginia. But we can see Jefferson's rationalist "enlightenment" as aimed at

encouraging each person to find spiritual and moral truth based on his or her own empirical experience, not on ecclesiastical authority. Similarly, Shakyamuni asked his disciples to be a light unto themselves, not blindly accepting what he said without their own inner examination of its truth. Vimalakirti in his dialogues on the meaning of emptiness and the nonreality of conditioned prejudices and assumptions also appeals to a kind of reason in the higher logic of reconciling apparent dichotomies. The wisdom expounded by Vimalakirti goes beyond conventional illusions and attachments to notions of purity, but is in accord with a deeper reason that understands the irrationality of rigidly adhering to one side of dualistic distinctions, instead of seeing their interrelationships.

Despite his brilliance, Jefferson's extensive shadow side suggests the limitations in citing complex, actual persons as exemplars of archetypal figures. The range of his extraordinary, noble qualities exemplifies and illuminates Vimalakirti-like activity, but Jefferson equivocated about his own slave-owning and the relationship between the races. Although sincerely troubled by slavery and at times publicly challenging its existence and its spread, Jefferson never overcame his own racial prejudice and his deep financial dependency on slave labor. And recent revelations indicate that he probably fathered children with one of his slaves. Jefferson remains a controversial and enigmatic character, but it may be unfair to judge historical figures by expecting them to accord with our contemporary perspectives without giving consideration to their social context. America still struggles with the scourge of racism. From our own cultural vantage point, Jefferson's remarkable shortcomings can be acknowledged and some of his conduct deeply deplored, without categorically dismissing and ceasing to appreciate his many valuable qualities, which may help inform our understanding of modes of bodhisattva activity.

In the years since they left the White House, Jimmy and Rosalynn Carter have exemplified the range of worldly beneficent activities of Vimalakirti. Before becoming governor and then president, Jimmy Carter's occupations included peanut farming and serving as officer on a nuclear submarine. Since his presidency, the Carters have devoted themselves to an impressive breadth of helpful work, winning the Nobel Peace Prize in 2002. Through the Habitat for Humanity organization, they have gone into poor neighborhoods and labored for long hours with hammers and nails to construct houses for needy families.

Jimmy Carter is an engaging and perceptive Sunday school lay teacher at

his Baptist church, and he applies his spiritual faith to works in the world. His Carter Center in Atlanta has created a broad array of programs, from providing monitors for elections in budding democracies in Africa and Latin America to extending numerous health-care projects worldwide. He has been especially active in mediating international disputes, making positive contributions, considered miraculous by many, in volatile trouble spots such as Haiti and Korea. In his diplomatic initiatives, Carter has acted as independently and as all-embracingly as Vimalakirti, sometimes getting better results than government operatives might have hoped for. Carter has fostered peace by using his varied experience with international leaders and his willingness to engage without prejudice, with sincerity and warmth as well as firmness, with all people, even dictators considered pariahs by more conventional career diplomats. In the sutra, Vimalakirti is never called on to conduct mediation or conflict resolution of this kind. But we might easily imagine a modern-day Vimalakirti utilizing his openness, diverse experience, and ease at entering disparate realms in order to help bring people together and work through conflicts.

Rosalynn has been a partner in much of Jimmy's work, from her participation in cabinet meetings during his presidency to her own charitable realms, for example founding a center for support of caregivers. She is also active at the Carter Center in developing programs to support reforms in mental-health-care policy. The scope of her involvement in the Carter Center projects makes Rosalynn, equally with Jimmy, an exemplar of Vimalakirti, or at the least analogous to the bodhisattva's goddess friend.

Gary Snyder has inspired a generation of American Zen students (and poets, backpackers, and environmentalists). His early translations of the Chinese Zen poet Hanshan "Cold Mountain" and his role as model for the main character of Jack Kerouac's novel *The Dharma Bums* were highly influential. Snyder is a serious student of Zen, having trained for years in the fifties and sixties at Rinzai Zen monasteries in Kyoto and continuing his meditation practice since then in his home in the Sierra foothills of California. But like Vimalakirti, Snyder is much more than a meditation adept.

A Pulitzer Prize–winning poet with many published volumes of poetry, Snyder shares Vimalakirti's eloquence. With working-class roots, Snyder has labored as a forest ranger, fire lookout, translator of ancient Chinese and Japanese texts, environmentalist, community organizer, amateur automobile mechanic, state government adviser and official, and now as a tenured

university professor. His wide interests encompass history, politics, biology, and anthropology, including a study of native cultures and mythic lore ranging across western North America to much of Asia and Australia.

Snyder could have received priest ordination from his Japanese teacher, but has remained committed to lay practice, having suggested that the old Japanese forms of ordination may not be appropriate to the current American context. The Zen community he established in the Sierra foothills models an amalgamated assembly of householder fellow practitioners who include manual laborers, professionals, dropouts, scholars, children, naturalists, and truck drivers, as if to encompass all of Vimalakirti's worldly realms.

Gary Snyder illuminates some of Vimalakirti's wizardly qualities as a trickster. Snyder frequently has written about or referred to the Native American trickster figure, Old Man Coyote. Many of Snyder's friends and colleagues have also pointed out his own coyote-like guise, often upsetting and playing with ordinary human conceptions, while also bringing primeval knowledge, assistance, and dignity. In one controversial example, Snyder has upset some traditional Buddhists who are devoted to principles of strict vegetarianism. While supportive of kindness to animals and of eating low on the food chain, Snyder has written of the integrity of native hunter folk, who summon their game with prayers, and respectfully venerate the offerings of life from animal spirits (and flesh). Snyder's call for responsible recognition of our place in the chain of critters, each of us yet another fruitful morsel in the great web of biological life and death, echoes Mahayana teachings of interrelatedness, but also unmasks the attachments to purity of some vegetarians.

Further blowing away preconceptions of virtue and compassion, and playing trickster to those with fixed views of not killing, Snyder the environmentalist has let it be known that he shoots the frogs that have invaded ponds and upset the ecosystem in his northern Sierra home terrain. He thereby poses a startling example of the complexity of the first precept in which not killing the frogs might amount to killing other lives in the fragile ecological balance. Snyder seems to relish upsetting any smugness among his American fellow Buddhists. He warns against co-opting Buddhist teaching into a comfortable, merely therapeutic, and hopelessly dualistic liberalism or humanism that fails to plumb the depths of true self and fundamental being, as taught by Vimalakirti.

In one of his masterpieces, the 1990 collection of essays called *The Practice of the Wild*, Gary Snyder describes the natural world of mountains and

rivers as a wilderness system. Snyder plays with the significance of the wild and wilderness as a vast metaphor encompassing senses of the open, energetic, free, spontaneous, unconditional, impermanent, exuberant, and dynamic, all as qualities of an independence that remains intimately mutual. He explores wildness as it pertains to society, psychology, land, and culture. This wilderness expounded by Snyder might be seen as a gloss on Vimalakirti's inconceivability and its depths and relevance for our world. With rigorous playfulness, Snyder discusses and unpacks the meanings of language, mind, and reality itself as wilderness regions, uncontrollable and unpredictable, but with their own rugged wisdom. With the experience of an accomplished poet, Snyder discusses "tawny grammar," and how the ecology of our language is a dynamic biological organism, not a product of calculation or regulation. Snyder does not indulge in merely abstract exposition, but subtly examines how we enact this wild in practice with our own wildness, "sauntering off the trail" with all due respect for the path as a guide. Snyder's way of meeting our lives as a robust wilderness beyond our attempts at management gives us a postmodern view of Vimalakirti's inconceivable liberation.

Turning to the quality of Vimalakirti's involvement in the wealth of the world, I envision Vimalakirti as transforming the function of accumulating material wealth, with its production of harmful inequities, into widely beneficial purposes and effects. As a modern case, one might consider the Rockefeller family, inheritors of a great fortune amassed by oil companies and later through the excesses of exploitation and appropriation of resources by multinational corporations. Yet the current generation of Rockefellers has cultivated the philanthropic tradition of the family, generously applying their substantial resources to greatly benefit many very worthy, cutting-edge developments in critical realms as diverse as education, religion, the environment, global peace, the sciences, and the arts.

We may reasonably speculate as to whether the current Rockefellers thus exemplify Vimalakirti's enlightened use of wealth. Might the remarkable benefits of the many good works endowed by the Rockefellers, and their sincere, benevolent intentions, outweigh in some cosmic balance the many harmful effects, some ongoing, caused by some of the activities that led to their fortune's accrual? Such questions, loaded with ambiguities, naturally flow from consideration of Vimalakirti's complex, bodhisattvic relationship to wealth and to the workings of the world.

Another contemporary example of generating and using wealth in a beneficial, illuminating manner is provided by a businesswoman named Anita Roddick, born in England of Italian immigrant parents. Roddick founded The Body Shop, a chain of highly successful international health and cosmetics stores dedicated to environmentally and spiritually constructive business practices, which has over a thousand shops in forty-four different countries around the world. In the manner of Vimalakirti, Anita Roddick has succeeded with an independent spirit and an outrageous playfulness that have been beneficial and liberating for her customers, employees, and suppliers.

Roddick advocates business as an arena for vitality, energy, and hope, "where the human spirit comes into play," and persistently challenges the notion that business is primarily about making profits. She believes companies can flourish by offering honest products and treating people decently. In attempting to create a new business paradigm, her company has never waged advertising campaigns or had a marketing department. Instead, Roddick has prospered by hard work and passionate commitment to both her store and her principles, congruent with Vimalakirti's teaching that liberation arises only amid passion and worldly involvement.

Roddick especially castigates as immoral the mainstream cosmetics industry that parasitically plays on women's fears and insecurities and promotes oppressive, artificial representations of beauty and glamour. Most large cosmetics companies make deceptive claims for supposed anti-aging concoctions and spend huge portions of their costs on marketing, packaging, and advertising. Roddick instead focuses on offering her shampoos, lotions, and body-care products in a variety of sizes, and using natural, organic materials created through environmentally friendly and nonharmful methods, without endangering threatened species or environments and without the cruel and unnecessary practices of animal testing.

Roddick is committed to following and promoting environmentally constructive practices, and she has collaborated on joint campaigns with Greenpeace, Friends of the Earth, Amnesty International, and other environmental and human rights groups. Body Shop employees and customers get personally involved in discussing current issues around these campaigns, although always with the company's soft-sell style. Roddick believes in service as a way of life and encourages branch stores to engage in local environmental campaigns, although focusing and limiting social-action displays so as not to interfere with customers' simply appreciating and purchasing

body–care products. Thus she educates her customers and staff while providing useful products, exemplifying business practices that share both the beneficial and entertaining aspects of Vimalakirti's colorful displays.

But the beneficial applications of wealth in the world suggested by the figure of Vimalakirti remain problematic for Anita Roddick, as for the Rockefellers. The very prosperity of Roddick's business has spawned published scrutiny and criticism that her company does not always live up to its environmental claims, and does not readily accept negative feedback. While Roddick's business practices may perhaps have fallen short of her ideals at times, by attempting to frame her company in an ethical context Roddick has helped establish a new standard for business ethics and helped support an active network of environmentally conscious new companies. The critiques might themselves be seen as signs of success in her aim of promoting higher ethical and environmental standards, which are now being applied to her company. Only through practice and increased attentiveness will such companies find out how to actually fulfill the goals of a new environmentally and socially productive business paradigm.

In an economic culture steeped in acquisitiveness, bottom-line profit margins, and the increasing corporate agglomerations machinated via hostile takeovers, it is difficult to readily or fully actualize the example of Vimalakirti. In light of the challenges of conducting honest business in our own context, we might all the more appreciate Vimalakirti, who "was honored as the businessman among businessmen because he demonstrated the priority of Dharma…[and] honored as the landlord among landlords because he renounced the aggressiveness of ownership."[6]

Film actor and director Clint Eastwood has exhibited a number of aspects of the Vimalakirti archetype. He exemplifies diversity of interest and talent in his pursuits as actor, film director, jazz aficionado, musician, restaurant owner, and even politician, having served as mayor of Carmel, California. Eastwood has been generous with his material resources. For example, he has supported programs to aid musicians and offered choice land for a nominal cost to construct a senior-citizen facility. As a landlord in Carmel, Eastwood has at times given assistance to tenants with limited means, and he has been active in raising support for fellow citizens whose homes were damaged by earthquake or floods. Eastwood's directorial efforts have shown unusual range for a mainstream Hollywood figure. His works include *Bird*, a biographical feature about the life of jazz great Charlie Parker.

The independent, rugged individualist character played by Eastwood in his early films, sometimes a gunslinger, sometimes a police detective, has some complicated but interesting resonances with Vimalakirti. This character developed out of Eastwood's roles in the Italian "spaghetti westerns" directed by Sergio Leone, many of which were directly influenced by samurai films such as Akira Kurosawa's classic *Yojimbo*. The samurai warrior ethos developed historically under the influence of one Japanese Zen version of the bodhisattva path. Loyalty, courage, fearlessness, and meditative concentration and presence were the most prized of samurai virtues. According to formulators of the samurai code, who were influenced by Confucianism even more than Buddhism, the samurai were supposed to present a model of noble, responsible character. But the hero of many samurai films, especially in the roles played by Toshiro Mifune, was the ronin, or masterless samurai, the tough, independent warrior cast out from social position, much like the gunslingers or outlaws in the old westerns. The whole history of Japanese Zen's relationship with the samurai class is open to criticism, inasmuch as Buddhist concentration practices and martial arts have sometimes been distorted into a rationale to justify violence and militarism. On the other hand, we might note Buddhism's historical origins in the military class of Siddhartha Gautama in India, and the great civilizing influence that the bodhisattva ideal has had on many Asian military cultures.

The characters played by Clint Eastwood have mostly been rugged individualists, independent and macho, but with their own personal sense of principle and integrity. This independence and the omnipotence of some of Eastwood's indestructible antiheroes echo the image of the independent layman Vimalakirti as the undefeatable champion dharma combatant, inexorably exposing the attachments and pretensions of all deluded or immature practitioners.

However, I mention Clint Eastwood in connection with Vimalakirti primarily because Eastwood's later films are worth considering as illuminating Vimalakirti's quality of the invalid as spiritual teacher. Traditional Buddhist teaching talks about the inevitable pain and disease of old age, sickness, and death. Most of Eastwood's later film roles, in pictures that he has frequently directed, depict an older man trying to meet the infirmity of aging with integrity, and the spiritual self-healing and transformation that occur when one faces uprightly the consequences of the life one has led. In films such as *Unforgiven* and *In the Line of Fire*, Eastwood has reprised the earlier gun-

slinger or independent law officer in the twilight of life, attempting to maintain some integrity and dignity in the midst of ailments, fading capacities, and the effects of previous life choices. Thus Eastwood has used his own aging to illuminate for his audience the spiritual struggles involved in aging, much as Vimalakirti used his sickness to point out the fundamental sickness of all living beings to the bodhisattvas.

Vimalakirti used his malady to clarify its underlying cause in the delusions of all beings. Helen Keller, perhaps the most acclaimed disabled person in modern times, found the spiritual resources to function with wisdom and power within the limitations of being blind and deaf. She became an educator to the public about the possibilities still available to the disabled and, then, like Vimalakirti, went beyond, to express radical concern and care for all suffering beings.

Helen Keller became blind, deaf, and mute when she was struck with a fever when less than two years old. Thanks to the intervention of an extraordinary teacher, Anne Sullivan, when she was seven, Keller was able to go on to develop remarkable knowledge and wisdom and to encourage many. As a child Keller had been locked into an inner world that was enraging and frustrating because she had no means to communicate. Sullivan was called a "miracle worker" because she was able to get through to the difficult, unruly child and introduce the concept of language to Keller. Thereafter Keller performed her own "miraculous displays," learning how to speak and attracting fame for her accomplishments while still very young.

Helen Keller pursued knowledge by learning five other languages, and studying history, mathematics, literature, astronomy, and physics, eventually graduating from Radcliffe College at the age of twenty-four. Keller learned through Sullivan's interpreting by spelling in Keller's hand with a manual alphabet, as well as via lip-reading with her fingers, and through Braille. She communicated by typing, speaking with her somewhat odd-sounding voice, and manually spelling in interpreters' hands. Thereby Keller was able to write numerous books, actively correspond with many people, and give lectures around the world, always displaying her great enthusiasm for life.

Possessed of an unusual wealth of inner experience resulting from being shut away from conventional perception, Helen Keller was a multidimensional woman who used her wisdom and knowledge in a great many realms. She developed a lifelong faith in the Swedenborgian religion with its philo-

sophical and cosmological validation of inner spiritual states and vision—familiar to Keller due to her limited external sensory input.

Keller was perhaps best known as a spokesperson for the blind, the disabled, and the mentally retarded, as she helped end the practice of locking away the blind and deaf in mental asylums. But Helen Keller applied her concern for the unfortunate to a range of issues of social justice. Her researches into disability and blindness revealed that class inequity was a contributing factor, as industrial accidents and inadequate medical care led to a higher incidence among the poor. She visited factories, slums, sweatshops, and workers on strike in mining or mill towns, lending her support, "smelling" the squalor, as she said, and listening to the pleas of those struggling, thereby educating herself to the devastating effects of class injustice.

Keller was also a leading figure in the women's suffrage movement, actively campaigning for women's suffrage in articles, lectures, and personal appeals to politicians, as well as marching at the front of suffrage rallies. Having worked so hard to transcend her early silence and find her voice, Keller was one of the founders of the American Civil Liberties Union in support of free speech. As a white woman from Alabama, she was an unusual early supporter of the NAACP.

As a vehement social critic and champion of the oppressed, Keller exhibited Vimalakirti's tenacious and fearless critical insight. Keller's radical political views led her to active involvement, writing and speaking on behalf of the Socialist Party, and later the Industrial Workers of the World, or Wobblies. But Keller was able to skillfully moderate her sometimes unpopular views and remained a spokesperson educating and raising funds on behalf of the blind and disabled, although she never abandoned her passionate support for social justice and equality. Like Vimalakirti, Helen Keller was an invalid undeterred from expressing compassion for a wide range of beings using her remarkable wisdom, powers, and knowledge.

Aside from renowned, remarkable cases, many anonymous sick and dying people can teach us of the truth of impermanence in their old age, sickness, and death. When we use our own ailments as skillful means, or when we can listen and learn from others' diseases the wisdom inherent in us all, we are in the realm of Vimalakirti. Enactment of Vimalakirti further manifests marvelous, creative displays in diverse worldly arenas, everywhere leaving astonishment and a fresh sense of vitality and expanded, luminous possibilities.

Beyond the Archetypal
Sustained Awakening

UNPACKING THE ARCHETYPAL

IN FULLY EMPLOYING the bodhisattva figures as archetypes, we must also realize the tentative, artificial nature of archetypes. The archetypal aspects of the bodhisattva figures are helpful as patterns. We can feel a sense of what it might mean to behave and function as a bodhisattva ourselves by examining the fearless insight and eloquence of Manjushri, the luminous helpful activity of Samantabhadra, the unmediated, unconditional generosity of Avalokiteshvara, the faithful witness of Jizo, the patience and loving concern of Maitreya, the clever, illuminating displays of Vimalakirti, and the selfless decision and determination of Siddhartha Gautama. However, all of their kindness and efforts are only manifest and real when we see the bodhisattva figures not as theoretical or mythological, but as actualities expressed in our world.

Beyond all the archetypal patterns, the life of the bodhisattva is in ordinary, everyday activity. In simple acts of kindness and gestures of cheerfulness, bodhisattvas are functioning everywhere, not as special, saintly beings, but in helpful ways we may barely recognize. The bodhisattvas are not glorified, exotic, unnatural beings, but simply our own best qualities in full flower.

The people I have cited as the bodhisattvas' exemplars are actual human beings. They are not archetypes. They provide illustrations of some aspects of the various bodhisattva figures. But we can see in many of these people that sometimes the greatest deeds and virtues also cast deep shadows, for example, with the brilliant Jefferson's slaveholding, as well as in the unmentioned human failings and foibles of a great many of the others. Archetypes

give us the opportunity to study the projections we make from our own internal dynamics, our innate bodhisattvic qualities. The point is not whether Mother Teresa is or is not worthy of being called a bodhisattva, or canonized as a saint, but that her story is unquestionably a focal point that attracts our own projections and aspirations toward goodness, toward bodhisattvahood.

Bodhisattvas are not merely archetypes. Bodhisattvas are great cosmic beings, helping us all to become bodhisattvas. Bodhisattvas are not who we think they are. Bodhisattvas are simply ordinary beings, making their way back to buddha. Bodhisattvas appear in the nooks and crannies of your life; soon you may start seeing them more clearly. Bodhisattvas are just around the corner. Bodhisattvas are extraordinary wondrous beings, bestowing blessings on all wretched, confused, petty creatures. Bodhisattvas are living in your neighborhood, waiting to say "Good morning" to you. Bodhisattvas are just like you and me. Bodhisattvas are kind and gentle. Bodhisattvas are not who we think they are. Bodhisattvas are tough and indefatigable. Bodhisattvas are not limited to a handful of amazing figures or famous people. Bodhisattvas are not limited by what we say they are or are not. We are all bodhisattvas. Bodhisattvas are not who we think they are. We cannot understand how wonderful bodhisattvas are. We are all bodhisattvas.

A STORY ABOUT STORIES

Searching for the archetypal qualities of each bodhisattva figure, what has emerged in this book is a collection of stories, or rather seven anthologies of stories. Through the anecdotes in sutras and folklore, and the data in iconography and etymology about Avalokiteshvara, for example, we can begin to get a sense of the range of this figure, of the archetypal qualities of bodhisattvic compassion. And yet the whole cannot be reduced to the sum of its parts. The dynamic fullness of the qualities of Avalokiteshvara or Jizo, of Maitreya or Samantabhadra, goes beyond whatever story we read and transcends the definitions we attach to these figures.

As Manjushri teaches us, the aim of awakening practice is to go beyond our stories, or to not get caught by our stories. We get fooled by our stories about ourselves and our world, thereby losing the true openness and wonder of our lives, and our intimate connection to all beings. Shakyamuni Buddha himself encourages us to go beyond archetypal fables when he proclaims his inconceivable life span in the *Lotus Sutra*. He states that the

account of the archetypal stages of his path to awakening—his leaving the palace, doing austerities, and sitting under the bodhi tree—is only a means to encourage and benefit beings, but that actually buddhas and bodhisattvas are ever present, replete in the very ground we walk on.

The experience of openness described by all buddhas and bodhisattvas involves letting all the narratives drop away, relaxing and letting go of all of the identifications and graspings that arise as a response to our cherished stories about the world. After everybody lives happily ever after, when we return home from all the plot lines, we are simply here, present with our breathing, our bodies and senses, even present with the wispy thought forms trailing by like clouds and haze in the vast, empty sky.

At the end of this very paragraph, the unreality of story might be glimpsed if the reader were then to stop reading, put this book down, sit quietly and just be present with sounds, with the sensation of breathing in and breathing out. At the end of this paragraph continue sitting comfortably wherever you are now, and just observe thoughts and sensations passing. Just let the thoughts pass along, and then observe the reappearance of more thoughts and feelings, sensing the bundling of thoughts into trains of discourse with their own impetus. Amid the passing thoughts, gently return to awareness of breathing, of sounds, of sensations. When this paragraph ends, very soon, continue to be present in this way, for just a few minutes.

If you now reflect on what that brief experience was like, you may try to verbalize it. But no account would encompass the entire reality and richness of your full experience in those few minutes. The actual experience of presence can be fragmentarily described or discussed, but it cannot be thoroughly encompassed by any tale about what happened.

When we become familiar and intimate with this space beyond story, we might seek to abide in the realm of no story, to fashion a nice, quiet hermitage divorced from all the stories of the world. But that would just be another story, the story about a person with no story line. As we return from the space between the dramas, reentering life and its problems to face all sentient beings, and our own humanity, we find stories reemerging.

Returning to story, all too often we just resume our old conditioned patterns of trying to control or manipulate the world of objects, or of being

victimized by the forces "out there." If we are aware, we can choose our own myths. We may choose to reclaim our former stories, but with a lighter touch. Or we may choose to discard some parts of some of the stories that we no longer care to enact. Or we may incorporate some brand-new stories, even stories of awakening.

The archetypal anthologies of stories about bodhisattvas can act as homeopathic remedies to our conditioned, unexamined stories. We can recast our own stories in terms of the stories of Manjushri, or Jizo, or Kanzeon. We can let go of stories of ourselves as victims or abusers, as powerless or full of ourselves and rife with conceit. All our stories about ourselves can be told as chapters in the great narrative of our awakening in total interconnectedness with all other beings. We can tell the story of our personal part in the story of everybody awakening together. We might borrow the stories of the bodhisattvas and see our own life story illuminated by the story of Manjushri's bright insight, or Samantabhadra's committed work in the world, or Jizo's healing witness to hellish situations.

These new stories are also illusions. But in the teaching and experience of interdependent co-arising, we learn that the selves we believe ourselves to be are fictions. The truth is wider and deeper than all the stories. We can recast our stories so that we are not caught by the stories, while still relating our stories as the most beautiful expressions possible for kindly awakening everyone from enslaving stories. Our addictions, misconduct, and confusion can be acknowledged in our enactment of an account of our liberation from these failings.

Buddhist liberation is about fully knowing our stories, and not being trapped by them. Stories have their own power. We cannot ignore them. Trying to force our old stories to go away just reinforces their grasp on us. But after listening quietly and carefully to the old, worn fables we have been telling ourselves, or that we were trained to relate by our world, we can gently let them go, see that they are only a part of a greater story including all beings. To paraphrase Walt Whitman, we each are vast, we each contain multitudes of stories, including stories about bodhisattvas, and about awakening from stories. Awakening to the suchness of reality, of our life just as it is, we find the fuller liveliness that the bodhisattvas are ever guiding us toward. Growing into the dynamic vitality of our deep interconnectedness with all being, we in turn become guides to others, helping awaken the life all around us.

AWAKENING FROM HISTORY—HISTORY AS STORY

It is a truism that history is written by the victors. Anyone who has lived through "historical" events knows that the account related later by newspapers or historians is a feeble, limited view of the reality of many people's complex experiences. Even when not intentionally distorted by the self-interests or unquestioned assumptions of forces controlling the media, the histories often miss central features in the immediate reality of events. How we currently define the past (these stories we tell about history) affects and helps define our awareness right now. But the stories do not accurately record the fullness of some former presence.

Certainly the contributions of trained historians are valuable in giving us more pieces of a picture, and in analyzing criteria for more fully examining each shard of our current mirror on the past. Relatively reliable history may illuminate the reality of past events and the manner in which they have impacted current conditioning, social or personal. And history distorted by unconscious assumptions or serving current special interests may distort the nature of the karma we currently face, and foster further delusion.

The history of Shakyamuni Buddha, or of historical Buddhist figures over the past twenty-five hundred years, is something we must assess from our own vantage points. We do not truly know from the diverse records what the man Siddhartha Gautama actually taught in northern India two and a half millennia ago. When we look at all the stories that have been told about what Shakyamuni Buddha taught his assemblies, the best we can do may be to realize which combinations of these stories help us to find our own story of awakening. We have to keep telling his story anew for each of us, and for each generation.

This is a slippery business. We cannot get away with simply telling the story that makes us feel good, that fuels our own conceits and self-serving stories. We have as a resource spiritual teachers and a whole body of traditional teachings and texts to help us avoid believing confused, enslaving stories. We study and absorb the old, faithful stories of spirit actualized so that we will not be trapped by any stories, especially stories that ultimately fail to help liberate our selves and our society from suffering. We create the history of the past and future in the stories we live out together in our world today. For the sake of the present, and for the sake of the future if you are Maitreya, we tell stories about the past and call them history.

And yet, when we thoroughly decide to take up the work of awakening together with all beings, and continue to rededicate ourselves to this proposition, it is definitely possible, beyond history, to know Shakyamuni Buddha, to see Siddhartha in his heroic struggles right now, face-to-face. We can sit eyeball to eyeball with Buddha, and with each of the bodhisattvas, without blinking, and also with blinking. We can make the stories of the heroic bodhisattvas our stories. We can live our own life thus.

THE BODHISATTVA STORY
FOR OUR TROUBLED WORLD

The major bodhisattva archetypes, along with basic bodhisattva vows and transcendent practices, can provide a useful spiritual grid of values with which to examine historical and current political developments. Some stories are more conducive to awakening and universal well-being than other stories. We can unearth and apply constructive, enlightening spiritual values to our considerations of current social issues, without violating Jeffersonian principles of separation of church and state. We can educate about useful stories, without branding or burning at the stake those still holding on to incomplete stories, or stories we deem false.

The bodhisattvas help us see ourselves. They also help us appreciate the world around us, and our place in it, including how we may be called to help change society. Contemporary bodhisattva exemplars may work in hospices tending to the dying, or they may work in slums trying to feed and assist the impoverished and forgotten. Daniel Ellsberg and Muhammad Ali felt called to oppose the horrors of the Vietnam War, whatever the cost to them personally. Helen Keller wished to help the disabled and demonstrate that dynamic life was still possible for those the world had dismissed. Through her explorations and research of the dark silent world beyond her senses of touch and smell, she was moved to radically devote her life to fighting all forms of social inequality and the resulting disabilities.

Values supportive of awakened awareness and of ethical precepts that emerge from seeking to benefit all beings can give us a path by which to return and live in the world. Bodhisattvas see that working on oneself and working in the world are not separate matters. Social actions impact one's own inner being; silent, upright sitting has a deep effect on the whole planet. There are as many ways to make this a kinder, gentler world as there are people living in it. Each story is an image of the whole story.

As the bodhisattva path meanders into our modern Western era, it reveals new options and directions and is itself being revised. Informed by experiments with socially engaged Buddhism, illuminated by Buddhist-Christian and Buddhist-Jewish dialogues, the bodhisattvas may find new ways to express themselves in order to address new situations and realms of suffering. Bodhisattvas will continue to explore arenas of global communication, conflict mediation, nonviolent social action, and environmental vision and reclamation. Inspired by Western psychology, the bodhisattvas will adapt traditional meditations and concentration methods to suit the novel obstacles of the Western psyche, and will continue to help people awaken to their own inalienable buddha natures.

Beneficial application of bodhisattva principles to current social issues does not rigidly adhere to any particular ideological political position or partisan program. Rather, bodhisattvic concerns operate flexibly as most helpful in changing situations, but always from the standpoint of encouraging beings to cooperatively express awakened nature. Bodhisattva values also can offer the socially concerned a base of calm concentration and insight into the ephemeral nature of conditions, and can moderate extreme, self-righteous expressions as they deviate from their original compassionate inspirations.

BRINGING IT ALL BACK HOME

This book has offered visions of the major bodhisattva figures as guides to psychologies for an awakening spiritual life. The bodhisattvas provide us with models and approaches, but ultimately we must each find our own constructive way of blossoming in the world. As Bob Dylan sings, "Each of us has our own special gift and you know this was meant to be true, and if you don't underestimate me I won't underestimate you."[1]

We all are wonderful, unique creatures, with our own combinations of talents, strengths, and insights. Each of us is a particular expression of the universe, a bright jewel in the vast, holographic network of the world. We can decide to do our best to enact our innermost intentions, our deepest selves, while also seeing others as prospective bodhisattvas, who are also awakening to their true potential. When we see each other as awakening beings in process, we do not underestimate each other and we can find creative ways to meet and support each other.

Finally we must go beyond the models and examples that inspire us,

beyond all the archetypes, and just fully be ourselves. With so much trouble in the world, it is important that we find ways of working together to sustain our intention. The crucial vow of bodhisattva practice is just to continue to awaken and care for all beings. And that is the story, and the beginning of many new stories, having begun once upon a time.

Bodhisattva Archetypes

SANSKRIT NAME; ENGLISH MEANING	OTHER NAMES	MAIN SUTRAS	REPRESENTATIVE MAHAYANA SCHOOLS/SECTS	MAJOR ELEMENTS OF ICONOGRAPHY
Shakyamuni Sage of the Shakyas	Siddhartha Gautama (pre-buddhahood)	All	All (less so in Pure Land, Huayan, Vajrayana)	earth-touching mudra; unadorned, long earlobes; head protuberance; emaciated Shakyamuni
Manjushri Noble, Gentle One	Manjughosha Wenshu (Chinese) Monju (Japanese)	*Prajnaparamita*; Appears prominently in many others, including *Avatamsaka, Vimalakirti*	Madhyamika informally: Chan/Zen Ritsu/Precepts	carries sword and/or prajnaparamita scroll; sometimes other implements; rides lion; youthful
Samantabhadra Universal Worthy or Goodness	Puxian (Chinese) Fugen (Japanese)	*Avatamsaka* [Flower Ornament] also *Lotus Sutra*	Huayan (Kegon in Japanese)	rides six-tusked elephant often in gassho in East Asia; may carry wish-fulfilling gem, lotus, or scepter
Avalokiteshvara Lord of What Is Seen / Regarder of the World's Cries	Chenrezig (Tibetan) Guanyin (Chinese) Kwanseum (Korean) Kannon (Japanese) Kanzeon (Japanese) Kanjizai (Japanese)	*Lotus Sutra* *Heart Sutra*	Tiantai Pure Land	complex, myriad figures, including: multiarmed and multi-headed forms; Amitabha Buddha in headdress; carries lotus and many other implements

Bodhisattva Archetypes

SANSKRIT NAME; ENGLISH MEANING	OTHER NAMES	MAIN SUTRAS	REPRESENTATIVE MAHAYANA SCHOOLS/SECTS	MAJOR ELEMENTS OF ICONOGRAPHY
Kshitigarbha Earth Womb, Treasury, or Storehouse	Dizang (Chinese) Jizo (Japanese)	*Sutra of the Past Vows of Earth Store Bodhisattva*	popular folk Buddhism	shaved-head monk; carries monk staff, wish-fulfilling gem
Maitreya Loving One	Milo or Milofe (Chinese) Miroku (Japanese)	Yogachara sutras and commentaries; also *Avatamsaka, Vimalakirti* some Pali suttas	Yogachara	appears as Buddha or bodhisattva; often sits with legs down, Western style; stupa may be carried or in headdress; pensive, contemplative pose
Vimalakirti Undefiled Name or Renown	Weimojie (Chinese) Yuima (Japanese)	*Vimalakirti nirdesha Sutra*	Chan/Zen [Informally]	layman's robes; armrest reflecting sickness

Bodhisattva Archetypes

SANSKRIT NAME	PRIMARY ASSOCIATED COSMIC FIGURES	MAJOR ASSOCIATED HISTORICAL FIGURES	SACRED SITES	PRIMARY PERFECTIONS
Shakyamuni	previous incarnations in jatakas	Ten great disciples; stepmother: Mahapraja-pati Gautami; wife: Yashodara	Bodhgaya Varanasi (Benares) Vulture Peak	effort meditation wisdom
Manjushri	Prajnaparamita; Yamantaka; Sarasvati	Tsongkhapa Prince Shotoku	Mount Wutai	wisdom ethical conduct meditation
Samantabhadra	Vairochana Buddha; Sudhana Vajrasattva	Eguchi	Mount Omei	vow knowledge meditation powers
Avalokiteshvara	Amitabha Buddha (Amida-Japanese) Tara Miaoshan	Bodhidharma the Dalai Lamas	Putoshan Island Potala palace Japan pilgrimage sites	generosity skillful means patience powers
Kshitigarbha	Yama, and the Ten Kings; Akashagarbha	Jin Qiaojue	Mount Jiushan Kyoto pilgrimage	vow ethical conduct powers effort

Bodhisattva Archetypes

SANSKRIT NAME	PRIMARY ASSOCIATED COSMIC FIGURES	MAJOR ASSOCIATED HISTORICAL FIGURES	SACRED SITES	PRIMARY PERFECTIONS
Maitreya	Eternal Mother (China)	Hotei Asanga Mahakashyapa Mahasattva Fu Xuanzang Kukai	Mount Fuji Japan pilgrimage sites	patience meditation generosity
Vimalakirti	Akshobhya Buddha	Wang Wei Layman Pang	All ten-feet-square huts	powers knowledge wisdom skillful means

Notes

1. THE BODHISATTVA IDEAL

1. Kazuaki Tanahashi, ed. and trans., *Moon in a Dewdrop: Writings of Zen Master Dogen* (New York: Farrar, Straus and Giroux, North Point Press, 1985), p. 69. In Dogen's essay *Genjokoan*, "Actualizing the Fundamental Point."

3. THE TEN TRANSCENDENT PRACTICES

1. One version of this dharani is:

Adande dandapati danda-avartani dandakushale dandasudhari sudhari sudharapati buddhapashyane [sarva] dharani avartani samvartant samga parikshate samghanirgatani dharmaparikshate sarvasattvaruta kaushalya nugate simha vikridite anuvarte vartani vartali svaha.

See Kato, Bunno, Yoshiro Tamura, and Kojiro Miyasaka, trans., *The Threefold Lotus Sutra: Innumerable Meanings, The Lotus Flower of the Wonderful Law, and Meditation on the Bodhisattva Universal Virtue* (New York: Weatherhill, 1975), p. 341.

4. SHAKYAMUNI AS BODHISATTVA

1. D. T. Suzuki, *Manual of Zen Buddhism* (New York: Grove Press, 1960), p. 155.

2. James W. Loewen, *Lies My Teacher Told Me: Everything Your American History Textbook Got Wrong* (New York: Touchstone, 1995), p. 247.

5. MANJUSHRI

1. Robert A. F. Thurman, ed., *The Life and Teachings of Tsong Khapa* (Dharamsala, India: Library of Tibetan Works and Archives, 1982), pp. 191–92.

2. Garma C. C. Chang, ed., *A Treasury of Mahayana Sutras: Selections from the Maharatnakuta Sutra* (University Park: Pennsylvania State University Press, 1983), "Manjushri's Discourse on the Paramita of Wisdom," pp. 102–3.

3. Ibid., in "The Prediction of Manjushri's Attainment of Buddhahood," pp. 177–78.

4. Ibid., p. 179.

5. Ibid., p. 183.

6. Thomas Cleary, trans., *The Book of Serenity* (Hudson, N.Y.: Lindisfarne Press, 1990), p. 3.

7. Ibid., p. 4.

8. Taigen Daniel Leighton and Shohaku Okumura, trans., *Dogen's Pure Standards for the Zen Community: A Translation of Eihei Shingi* (Albany: State University of New York Press, 1996), p. 139.

9. Albert Einstein, *The World As I See It* (New York: Philosophical Library, 1949), p. 28.

10. Ibid., p. 26.

11. Paul Jay Robbins, "Bob Dylan As Bob Dylan," interview in the *Los Angeles Free Press*, Sept. 17, 1965, reprinted in *On the Tracks*, no. 9, Grand Junction, Colorado, February 1997, p. 13.

12. Bob Dylan, *Lyrics, 1962–1985* (New York: Alfred A. Knopf, 1985), in "Visions of Johanna," p. 223.

13. Ibid., in "Every Grain of Sand," p. 462.

14. Ibid., in "Ballad in Plain D," p. 143.

6. SAMANTABHADRA

1. Thomas Cleary, trans., *Entry into the Realm of Reality, the Text: The Gandavyuha, the Final Book of the Avatamsaka Sutra* (Boston: Shambhala, 1989), p. 379.

2. J. C. Cleary, *Zibo: The Last Great Zen Master of China* (Berkeley: Asian Humanities Press, 1989), p. 140.

3. Author's translation, from the ending of Dongshan's "Song of the Jewel Mirror Samadhi." See Taigen Daniel Leighton with Yi Wu, trans., *Cultivating the Empty Field: The Silent Illumination of Zen Master Hongzhi* (Boston: Tuttle Publishing, 2000), pp. 76–77; and William F. Powell, trans., *The Record of Tung-shan* (Honolulu: Kuroda Institute, University of Hawaii Press, 1986), pp. 63–65.

4. William Blake, *Complete Writings*, rev. ed., edited by Geoffrey Keynes (London: Oxford University Press, 1966), "There Is No Natural Religion" and "All Religions Are One," p. 98.

5. Ibid., "London," p. 216.

6. Northrop Frye, *Fearful Symmetry: A Study of William Blake* (Princeton: Princeton University Press, 1947), p. 21.

7. William Blake, *Complete Writings*, "The Marriage of Heaven and Hell," p. 151.

8. Ibid., "Auguries of Innocence," p. 431.

9. Ibid., "The Marriage of Heaven and Hell," p. 151.

10. Ibid., p. 154.

11. Ibid., p. 151.

12. Ibid., p. 160.

13. Peter Ackroyd, *Blake* (New York: Alfred A. Knopf, 1996), p. 367.

14. Gaetano Kazuo Maida, "Plan for Improvisation: An Interview with Pete Seeger," in *Whole Earth Review*, no. 84 (winter, 1994), p. 38.

15. Rosemary Treble, *Van Gogh and His Art* (Northbrook, Ill.: Book Value International, 1975), p. 73.

7. AVALOKITESHVARA (GUANYIN, KANNON)

1. Author's translation. For another version and the context see Leon Hurvitz, trans., *Scripture of the Lotus Blossom of the Fine Dharma* (New York: Columbia University Press, 1976), p. 319.

2. Cleary, trans., *The Book of Serenity*, p. 229.

3. Ibid., p. 229.

4. Ibid., p. 230.

5. Author's translation. For another version and the context, see Tanahashi, ed. and trans., *Moon in a Dewdrop: Writings of Zen Master Dogen*, p. 70.

6. Kyoko Motomichi Nakamura, trans. and ed., *Miraculous Stories from the Japanese Buddhist Tradition: The Nihon Ryoiki of the Monk Kyokai* (Cambridge: Harvard University Press, 1973), p. 196.

7. Ibid., p. 237.

8. Thomas Cleary and J. C. Cleary, trans., *The Blue Cliff Record*, vol. I (Boulder, Colo.: Shambhala, 1977), p. 1.

9. Rodger Kamenetz, *The Jew in the Lotus* (San Francisco: HarperSanFrancisco, 1995), p. 106.

10. Erica Anderson, *The Schweitzer Album: A Portrait in Words and Pictures*, Additional Text by Albert Schweitzer (New York: Harper & Row, 1965), p. 161.

11. Ibid., p. 174.

12. Mitsu Suzuki, *Temple Dusk: Zen Haiku*, trans. Kazuaki Tanahashi and Gregory Wood (Berkeley: Parallax Press, 1991), pp. 136, 149, 141.

13. Shosan Victoria Austin, "Suzuki Sensei's Zen Spirit," in *Buddhist Women on the Edge: Contemporary Perspectives from the Western Frontier*, ed. Marianne Dresser (Berkeley: North Atlantic Books, 1996), pp. 210–11.

8. Kshitigarbha (Jizo)

1. Buddhist Text Translation Society; Bhikshunis Heng Hsien, Heng Ch'ih, and Upasaka Kuo Jung Epstein, trans., *Sutra of the Past Vows of Earth Store Bodhisattva* (Talmage, Calif.: Dharma Realm Buddhist University, 1982), p. 19.

2. Elie Wiesel, *One Generation After* (New York: Random House, 1970), pp. 38–39.

3. Ibid., p. 48.

4. Toni Morrison, *Beloved* (New York: Alfred A. Knopf, 1987), p. 66.

5. Thomas Merton, "Thomas Merton's View of Monasticism," in *The Asian Journal of Thomas Merton* (New York: New Directions, 1975), p. 305.

6. Ibid., p. 306.

7. Ibid., p. 307.

8. John Fraim, *Spirit Catcher: The Life and Art of John Coltrane* (West Liberty, Ohio: GreatHouse, 1996), pp. 189–90.

9. MAITREYA

1. Taigen Daniel Leighton and Kazuaki Tanahashi, translations of poems by Ryokan, *in Essential Zen*, ed. Tanahashi and Tensho David Schneider (San Francisco: HarperSanFrancisco, 1994), p. 132.

2. Lew Welch, *Ring of Bone: Collected Poems 1950–1971* (San Francisco: Grey Fox Press, 1979), pp. 196–98.

3. Leighton and Okumura, trans., *Dogen's Pure Standards for the Zen Community*, p. 149.

10. VIMALAKIRTI

1. Robert A. F. Thurman, trans., *The Holy Teachings of Vimalakirti: A Mahayana Scripture* (University Park: Pennsylvania State University Press, 1976), p. 66.

2. Ibid., p. 50–51.

3. Thomas Cleary and J. C. Cleary, trans., *The Blue Cliff Record*, vol. 3, p. 541.

4. Cleary, trans., *The Book of Serenity*, p. 201.

5. Leighton with Wu, trans., *Cultivating the Empty Field*, p. 70.

6. Robert A. F. Thurman, trans., *The Holy Teachings of Vimalakirti*, p. 21.

11. BEYOND THE ARCHETYPAL

1. Dylan, *Lyrics*, 1962–1985, in "Dear Landlord," p. 259.

Selected, Annotated Bibliography

Books are listed by chapters to help readers find material for particular subjects, and for references cited in chapters. Some books are listed in more than one chapter.

GENERAL REFERENCES

The following are books consulted as general references for all of the bodhisattvas. Some will also be listed in relevant chapters.

Abe, Ryuichi. *The Weaving of Esoteric Mantra: Kukai and the Construction of Esoteric Buddhist Discourse*. New York: Columbia University Press, 1999. Excellent source for Kukai (Maitreya chapter), and Vajrasattva (Samantabhadra).

Berger, Patricia, and Terese Tse Bartholomew, eds. *Mongolia: The Legacy of Chinggis Khan*. San Francisco: Asian Art Museum of San Francisco, 1995.

Bhattacharyya, Benoytosh. *The Indian Buddhist Iconography*. Calcutta: Firma K. L. Mukhopadhyay, 1968.

Buswell, Robert E., Jr. and Robert M. Gimello, editors. *Paths to Liberation: The Marga and Its Transformations in Buddhist Thought*. Honolulu: University of Hawaii Press, 1992.

Ch'en Kenneth. *Buddhism in China: A Historical Survey*. Princeton: Princeton University Press, 1964.

Dayal, Har. *The Bodhisattva Doctrine in Buddhist Sanskrit Literature*. Delhi: Motilal Banarsidass, 1932.

Eggenberger, David, ed. *McGraw-Hill Encyclopedia of World Biography: Twentieth Century Supplement*, vols. 13–16. Palatine, Ill.: J. Heraty, 1987. For Thomas Edison, Carl Jung, Albert Schweitzer, Gertrude Stein.

Eliade, Mircea, editor in chief. *The Encyclopedia of Religion*. 16 vols. New York: Macmillan, 1989.

Getty, Alice. *The Gods of Northern Buddhism: Their History, Iconography, and Progressive Evolution Through the Northern Buddhist Countries*. Oxford: Oxford University Press, 1914. Reprint, Rutland, Vt.: Charles E. Tuttle, 1962.

Hakeda, Yoshito S., trans. with commentary. *Kukai: Major Works*. New York: Columbia University Press, 1972. "The Secret Key to the Heart Sutra" is especially relevant, and first inspired me to think about the bodhisattvas as archetypes.

Hirakawa, Akira. *A History of Indian Buddhism: From Sakyamuni to Early Mahayana*. Trans. and ed. by Paul Groner. Honolulu: University of Hawaii Press, 1990.

Ingram, Catherine. *In the Footsteps of Gandhi: Conversations with Spiritual Social Activists.* Berkeley: Parallax Press, 1990. See interviews with the Dalai Lama, Thich Nhat Hanh, Ram Dass, Joanna Macy, and Gary Snyder.

Johnson, Allen, and Dumas Malone, eds. *Dictionary of American Biography.* 20 vols. Published under the auspices of the American Council of Learned Societies. New York: Scribner's, 1928–58. For Rachel Carson, Clint Eastwood, Thomas Edison, Margaret Mead, Jackie Robinson, Gertrude Stein, Gloria Steinem.

Kasahara, Kazuo, ed. *A History of Japanese Religion.* Tokyo: Kosei Publishing Co., 2001.

Kawai, Hayao. *The Buddhist Priest Myoe: A Life of Dreams.* Translated by Mark Unno. Venice, Calif: Lapis Press, 1992.

Kawamura, Leslie S., ed. *The Bodhisattva Doctrine in Buddhism.* Waterloo, Ontario: Canadian Corporation for Studies in Religion, 1981.

Kunsang, Erik Perna, trans. *The Lotus-Born: The Life Story of Padmasambhava*, Composed by Yeshe Tsogyal. Boston: Shambhala, 1993.

Kyotaro, Nishikawa, and Emily Sano. *The Great Age of Japanese Buddhist Sculpture: A.D. 600–1300.* Fort Worth: Kimball Art Museum/ Japan Society, 1982.

Lopez, Donald S., ed. *Buddhism in Practice.* Princeton: Princeton University Press, 1995.

_____. *Religions of China in Practice.* Princeton: Princeton University Press, 1999.

Lopez, Donald S., and Steven C. Rockefeller, eds. *The Christ and the Bodhisattva.* Albany: State University of New York Press, 1987. Especially Luis O. Gomez, "From the Extraordinary to the Ordinary: Images of the Bodhisattva in East Asia" and Robert Thurman, "The Buddhist Messiahs: The Magnificent Deeds of the Bodhisattvas."

Loy, David. "The Dharma of Emanuel Swedenborg: A Buddhist Perspective." In *Buddhist-Christian Studies*, vol. 16, 1996. Relevant background. to William Blake, John "Appleseed" Chapman, and Helen Keller.

Matsunaga, Alicia. *The Buddhist Philosophy of Assimilation.* Rutland, Vt.: Charles E. Tuttle, 1969.

Matsunaga, Daigan, and Alicia Matsunaga. *Foundations of Japanese Buddhism.* 2 vols. Los Angeles: Buddhist Books International, 1976.

Miura, Isshu, and Ruth Fuller Sasaki. *Zen Dust: The History of the Koan and Koan Study in Rinzai (Lin-chi) Zen.* New York: Harcourt, Brace & World, 1966. An extremely valuable resource with voluminously comprehensive footnotes, unfortunately omitted in its republication as *The Zen Koan: Its History and Use in Rinzai Zen.*

Mori, Hisashi. *Sculpture of the Kamakura Period.* Trans. by Katherine Eickmann. New York: Weatherhill/Heibonsha, 1974.

Prip-Moller, Johannes. *Chinese Buddhist Monasteries: Their Plan and Its Function As a Setting for Buddhist Monastic Life.* Hong Kong: Hong Kong University Press, 1937.

Rhie, Marylin M., and Robert A. F. Thurman. *Wisdom and Compassion: The Sacred Art of Tibet.* New York: Harry N. Abrams, 1991.

Sangharakshita. *The Eternal Legacy: An Introduction to the Canonical Literature of Buddhism.* London: Tharpa Publications, 1985. A valuable survey reference for the sutras.

Saunders, E. Dale. *Mudra: A Study of Symbolic Gesture in Japanese Buddhist Sculpture.* Princeton: Princeton University Press, 1960.

Sawa, Takaaki. *Art in Japanese Esoteric Buddhism.* Translated by Richard L. Gage. New York: Weatherhill/Heibonsha, 1972.

Schumacher, Stephen, and Gert Woerner, eds. *The Encyclopedia of Eastern Philosophy and Religion.* Boston: Shambhala, 1994.

Soothill, William Edward, and Lewis Hodous. *A Dictionary of Chinese Buddhist Terms.* Delhi: Motilal Banarsidass, 1937.

Stone, Jacqueline. *Original Enlightenment and the Transformation of Medieval Japanese Buddhism.* Honolulu: University of Hawaii Press, 1999.

Suzuki, Shunryu. *Zen Mind, Beginner's Mind.* New York: Weatherhill, 1970.

Tanabe, George J., Jr. *Religions of Japan in Practice.* Princeton: Princeton University Press, 1999.

_____. *Myoe the Dreamkeeper: Fantasy and Knowledge in Early Kamakura Buddhism.* Cambridge: Harvard University Press, 1992.

Trungpa, Chogyam, Rinpoche. *Visual Dharma: The Buddhist Art of Tibet.* Berkeley: Shambhala, 1975.

Vessantara. *Meeting the Buddhas: A Guide to Buddhas, Bodhisattvas, and Tantric Deities.* Birmingham, England: Windhorse Publications, 1993.

Williams, Paul. *Mahayana Buddhism: The Doctrinal Foundations.* London: Routledge, 1989. An excellent overview of Mahayana philosophy.

1. THE BODHISATTVA IDEAL

Bolen, Jean Shinoda. *Goddesses in Everywoman: A New Psychology of Women.* New York: Harper Perennial, 1984.

_____. *Gods in Everyman: A New Psychology of Men.* New York: Harper & Row, 1989.

Cleary, Thomas, trans. *The Flower Ornament Scripture: A Translation of the Avatamsaka Sutra.* 3 vols. Boston: Shambhala, 1983–1986. See Chapter 26, "The Ten Stages," and chapter 39, "Entry into the Realm of Reality."

Hurvitz, Leon, trans. *Scripture of the Lotus Blossom of the Fine Dharma.* New York: Columbia University Press, 1976. Chapter 25, "The Gateway to Everywhere of the Bodhisattva He Who Observes the Sounds of the World," and the prodigal son story in chapter 4, "Belief and Understanding."

Leighton, Taigen Daniel, with Yi Wu, trans. *Cultivating the Empty Field: The Silent Illumination of Zen Master Hongzhi.* Rev. ed. Boston: Tuttle Publishing, 2000.

Snyder, Gary. *The Practice of the Wild.* New York: Farrar, Straus and Giroux, North Point Press, 1990.

Tanahashi, Kazuaki, ed. and trans. *Moon in a Dewdrop: Writings of Zen Master Dogen*. New York: Farrar, Straus and Giroux, North Point Press, 1985.

Thurman, Robert A. F. "Buddhist Monasticism: A Spiritual and Social Perspective." Unpublished manuscript for Vinaya Conference, San Francisco, 1990.

2. MAHAYANA HISTORY

Buddhist Text Translation Society; Bhikshuni Heng Tao, trans. *Buddha Speaks the Brahma Net Sutra: The Ten Major and Forty-eight Minor Bodhisattva Precepts*. Talmage, Calif: Dharma Realm Buddhist University, 1982.

Chang, Garma C. C., ed. *A Treasury of Mahayana Sutras: Selections from the Maharatnakuta Sutra*. University Park: Pennsylvania State University Press, 1983.

Chien, Cheng, Bhikshu, trans. *Manifestation of the Tathagata: Buddhahood According to the Avatamsaka Sutra*. Boston: Wisdom Publications, 1993.

Cleary, Thomas, trans. *Buddhist Yoga: A Comprehensive Course*. Boston: Shambhala, 1995. This is a translation of the Samdhinirmochana Sutra.

_____, trans. *Entry into the Inconceivable: An Introduction to Hua Yen Buddhism*. Honolulu: University of Hawaii Press, 1983.

_____, trans. *Entry into the Realm of Reality, the Guide: A Commentary on the Gandavyuha, by Li Tongxuan*. Boston: Shambhala, 1989.

_____, trans. *Entry into the Realm of Reality, the Text: The Gandavyuha, the Final Book of the Avatamsaka Sutra*. Boston: Shambhala, 1989.

_____, trans. *The Flower Ornament Scripture: A Translation of the Avatamsaka Sutra*. 3 vols. Boston: Shambhala, 1983–86.

Conze, Edward, trans. *Buddhist Scriptures*. Baltimore: Penguin Books, 1959.

_____, trans. *The Perfection of Wisdom in Eight Thousand Lines and Its Verse Summary*. Bolinas, Calif: Four Seasons Foundation, 1973.

Gregory, Peter N. *Tsung-mi and the Sinification of Buddhism*. Honolulu: University of Hawaii Press, 2002.

Hakeda, Yoshito S., trans. with commentary. *The Awakening of Faith; Attributed to Asvaghosha*. New York: Columbia University Press, 1967.

Hurvitz, Leon, trans. *Scripture of the Lotus Blossom of the Fine Dharma*. New York: Columbia University Press, 1976.

Ishida, Hoyu. *Myokonin O-Karu and Her Poems of Shinjin*. Kyoto: International Association of Buddhist Culture, 1991.

King, Sallie B. *Buddha Nature*. Albany: State University of New York Press, 1991.

Mizuno, Kogen. *Buddhist Sutras: Origin, Development, Transmission*. Tokyo: Kosei Publishing, 1982.

Muller, Charles, trans. *The Sutra of Perfect Enlightenment: Korean Buddhism's Guide to Meditation.* Albany: State University of New York Press, 1999.

Nagao, Gadjin. *Madhyamika and Yogacara: A Study of Mahayana Philosophies.* Trans. and ed. by L. S. Kawamura. Albany: State University of New York Press, 1991.

Powers, John, trans. *Wisdom of Buddha: The Samdhinirmocana Sutra.* Berkeley: Dharma Publishing, 1995.

Price, A. F., and Mou-Lam Wong, trans. *The Diamond Sutra and the Sutra of Hui Neng.* Berkeley: Shambhala, 1969.

Reeves, Gene, ed. *A Buddhist Kaleidoscope: Essays on the Lotus Sutra.* Tokyo: Kosei Publishing Co., 2002.

Sangharakshita. *The Eternal Legacy: An Introduction to the Canonical Literature of Buddhism.* London: Tharpa Publications, 1985.

Schopen, Gregory. *Bones, Stones, and Buddhist Monks: Collected Papers on the Archaeology, Epigraphy, and Texts of Monastic Buddhism in India.* Honolulu: University of Hawaii Press, 1997.

Suzuki, D. T., trans. *The Lankavatara Sutra: A Mahayana Text.* London: Routledge & Kegan Paul, 1932.

Thurman, Robert A. F., trans. *The Holy Teachings of Vimalakirti: A Mahayana Scripture.* University Park: Pennsylvania State University Press, 1976.

Watson, Burton, trans. The *Lotus Sutra.* New York: Columbia University Press, 1993.

Wayman, Alex, and Hideko Wayman, trans. *The Lion's Roar of Queen Srimala.* New York: Columbia University Press, 1974.

Yamamoto, Kosho, trans. *The Mahaparinirvana Sutra.* 3 vols. Oyama, Japan: Karinbunko, 1973.

3. THE TEN TRANSCENDENT PRACTICES

Aitken, Robert. *The Practice of Perfection: The Paramitas from a Zen Buddhist Perspective.* New York: Pantheon Books, 1994.

_____. *The Mind of Clover: Essays in Zen Buddhist Ethics.* New York: Farrar, Straus and Giroux, North Point Press, 1984.

Anderson, Tenshin Reb. *Being Upright: Zen Meditation and the Bodhisattva Precepts.* Berkeley: Rodmell Press, 2001.

_____. *Warm Smiles from Cold Mountains: A Collection of Talks on Zen Meditation.* San Francisco: San Francisco Zen Center, 1995.

Batchelor, Stephen, trans. *Guide to the Bodhisattva's Way of Life by Acharya Shantideva.* Dharamsala, India: Library of Tibetan Works and Archives, 1979. A classic text on the transcendent practices.

Chang, Garma C. C. *The Hundred Thousand Songs of Milarepa.* New York: Harper & Row, 1962.

_____. *A Treasury of Mahayana Sutras: Selections from the Maharatnakuta Sutra.* University Park: Pennsylvania State University Press, 1983. See "The Definitive Vinaya."

Cleary, Thomas, trans. *The Flower Ornament Scripture: A Translation of the Avatamsaka Sutra*. 3 vols. Boston: Shambhala, 1983–86. Especially chapter 21, "Ten Practices," and chapter 26, "The Ten Stages."

Hurvitz, Leon, trans. *Scripture of the Lotus Blossom of the Fine Dharma*. New York: Columbia University Press, 1976.

Hyde, Lewis. *The Gift: Imagination and the Erotic Life of Property*. New York: Vintage Books, 1979.

Kato, Bunno, Yoshiro Tamura, and Kojiro Miyasaka, trans. *The Threefold Lotus Sutra: Innumerable Meanings, The Lotus Flower of the Wonderful Law, and Meditation on the Bodhisattva Universal Virtue*. New York: Weatherhill, 1975.

Leighton, Taigen Daniel, and Shohaku Okumura, trans. *Dogen's Pure Standards for the Zen Community: A Translation of Eihei Shingi*. Albany: State University of New York Press, 1996.

Nhat Hanh, Thich. *For a Future to Be Possible: Commentaries on the Five Wonderful Precepts*. Berkeley: Parallax Press, 1993.

_____. *Interbeing: Commentaries on the Tiep Hien Precepts*. Rev. ed. Berkeley: Parallax Press, 1993.

Price, A. F., and Mou-Lam Wong, trans. *The Diamond Sutra and the Sutra of Hui Neng*. Berkeley: Shambhala, 1969.

Reps, Paul, and Nyogen Senzaki. *Zen Flesh Zen Bones: A Collection of Zen and Pre-Zen Writings*. Garden City, N.Y.: Doubleday Anchor Books. See stories 37, "Publishing the Sutras," 11 and 60, "The Tunnel."

Sato, Shunmyo. *Two Moons: Short Zen Stories*. Trans. by Rev. and Mrs. Shugen Komagata and Daniel Itto Bailey. Honolulu: Hawaii Hochi, 1981.

Thurman, Robert A. F., trans. *The Holy Teachings of Vimalakirti: A Mahayana Scripture*. University Park: Pennsylvania State University Press, 1976.

4. SHAKYAMUNI AS BODHISATTVA

Aitken, Robert, trans. *The Gateless Barrier: The Wu-men Kuan (Mumonkan)*. New York: Farrar, Straus and Giroux, North Point Press, 1990. See case 6 for the transmission to Mahakashyapa.

Cleary, Thomas, trans. and commentary. *No Barrier: Unlocking the Zen Koan, A New Translation of the Mumonkan*. New York: Bantam Books, 1993. See case 6.

_____, trans. *Shobogenzo: Zen Essays by Dogen*. Honolulu: University of Hawaii Press, 1986.

Ellsberg, Daniel. "The First Two Times We Met." In *Gary Snyder: Dimensions of a Life*, edited by Jon Halper. San Francisco: Sierra Club Books, 1991.

_____. *Secrets: Revealing the Pentagon Papers: A Memoir*. New York: Viking Press, 2002.

_____. "The Rolling Stone Interview" by Jann Wenner. San Francisco: Straight Arrow Publishers, 1973.

_____. Preface to *A Year of Disobedience*, by Joseph Daniel. Boulder, Colo.: Daniel Productions, 1979.

Hauser, Thomas. *Muhammad Ali: His Life and Times.* New York: Simon & Schuster, 1991.

Hirakawa, Akira. *A History of Indian Buddhism: From Sakyamuni to Early Mahayana.* Trans. and edited by Paul Groner, Honolulu: University of Hawaii Press, 1990. See chapter 2, "The Life of the Buddha."

Hurvitz, Leon, trans. *Scripture of the Lotus Blossom of the Fine Dharma.* New York: Columbia University Press, 1976. Chapters 15 and 16, "Welling Up Out of the Earth" and "The Life Span of the Thus Come One."

Ishigami, Zenno, ed. *Disciples of the Buddha.* Translated by Richard L. Gage and Paul McCarthy. Tokyo: Kosei Publishing, 1989.

Kalupahana, David J., and Indrani Kalupahana. *The Way of Siddhartha: A Life of Buddha.* Boulder, Colo.: Shambhala, 1982.

Kazantzakis, Nikos. *Saint Francis.* New York: Simon & Schuster, 1962.

Kelen, Betty. *Gautama Buddha: In Life and Legend.* New York: Avon Camelot, 1967.

Kim, Hee Jin. *Dogen Kigen: Mystical Realist.* Tucson: University of Arizona Press, 1975.

Kodera, Takashi James. *Dogen's Formative Years in China: An Historical Study and Annotated Translation of the "Hokyo-ki."* Boulder, Colo.: Prajna Press, 1980.

Loewen, James W. *Lies My Teacher Told Me: Everything Your American History Textbook Got Wrong.* New York: Touchstone, 1995.

Rahula, Walpola. *What the Buddha Taught.* Rev. ed. New York: Grove Press, 1974.

Strong, John S. "A Family Quest: The Buddha, Yasodhara, and Rahula in the Mulasarvastivada Vinaya." In *Sacred Biography in the Buddhist Traditions of South and Southeast Asia,* ed. by Juliane Schober. Honolulu: University of Hawaii Press, 1996. This excellent, illuminating article is my primary source for the Mahayana view of Shakyamuni's home-leaving and his family's role.

Suzuki, D. T. *Manual of Zen Buddhism.* New York: Grove Press, 1960.

Tanahashi, Kazuaki, ed. *Moon in a Dewdrop: Writings of Zen Master Dogen.* New York: Farrar, Straus and Giroux, North Point Press, 1985.

Walshe, Maurice. *Thus Have I Heard: The Long Discourses of the Buddha; Digha Nikaya.* London: Wisdom Publications, 1987.

Wray, Elizabeth, Clare Rosenfield, and Dorothy Bailey. *Ten Lives of the Buddha: Siamese Temple Paintings and Jataka Tales.* New York: Weatherhill, 1972.

Yamada, Koun, trans. *Gateless Gate.* Los Angeles: Center Publications, 1979. See case 6.

5. MANJUSHRI

Aitken, Robert, trans. *The Gateless Barrier: The Wu-men Kuan.* New York: Farrar, Straus and Giroux, North Point Press, 1990.

Chang, Garma C. C., ed. *A Treasury of Mahayana Sutras: Selections from the Maharatnakuta Sutra.* University Park: Pennsylvania State University Press, 1983. Includes "Manjushri's

Discourse on the Paramita of Wisdom," and "The Prediction of Manjushri's Attainment of Buddhahood."

Cleary, Thomas, trans. *The Book of Serenity*. Hudson, N.Y.: Lindisfarne Press, 1990.

_____, trans. *Entry into the Inconceivable: An Introduction to Hua Yen Buddhism*. Honolulu: University of Hawaii Press, 1983.

_____, trans. *Entry into the Realm of Reality, the Guide: A Commentary on the Gandavyuha*, by Li Tongxuan. Boston: Shambhala, 1989.

_____, trans. *The Flower Ornament Scripture: A Translation of the Avatamsaka Sutra*. 3 vols. Boston: Shambhala, 1983–1986.

_____, trans. and commentary. *No Barrier: Unlocking the Zen Koan, A New Translation of the Mumonkan*. New York: Bantam Books, 1993.

Cleary, Thomas, and J. C. Cleary, trans. *The Blue Cliff Record*. 3 vols. Boulder, Colo.: Shambhala, 1977. See case 35.

Conze, Edward, trans. *The Perfection of Wisdom in Eight Thousand Lines and Its Verse Summary*. Bolinas, Calif.: Four Seasons Foundation, 1973.

Dylan, Bob. *Lyrics, 1962–1985*. New York: Alfred A. Knopf, 1985.

Einstein, Albert. *The World As I See It*. New York: Philosophical Library, 1949,

Getty, Alice. *The Gods of Northern Buddhism: Their History, Iconography, and Progressive Evolution Through the Northern Buddhist Countries*. Oxford: Oxford University Press, 1914. Reprint Rutland, Vt.: Charles E. Tuttle, 1962.

Gomez, Luis O., "From the Extraordinary to the Ordinary: Images of the Bodhisattva in East Asia." In *The Christ and the Bodhisattva*, edited by Donald S. Lopez and Steven C. Rockefeller. Albany: State University of New York Press, 1987.

Gray, Michael. *Song & Dance Man III: The Art of Bob Dylan*. London: Continuum, 2000.

Hirakawa, Akira. *A History of Indian Buddhism: From Sakyamuni to Early Mahayana*. Trans. and edited by Paul Groner, Honolulu: University of Hawaii Press, 1990.

Joyce, James. *Finnegans Wake*. 1939. Harmondsworth, England: Penguin Books, 1976.

_____, *Ulysses*. New York: Modern Library, 1942.

Leighton, Taigen Daniel, and Shohaku Okumura, trans. *Dogen's Pure Standards for the Zen Community: A Translation of Eihei Shingi*. Albany: State University of New York Press, 1996.

Price, A. F. and Mou-Lam Wong, trans. *The Diamond Sutra and the Sutra of Hui Neng*. Berkeley: Shambhala, 1969.

Rhie, Marylin M., and Robert A. F. Thurman. *Wisdom and Compassion: The Sacred Art of Tibet*. New York: Harry N. Abrams, 1991.

Robbins, Paul Jay. "Bob Dylan As Bob Dylan." An interview in the *Los Angeles Free Press*, Sept. 17, 1965. Reprinted in *On the Tracks*, no. 9 (Feb. 1997), Grand Junction, Colo.

Saunders, E. Dale. *Mudra: A Study of Symbolic Gesture in Japanese Buddhist Sculpture*. Princeton: Princeton University Press, 1960.

Scobie, Stephen. *Alias Bob Dylan.* Red Deer, Alberta: Red Deer College Press, 1991.

Steinem, Gloria. *Moving Beyond Words.* New York: Simon & Schuster, 1994.

Thomson, Elizabeth, and David Gutman, eds. *The Dylan Companion.* New York: Delta, 1990.

Thurman, Robert A. F., trans. *The Holy Teachings of Vimalakirti: A Mahayana Scripture.* University Park: Pennsylvania State University Press, 1976.

_____, ed. *The Life and Teachings of Tsong Khapa.* Dharamsala, India: Library of Tibetan Works and Archives, 1982.

Twain, Mark. *The Prince and the Pauper.* New York: Harper, 1909.

Wayman, Alex, trans. *Chanting the Names of Manjushri: The Manjusri-Nama-Samgiti; Sanskrit and Tibetan Texts.* Boston: Shambhala, 1985.

Welch, Holmes. *The Practice of Chinese Buddhism: 1900–1950.* Cambridge: Harvard University Press, 1967.

Xu Yun. *Empty Cloud: The Autobiography of the Chinese Zen Master.* Tran. by Charles Luk. Longmead, England: Element Books, 1988.

Yamada, Koun, trans. *Gateless Gate.* Los Angeles: Center Publications, 1979.

6. SAMANTABHADRA

Ackroyd, Peter. *Blake.* New York: Alfred A. Knopf, 1996.

Birnbaum, Raoul. *The Healing Buddha.* Boston: Shambhala, 1989.

Blake, William. *Complete Writings.* Ed. by Geoffrey Keynes. London: Oxford University Press, 1966.

Carson, Rachel. *The Sea Around Us.* New York: Oxford University Press, 1951.

_____. *Silent Spring.* Boston: Houghton Mifflin, 1962.

Chang, Garma C. C., *The Buddhist Teaching of Totality: The Philosophy of Hwa Yen Buddhism.* University Park: Pennsylvania State University Press, 1971.

Chien, Cheng, Bhikshu, trans. *Manifestation of the Tathagata: Buddhahood According to the Avatamsaka Sutra.* Boston: Wisdom Publications, 1993.

Cleary, J. C. *Zibo: The Last Great Zen Master of China.* Berkeley: Asian Humanities Press, 1989.

Cleary, Thomas, trans. *Entry into the Inconceivable: An Introduction to Hua Yen Buddhism.* Honolulu: University of Hawaii Press, 1983.

_____, trans. *Entry into the Realm of Reality, the Guide: A Commentary on the Gandavyuha by Li Tongxuan.* Boston: Shambhala, 1989.

_____, trans. *Entry into the Realm of Reality, the Text: The Gandavyuha, the Final Book of the Avatamsaka Sutra.* Boston: Shambhala, 1989.

_____, trans. *The Flower Ornament Scripture: A Translation of the Avatamsaka Sutra.* 3 vols. Boston: Shambhala, 1983–86. Especially chapter 3, "The Meditation of the Enlight-

ening Being Universally Good"; chapter 6, "Vairocana"; chapter 11, "Purifying Practice"; chapter 26, "The Ten Stages"; chapter 36, "The Practice of Universal Good"; and chapter 39, "Entry into the Realm of Reality," published separately as *Entry into the Realm of Reality, the Text* (see above).

_____, trans. *Shobogenzo: Zen Essays by Dogen*. Honolulu: University of Hawaii Press, 1986. For "Ocean Seal Concentration" essay and introduction.

Dilgo Khyentse Rinpoche. *The Excellent Path to Enlightenment: Oral Teachings on the Root Text of Jamyang Khyentse Wangpo*. Ithaca, N.Y.: Snow Lion Publications, 1996. For Tibetan Vajrasattva practice.

Fischer, Louis. *Gandhi: His Life and Message for the World*. New York: New American Library, 1954.

Frye, Northrop, *Fearful Symmetry: A Study of William Blake*. Princeton: Princeton University Press, 1947.

Heng Sure, Rev. "Transforming Sacred Literature into Ritual: Jingyuan (1011–1088) and Development of the Avatamsaka Liturgy in Song China." Ph.D. Dissertation, Graduate Theological Union, Berkeley, 2002.

Hurvitz, Leon, trans. *Scripture of the Lotus Blossom of the Fine Dharma*. New York: Columbia University Press, 1976. Chapter 28, "The Encouragements of the Bodhisattva Universally Worthy."

Kahn, Roger. *The Boys of Summer*. New York: Harper & Row, 1971.

Kato, Bunno, Yoshiro Tamura, and Kojiro Miyasaka, trans. *The Threefold Lotus Sutra*. New York: Weatherhill, 1975. The "closing sutra" for the Lotus Sutra, "The Sutra of Meditation on the Bodhisattva Universal Virtue"; and chapter 28, "Encouragement of the Bodhisattva Universal Virtue."

King, Martin Luther, Jr. *I Have a Dream: Writings and Speeches That Changed the World*. San Francisco: HarperSanFrancisco, 1992.

LaFleur, William. *The Karma of Words: Buddhism and the Literary Arts in Medieval Japan*. Berkeley: University of California Press, 1983. Includes information on Eguchi, along with illuminating discussion of Buddhism in literary Japan.

Maida, Gaetano Kazuo. "Plan for Improvisation: An Interview with Pete Seeger." In *Whole Earth Review* no. 84 (winter 1994).

Moon, Susan. "Sailing in the Earthship: An Interview with Mayumi Oda." In *Turning Wheel* (summer 1993).

Musick, Phil. *Who Was Roberto? A Biography of Roberto Clemente*. New York: Doubleday & Co., 1974.

Oda, Mayumi. *Goddesses*. Volcano, Calif. Volcano Press, 1988.

Phelps, Dryden Linsley, and Mary Katharine Willmott, trans. *Pilgrimage in Poetry to Mount Omei*. Hong Kong: Cosmos Books, 1982.

Powell, William F., trans. *The Record of Tung-shan*. Honolulu: Kuroda Institute, University of Hawaii Press, 1986.

Raine, Kathleen. *William Blake*. New York: Oxford University Press, 1970.

Stone, Irving, ed. *Dear Theo: The Autobiography of Vincent Van Gogh*. New York: Doubleday & Co., 1937.

Suu Kyi, Aung San. "You Could Start by Convincing a Friend" (an interview), and "Burma's Aung San Suu Kyi on Why Women Should Lead." In *Shambhala Sun*, Halifax, Nova Scotia (January 1996).

Treble, Rosemary. *Van Gogh and His Art*. Northbrook, Ill.: Book Value International, 1975.

Watson, Burton, trans. *The Lotus Sutra*. New York: Columbia University Press, 1993. Chapter 28, "Encouragements of the Bodhisattva Universal Worthy."

7. AVALOKITESHVARA (GUANYIN, KANNON)

Anderson, Erica. *The Schweitzer Album: A Portrait in Words and Pictures; Additional Text by Albert Schweitzer*. New York: Harper & Row, 1965.

Austin, Shosan Victoria. "Suzuki Sensei's Zen Spirit." In *Buddhist Women on the Edge: Contemporary Perspectives from the Western Frontier*, edited by Marianne Dresser. Berkeley: North Atlantic Books, 1996.

Blofeld, John. *Bodhisattva of Compassion: The Mystical Tradition of Kuan Yin*. Boston: Shambhala, 1977.

Campany, Robert Ford. *Strange Writing: Anomaly Accounts in Early Medieval China*. Albany: State University of New York Press, 1996.

Cleary, Thomas, trans. *The Book of Serenity*. Hudson, N.Y.: Lindisfarne Press, 1990.

_____, trans. *Entry into the Realm of Reality, the Text: The Gandavyuha, the final book of the Avatamsaka Sutra*. Boston: Shambhala, 1989.

Cleary, Thomas, and J. C. Cleary, trans. *The Blue Cliff Record*. 3 vols. Boulder, Colo.: Shambhala, 1977.

Cook, Francis H. *Sounds of the Valley Streams: Enlightenment in Dogen's Zen*. Albany: State University of New York Press, 1989. See the translation of Dogen's "Kannon" essay with his commentary on the "Reaching back for the pillow at midnight" koan.

Hitchens, Christopher. *The Missionary Position: Mother Teresa in Theory and Practice*. Verso, 1995.

Hurvitz, Leon, trans. *Scripture of the Lotus Blossom of the Fine Dharma*. New York: Columbia University Press, 1976.

Kamenetz, Rodger. *The Jew in the Lotus*. San Francisco: Harper, 1995.

Kawai, Hayao. *Dreams, Myths and Fairy Tales in Japan*. Einsiedeln, Switzerland: Daimon, 1995. A Japanese Jungian analyst's discussion of Japanese dream records and folklore.

LaMotte, Etienne, trans. *Suramgamasamadhisutra: The Concentration of Heroic Progress*. Trans. from the French by Sara Webb-Boin. London: Curzon Press, 1998.

Lu, K'uan Yu [Charles Luk]. *The Secrets of Chinese Meditation*. New York: Samuel Weiser, 1964.

_____, trans. *The Surangama Sutra.* London: Rider & Co., 1966. For meditation on sound.

Matsunaga, Alicia. *The Buddhist Philosophy of Assimilation.* Rutland, Vt: Charles E. Tuttle, 1969. Contains an extremely helpful account of the seven primary iconographic forms of Avalokiteshvara, and the thirty-three Guanyins.

Matsunaga, Daigan, and Alicia Matsunaga. *Foundations of Japanese Buddhism.* 2 vols. Los Angeles: Buddhist Books International, 1976.

Mills, D. E. *A Collection of Tales from Uji: A Study and Translation of Uji Shui Monogatari.* Cambridge, England: Cambridge University Press, 1970. A rich thirteenth-century compilation of Japanese folklore. See stories 89, "How Kannon Came to Take the Waters at Tsukuma Hot Springs," and 108, "How a Girl from Tsuruga was Aided by Kannon."

Nakamura, Kyoko Motomichi, trans. and ed. *Miraculous Stories from the Japanese Buddhist Tradition: The Nihon Ryoiki of the Monk Kyokai.* Cambridge: Harvard University Press, 1973. Late eighth-century compilation of miracle tales. See stories II.26, II.34, and III.12.

Nattier, Jan. "The Heart Sutra: A Chinese Apocryphal Text?" In *Journal of the International Association of Buddhist Studies* 15, no. 2 (1992). A brilliant scholarly analysis of the Chinese origins of the *Heart Sutra.*

Palmer, Martin, and Jay Ramsay with Man-Ho Kwok. *Kuanyin: Myths and Prophecies of the Chinese Goddess of Compassion.* London: Thorsons, 1995.

Sangharakshita. *The Eternal Legacy: An Introduction to the Canonical Literature of Buddhism.* London: Tharpa Publications, 1985.

Sasaki, Ruth Fuller, Yoshitaka Iriya, and Dana R. Fraser, trans. *The Recorded Sayings of Layman P'ang. A Ninth-Century Zen Classic.* New York: Weatherhill, 1971.

Sawa, Takaaki. *Art in Japanese Esoteric Buddhism.* Trans. by Richard L. Gage. New York: Weatherhill/Heibonsha, 1972.

Spink, Kathryn, ed. *Life in the Spirit. Reflections, Meditations, Prayers; Mother Teresa of Calcutta.* San Francisco: Harper & Row.

Suzuki, Mitsu. *Temple Dusk: Zen Haiku.* Trans. by Kazuaki Tanahashi and Gregory Wood. Berkeley: Parallax Press, 1991.

Tanahashi, Kazuaki, ed. *Moon in a Dewdrop: Writings of Zen Master Dogen.* New York: Farrar, Straus and Giroux, North Point Press, 1985.

Tingley, Nancy. "Avalokitesvara in Javanese Context: Mandala, Kutagara and Amoghapasa." Unpublished manuscript, 1996.

8. KSHITIGARBHA (JIZO)

Bays, Jan Chozen. *Jizo Bodhisattva: Modern Healing & Traditional Buddhist Practice.* Boston: Tuttle Publishing, 2002. A fine new work on Jizo practice.

Bolen, Jean Shinoda. *Goddesses in Everywoman: A New Psychology of Women.* New York: Harper Perennial, 1984. See chapters on Demeter and Persephone.

Buddhist Text Translation Society; Bhikshunis Heng Hsien, Heng Ch'ih, and Upasaka Kuo

Jung Epstein, trans. *Sutra of the Past Vows of Earth Store Bodhisattva.* Talmage, Calif: Dharma Realm Buddhist University, 1982. The standard English version of the sutra.

De Visser, Marinus W. *The Bodhisattva Akasagarbha (Kokuzo) in China and Japan.* Amsterdam: Verhandeligen Der Koninklijke Akademie Van Wetenschappen Te Amsterdam Afdeeling Letterkunde Niuuwe Reeks, deel 30, no. 1 (1931).

_____. *The Bodhisattva Ti-Tsang (Jizo) in China and Japan.* Berlin: Osterheld & Co., 1914. An exceptional scholarly study of Jizo (still easily the most comprehensive in English) that richly deserves modern re-publication.

Eliade, Mircea. *Shamanism: Archaic Techniques of Ecstasy.* Princeton: Princeton Universioty Press, 1972.

Fraim, John. *Spirit Catcher: The Life and Art of John Coltrane.* West Liberty, Ohio: GreatHouse, 1996.

Glassman, Hank. "The Nude Jizo at Denkoji: Notes on Women's Salvation in Kamakura Buddhism." In *Women and Pre-modern Japanese Buddhism,* ed. by Barbara Ruch. Ann Arbor: Michigan Center for Japanese Studies, forthcoming.

Gomez, Luis O. "From the Extraordinary to the Ordinary: Images of the Bodhisattva in East Asia." In *The Christ and the Bodhisattva,* edited by Donald S. Lopez and Steven C. Rockefeller. Albany: State University of New York Press, 1987. A very helpful discussion of perspectives on the bodhisattvas; includes several Jizo folk stories referred to in this chapter.

Halifax, Joan. *Shamanic Voices: A Survey of Visionary Narratives.* New York: E. P. Dutton, 1979.

Harner, Michael. *The Way of the Shaman.* New York: Bantam, 1982.

LaFleur, William. "The Cult of Jizo: Abortion Practices in Japan and What They Can Teach the West." In *Tricycle* 4, no. 4 (summer 1995).

_____. *Liquid Life: Abortion and Buddhism in Japan.* Princeton: Princeton University Press, 1992. A contemporary study of the ethical implications of the mizuko ceremony, including Jizo's role.

Merton, Thomas. "Thomas Merton's View of Monasticism." In *The Asian Journal of Thomas Merton.* New York: New Directions, 1975.

Mills, D. E. *A Collection of Tales from Uji: A Study and Translation of Uji Shui Monogatari.* Cambridge, England: Cambridge University Press, 1970. See story 16, "How a Nun Saw Jizo."

Morrison, Toni. *Beloved.* New York: Alfred A. Knopf, 1987.

_____. *Jazz.* New, York: Alfred A. Knopf, 1992.

Nhat Hanh, Thich. *Being Peace.* Berkeley: Parallax Press, 1987.

_____. *Call Me by My True Names: The Collected Poems of Thich Nhat Hanh.* Berkeley: Parallax Press, 1993.

_____. *Love in Action.* Berkeley: Parallax Press, 1993.

_____. *Touching Peace: Practicing the Art of Mindful Living.* Berkeley: Parallax Press, 1992.

Powell, William. "Literary Diversions on Mount Jiuhua: Cults, Communities and Culture." In *The Sacred Mountains of East Asia,* ed. by John Einarsen. First published in *Kyoto Journal,* no. 25 (1993); re-published by Shambhala, 1995.

Schneider, Tensho David. *Street Zen: The Life and Work of Issan Dorsey.* Boston: Shambhala, 1993.

Teiser, Stephen F. *The Scripture on the Ten Kings and the Making of Purgatory in Medieval Chinese Buddhism.* Honolulu: University of Hawaii Press, 1994.

Waddell, Norman. *The Essential Teachings of Zen Master Hakuin.* Boston: Shambhala, 1994.

Walsh, Roger. *The Spirit of Shamanism.* Los Angeles: Jeremy P. Tarcher, 1990.

Wiesel, Elie. *All Rivers Run to the Sea.* New York: Alfred A. Knopf, 1995.

_____, *Night.* trans. from the French by Stella Rodway. New York: Bantam, 1960.

_____. *One Generation After.* New York: Random House, 1970.

Yamada, Patricia. "The Worship of Jizo." *Kyoto Journal* (spring 1987). A useful overview of Japanese Jizo worship.

9. MAITREYA

Abe, Ryuichi, and Peter Haskel, trans. with essays. *Great Fool: Zen Master Ryokan; Poems, Letters, and Other Writings.* Honolulu: University of Hawaii Press, 1996.

Cleary, J. C., trans. with commentary. *A Buddha from Korea: The Zen Teachings of T'aeg'o.* Boston: Shambhala, 1988. The introduction provides a useful summary of White Lotus and Korean Buddhist histories.

Cleary, Thomas, trans. *Entry into the Realm of Reality, the Text: The Gandavyuha, the Final Book of the Avatamsaka Sutra.* Boston: Shambhala, 1989.

Cleary, Thomas, and J. C. Cleary, trans. *The Blue Cliff Record.* Boulder, Colo.: Shambhala, 1977. Vol. 2. For Mahasattva Fu, see case 67 and the end biographies.

Conze, Edward, trans. *Buddhist Scriptures.* Baltimore: Penguin Books, 1959.

_____, trans. *The Perfection of Wisdom in Eight Thousand Lines and Its Verse Summary.* Bolinas, Calif: Four Seasons Foundation, 1973. See chapter 6 for Maitreya's dedication and jubilation.

Gomez, Luis O. "From the Extraordinary to the Ordinary: Images of the Bodhisattva in East Asia." In *The Christ and the Bodhisattva,* ed. by Donald S. Lopez and Steven C. Rockefeller. Albany: State University of New York Press, 1987.

Hurvitz, Leon, trans. *Scripture of the Lotus Blossom of the Fine Dharma.* New York: Columbia University Press, 1976. See chapter 1, "Introduction," and chapter 28, "The Encouragements of the Bodhisattva Universally Worthy."

Jung, C. G. *Memories, Dreams, and Reflections.* Rev. ed. Recorded and ed. by Aniela Jaffe. Trans. by Richard Winston and Clara Winston. New York: Vintage Books, 1973.

Kusan Sunim, *The Way of Korean Zen.* Translated by Martine Fages. Ed. with introduction by Stephen Batchelor. New York: Weatherhill, 1985.

LaMotte, Etienne. *History of Indian Buddhism: From the Origins to the Saka Era.* Translated from the French by Sara Webb-Boin. LouvainParis: Peeters Press, 1988.

Leighton, Taigen Daniel. "Being Time Through Deep Time." *Tricycle* 5, no. 4 (summer, 1996).

_____. "Now Is the Past of the Future." *Shambhala Sun,* Halifax, Nova Scotia (September 1996).

Leighton, Taigen Daniel, and Shohaku Okumura, trans. *Dogen's Pure Standards for the Zen Community.* Albany: State University of New York Press, 1996.

Leighton, Taigen Daniel, and Kazuaki Tanahashi. Trans. of poems by Ryokan in *Essential Zen,* ed. by Kazuaki Tanahashi and Tensho David Schneider. San Francisco: HarperSanFrancisco, 1994.

Li Rongxi, trans., *A Biography of the Trpitika Master of the Great Ci'en Monastery of the Great Tang Dynasty.* Berkeley: Numata Center for Buddhist Translation and Research, 1995. A traditional Chinese biography of Xuanzang.

Macy, Joanna. *Despair and Personal Power in the Nuclear Age.* Philadelphia: New Society Publishers, 1983.

_____. *Widening Circles: A Memoir.* Gabriola Island, B.C.: New Society Publishers, 2000.

_____. *World As Lover, World As Self.* Berkeley: Parallax Press, 1991.

Matsunaga, Alicia. *The Buddhist Philosophy of Assimilation.* Rutland, Vt.: Charles E. Tuttle, 1969.

Miura, Isshu, and Ruth Fuller Sasaki. *Zen Dust: The History of the Koan and Koan Study in Rinzai Zen.* New York: Harcourt, Brace & World, 1966. See the entry for Mahasattva Fu, pp. 262–64.

Nakamura, Kyoko Motomichi, trans. and ed. *Miraculous Stories from the Japanese Buddhist Tradition: The Nihon Ryoiki of the Monk Kyokai.* Cambridge: Harvard University Press, 1973.

Naquin, Susan. *Millenarian Rebellions in China: The Eight Trigrams Uprising of 1813.* New Haven: Yale University Press, 1974.

Naquin, Susan, and Evelyn Rawski. *Chinese Society in the Eighteenth Century.* New Haven: Yale University Press, 1987.

Price, Robert. *Johnny Appleseed: Man and Myth.* Bloomington: Indiana University Press, 1954.

Ram Dass. *Be Here Now.* Cristobal, N.M.: Lama Foundation, 1971.

_____. *Still Here: Embracing Aging, Changing and Dying.* New York: Riverhead Books, 2000.

Seed, John, Joanna Macy, Pat Fleming, and Arne Naess. *Thinking Like a Mountain: Towards a Council of All Being.* Santa Cruz, Calif.: New Society Publishers, 1988.

Sowash, Rick. *A Book of Ohio Heroes.* Bowling Green, Ohio: Gabriel's Horn Publishing, 1997. See chapter on John Chapman.

Sponberg, Alan. "Meditation in Fa-hsiang Buddhism." In *Traditions of Meditation in Chinese Buddhism,* edited by Peter Gregory. Honolulu: University of Hawaii Press, 1987.

Sponberg, Alan, and Helen Hardacre, eds. *Maitreya*. Princeton: Princeton University Press, 1986. This is an excellent scholarly overview and source for much of the history of the Maitreya figure.

Suzuki, D. T. *Manual of Zen Buddhism*. New York: Grove Press, 1960. See section on Ten Oxherding Pictures, including picture of Hotei.

Ter Haar, B. J. *The White Lotus Teachings in Chinese Religious History*. Honolulu: Universtty of Hawai'i Press, 1999.

Thoreau, Henry David. *Walden, or, Life in the Woods*. New York: Vintage Books, 1991.

Thurman, Robert A. F., trans. *The Holy Teachings of Vimalakirti: A Mahayana Scripture*. University Park: Pennsylvania State University Press, 1976. See chapter 4 for Vimalakirti's critique.

Watson, Burton, trans. *Ryokan: Zen Monk-Poet of Japan*. New York: Columbia University Press, 1977.

Welch, Lew. *Ring of Bone: Collected Poems 1950–1971*. San Francisco: Grey Fox Press, 1979.

Willis, Janice Dean, trans. *On Knowing Reality: The Tattvartha Chapter of Asanga's Bodhisattvabhumi*. New York: Columbia University Press, 1979. See the introduction for the story of Asanga and the dog.

Wriggins, Sally Hovey. *Xuanzong: A Buddhist Pilgrim on the Silk Road*. Boulder: Westview Press, 1996.

10. VIMALAKIRTI

Ariail, Dan, and Cheryl Heckler-Feltz. *The Carpenter's Apprentice: The Spiritual Biography of Jimmy Carter*. Grand Rapids, Mich.: Zondervan Publishing House, 1996.

Cleary, Thomas, trans. *The Book of Serenity*. Hudson, N.Y.: Lindisfarne Press, 1990. See case 48.

Cleary, Thomas, and J. C. Cleary, trans. *The Blue Cliff Record*. 3 vols. Boulder, Colo.: Shambala, 1977. See case 84.

Foner, Philip S., ed. *Helen Keller, Her Socialist Years: Writings and Speeches*. New York: International Publishers, 1967.

Gaustad, Edwin S. *Sworn on the Altar of God: A Religious Biography of Thomas Jefferson*. Grand Rapids, Mich.: William B. Eerdmans Publishing, 1996.

Halper, Jon, ed. *Gary Snyder: Dimensions of a Life*. San Francisco: Sierra Club Books, 1991.

Keene, Donald, editor. *Anthology of Japanese Literature: From the Earliest Era to the Mid–nineteenth Century*. N.Y.: Grove Press, Inc., 1955. Along with other important works, includes Kamo No Chomei's "Record of My Ten-Foot-Square Hut."

LaMotte, Etienne, trans. (from Chinese to French) *The Teaching of Vimalakirti*. Translated from French by Sara Boin. London: Routledge & Kegan Paul, 1976. An excellent scholarly translation with valuable notes and essays.

Leighton, Taigen Daniel, with Yi Wu, trans. *Cultivating the Empty Field: The Silent Illumination of Zen Master Hongzhi*. Rev. ed. Boston: Tuttle Publishing, 2000.

Loewen, James W. *Lies My Teacher Told Me: Everything Your American History Textbook Got Wrong*. New York: Touchstone, 1995. A valuable source on the truth about Helen Keller, Jefferson, and other misrepresentations of history.

Roddick, Anita. *Body and Soul*. New York: Crown Publishers, 1991.

Sasaki, Ruth Fuller, Yoshitaka Iriya, and Dana, R. Fraser, trans. *The Recorded Sayings of Layman Pang*. New York: Weatherhill, 1971.

Schwarz, Benjamin. "What Jefferson Helps to Explain." *Atlantic Monthly* 279, no. 3 (March 1997).

Siegel, Scott. *Encyclopedia of Hollywood*. New York: Facts on File, 1990.

Snyder, Gary. *Mountains and Rivers Without End*. Washington, D.C.: Counterpoint, 1996.

_____. *A Place in Space*. Washington, D.C.: Counterpoint, 1995. Including "The Incredible Survival of Coyote."

_____. *The Practice of the Wild*. New York: Farrar, Straus and Giroux, North Point Press, 1990.

_____. *The Real Work: Interviews and Talks 1964–1979*. New York: New Directions, 1980.

Thurman, Robert A. F., trans. *The Holy Teachings of Vimalakirti: A Mahayana Scripture*. University Park: Pennsylvania State University Press, 1976. The standard English version, translated from the Tibetan.

Utne, Eric, with comments by Anita Roddick, Jon Entine, and others. "Beyond the Body Shop Brouhaha." *Utne Reader* (January–February 1995).

Watson, Burton, trans. *The Vimalakirti Sutra*. New York: Columbia University Press, 1997. A new translation from the Chinese.

Yu, Pauline, trans. and commentary. *The Poetry of Wang Wei*. Bloomington: Indiana University Press, 1980.

11. BEYOND THE ARCHETYPAL

Dylan, Bob. *Lyrics, 1962–1985*. New York: Alfred A. Knopf, 1985.

Loewen, James W. *Lies My Teacher Told Me: Everything Your American History Textbook Got Wrong*. New York: Touchstone, 1995.

Loy, David R. *A Buddhist History of the West: Studies in Lack*. Albany: State University of New York Press, 2002.

Meade, Michael. *Men and the Water of Life: Initiation and the Tempering of Men*. San Francisco: HarperSanFrancisco, 1993. A wonderful book about stories.

Index

About the Author

 TAIGEN DAN LEIGHTON is a Soto Zen priest and Dharma successor in the lineage of Shunryu Suzuki Roshi. Taigen first studied Buddhist art and culture in Japan in 1970, and began formal everyday meditation practice in 1975 at the New York Zen Center with Kando Nakajima Roshi. Taigen graduated in East Asian Studies and studied Japanese language at Columbia College. Through the 70s he was an award-winning documentary film editor in New York and San Francisco.

Taigen began to work full time for the San Francisco Zen Center in 1979, and resided for years there as well as at Tassajara Monastery and Green Gulch Farm Zen Center. He was ordained in 1986 by Reb Anderson Roshi. Taigen also resided for two years in Kyoto, Japan, practicing with several Japanese Soto Zen teachers, including a monastic practice period.

Taigen founded the Mountain Source Sangha meditation groups in Bolinas in 1994, since then adding branches in San Rafael and San Francisco. He received Dharma Transmission in 2000 from Reb Anderson.

Taigen teaches at the Berkeley Graduate Theological Union and has taught at a number of other universities. He has been active in many interfaith dialogue programs, including extensive work with Buddhist-Christian dialogue, and has also studied Native American spiritual practice. He has long been active in diverse engaged Buddhist programs for social justice.

Taigen is co-translator and editor of several Zen texts including: *Cultivating the Empty Field; The Wholehearted Way;* and *Dogen's Pure Standards for the Zen Community.* His translation together with Shohaku Okumura of *Eihei Koroku,* Dogen's monumental *Extensive Record,* is forthcoming from Wisdom Publications.

Wisdom Publications

WISDOM PUBLICATIONS, a not-for-profit publisher, is dedicated to making available authentic Buddhist works for the benefit of all. We publish translations of the sutras and tantras, commentaries and teachings of past and contemporary Buddhist masters, and original works by the world's leading Buddhist scholars. We publish our titles with the appreciation of Buddhism as a living philosophy and with the special commitment to preserve and transmit important works from all the major Buddhist traditions.

To learn more about Wisdom, or to browse books online, visit our website at wisdompubs.org. You may request a copy of our mail-order catalog online or by writing to:

<div align="center">

WISDOM PUBLICATIONS
199 Elm Street
Somerville, Massachusetts 02144 USA
Telephone: (617) 776-7416
Fax: (617) 776-7841
Email: info@wisdompubs.org
www.wisdompubs.org

</div>

THE WISDOM TRUST

As a not-for-profit publisher, Wisdom is dedicated to the publication of fine Dharma books for the benefit of all sentient beings and dependent upon the kindness and generosity of sponsors in order to do so. If you would like to make a donation to Wisdom, please do so through our Somerville office. If you would like to sponsor the publication of a book, please write or email us at the address above.

Thank you.

Wisdom is a nonprofit, charitable 501(c)(3) organization affiliated with the Foundation for the Preservation of the Mahayana Tradition (FPMT).